WOMEN AND WARFARE
IN THE ANCIENT WORLD

*In memory of my mother, who had too many battles
and
For Elena, who I hope will have far fewer*

WOMEN AND WARFARE IN THE ANCIENT WORLD

MYTH, LEGEND AND REALITY

Karlene Jones-Bley

PEN & SWORD HISTORY

AN IMPRINT OF PEN & SWORD BOOKS LTD.
YORKSHIRE – PHILADELPHIA

First published in Great Britain in 2024 by
PEN AND SWORD HISTORY
An imprint of
Pen & Sword Books Ltd
Yorkshire – Philadelphia

Copyright © Karlene Jones-Bley, 2024

ISBN 978 1 39906 891 8

The right of Karlene Jones-Bley to be identified as Author of this work has been asserted by her in accordance with the Copyright, Designs and Patents Act 1988.

A CIP catalogue record for this book is available from the British Library.

All rights reserved. No part of this book may be reproduced or transmitted in any form or by any means, electronic or mechanical including photocopying, recording or by any information storage and retrieval system, without permission from the Publisher in writing.

Typeset in Times New Roman 10.5/13 by
SJmagic DESIGN SERVICES, India.
Printed and bound in the UK by CPI Group (UK) Ltd.

Pen & Sword Books Limited incorporates the imprints of Archaeology, Atlas, Aviation, Battleground, Digital, Discovery, Family History, Fiction, History, Local, Local History, Maritime, Military, Military Classics, Politics, Select, Transport, True Crime, After the Battle, Air World, Claymore Press, Frontline Publishing, Leo Cooper, Remember When, Seaforth Publishing, The Praetorian Press, Wharncliffe Books, Wharncliffe Local History, Wharncliffe Transport, Wharncliffe True Crime and White Owl.

For a complete list of Pen & Sword titles please contact:
PEN & SWORD BOOKS LIMITED
George House, Units 12 & 13, Beevor Street, Off Pontefract Road,
Barnsley, South Yorkshire, S71 1HN, England
E-mail: enquiries@pen-and-sword.co.uk
Website: www.pen-and-sword.co.uk

or

PEN AND SWORD BOOKS
1950 Lawrence Rd, Havertown, PA 19083, USA
E-mail: uspen-and-sword@casematepublishers.com
Website: www.penandswordbooks.com

Maps created by Bley Geographics

Contents

Preface .. vii
Acknowledgements ... viii
List of Illustrations ... x
Abbreviations .. xi
Introduction ... xii
 Virgins, Viragos and Amazons xvi
 The Effects of War on Women xviii
 Women Do Not Fight .. xix
 Women Do Fight .. xxiii
 Methodology .. xxiv

Chapter 1 In the Beginning: Mythological Figures 1
 Mesopotamian War Goddesses 2
 Ugaritic War Goddesses ... 7
 Egyptian War Goddesses ... 10
 Common Themes Among the Goddesses 11
Chapter 2 Indo-European Goddesses Affiliated with War 16
 The Hittites .. 16
 The Iranian Goddesses .. 19
 The Greek Goddesses .. 20
 The Armenian Goddess ... 29
 The Roman Goddesses .. 29
 The Celtic Goddesses .. 31
 Continental and British Goddesses 33
 The Irish Celts ... 34
 The Germanic Goddesses ... 37
 The Slavic Goddess ... 44
 The Indic Goddesses ... 45
 Summary of Chapters 1 and 2 50
Chapter 3 Legendary Figures – Mortal and Supernatural 53
 The Amazons ... 54
 The Greeks .. 64
 The Romans ... 66
 The Persians .. 67

	The Celts	69
	Germanic Legends	74
	The Scandinavians	75
	The Balkans	80
	An Indic Legend	80
	Back to Britain and a Segue to History	81
	Summary	82
Chapter 4	Archaeological Evidence	83
	A Warrior's Grave	85
	Modern Evidence from the West	86
	The Steppe Evidence	92
	The Physical Evidence	96
	Recent Finds	100
	Wheeled Vehicles	103
Chapter 5	Historical Women Through the Roman Period	108
	The Near East	111
	The Iranian Speakers	115
	Anatolia	116
	The Greeks	119
	Macedonia	120
	The Romans	124
	The Celts	131
	The Germanic People	140
	Palmyra	141
	The Goths	143
Chapter 6	Historical Women from the Roman Period to 1492	145
	Byzantium	146
	The Slavs	148
	The Anglo-Saxons	149
	Post-Conquest Britain	157
	The Continent and Beyond	170
	India	175
	Non-Royal Women	175
	The Iberian Peninsula	177

Conclusion	183
Endnotes	187
Bibliography	207
Classical References	235
Index	238

Preface

This book is concerned with the earliest aspects of women in war. These early references tend to be mythological and refer to goddesses or legendary women. Nevertheless, it is useful to address this material, for myths and legends often encode the cultural truths and values in a society and endure behind the historical women in war and the archaeological remains left behind, thereby giving credence to my argument.

The purpose of this book is to show that women, both mythological and real, have been involved in military matters as long as we have had writing, and the archaeology supplies evidence of the presence of women on the battlefield even before this.

A first impression may be that this book is about goddesses. It is not. There are, indeed, many goddesses between the covers of the book, but they are by no means the primary subject. The goddesses are a backdrop whose purpose is to set the cultural stage for the real women that will act upon it. This book is about women who have dealt with war – and not just on the battlefield. The only goddesses featured are those that have connections to war, and while there are many very interesting details beyond the martial aspects of these divinities, they are best found in more specialised volumes – of which there are many. This book is not one of those, nor was it intended to be.

Acknowledgements

As no parent raises a child alone, no author writes in isolation. I am indebted to so many colleagues, friends and sometimes casual acquaintances who have encouraged me in the overlong gestation of this project. Here, I include my major debts knowing I have neglected many more.

First, I must acknowledge my debt to the many scholars (both alive and dead) who unknowingly contributed to this work, and the museums that so generously gave me permission to reproduce illustrations.

I am forever grateful to the late Vladislav Ivanovich Mamontov of Volgograd, Russia, for allowing me to use his unpublished site reports and the friendship he gave me during my first trips to the Soviet Union. I am also indebted to other Russian colleagues who became friends: Svetlana Sharapova, Natalia Berseneva and Ludmila Koryakova, who sent copies of their extremely useful and greatly appreciated work to me. Again, from Russia, I must include my late dear friend Natasha Kharkovskaya, whose encouragement in my work was given with such joy and affection even in her last days.

A 1997 version of this book, in the form of a paper, was published in Russian in *STRamym: STRukmury i kama STRofy,* St Petersburg, Russia, thanks to my Moldovan colleague, also turned friend, Igor Manzura, thereby starting me on this road.

Somewhat later, Mary Bachvarova of Willamette University, Salem, Oregon, invited me in 2004 to present later views on this subject in a lecture entitled '*Arma Feminasque Cano:* Indo-European Warrior Women', sponsored by the Archaeological Institute of America, Salem Society, Willamette University. Still later, in 2008, Katheryn Linduff and Karen Rubinson asked me to contribute to their volume *Are all Warriors Male?*, where more thoughts on the subject were presented. From this point, my thoughts of a paper grew into a book.

Drafts of the book that were too early read by Miriam Dexter and the late Paula Coe, who moved me away from a number of errors. Several anonymous reviewers – even the ones that were not too kind – made important comments and suggestions that resulted in significant improvements.

Two close friends and scholars from very different fields, Mei Nakachi and Brenda Wright, provided outsiders' views and asked thought-provoking

Acknowledgements

questions. Bonnie Barr, Kathleen Blackburn and Mary Hetherington just kept wondering when I would finish.

Leigh Hansen, whose first language I and others believe is Latin, saved me from some linguist embarrassments, while Deborah Anderson introduced me to the mysteries of Unicode.

My dear friend and colleague Angela Della Volpe listened, read and commented throughout the process over many three-hour lunches.

The wonderful maps were drawn by Andrew Bley, my cartographer son, who was very patient with me through the many changes I made to them.

I am fortunate to have a very supportive family particularly my husband, Kenneth Bley, who not only helped with proof reading but was tolerant of so many makeshift or take-out dinners. Happily, on more than one occasion our son Christopher, and his culinary skills stepped into the breach. My daughter-in-law, Luciana, and grandchildren, Ryan and Elena, were always encouraging about my work.

My debt to my treasured friend and colleague Martin Huld is without measure. Our discussions of this work beginning in its embryonic phase to the final production have inspired me, encouraged me, and by his insightful questions, comments and criticisms, added to my understanding of the topic. He has made numerous recommendations that I have incorporated, some acknowledged in the text, but many more undoubtedly simply absorbed.

I am sure I have neglected more than one person, and I beg their forgiveness.

It goes without saying, all errors are mine alone.

List of Illustrations

1. Akkadian cylinder seal impression of the goddess Ishtar in her warrior aspect with her lion. (Photo Number 064706) (Courtesy of the Institute for the Study of Ancient Cultures of the University of Chicago)

2. Death of Penthesilea at the hands of Achilles. Black-figure amphora signed by Exekias with names included. (Museum number 1836,0224.127) (Courtesy of the British Museum)

3. Sketch of archaeological grave found and labelled 'Bj.581' by Hjalmar Stolpe. Birka, Sweden. Drawn by Evald Hansen, 1889.

4. Marble Relief of Two Female Gladiators from Halicarnassus. (Museum number 1847,0424.19) (Courtesy of the British Museum)

5. The Wedding Feast of the Empress Matilda and Henry V. (Courtesy of The Parker Library, Corpus Christi College Cambridge, MS 373, fo. 95b: by courtesy of the Master and Fellows of Corpus Christi College Cambridge)

6. Queen Isabella I of Spain, Queen of Castile (1451–1504), ca. 1470–1520. (RCIN 403445) (Courtesy of the Royal Collection Trust)

Map 1. The Ancient Near East: Generalised Areas, Various Time Periods

Map 2. Early Distribution of Major Indo-European Language Groups

Map 3. Britain: ca. AD 900 to 918

Map 4. Iberia Generalised Regions: ca. AD 1150 to 1492

Abbreviations

ASC	*Anglo-Saxon Chronicle*
Av.	*Avesta*
AVS	*Atharva-Veda Samhitā*
ca.	circa
CIL	*Corpus Inscriptionum Latinarum*
FGrHist	*Die Fragmente der griechischen Historiker*
IE	Indo-European
JIES	*Journal of Indo-European Studies*
PIE	Proto-Indo-European
r.	reign
RV	*Rigveda*
RIB	Roman Inscriptions of Britain (https://romaninscriptionsofbritain.org)
SHA	*Scriptores Historiae Augustae*

Introduction

The subject of women and warfare has captivated audiences at least from the time of the ancient Greeks and has been written about repeatedly, stimulating the imaginations of both serious scholars and members of the lunatic fringe. The converse of notions of women in war, whether sober or fantastic, is the equally implausible denial that they have had any part in warfare at all. The idea that war is an exclusively male occupation is also an ancient claim as old at least as Homer, who proclaimed: 'war shall be for men' (*Iliad* 6: l. 492), and repeated in modern times 'Women … do not fight … [W]arfare … is an entirely masculine activity' (Keegan 1993: 76). But if war is an entirely male activity, why do we find so much evidence for women being engaged, one way or another, in war and why is the evidence of their involvement in many levels of warfare so widespread and ancient? The answer, of course, is that it is not an entirely masculine activity. From our earliest writings we learn of women involved in war. These women, or female figures, appear not only as historical, living women, but also as mythical and legendary figures, and the stories of these females come from all over the world. We find military women on all continents except Antarctica. We hear of women leading armies into battle – confirming the fact that women not only fight, but also command troops and are deeply involved in warfare.

Our first literary reference to fighting women comes from the *Iliad*, but even this reference is already seen as ancient as it comes from Priam's memory. He recalls his youthful military exploits 'on the day when the Amazons, peers of men, came' (3.189). This first mention of women in combat establishes them not only as good fighters, but worthy of praise by a man. Following this first reference to women in combat, the number of books and references to women engaged in warfare has grown massively in number, certainly to hundreds if not thousands.

Much of what we know about these fighting women in the most ancient world comes to us from legend via literary sources. History, of course, has given us accounts of women who have taken to the battlefield, but these accounts, while generally considered uncommon, are not particularly rare. Most often the same women are repeatedly presented, which obscures the scope of their existence and reduces the number of military women to a much smaller size than is warranted.

Introduction

Until fairly recently, archaeological evidence has not been seriously explored and mythological evidence has been considered just that – myth – and not assessed as part of the mindset of the society that produced the myth. This book attempts to remedy this disconnect by integrating evidence of myth, legend, archaeology and history. It does so by showing that the historical record is much broader than often assumed, that there are historical parallels to some aspects of the myths and that there is archaeological confirmation for women participating as combatants and commanders in warfare. This work further demonstrates that by widening the scope of women's activities in military matters to include not only actual combat, but to the larger organised conflict that uses armed members structured in a hierarchy that includes strategy, planning and support, we find that women had a greater role in warfare than has been previously recognised. This enlarged sphere of military involvement gives further justification for looking at mythological and cultural sources as well as archaeological and historical ones. The mythological evidence for women in war, which is infrequently presented, shows how it is linked to other factors concerning women and war. In order to demonstrate the cogency of this evidence, I also present in the final two chapters short accounts of individual historic women that validate my analysis.

In this work, I bring together the various cultural aspects of women as they relate to war in the ancient world up to about the end of the medieval period – specifically 1492. In my view, it is the mythological and legendary evidence that reveals the mindset of people. While not tangible, these cultural aspects present evidence for many of the military activities of women.

An objective evaluation of the archaeological evidence seems equally important, particularly for the earliest periods. Moreover, some of the very latest scientific evidence that has come to light in the last decade seems to confirm if not the 'feministic' of war, at least the confirmation of women in war.

Few would question applying the term 'warrior woman' to Joan of Arc, and most of the works on this subject are confined to those women who did take to the battlefield, as exemplified by St Joan. Although most definitions of a 'warrior woman' are confined to one who takes up arms and goes into combat, it is clear to me that this is too narrow and simplistic a characterisation. There is more to the subject of women and warfare than just women taking up arms. This book addresses not only the subject of those women on the battlefield, but also those women who were in one way or another involved in other military activities. Here I present women, be they mythical, legendary or historical, who were intimately involved with war, including those women who were involved in military planning and training. Although Elizabeth I of England did not lead her army into combat, she was responsible for raising it and was

the person ultimately in charge of the army, if not the battles themselves. In the usual meaning of the phrase, Elizabeth would not be called a 'warrior woman' because she did not go onto the battlefield, but Frazer (1988) rightly categorises her as a 'Warrior Queen'.[1]

Although the final chapters of this work are devoted to historical women who illustrate the military qualities set down earlier, it is meant neither as a definitive catalogue of women involved in war nor as an in-depth examination of the female military psyche. What I propose to show is how entrenched female participation has always been in war, how the mythology of ancient people prefaced and presaged this participation, and how women who took on the military role could be as aggressive and merciless as any man. There are also certain sub-themes that run through this work principally in the mythological and legendary figures. For example, war goddesses are frequently associated with fertility, sex and virginity. Water, birds (particularly carrion birds) and horses are also commonly found linked to them (Chapters 1–3). The historic women we will examine are most often noble women, but this narrow scope may simply be a function of the preservation of evidence.

As mentioned, women who have gone into battle can be found throughout the world, but in the Western world, when asked to give the name of a woman who went into battle, Joan of Arc is quite likely to be the first response. While the Maid of Orleans may be the most famous woman warrior, she is neither alone nor by any means the earliest woman in literature to take to the battlefield – this place goes to the Amazons of Priam's memory, and whose celebrity remains with us even today. This group of women has become synonymous with 'warrior women' but are most often considered myth – or at the very least, legend. The *Iliad*, in which they are first recorded, was composed and transmitted orally during the preliterate Dark Ages of Greece but only committed to writing during the early classical period of the sixth century BC. It is, however, the much earlier Sumerians who first gave us militant females in the form of 'war goddesses'. These divinities appear in some of the earliest texts written nearly 5,000 years ago. These martial goddesses and their Near Eastern successors significantly influenced the Greek literary tradition, particularly in Hesiod and Homer, as Martin West (1997) has so cogently shown. Later Greek authors such as Aeschylus characterised the Amazons as 'flesh-devouring' (κρεοβόρος) who rode on 'steed-like camels' (ἱπποβάμοσιν), but he also said they were nomadic (*Suppliant Maidens* 283–87) and that they hated all men (*Prometheus* 726).

Following in the epic path of Homer, Virgil provided continuity in the Western literary tradition by giving us Camilla, with whom he compared the Amazons, as a model for the motif of the warrior woman. Sharrock (2015: 158–59) points out that, 'So powerful is the myth of the Amazon that

representations of any female warrior in antiquity will naturally tend to become an Amazon – so much so that even the most "liberated" female soldier in the ancient world, Virgil's Camilla, is inevitably drawn into an Amazonian simile'. Reference to Amazons continued to appear throughout the Middle Ages. Scholars such as Orosius (ca. AD 380 – ca. 418), the Late Roman priest from Hispania, gave a history of the Amazons in Book 1 of his *History against the Pagans*, and Jordanes in his Gothic history, *Getica*, (sixth century) repeated the views on Amazons of earlier authors (Mierow 1915.) Writers of other genres also kept Amazon stories alive. Poets such as John Gower (ca. 1330–1408) related the story of Achilles' son's encounter with Penthesilea,[2] and a collection of legends known as the *Alexander Romance* (Stoneman 1991) are filled with tales of Alexander's dalliances with Amazon queens that continued the lore of these legendary warriors. Even outside the classical sphere, we are told of Amazons in early Irish tales when some of the earliest Irish settlers come upon 'the land of the Amazons' (Macalister 1939, §II: 155). The Amazonian legend became so culturally ingrained that Shakespeare even used it as an adjective to describe Coriolanus' 'Amazonian chin'.

Our first visual depiction of fighting women again comes from the Greeks, on a terracotta shield from Tiryns dating to ca. 700 BC (von Brothmer 1957, pl. Ia-b). It shows Achilles killing Penthesilea, the celebrated Amazon queen. Numerous other vessels give us examples based on mythology and legends of women as warriors in antiquity. These artworks are well known and present what the Greeks thought of the Amazons. It is, however, with the Greek historian Herodotus in the fifth-century BC that we get our first substantial information that is meant to be neither literary nor romantic but historical. The result of the Greek preoccupation with the Amazons caused these 'warrior women' to become thoroughly entrenched in Western culture.

Although actual evidence for women in battle has been known for some time, the idea of women as warriors has frequently been denied, overlooked, dismissed as literary fantasy or reinterpreted as an instrument to keep society (read 'women') in line. Still the stories, myths and legends have survived millennia, and we must ask why. Legends and fairy tales often discuss dark aspects of society that are too painful to confront head on. For example, *Hansel and Gretel* tells of child abandonment, child abuse and its eucatastrophic narrative hopes for survival and avoidance of those dangers. None of the fairy tales written down by the Brothers Grimm recounts an actual historical event, but each addresses a real-life situation or problem.

While the Greeks obviously were uncomfortable with women as combatants, the idea did occur to them. That Theseus and Achilles defeat their Amazon adversaries assures the Greeks that they, too, will prevail even against such all-out warfare. The fact that battles with Amazons are not beneath Theseus's and Achilles's 'manhood' shows that the Greeks regarded the Amazons as real

and worthy adversaries. An enemy employing female troops was waging a war of desperation and thus a ferocious enemy. We have individual goddesses, legendary female fighters, queens and even groups of women within some cultural sets who have taken on armies, some of whom have been victorious and others who have fallen to the greater abilities of their male opponents. These warrior women are sporadically attested, and because of this uncertain record, they have been viewed somewhat as freaks of nature. Because many societies have difficulty thinking of women as fighters, it may have been easier to think of female warrior stories as myth or legend. Yet, the stories are encountered repeatedly throughout the world. The women in these stories are neither docile nor do they fit into the traditional role of wife and mother – they are 'the Other'. This is what the Greeks thought of the Amazons who were believed to have been such a threat to Greek society. As we will see, historical women who can also be thought of as 'Other', such as Matilda of Tuscany, and were referred to as 'amazons' (see Chapter 6). Clearly the legend of the Amazons has never been forgotten, and it has been periodically revamped as with the twentieth century comic book character, Wonder Woman, and revised anew in the 2017 movie as women's roles in society have been seen to change yet again.

Virgins, Viragos and Amazons

The military women we will examine in this work possess at least three characteristics in common. They are recurrently thought of, or described as, *virgins*, are characterised as *viragos* and very often labelled as *amazons*.[3] For a woman to remain a virgin is out of the ordinary as the 'natural' role of a woman is typically regarded as motherhood; viragos are women who take charge in instances of conflict; and they are named Amazon after the legendary warrior women of the Eurasian Steppe. We see these characteristics not only in myth and legend, but also in historical figures. Because military characteristics are less commonly attributed to women than men, the women who do possess them have caused men, as well as other women, to regard them as extraordinary. The Amazons have become the personification of the female warrior. Amazons were warriors, said by Hippocrates (Airs Waters Places 17) and other classical authors to be virgins, and were viragos in the truest sense of the word; they were, therefore, the 'Other'. That is, the 'Other' were women or female figures that did not fall primarily into the category of wife or mother, and their defining characteristic was that men did not dominate them. While they did not lose their ability to carry out traditional feminine roles, and they may have fulfilled them secondarily, these women played another role – that of warrior, and although they have been interpreted in many ways, it is their military activities on which this book concentrates.

Introduction

The Greeks saw the Amazons as ἀντιάνειραι (*Iliad* 3.189, 6.186) 'equals (peers) of men' or 'those who fight like men', but also as Οἰόρπατα 'killers of men' (Herodotus 4.110). While the Greeks first brought Amazons to us, they are best defined by a word given to us through Latin – 'viragos'. The word *virago* is derived from the Latin *vir* 'man'.[4] 'A woman having the qualities of a man: a) a physically strong woman. b) a warlike or heroic woman; (esp. applied to goddesses)'.[5] These are commanding women with great courage, strength of character and extraordinary behaviour. I am, however, less concerned with female masculinity and courage as Penrose (2016) defines these characteristics, and more concerned with women who see a situation that needs attention and attends to it.

Another characteristic, which is often associated with our group of 'Other', (although less frequent than the other two) is virginity. Virginity, along with its opposite behaviour, engaging in sex (sometimes promiscuous sex), often plays a role in the military aspect of women, particularly those of legend or myth, but not exclusively so. Virginity and sexual behaviour are two sides of the sexual coin; the former is in many (but not all) societies considered a virtue, while the latter is often associated with nomadic or barbaric peoples mentioned by Herodotus and considered uncivilised. In modern Western culture the concept of virginity is fairly straight forward – someone who has not yet engaged in sexual intercourse. This is not necessarily so in other or earlier societies. Hastrup (1993: 35) points out that:

> [t]he significance of virginity cannot be understood all by itself. As a biological fact, yes, but not as a social fact, a fact that enters into the lives of young women as a demand or as a virtue. We have to know the meaning of virginity in relation to a larger social whole, and in relation to the evaluation attached to different stages of a woman's life.

A warrior woman's sex life is frequently a point of discussion, often a characteristic of being 'the Other'. Clearly there is a double standard because a male warrior's sex life is rarely if ever mentioned, but Elizabeth I is known as 'the virgin queen', and Catherine the Great of Russia is frequently noted for the number of her lovers. While Elizabeth's father, Henry VIII, is well known for his many wives, this is usually put down to his desire for a son, and not for his sexual pleasure. One of Catherine's predecessors, the Empress Elizabeth, daughter of Peter the Great, was also known for her many lovers but never officially married. Peter the Great's sex life can be surmised by his having fathered fourteen children. Attention is always drawn to the sex life of a woman, but that of a man is glossed over. We can thus conclude that a man's sex life doesn't need comment even if he had numerous partners, but

a woman's was ripe for discussion – particularly if she strayed outside the marriage bed. We will see this situation with a number of the historical women we survey in Chapters 5 and 6.

The Effects of War on Women

Although we have a fair amount of evidence for women working outside the home in antiquity (see Stol 2018: 339–90), for much of human history a woman's place was thought to be in the home, bearing children and taking care of the needs of her family. However, if the men of a woman's family were engaged in warfare, the women were also so occupied.

No matter the war, women (and children) are the overwhelming victims, perhaps not in the actual battles but certainly as an end result – not to mention the physical abuse inflicted on them as they are treated as objects to be used or prizes to be kept. One need only think of Achilles sulking over the loss of his 'prize' to see that the insult of losing Briseis is not because of his desire for her but because of the assault on his ego.[6] To be a 'prize' is tantamount to slavery which, along with rape, is all too common a weapon in war – not only in the past, but today. The threat of slavery or rape or both was, and remains, a real and present fear of a woman lacking effective protection from male members of the family or society.[7] Another Homeric example is Andromache's fear that her husband Hector would be killed and the Trojans would lose the war, leaving her as a 'prize' to be taken – a fear ultimately realised.

Men, if they survive war, undoubtedly also suffer, whether it is what we today call 'post-traumatic stress disorder', or a permanent physical wound.[8] However, they also have the glory, and the stories of their participation in war have repeatedly been told. They have saved their society and gained social status. The stories of women are less often heard. Women, no matter the outcome, have the grief. Women are the mothers of soldiers, the wives of soldiers, the sisters of soldiers or the daughters of soldiers; it was the extraordinarily fortunate woman who did not lose a male relative. In ancient times when men went off to war, women were the ones who remained behind to raise the children, run the household and protect the home from intruders. When a husband was killed, these responsibilities remained hers until, and only if, she could find a new husband. When a son was killed, she had to live with the sadness. When a father or brother was killed, a girl had to increase her workload and hope for a good marriage. In the ancient world, war affected every aspect of a woman's life.

While all of this was undoubtedly true for most women, the 'Other' were the exceptions. These were the women who, while bearing the burdens of war,

also took action against it. From some of our earliest literary sources we hear of women who did not fit into the pattern of grieving wife and mother. These 'Other' were not conventional women – they were viragos and did not behave in an orthodox manner.

Women Do Not Fight

War is more than just fighting. To consider only actual combat as war is too limiting. Fighting is, of course, the down and dirty part of war, but we cannot exclude the less violent aspects that involve such undertakings as training, planning and cooperation with allies. Many of the women in this study, both historical and legendary, did not actually go into battle, but the non-combatants played important often-essential roles. There were the planners who may never have seen the battlefield, the leaders who stayed behind the battle lines, and those that fall into the category of 'camp followers', a regrettable phrase that demeans the women who performed indispensable services such as cooking, laundry and healing.[9] Ducrey (2015: 184) is correct when he points out that it would 'be simplistic to imply that because women did not line up in the hoplite phalanx, the role they took on in the fighting forces, and even their participation in military campaigns, were trivial or insignificant'. What the women and female figures we will examine have in common is their close connection with war, either directly as leaders, fighters and those providing logistical support, or as those more indirectly involved such as organisers, planners, trainers and even spies. These are positions that are rarely discussed but ones that are crucial in all wars and have many times been carried out by women. There is, unfortunately, no good phrase to describe these non-combatant women, and, as a consequence, I have chosen to retain 'warrior women', problematic as that well-worn phrase may be.

We need to ask why, for some, the thought of female warriors is a subject of such fascination yet is not the case when we look at male warriors. We have no trouble thinking of women as cruel (the wicked stepmother comes to mind), but the notion of a woman taking up arms has caused societies, until quite recently, to draw a breath and think that this role is not natural in the female character. This is by no means a new perception.

Xenophon (*The Economist* 22–23) told us that men were suited for the outdoors and military marches but women were for the indoors. However, his view was presaged, as we have seen, by Homer who has Hector dismiss the women to do their feminine tasks while 'war shall be for men' (*Iliad* 6: 492). This view that women should not be involved in military matters remained until modern times and led Graf (1984: 245) to tell us (when speaking of ancient Greek women) 'Women did not fight ... Thus, they were only passive

participants, the victims or the booty'. Certainly, women were victims or booty, but not all women were 'passive participants'. Undeniably the role of men in battle is much greater than that played by women, but a look at history will show numerous names of women involved in military matters. Many of these women found throughout the world and throughout history can be unearthed in a number of works that chronicle 'women warriors' (see Salmonson 1991; D. Jones 1997; Pennington 2003), and some of these women will be found in Chapters 5 and 6 of this book, but there are undoubtedly untold numbers of women whose names are lost to us forever. Why are we so accepting of men as warriors, and why do we think of women in a warrior position as a peculiarity? It has even been denied that women have a place in military activities. The following extended quotation written by a noted war historian as late as 1993 bears scrutiny as it speaks to a number of issues that will be raised in this work:

> Half of human nature – the female half – is ... highly ambivalent about warmaking. Women may be both the cause or pretext of warmaking – wife-stealing is a principal source of conflict in primitive societies – and can be the instigators of violence in an extreme form; Lady Macbeth is a type who strikes a universal chord of recognition; they can also be remarkably hard-hearted mothers of warriors, some apparently preferring the pain of bereavement to the shame of accepting the homeward return of a coward. Women can, moreover, make positively messianic war leaders, evoking through the interaction of the complex chemistry of femininity with masculine responses a degree of loyalty and self-sacrifice from their male followers which a man might fail to call forth. Warfare is, nevertheless, the *one human activity from which women, with the most insignificant exceptions, have always and everywhere stood apart*. Women look to men to protect them from danger, and bitterly reproach them when they fail as defenders. Women have followed the drum, nursed the wounded, tended the fields, and herded the flocks when the man of the family has followed his leader, have even dug the trenches for men to defend and laboured in the workshops to send them their weapons. *Women, however, do not fight*. They rarely fight among themselves and *they never, in any military sense, fight men*. If *warfare* is as old as history and as universal as mankind, we must now enter the supremely important limitation that it is *an entirely masculine activity* (Keegan 1993: 75–76). [Emphasis added.]

Even if one were to accept this idea about the 'insignificant exceptions' of women in warfare (and I do not), and despite the changes taking place in the

early twenty-first century, war has never been an 'entirely masculine activity'. Whenever and wherever there has been war, women have been involved one way or another. The 2015 Nobel Prize for Literature was awarded to Svetlana Alexievich of Belarus for her collective work, one of which was *The Unwomanly Face of the War [War's Unwomanly Face]*. A passage from her Internet home page is instructive as a response to Keegan:

> More than a million Soviet women saw action at the frontlines of the Second World War. They were aged from fifteen to thirty years. They mastered the various military professions becoming pilots, tank drivers, machine-gunners, snipers, and many others. They were not only nurses and doctors as in the previous wars. However after the victory men forgot about those women. Men stole the victory from the women.
>
> In my book the women soldiers talk about those aspects of the war, which men never mentioned. We did not know about such a war. Men described their exploits while women talked about something else. For example, how frightening it was to walk along a field covered with dead bodies, scattered about like potatoes, all very young. You feel sorry for all of them, both the Russian and the Germans. (Alexievich, Internet Home Page, 2006. Accessed 8 October 2015.).

While this quotation speaks to a war of the twentieth century, one cannot help but believe it also reflects the actions and emotions of women in earlier times.

From the Keegan quotation at least eight points stand out, some of which will be themes that appear throughout our study of ancient women involved in warfare. Some of these points will be shown to be true while others can be dismissed out of hand.

1. Women are 'highly ambivalent about warmaking'.
 In general, women are less enthusiastic about going to war than men, but while men see the glory as they march off to war and women may show initial enthusiasm for 'the cause', this soon changes when faced with the grief of men either not returning or returning maimed in body and mind. We see this in Andromache's anticipation of Hector's death and ultimately her acceptance of it.

2. '[W]ife-stealing is a principal source of conflict in primitive societies'.
 Despite it being the genesis of two of the best-known wars in literary antiquity, the Sabine War and the Trojan War, wife stealing does not usually rise to the level of war. It may be a source of some conflict in

primitive societies and may even result in a blood feud in some societies, but it is not a major cause of war, and we will not see it as a factor in this work.

3. The ambitious woman who desires power.
 While there are examples of women who desired power seemingly for its own sake – we will see this with the Roman Fulvia – there is no evidence for megalomania on the scale of Alexander, Napoleon or Hitler.

4. Mothers who prefer dead heroes to live cowards.
 Hard-hearted mothers may occur in some societies (and we do see this in Sparta), but it is not so evident elsewhere.

5. Women as messianic war leaders.
 There is little evidence for female 'messianic war leaders', in its biblical sense, perhaps the closest being Joan of Arc, who claimed to be carrying out the will of her voices that were sent from God. Matilda of Tuscany might qualify as she fought for the Pope. In the political sense, the list of 'messianic leaders' (a better word would be charismatic) might be extended to women such as Amage, Boudica, Æthelflæd, as well as Matilda of Tuscany. It is the charismatic quality of the individual that attracts followers and certainly an army would never follow a woman or a man who did not demonstrate charismatic conviction.

6. Women who are camp followers.
 Men may have done most of the fighting but the women who were 'camp followers' supplied necessary (and undoubtedly welcome) logistical support that should not be underestimated. Where would any army be without its supply lines? Even Napoleon believed an army marched on its stomach.

7. 'Women … do not fight'.
 We will see that this is not true, e.g., Tomyris, Fulvia, Boudica, Æthelflæd, Beatrice of Lorraine, Matilda of Tuscany, Jeanne de Champagne, Nicolaa de la Haye, Urraca of Leon-Castile, Teresa of Portugal, Isabella of Castile and others all went into battle.

8. War 'is an entirely masculine activity'.
 This, as we shall see, is patently false.

Without question, women have been less directly involved in war battles than men and their ambivalence undoubtedly results from the knowledge that their men may be killed, but to regard it as an 'entirely masculine activity' is a gross exaggeration.[10] Without using the word, Keegan speaks of the 'virago' in the form of Lady Macbeth and 'messianic war leaders'. To say women are not

involved in war because they only tend the wounded, take up the necessary tasks to keep the home economy going, and when necessary, provide logistical support to the army, is somewhat like saying a woman doesn't 'work' if she stays at home to mind the children, cook, clean and run the household.

To say 'women ... do not fight' is simply not true and as a military historian Keegan should know this. One needs to look no farther back than the Second World War to find many women, particularly, as we have seen, Soviet women, in the front lines. Several recent books have made this point when dealing with earlier periods.[11] While women may be less likely to go into battle, there is little evidence to suggest they shirk from it when necessity calls. As for being 'messianic war leaders', Keegan's reasoning may be valid, but this could also be attributed to the fact that females as war leaders *are* much less common than males and *need* to be 'messianic' (under his definition) to achieve the position. It is also this last point that may give us part of the answer as to why society has a fascination with women who go into battle. They defy the expected. While not impossible, it is much less usual than men in war; it is more the 'man bites dog' phenomenon.

Women are obviously affected by war, not just by the death of men close to them but by all the men in a woman's society as well. We need to remember that women raised the boys who became warriors. When the male head of a household had to leave or was killed, it was the oldest boy who then became 'the head of the house'. Boys who showed 'manly' characteristics were encouraged, and rough play was the training ground for warriors. This can be seen in the early Olympic Games[12] that numbered among the events not only hand-to-hand combat (boxing, wrestling in a standing position, and *pankration* – another type of wrestling where all moves save biting and eye and nose gouging were allowed), but also incorporated running in armour (specifically, helmet, shield and greaves) as one of the competitions. Although women were excluded from the Olympic Games, even as observers, Pausanias (V.16.4) describes the Olympian-like competition, the Heraia, in which girls ran foot races.

Women Do Fight

Evidence for women taking part in military matters comes from many areas of the world, but I will confine myself primarily to the Indo-European-speaking world, which is my area of expertise; however, I will draw on non-Indo-European examples to press or clarify a point. Obviously female engagement in warfare is not a uniquely Indo-European concept, nor did it originate with Indo-European speakers. The Egyptians, for example, claimed four goddesses with a war aspect, but seldom, if ever, do goddesses maintain a war aspect solely – like actual women, they had several roles to play. While women of the past may not have been members of armies,[13] there are historical figures

almost unknown in the Western world that are well known within their own spheres, e.g., Tomoe Gozen of Japan[14] and the Trung sisters and Trieu Thi Trinh of Vietnam.[15]

The Indo-European world includes most of Europe, much of the Indian subcontinent, and parts of the Near East, and portions of western and central Asia (Map 2). This vast area results in a divergent type of evidence. First, of course, we have the classical authors beginning with Herodotus. Strabo, Dio Cassius, Diodorus Siculus, Caesar and Tacitus, among others, who regale us with the military prowess and physical strength of Celtic women and the Amazons. Moreover, we have examples of women who joined in battles when necessary, such as Celtic women who not only stood on the side lines of a battle but also cheered on their men and taunted the enemy, and Corcyrean women who threw roof tiles on to their enemies (Caesar, *The Gallic War* 1.51; Tacitus, *Germania* 7–8; *Annals* 14.30 and 34; Thucydides 3.74.1).

Methodology

Until the inroads made by recent scholars, the exceptions noted above, and notwithstanding the role women have played in the regular military in the recent wars in Iraq and Afghanistan, the idea of women taking up arms has generally remained in the fields of mythology, folklore or satire.[16] Still, there is a large amount of material that has been overlooked and needs careful examination, hence the necessity of the present work.[17]

Much of what is written here can be found elsewhere, but I believe this is the first time these diverse types of evidence have been gathered in one place. The categories of women engaged in warfare serve to illustrate my thesis that women, or at least female figures (some mythical or legendary), were more actively involved in warfare than has previously been studied, and their indirect involvement in war included actions other than actual battle. In addition to actual women on the field, the inventory of female war figures and the evidence for them fall into at least four categories:

1. Mythological figures, as typified by goddesses of war.
2. The Amazons personify the legendary war-like figures, but there are also trainers in the military arts, such as the Celtic trainers of warriors. Additionally, there are figures that stand on the side lines encouraging soldiers in battles, or the females found in the Norse sagas and elsewhere, some of whom seem to straddle the line between legend and myth, or even legend and history. Often these female warrior figures are found only in accounts of battles as presented by the ancient authors.

3. The archaeological information comes primarily from graves that provide grave goods and physical evidence on skeletons that demonstrate the active role of women in battle. Very recent studies present surprising new evidence.
4. Lastly, historical figures personally involved in warfare that we will survey were, with few exceptions, women of royalty or at least from the aristocracy.

In the first three chapters of this work, we will be dealing with a vast amount of time and space, as well as multiple traditions that while even those that may fall under the heading of Indo-European are still greatly varied. In these early chapters, we will be working with myth and legend, which, for lack of a better word are fungible. Despite an attempt to categorise it, this material often defies classification that consequently results in a great deal of overlap. Even in the areas where our sources are most complete, like classical mythology, we come across situations that seem irrational. When archaeologists present us with new findings that clears up a lacuna in our knowledge, we rejoice, but new discoveries may also present new questions.

The material is presented in roughly chronological order beginning with the oldest written records of the Near East. I then take up those Indo-European groups that give us the earliest information. First will be the earliest Indo-European material found with the Hittites and then the Iranians. From there we move on to the classical material that provides us with the greatest amount of mythological evidence. The Celtic and Germanic people follow primarily because we know so much of their mythology through the classical authors. The Indic material comes last because it is most unlike the mythology found in the more westerly Indo-European contexts.

A few brief comments are necessary about the evidence. First, the sources for this work are varied and extensive. Consequently, I employ numerous quotations, as they are frequently the best evidence for the time, particularly in Chapter 1. Some sources are mythological and some misogynistic, but both show the cultural context and mindset of the societies from which they come. Next, I must admit to being fairly agnostic in terms of theory and deal with it sparingly, be it mythological, historical, archaeological or feminist. I prefer to let the data speak for itself and permit a theoretical stance to emerge from the data rather than confine data into a single theoretical straightjacket. Any theoretical consistency is not always easy as redactors and translators of the various myths and legends often conflict. This diversity is especially true when it comes to the Celtic material. Our sources for Celtic religion are not well founded and frequently depend on legendary tales. Unlike the Greek and Roman material that is fairly well defined, the Celtic evidence does not make sharp distinctions between who is a deity and who is not. The authors who had set

down our earliest information about Celtic myths and legends had conflicting religious or political interests. These authors were often Christian scholars who 'Christianised' much of the pagan material. A similar problem is found with the Norse material. Something of a reversal comes with the Indic evidence in that it is not always clear if we are dealing solely with Indo-European material or a combination of it with the substrate material.

When we get to historical figures, there is also conflict even with primary sources such as the *Anglo-Saxon Chronicle* where there are several versions, and it depends on which version one reads as each version will present (or even omit) some events depending on the chronicler's own viewpoint. The archaeological evidence is no better, first because of its scarcity and second because of the overwhelming bias for determining an occupant of a grave to be male if the grave contained weapons. There is also the simple bias against the study of females. It was only after the work of scholars such as Pomeroy (1975), Lefkowitz and Fant (1982), and Lefkowitz (1986), that goddesses and mortal women took their rightful place in Classical studies.

Although the Celtic myths are well known, we will see that the Celts were not alone in having mythical women involved in battle. Furthermore, we have the quasi-historical Norse sagas with tales that some scholars consider fictitious but that give us examples of women going into battle and not shying away from blood revenge. We again should recall the Amazons and even the Valkyries who claimed the bodies of fallen soldiers. All of these female figures speak of women and war in one guise or another, thereby revealing cultural attitudes.

Iconography, which is quite often connected to mythology, provides us with still another source of evidence and offers us many representations of women in battle or sporting weapons.[18] Although the iconography cannot be looked upon in the same way as modern war photographs, it shows what people were imagining and how they interpreted real and unreal events. The Amazonomachy may not record an actual battle, but the frequency of this type of representation shows the importance placed on the myth of a battle between Greeks and Amazons, whether it was real or imaginary.

Myths and legends offer us insight into a society's view of war goddesses, but they also give us a number of legendary women who were not divine but were involved in military matters; these are often teachers of heroes who may also have provided them with weapons.

When we come to historical figures, we are faced with yet another problem and that is the dearth of information about women. We know many names, and a search of the Internet provides dozens, if not hundreds, of women who are said to have engaged in battle. But when it comes to actual knowledge about them, we are mostly given information about the men around them. A good example of this is Æthelflæd of Mercia; a victim of what Fraser (1988) calls the 'Appendage Syndrome'.

Introduction

Powerful authoritative men surrounded her, but she too was engaged in perilous acts, building fortresses and conquering towns and enemies that are reported in the *Anglo-Saxon Chronicle* and elsewhere. Nevertheless, we know distressingly little about the woman herself. In Æthelflæd's case we are fortunate that it is her military activities that interest us, as it is for that she is almost solely known.

Numerous historical queens and aristocratic women are noted for their military prowess as we will see in Chapters 5 and 6, but it is Joan of Arc who personifies the peasant woman dressed in armour leading an army. Despite Joan's accomplishments on the battlefield, she was unable to achieve political success and was burned at the stake in 1431. Joan's story is too well known to be retold here, and so we end with Isabella of Castile whose battlefield exploits are less well known than Joan's, but who was much more successful politically. After Isabella, we enter the modern world and the word 'ancient' in the title of this work can no longer be justified.

The best evidence for women who actually engaged in battle in ancient times is found most abundantly in two extremes of the Indo-European world – the Celts in the far west and those referred to as Amazons (and thought by many to be mythical or legendary) in the east. This geographical distribution would, if linguistic, point to archaic survivals on the periphery of the Indo-European world. What the distribution *does not* indicate, and this I emphasise, is a matriarchal substrate, as some would have us believe. Still these peripheral areas, for whatever reason, are where we most easily find actual fighting women. While I reject the matriarchal substrate model another view put forth by Jean Markale might be considered, at least in regard to the Celts:

> Celtic society was full of archaisms largely gathered and integrated from the original inhabitants of Western Europe. It was halfway between the patriarchal type of society, which was agricultural and based on the ownership of land by the father of the family, and matriarchal societies, in which the mother, or women in general, remained the basic link in the family and a symbol of fertility. (Markale 1975: 39–40).

Notwithstanding the writings of classical authors on the Celts and the mythological evidence, the question remains: were there Celtic women who engaged in battle? There is little archaeological support, as we will see, to suggest there were. That said, there is some archaeological evidence that shows us that women fought side by side with men at the hillfort of Maiden Castle and perhaps other hillforts in southern England against the Romans as demonstrated by body and head wounds (Harding 1985: 124–26). In the grave, swords, armour, shields and helmets are considered almost exclusively male

items, but then we have questionable items such as chariots that need to be dealt with separately. From the opposite end of Europe on the Eurasian Steppe, women contemporary with the Celts not only engaged in battle but were also buried with their warrior equipment; these women bear indications of head and limb wounds typical of battle injuries, and their sex has been established through anthropological examination of the skeletal remains and DNA. For a somewhat later period, we have Viking material that has come to light in the last few years and has brought unexpected results.

Although we might think that the archaeological evidence would clarify the question of what defines women warriors – she who has weapons is, she who lacks them isn't – it does not. In fact, the archaeologists' conclusions often lead to further questions. Some scholars take the presence of weapons as proof of 'warriorhood', but others do not. Weapons alone do not confirm military activities. In fact, defining what a weapon is can be problematic. Knives alone, for example, should be discounted as only weapons; they have other less lurid but quite commonplace uses. The knife was probably the most basic of early human tools and was used to skin and dress animals, prune twigs and branches from trees, peel the inner bark to make rope or twine, as well as used in food preparation and eating. Bows and arrows could have been used for hunting and not necessarily for fighting. Aside from helmets and armour, swords are perhaps the only true weapons (Huld 1993) that can identify a warrior.

* * * *

The first three chapters of this book lay the groundwork for what follows and deal with mythical and legendary female figures and the symbolism attached to them. In the first chapter the reader is introduced to the most ancient war goddesses that predate the Indo-European mythical and legendary figures. Chapter 2 presents the Indo-European goddesses and Chapter 3, legendary figures. These figures are found in some of our oldest written records. Chapter 4 presents archaeological evidence, some quite old and some as recent as 2019. Examples of historical women are reviewed in Chapters 5 and 6. These women exemplify the historical virgins, viragos and amazons characterised in the first chapters and illuminate these characteristics. It is not always possible to separate history as objective fact from social attitudes and beliefs that appear in legend and myth; my aim, therefore, is twofold. First to present the underlying attitudes towards a woman's role in warfare that are found in ancient societies and illustrate that women's participation in matters of war are neither an inconceivable aberration, a peculiar anomaly, nor even especially new. Women have always had a role to play in war as far back as the earliest writings and undoubtedly even farther.

Introduction

My second aim is to present historical examples. By presenting these examples, I illustrate (contrary to some scholar's beliefs) that women do fight, not always perhaps in the same way that men fight and certainly not as much, but they do fight. When we examine the historical women who went into battle, the battle is, despite the focus of this work, much less important than the circumstances that put these women into the position of taking up the sword. Frequently, as in the case of Isabella of France, wife of England's Edward II, they were ostensibly protecting the inheritance of their sons, and the military action was a result of the failure of earlier political action. It is this circumstance that carries the aspect of fecundity from the area of mythology into the historical as it is by bearing a son that a queen cemented her position. A religious cause such as that defended by Matilda of Tuscany and Isabella of Castile is another reason these extraordinary women went into battle. We might also include Æthelflæd in this category. Although she was also a Christian fighting against the pagan Vikings, religion seems to have been a smaller factor. Some women fought for the throne that they deemed rightly theirs, as did the Empress Matilda and Cleopatra VII, the best known of the many Cleopatras.

It needs to be said that in this work, references to women, females and female figures, pertain to individuals who present as biological females. To expand this term to include the broader term 'gender' would have changed my premise. Many women, for numerous reasons, have chosen to enter a realm that has so often been considered unsuitable for a woman. The reasons women joined armies varies widely – to find a lost husband or lover, being in a battle area with little choice than to disguise oneself as a man, a desire to be a man, or simply a desire to fight. Some women may have been non-gender conforming and craving a male life or only wanting adventure.[19] The reason doesn't matter; they presented to society as biological women engaging in what is generally considered a male activity. While the issues of gender are extremely important, seriously complex and enormously interesting (see Arnold 1991a; 2002; Nelson and Rosen-Ayalon 2002; Moilanen *et al.* 2021), this work focuses on the biological female, which by itself is complicated. Moreover, from an archaeological point of view, sex determination can be very difficult even though we now have DNA as a tool; to determine if a female skeleton did not conform to ordinary social sexual determination is extremely difficult, although strides are being made in that direction.[20] Because gender is such an amorphous concept when applied to past cultures, for the purposes of this work, it is best left out of the discussion. Some will not agree with this position, but these are the parameters I have set for myself.

This book is designed for both students and the general reader. It is hoped that both will find it useful and informative, pique the reader's interest and that the reader will use it as a platform for further investigation into the subjects presented. The expansiveness of this work has required a large number, and

wide variety, of sources. While most are easily available, some readers may find them confusing without certain background information that might seem obvious to others with more specialised knowledge. Some points may present challenges that might have been omitted, but my feeling in presenting them again, outside of their scholarly repose, has been that they touch on questions that inevitably arise in the minds of curious but non-specialist readers. I particularly refer to opinions and discoveries that relate to etymologies and religious texts. Wherever possible, I have tried to avoid these problems by giving references for the sources I have used.

Although the majority of evidence for women engaging in battle in the most ancient times in one form or another (that is during the time of ancient authors and earlier) is found on the periphery, it is not confined to it. In the following chapters we will see female figures (both mythical and legendary) across the Indo-European world that took up arms or carried out supporting roles in battle. Almost all fall into one or more of the three categories of virgins, viragos or amazons.

The purpose of this work is threefold: first, to illustrate that warfare is not solely a male activity; second, that women were not just weapon-wielding Amazons, amazon-like figures, or whimpering bystanders, and perhaps most importantly, third, that women have been involved in conflict for at least as long as we have had texts referring to warfare. I will show through a broad range of evidence that women have always been involved in war as direct and indirect participants in both the real world and that of myth and legend. I will examine the characteristics that have come to be associated with these women and present the archaeological evidence that supports my thesis that women have always participated in military activities. To paraphrase Virgil, *Arma feminasque cano*, 'I sing about arms and women'. While Virgil's subject was a single man and arms, my subject is women and arms – women who took up the sword and went into battle, encouraged men to do so, organised and led them or supported them along the way.

Chapter 1

In the Beginning: Mythological Figures

Because war was a component of life that affected all aspects of a woman's existence, it is not surprising that war, like many other important facets of life, was placed under the purview of divinities. Evidence for these divinities is found in Sumerian and the near contemporaneous Egyptian texts, which are the earliest writings we possess. War divinities are also found in the later Indo-European texts. These gods are both masculine and feminine, but in terms of behaviour, there are marked differences between male and female war divinities. The female deities are not merely female versions of their male counterparts. In the case of the male Indo-European gods, they take on more active and physical aspects of war and rarely interact with the warrior on a personal footing. The goddesses, however, may occasionally be quite active participants, but they are, by and large, less involved in actual battle. The Indo-European goddesses typically nurture and protect their protégés in face-to-face encounters, but in general act more as instigators or advisors using weapons that are more abstract than those of the male gods.

The Indo-European war deities may be characterised by their weapons, which can be seen as their symbols of power and in ancient texts denote the gods themselves. Indra has his *vajra* or club,[1] and in the *Rigveda* the word *vajra* is largely confined to Indra; Mithra's *vazrō*, the etymological equivalent of *vajra*, is described in the *Avesta* as a sharp-edged, hundred-bladed instrument, which implies a mace-like weapon. Thor wields *Mjöllnir*, his deadly hammer, and Oðinn's spear is *Gungnir* (both were reportedly made by dwarfs); Zeus hurls his famous lightning bolt, forged for him under Mount Aetna by the Cyclopes.

The weapons represented with the goddesses are, usually, less tangible and more generic, serving more as identifiers of their warrior aspects than weapons to be used in combat. The intangible weapons used by a number of the goddesses fall primarily into three categories: magic, interference or in a number of cases – particularly the Irish – sex. The tangible weapons of war goddesses are more often defined, or at least regarded, as defensive. For example, in art, Athena is frequently depicted with a spear, but there is little

reference to it in the texts. Her chief emblem is the *aigis* (Latin *aegis*), the (goat-skin) shield[2] of Zeus, and she also is frequently shown wearing a helmet, both of which serve primarily to protect and defend – they are rarely, however, mentioned as items of assault. Artemis, the Greek goddess who possesses the bow, is much more of a huntress and less frequently seen as a warrior, but it should be remembered that to the ancients, hunting was often thought of as training for warfare.

The Indo-Europeans certainly did not invent the idea of a war goddess. The largest religious text composed in an Indo-European (IE) language, the Indic *Rigveda*, gives no indication of a war goddess, nor does its Iranian counterpart, the *Avesta*.[3] In fact, it is quite clear that very powerful war goddesses pre-date the Indo-Europeans, or at least their arrival in the Near East.

Because we first see war goddesses in the Near East, we will begin with a short overview of some of these deities and their general attributes. In the next chapter we will move on to a more extensive review of the Indo-European goddesses who display war aspects.

Despite a sometimes-confusing variation in the spelling of names that result from various transliteration methods, these Near Eastern war goddesses display a number of common characteristics, some of which emerge in their later Indo-European counterparts but not to the degree that would suggest a common source. This postulation, however, suggests an original unity of cultic practice no longer contained in the linguistic or onomastic sources and intimates that some of these divinities' attributes may result from substrate influences or cultural contacts that created a common culture of the Near East expressed in Sumerian, Akkadian, Assyrian, Babylonian and the Semitic Ugaritic; Sumerian and Akkadian, however, were the main languages. Later, we will see that there are cases where the myths of some Indo-European peoples were built on a mythological foundation already present and usually originating from the Near East. Nevertheless, despite these similarities, we should not think of Near Eastern mythology as ancestral to Indo-European mythology. In the case of the best documented of the Near Eastern war goddesses, we will see that there were commonalities, but we will also see there are individual peculiarities that argue for a case of parallel evolution. Although war aspects appear in the iconography, the true extent of the power of the Near Eastern war goddesses is best seen in the literature, thus extensive quotations of the literature are given.

Mesopotamian War Goddesses

Inanna

The earliest and most influential of the Near Eastern goddesses is Inanna, 'queen of heaven', the dominant divinity of the Sumerian civilization

(ca. 4500–2000 BC) that first gave us writing in the form of cuneiform, followed shortly by the Egyptians, who developed hieroglyphs.[4] Inanna first appears in the late fourth millennium BC, associated with the city of Uruk one of the earliest cities in the Near East. Sexuality is closely associated with her. It should be kept in mind that Inanna is the singular deity known from the beginning of the Babylonian civilization but over millennia 'her identity underwent a continual process of reinterpretation and syncretism, mutation and fossilisation, fusion and fission which generated a goddess who was a complex multi-layered conglomerate' (Westenholz 2009: 333).

Her pointed hat with multiple horns indicates Inanna's divinity. She is also winged and in her guise as a war goddess she is shown with weapons on her back and is associated with a lion. Both Inanna and Ištar, of the later Akkad Empire (ca. 2334–2154 BC), and with whom she is so closely related, were the most influential of all goddesses in ancient Mesopotamia.[5] Moreover, they are linked to the point of being nearly indistinguishable and share many characteristics, including the enigmatic nature of their names. The earliest reference to Inanna appears in Sumerian sources incised on clay tablets found in southern Iraq as an archaic pictograph Inanna-ur-sag, 'Inanna is a warrior', dating to the late fourth millennium BC. She was the patron divinity of Uruk, but it is not until the end of the third millennium that Inanna of Uruk is addressed as 'Lady of Battle'. The cuneiform sign for Inanna dates to the beginning of the third millennium BC, but it appears in numerous ancient Near Eastern cultures and their mythologies. Inanna's complexity can be seen in that she appears in a number of cultures with a variety of names transliterated in a variety of ways further complicating the issue (Sumerian: Innin, Inninna, Inana; Akkadian: Ištar; Hittite and Hurrian: Šauška; Greek: Astarte). Adding to her ambiguity is her apparent androgyny (Westenholz 2009: 332–36 and n. 1, 345). While each representation has varying attributes, including love, fertility, procreation and sensuality, war is always one of them. Groneberg (2009: 322) points out that:

> Inanna-Ishtar [is], at the same time goddess of war and goddess of love and fertility [and that] [t]his goddess not only controlled the fertility of plants and animals, as well as humans, and thus was ultimately responsible for all wealth and offspring, but, in addition, she stabilised the king's power, allowing him to protect his realm also by destroying his enemies.[6]

Inanna's ancestry is likewise uncertain. She is the daughter of the moon-god Nanna-Suen, but in Uruk, she is the daughter of An, the sky god and sister (sometimes twin) of the Sumerian sun god Utu. She is also regarded as the daughter of Enlil or Enki (Black and Green 1992: 182) in some other traditions, she is even the younger sister of Ereshkigal, queen of the

Netherworld with whom she has a great rivalry. Although not permanently linked to any single partner, Išme-Dagan, king of Isin, is called her husband, but the Akkadian war god, Zababa, is also said to be her consort (Lurker 1987: 388). Tammuz the vegetation god is also called her husband (R. Thompson 1928: n. 33:2).

Inanna had many cult cities, but Uruk[7] (Map 1) was the city in which she had her main shrine. We should keep in mind that chronology is important here as cult cities changed over time, and syncretism with other deities was also at work. Her primary function is sex – but not in the loving, romantic sense.[8] Sex for her is a force of erotic power rather than procreative energy, despite her many associations with fertility and prosperity.

Her connection with fertility and prosperity can be seen on the well-known Uruk Vase. This one-metre-high alabaster vase, found in level III at Uruk (ca. 3000 BC or earlier) shows her receiving a procession of people carrying produce that is led by a priest (Westenholz 2009, fig. 23.2). Selz comments that there must have been two Uruk vases and that the metre-high remains of the vase 'clearly demonstrate[s] the goddess' relationship with vegetable and animal fertility' (2000: 30, 40, nn. 12, 14, 15).

She is a goddess of many domains (including love, light and life), has both male and female aspects, and carries the epithet 'destroyer of Kur'.[9] On her female side, she is a love goddess but a divinity with aggressive sexuality. This duality of attributes allowed her to strip men in battle of their manhood. Her control over human sexuality even allowed her to 'turn a man into a woman and a woman into a man'.[10] Here, however, we are interested in Inanna as a war goddess, which is clearly presented in a hymn to her:

> When I stand in the front (line) of battle
> > I am the leader of all the lands,
> when I stand at the opening of the battle,
> > I am the quiver ready to hand,
> When I stand in the midst of the battle,
> > I am the heart of the battle,
> > the arm of the warriors,
> when I begin moving at the end of the battle,
> > I am an evilly rising flood,
> when I follow in the wake of the battle,
> > I am the woman (exhorting the stragglers):
> > 'Get going! Close (with the enemy)!' (Jacobsen 1976: 137).

Her war qualities are again well defined in *Inana and Išme-Dagan*, and it is these war qualities that anticipate those of later war goddesses:

> Holy Inana was endowed by Enlil and Ninlil with the capacity to
> make the heavens shake, to make the earth tremble, to hold the four
> directions in her hand and to act grandly as their lady, to shout with
> wide open mouth in battle and combat and to wreak carnage (?), to
> butt all at once valiantly (?) like a wild bull, to make the earth drink
> the blood of enemies like water and to pile up their bodies, to take
> captive their overwhelmed (?) troops and to make them serve, to
> make the people ascend from below to above, to make the foreign
> people change their place, and to turn light to darkness and darkness
> to light. They made her without rival in heaven and earth.
> (Black *et al.* 2006: 91, ll. 7–18).

The Sumerian goddess was celebrated by Enheduanna, daughter of Sargon the Great (ca. 2334–2279 BC, founder of the Dynasty of Akkad) and high priestess of Nanna, the titular deity of Ur. In the Hymnal Prayer of Enheduanna, *A Hymn to Inana*, we learn that even the supreme god, An, dare not go against Inanna. Her power is absolute.

> she cuts to pieces him who shows no respect. ...
>
> no one dares turn against her (Black *et al.* 2006: 94, ll. 23 and 25).

* * * *

> Her wrath is ..., a devastating flood which no one can withstand. ...
>
> she abases those whom she despises (Black *et al.* 2006: 94, ll. 29–30).

* * * *

> To destroy, to build up, to tear out and to settle are yours Inana. To turn a man into a woman and a woman into a man are yours, Inana. Desirability and arousal, goods and property are yours, Inana. Gain, profit, great wealth and greater wealth are yours, Inana. Gaining wealth and having success in wealth, financial loss and reduced wealth are yours, Inana. Observation, choice, offering, inspection and approval are yours, Inana. Assigning

virility, dignity, guardian angels, centres are yours, Inana. (Black
et al. 2006: 96, ll. 121–31).

In lines 43–50 Inanna is so terrifying that even other gods flee. No deity is
beyond her. Her wrath reaches all.

In her joyful heart she performs the song of death on the plain.
She performs the song of her heart. She washes their weapons
with blood and gore, … . Axes smash heads, spears penetrate and
maces are covered in blood. Their evil mouths… the warriors. …
On their first offerings she pours blood, filling them with blood'
(ibid., 94, ll. 42–48).

* * * *

Her howling is like Iskur's [chief Sumerian weather deity] and
makes the flesh of all the lands tremble. No one can oppose her
murderous battle – who rivals her? (ibid., 96, ll. 252–55).

In her capacity as both goddess of war and love, Inanna cruelly conquered
the rebellious people of Mount Ebiḫ and halted the procreative abilities of
their entire world including vegetation, because 'as I, Inana, approached the
mountain range of Ebiḫ it showed me no respect' (Black et al. 2006: 335).

Inanna personifies the virago. Iconographically, she is frequently seen nude
and standing on or with a lion; her symbols are a mace and the lion. (See Black
and Green 1992, figs. 16, 31, and 87). The lion symbol is seen later in an
Indo-European context with the later Greek goddess Rhea and her Anatolian
counterpart, Cybele (Hittite Kubaba), but over time the lion symbolism becomes
less prominent, although later we will see that the Indic goddess, Druga, rides
a savage lion.

Inanna/Ištar (Ishtar)

Other areas of the Near East had their own versions of Inanna. Ištar (Ishtar) is
the second most renowned war goddess and frequently she is indistinguishable
from Inanna. The fusion of these two goddesses is difficult to explicate, but
by the Akkadian Empire (ca. 2334–2159 BC) (Budin and Turfa 2016: 6), Ištar
is seen as the Akkadian and Babylonian goddess of love and war. By the
second millennium BC, Ištar becomes protective of the king as '"mistress
of battle and warfare" who stands at the sides of kings and smashes their
enemies. Her frenzy in battle is constantly mentioned in hymns … [and]
[i]mages of Ishtar were carried into battle at the head of the armies' (Westenholz
2009: 340). By the Neo-Assyrian Empire and the great king Ashurbanipal
(669–627 BC), a temple 'dedicated to Mulissu, Ishtar of Nineveh, had stood

in the same place for over a thousand years' (Reade 2018: 20). Although Ashurbanipal was a great scholar in addition to commanding a great army, he did not go into battle himself, but sent in a general under the guidance of the war goddess Ishtar, who protected him as evidenced in Ashurbanipal's official inscriptions:

> The goddess Ishtar ... was holding a bow at her side [and] she was unsheathing a sharp sword that [was ready] to do battle. You [Ashurbanipal] stood before her [and] she was speaking to you like [your own] birth-mother. The goddess Ishtar, the sublime one of the gods, called out to you instructing you, saying: 'You plan to wage war. In the place where my attention is fixed, I myself will set out'. You [then] said to her, saying: 'Let me go with you, wherever you go, O Lady of Ladies!' She replied to you saying: 'You will stay in the place where you are [currently] residing. Eat food, drink wine, make music, [and] revere my divinity. Once I have gone [and] accomplished this task, [then] I will let [you] achieve your heart's desire. Your face will not become pale, your feet will not tremble, you will not wipe off your sweat in the thick of battle'. (J. Taylor 2018: 93–94)

Ugaritic War Goddesses

Anat

Ugaritic mythology provides us with several other important goddesses. Anat (Anath),[11] the chief West Semitic goddess of love and war, is known from a number of Near Eastern sources and from the Ras Shamra texts. In Ugaritic mythology, 'Anat stands out as a volatile, independent, adolescent warrior and a huntress' (Westenholz 1998: 87). While Walls prefers to give Anat the primary epithet of 'Maiden', *btlt*, he notes: 'scholars frequently identify her as an erotic goddess of love and fertility' (Walls 1992: 1-2), but like some recent scholars he rejects the fertility label. She fights the battles of her brother, the weather god Baal, and along with him, 'was part of the annual life of nature, as this was experienced in the religious cult' (Kapelrud 1969: 9). Without going through the many complexities of this goddess, we know that she was one of the three Canaanite-Phoenician goddesses of war, along with Astarte (Ashtaroth) and Asherah.

Anat is the Canaanite (West Semitic) warrior goddess with the epithets *btlt*, 'usually rendered "virgin" but actually meaning a young unmarried woman, *št* "woman", and *hbly* "destroyer"' (Westenholz 1998: 79). She played a role

in Egypt as early as the sixteenth century BC, perhaps brought to Egypt by the Hyksos as mentioned in the fourteenth-century BC Amarna tablets,[12] but she does not have Egyptian origins. Moreover, Walls (1992: 78) points out that *btlt* only occurs in the Ugaritic text 'as an epithet of Anat and thus there is no additional evidence concerning the precise nature of its designation'. Furthermore, other Semitic cognates of *btlt* render the term more as a 'nubile girl, adolescent', and not precisely 'virgin' in the modern English sense. The nubile designation also comports with the general depiction of her as 'young and nubile, with small breasts and a thin body' (ibid., 83), leading Walls to use the term 'maiden'.

Anat's sexual activities have been much discussed by scholars, as has her relationship to her brother, the god Baal, leading scholars to say they had a sexual relationship (ibid., 112–59); Walls considers it a possibility (ibid., 219).

For our purposes, it is Anat's warlike attributes that are of most interest. It is the 'destroyer' epithet that takes precedence in her actions as she is known for her violent nature and actions. She is a vanquisher of Baal's enemies, but threatens to smash the skull of her father El if he doesn't give in to her demands. Although, because of a break in the text, we neither know who her enemy is, nor why she attacks them with such tremendous bloodletting – to the point that she 'wade[s] up to her thighs in the standing blood' (ibid., 163); this is our introduction to Anat in the Baal Cycle (*KTU* 1.3 ii 3–iii 2). Her violence is gargantuan, but the Ugaritic texts do not give an explanation. Like some of his contemporary mythologist, Walls rejects Anat as a fertility goddess but recognises 'the relation of Anat to the actions of Baal in the Baal Cycle in order to evaluate her role in promoting natural fertility' (ibid., 162).

Anat is identified with the Mesopotamian Inanna-Ishtar, the Greek Athena, the Hittite Ištar-Šauška, and the Hindu goddesses Durgā and Kālī. As we will see later in this chapter, much like Kālī, Anat wears body parts as jewellery.

In Egypt she has a relationship with several pharaohs, particularly Ramses II, and at Memphis is identified with the goddess Sekhmet. In Egypt she has a royal function identified by the *atef* crown she wears, which is the same crown worn by Astarte (Cornelius 2008: 92).

Anat is also shown at Tanis protecting the pharaoh Rameses II (ca. 1279–1212 BC), who called himself 'the man nourished by Anta' and 'the beloved one of Anta'.

Anat is sometimes a winged goddess and bears the epithet 'Virgin Anat'. In Ugaritic poetry, column II CAT 1.1 of the Baal Cycle, shows us how particularly ferocious and bloodthirsty Anat could be.

And look! Anat fights in the valley,
Battles between the two towns.
She fights the people of the se[a]-
 shore,
Strikes the populace of the
 su[nr]ise.
Under her, like balls, are head[ds,]
Above her, like locusts, hands,
Like locusts, heaps of warrior-hands.
She fixes heads to her back,
Fastens hands to her belt.
Knee-deep she glea[n]s in warrior-
 blood,
Neck-deep in the gor[e] of soldiers.
With a club she drives away captives,
With her bow-string, the foe.

Anat's Cannibalistic Feast
And look! Anat goes to her house,
The goddess takes herself to her
 palace,
Unsated with her fighting in the
 valley,
With battling between the two towns.
She arranges chairs for the soldiery,
Arranges tables for hosts.
Footstools for heroes.
Hard she fights and looks about,
Battling Anat surveys.
Hard she fights and looks about,
Battling Anat surveys.
Her innards swell with laughter,
Her heart fills with joy,
Anat's innards with victory.
Knee-deep she gleans in warrior-
 blood,
Neck-deep in the gore of soldiers,
Until sated with fighting in the
 house,
With battling between the tables

Anat cleans Her Palace and Herself
Warrior-blood is wiped [from] the
	house,
Oil of peace is poured in a bowl.
Adoles[ce]nt Anat washes her hands,
The In-law of the Peoples, her fingers
[She] washes her hands in warrior-
	blood,
Her [fi]ngers in the gore of the soldiers
	(Smith 1997: 107–108, Column II, ll. 5–36).[13]

Astarte

Astarte, like Anat, is famed for her beauty and is related to Baal. Although she, too, is found in the Ugaritic texts, she is less prominent than Anat. Astarte is not only armed as a warrior, but also hunts with a spear. The Egyptian texts associate her with chariots and particularly with horses; she is frequently depicted iconographically on horseback (Cornelius 2008: 93, figs. 4.1, 4.2, 4.4, 4.4a). In her equestrian persona she is associated with pharaohs Ramses II and Tutmoses IV (ibid., figs. 4.4, 4.4a, but is also seen standing with pharaohs Amenophis II, Merneptah, Siptah, as well as Ramses II (ibid., figs. 3.4, 1.8, 3.5, 1.1a, 3.6). She is also depicted with non-royal personages, indicating a popularity among ordinary people (ibid.: 85, figs. 4.3).

Anat and Astarte are sometimes difficult to distinguish, particularly in Egypt, but it is usually Astarte who is seen on horseback (see Cornelius 2008, fig. 4.5). Astarte is one of the few (perhaps only) war goddess associated with horses; her weapons are the spear and shield, sometimes she is seen with a bow and arrows as well as battle axe and lance. She later, however, loses her war aspect in Egypt (Kapelrud 1969: 15).

Egyptian War Goddesses

Egypt's cow goddess, Hathor, also had similarities to Inanna in that she had some of the same characteristics, namely beauty and sex; the cow was her symbol, and she had the head of a cow. Despite her being the goddess of the arts, she, too, had a war aspect – she not only 'slew mankind in the desert', but found it 'pleasant in my heart' (*The Deliverance of Mankind from Destruction* fourteenth to twelfth centuries BC) (Pritchard 1958: 4; Dexter 1990: 24). Hathor is an ancient goddess known from the Old Kingdom, and in her warrior aspect she is known to appear as Sekhmet. The Greeks, who ruled Egypt for about 300 years prior to the Roman occupation, equated her with Aphrodite.

Sekhmet 'the mighty one' spread terror and went into battle with pharaoh. She was often described as the pharaoh's mother, and the many statues of her often depict her as a lioness or a woman with a lion's head (see Lurker 1974: 105). Furthermore, Sekhmet was associated with magic and sorcery and as an extension of these, with healing. (See Lurker 1974: 85 and 106.) We will see that healing is an aspect found not infrequently with war goddesses – the connection of war with healing is an obvious one, but beauty, although less obvious, is also a usual component of war goddesses.

Another Egyptian war goddess, Neith, was armed with a shield, two crossed arrows and a bow, and was also a mortuary goddess known to watch over Osiris' bier (Lurker 1974: 85).

Another far less notable Near Eastern war goddess is Nanja (Lurker 1987: 245), a Sumerian and Akkadian goddess of sex and possibly war.

Common Themes Among the Goddesses

When we look closely at these deities, there are a few themes that weave through them and their associated literature. While goddesses are almost universally considered beautiful, beauty is rather abstract as it means different things in different cultures. Long necks exaggerated by metal rings may be considered beautiful in parts of Burma, but they are not in other parts of the world – or even other parts of Burma. Beauty can only be defined within a given society, but in all societies, beauty is a positive attribute. In Byzantium during the eighth and ninth centuries, the selection of a bride for a future emperor was often based on a 'bride-show', in which the appearance of a future empress was deemed more important than her birth or background (Garland 1999: 5). By calling these goddesses 'beautiful', the society is evaluating their role as a positive one, even when she may display what appears to be a negative attribute.

In the Introduction, we noted that Hastrup (1993: 35) held that, 'virginity cannot be understood all by itself'. It can be understood as a 'biological fact', but not all societies considered *virgo intacta* the sole meaning. We must know the meaning of virgin in relation to a larger cultural whole, and in relation to the evaluation attached to different stages of a woman's life. Dexter (1990: 161) puts a somewhat different bent on it. She states:

> [f]eminine virginity was an asset in ancient Indo-European mythology, and often in human life as well. In other ancient cultures, women in their virgin state were often autonomous. But virginity has another, also significant, function within a

male-centered society: it is the state which renders a woman a 'storehouse' of untapped energy, energy which she will, in her next stage, impart to man.

She goes on to say:

> The term 'virgin' did not always refer to a physical state, one which implied chastity ... [T]he term may well have been a figurative one which pertained to age, not necessarily chronologically, but qualitatively. A virgin was in the youth of her powers, in the process of storing them, and, as such, her 'batteries' were 'fully charged'. Indeed, virgins not only stored untapped energy for men, but they were also able to transmit their powers to them in a non-sexual manner, without diminishing those powers. Therefore, a virgin, at least on the celestial level, could be perpetually young.

This, we will see, can apply to both the very early goddesses as well as the later Indo-European goddesses.

On its face, a sex goddess and virginity (in modern Western terminology) are an oxymoron – but virginity and sex are often attributes of war goddesses. Anat, among other Near Eastern war goddesses, is called 'virgin', although given some of the passages seen above, as well as many others, she clearly was not in any anatomical sense of the word a virgin. Walls, who examined the work of several scholars who use the Semitic word *btlt* in this context (often thought of as virgin), takes the view that *btlt* should be seen not so much as an anatomical virgin, but a 'youthful female' more in line with the Akkadian word *batultu*. *Batultu* refers to a nubile adolescent girl and 'primarily denotes an age group although in certain contexts it does appear to specify "virgin"'. Consequently, Walls (1992: 78–79) prefers to translate *btlt* as 'maiden' rather than 'virgin'.

In the Near East virginity was (and still is) highly valued. It was 'a symbol of youth and purity' (Kapelrud 1969: 30). The goddess Ištar, like Anat, is frequently referred to as a virgin (ibid.). Kapelrud discusses a number of explanations espoused by other scholars for what seems to be a contradiction in the case of these goddesses, but it is his view that I think is the most persuasive. He points out that the Semitic term *btlt* is frequently, but not exclusively, used with Anat. In Hebrew, and he sees no reason that it would not mean the same in Ugaritic (also a Semitic language), the word means an unmarried, chaste woman, a woman old enough to bear children but who has not. It further implies that the woman has no husband and that she is technically a 'virgin'. 'He concludes that *btlt* is an honorary title used for these goddesses because they never lose their youth or beauty and are always "new"' (ibid., 27–29).[14]

Pomeroy also points to this but from a slightly different angle. She considers that the Greek goddesses Athena and Artemis evolved from the idea of mother goddesses who would not be confined to a monogamous union and that '[t]heir failure to marry ... was misinterpreted as virginity by succeeding generations of men who connected loss of virginity only with conventional marriage' (Pomeroy 1975: 6). Later scholars view them quite differently. Budin (2016: 39) refers to Athena as androgynous, but Deacy (2008: 82) sees her more in line with the nubile sexually attractive young women portrayed in other Greek myths but escapes (or nearly escapes) the advances of the god Hephaestus. Budin (2016: 40) claims Artemis is a virgin because she never grows up and cannot be tamed. Even the Greek love goddess, Aphrodite who counts Adonis, Hermes, Anchises, Ares and Dionysus, among her lovers – not to mention her husband Hephaestus – is referred to (albeit in disguise) as 'like an unmarried girl in stature and appearance'.[15]

Again, looking beyond, the modern English dictionary definition of 'virgin', there is another view of virginity that should be considered. Elizabeth Barber (2013) has dissected a number of fairy tales and come to some noteworthy conclusions. In her chapter on 'The Cosmic Arrow', she gives a version of the Russian fairy-tale 'The Frog Princess'.[16] Her analysis concludes that, in some areas, fertility is the important issue and that 'conception, not intercourse, defined the consummation of marriage' (Barber 2013: 158). Therefore, in this case we would conclude that virginity does not mean never having had intercourse, but rather never having conceived. She points out that in early agrarian societies fertility was very important and a girl's ability to prove she was fertile before marriage was important, although this emphasis on showing fertility before the wedding relaxed in later times. Although many, if not most, ancient societies did not approve of pre-marital sex (see Sissa 1990), later Christianity completely closed the door on the idea of proving fertility before the marriage.

A short digression to yet another form of virginity takes us to the Indic Mādhavī. Although she does not have a warrior aspect, a slight detour about her virginity is of interest. Mādhavī is one of a number of 'regenerating virgins'.[17] Her story is rather long and quite complicated. The central point here is that virginity is critical to 'the dependence of the king on virginal support is a theme attested in the three mainstays of Indo-European comparative mythology – India, Rome and Scandinavia – and, with a curious twist of the virginal angle, in Ireland as well' (Puhvel 1987: 256). Mādhavī is the daughter of King Yāyati and their stories can be found in Books 1 and 5 of the great Indic epic the *Mahābhārata*. However, Mādhavī, unlike other characters, just appears without a genealogy aside from her father. She is offered as a gift to the ascetic Galava, who is in need of 800 moon-white horses, each with one black ear. Galava's plan is to sell Mādhavī to a wealthy royal in need of an heir in

order to acquire his horses. Ultimately, he sells her four times in order to amass all the horses. After each birth Mādhavī regains her virginity, and after the fourth birth she goes off to the forest and lives like a doe (Book 5(54)113–19). Puhvel likens Mādhavī to the Irish Queen Medb (who had numerous husbands and lovers) while accepting their many differences. He also provides us with another view of virginity 'a holding back of potential, of procreative (and by extension salvational) storage' (Puhvel 1987: 265).

However one chooses to define the English word 'virgin', and given this background, the word is not as straightforward as is usually thought. In modern English there is little if any doubt as to the meaning of the word 'virgin'. Nevertheless, when the word is used to translate a non-English word, particularly one that does not share the same culture that is found in a modern English-speaking society, one needs to use the word with caution, as in a different contextual nuance found outside of English may be in play. Here we are interested in virginity only because of its association with the Amazon warriors.

Animals, and particularly birds, have frequent connections to war deities. It is only when we consider the kind of birds – primarily carrion feeders or predatory birds – that the connection between birds and death becomes explicable. But water birds, such as geese, perhaps because of their aggressiveness, are also frequently associated with war goddesses. In terms of animals, the lion symbol is seen often with the early Near Eastern goddesses, but it is the bird and equine connections, which may not appear obvious at first, that become the dominant animal symbols. Equines are not only a means of transportation but were used in war from very early times and often placed in graves as transport to the Otherworld. This custom was found frequently on the Eurasian Steppe. (See Gening 1979; Rolle 1989; Jones-Bley 2006a.)

We first have evidence for these war goddesses around the late fourth millennium BC. This is the time in which writing first appears and cities begin to flourish. Cities could only exist once agriculture was firmly established and created enough surplus food to feed the populations of the cities. It is quite clear that this took several millennia, beginning around the eleventh–tenth millennia BC in the very areas where cities were later established – Uruk in Sumer being the first for which we have written evidence in the fourth millennium BC.

During the period between the beginnings of agriculture and the earliest writing, myths and legends, along with appropriate deities, were established and firmly entrenched in the local societies. It is from these early myths and legends that later deities and religion grew into more advanced stages so that the earlier versions faded in memory, leaving only the evolved mythology without the earliest antecedents that would explain conflicting ideas – a war goddess connected to fertility and a sex goddess connected to virginity.

Without going into the details of these mythologies that are well known (see Kramer 1972; Dalley 1989; Leick 2009, Part V), what we seem to have,

broadly speaking, is a life cycle. Goddesses are by nature beautiful – beauty representing youth and fertility. Water is not only essential for crop fertility, but also a necessity to supply the growing cities. Death is the antithesis of fertility and thus the conflict with the Underworld. Here the war goddess represents the struggle of life and as a mother who will do battle to protect her young. The war goddess does not shy away from violence to protect her society. This may also account for the number of war goddesses found, particularly in this early period. Furthermore, this makes their fertility the prime issue, and in agricultural societies, crop fertility is dependent on water, so the goddess is often associated with some watery manifestation, which like her youth and beauty underscores her fertility. In the Ugaritic *The Baal and 'Anat Cycle*, Anat takes on her fellow divinity, Môt, the god of death and infertility, and fights him furiously in order to defeat him after Môt kills (temporarily) Baal the rain and vegetation (thus fertility) god.[18]

> She seizes the god Môt
> With a sword she cleaves him
> With a pitchfork she winnows him
> With fire she burns him
> With millstones she grinds him
> In the fields she plants him (Gordon 1949: 45, ll. 31–36).

* * * *

For the purposes of this work, it is important to keep in mind that these early goddesses are background, as they precede by millennia the Indo-European goddesses. Although the two groups may share some characteristics and attributes, as we will see in the next chapter. Nonetheless, it is generally believed that the Indo-European goddesses are independent from those of the Near East. The purpose of this short chapter has been to show that war goddesses appear about as early as the first writing, suggesting they were part of societies' beliefs even earlier. This also demonstrates that females involved in war are anything but new.

Chapter 2

Indo-European Goddesses Affiliated with War

Having briefly surveyed the Near Eastern background, we can now turn our full attention to the deities that are found across the Indo-European speaking world from India to Ireland who are actually war goddesses or divinities that have a war connection. As is the case with the Near Eastern deities, few Indo-European war goddesses are known solely by their war aspect. Each Indo-European deity has additional functions, the incidence of which may vary among the linguistic groups, and sometimes even within a group. As with the Near Eastern divinities, there are some characteristics and symbols that are frequently associated with these divinities.

For convenience, we will examine the IE war goddesses according to language groups, but we will see that these deities are more prevalent in some groups than in others. We will begin our analysis with the Hittites, who were closest in time and geography to the Near Eastern divinities. We will then move on, in roughly chronological order, to the Iranians then Greeks and Romans, where we have our greatest mythological knowledge, and then on to the Celtic, Germanic and Slavic peoples' goddesses ending with those of the Indic people.

The Hittites

Šauška
The Hittites were said to be the people with a thousand gods, and this statement is probably not too far off the mark, as the Hittites had no problem appropriating the deities of the people they conquered, and a number of war goddesses similar to the Near Eastern ones appear within the Hittite pantheon. The goddess Ištar appears first in Anatolia in an equestrian form, around the fifteenth century BC. This is more or less about the time that king Tudhaliya I/II's[1] (ca. 1400–1380 BC) wife, Nikalmati, whose name is Hurrian (a non-Indo-European language), first appears in the dynastic list (Gurney 1977: 13). It is also about this time that the important Hurrian goddess, Šauška,[2] who was parallel to Ištar in many respects (Beckman 1998), comes on the scene.

Šauška had a number of complications. Despite originally being a Hurrian goddess she 'became amalgamated with Ištar' (Wilhelm 1989: 51), and her name is written Ištar in cuneiform texts further emphasising the connection of the two. Throughout the Hittite empire, Šauška-Ištar remained popular in Hattuša, the capital of the Hittite empire, but as many as twenty-five variants of Ištar, are known from the Hattuša archives. The variations are named for geographical areas or towns. Nevertheless, Ištar of Nineveh and Ištar of Šamuha remained the most frequently used (ibid.; Burney 2004: 137–38). Devotion to Šauška went beyond the Hittites and Hurrians as she was the supreme goddess of the Mitanni,[3] amalgamated with Išhara in Syria, and identified with Astarte in Ugarit.

Prior to Šauška's arrival in Anatolia, she is first attested in Mesopotamia in the Ur III period (2047–1940 BC) and merged with Ištar most famously at Nineveh (Wilhelm 1989: 51). A statue of this goddess was thought to have healing qualities, and twice the statue was sent to Egypt by the Mitanni king, Tušratta, to restore the health of the pharaoh Amenophis III (1390–1352 BC). The second time the statute was sent was shortly before the pharaoh's death (ibid., 31, 51). A small unique semi-nude ivory statuette said to be a representation of Šauška wearing a tall hat with curly horns of divinity was found at Nuzi, a Hurrian city located in what is today Iraq (see Stein 1989, fig. 4). She is dressed in a cutaway coat, one upturned boot, and holds a Hittite battle-axe. In her guise as goddess of healing, Šauška-Ištar became the patron goddess of Hittite King Ḫattušili III (1420–1400 BC) who had been a sickly child and whose wife, the Great Queen Puduḫepa, was the daughter of an Ištar priest. In addition to healing, Šauška was also a goddess of fertility and love (Burney 2004: 239). In her war aspect, she is in human form like Ištar with wings. Like the goddess Inanna, her weapon was a mace and her animal symbol the lion and is often depicted standing with a lion and two attendants.

Šauška had both male and female attributes and characteristics. At the Hittite rock sanctuary of Yazılıkaya, not far from Hattuša, Šauška is grouped with both the male and the female deities and both her male and female attributes are sacrificed to in a Hurrian ritual. In a further complication, because she is 'mistress of sexuality, she is able to punish enemies and oath-breakers by instilling in them behaviour characteristic of the opposite sex, a power that was also credited to the Mesopotamian Inanna-Ištar' (Wilhelm 1989: 52). It was in her male aspect that she was the war god and god of the battlefield.

> But it was her dual aspect which enabled her to exercise to the full her powers over human activity and behaviour. For as she chose, she could move men to peace and love and harmony, or to hatred and conflict. Her dual aspect also enabled her to deprive the enemy of their manhood on the battlefield, to 'change them into women' and so render them incapable of fighting (Bryce 2004: 147).

While not an exact corollary, we will see later in this chapter that this draining men of their fighting strength is reminiscent of the Irish Macha's curse on the Ulstermen in their time of need.

Like the Near Eastern war goddesses, the love aspect of Šauška-Ištar was an aggressive type of sexuality, 'arousing passions closely akin to those which incite men to war' (ibid.), but she does not seem to reach the ferociousness found in her Near Eastern counterparts. This is clearly seen in the *Kumarbi Cycle*, one of the most important myths written in Hittite. In the 'Song of Ḫedammu', Šauška plans with her brother, the chief Hittite god Tessube, to seduce Ḫedammu, a huge male sea monster, and thereby overcome him. She bathes and anoints herself with perfumed oil in order to seduce him (Hoffner 1998: 50–55), but she does not wallow in blood and gore as we saw with the Near Eastern goddesses.

Sun Goddess of Arinna

Despite the importance of Šauška-Ištar, it is the Sun Goddess of Arinna whom the Hittites seem to have had as their most important war goddess, and like other war goddesses, war was only one of her several aspects,[4] but we learn from the *Annals of King Muršili II* that it is Arinna who was called upon when King Muršili II (1321–1295 BC) went into battle (Bryce 2004: 98).

The Sun Goddess of Arinna was one of the main and earliest Hittite deities and their supreme goddess. She is considered the wife of the Storm God of Ḫatti. Like so many of the Hittite divinities, she was not original to the Hittites – she was adopted from the Hattic people from whom the Hittites took over in central Anatolia. She had been '"Queen of the Ḫatti Land" and was the deity who "guides kingship and queenship in the Ḫatti land"' (Teffeteller 2001: 352). We first hear of her in the seventeenth century BC during the Old Kingdom in the *Annals of King Ḫattušili I* (ca. 1650–1620 BC) (Gurney 1977: 11). It was she, as well as other deities, who was said to be with Ḫattušili when he went into battle (Bryce 2004: 101), and it is from these *Annals* that we learn that the Sun Goddess ran before the king in battle to ensure his victory. Twice she is called GAŠAN-*JA* 'my lady'. 'Ḫattušili declares himself "beloved of the Sun-goddess of Arinna"'. She is his protectress, champion in warfare, and leads him into battle (Gurney 1977: 11–12).

'She gives him victory and he brings back booty, silver and gold, to her temple' (Teffeteller 2001: 351–52 and ns. 16–17). The latest preserved Hittite prayer is a plea for military victory (1237–1209 BC) addressed to her by King Tudhaliya IV (Collins 2007: 154). Despite her calling for victory and running before the king in battle, it is not clear that she actually engaged in combat.

Arinna also lacks the tendency for violent sex, but like so many other Indo-European war goddesses, is closely associated with water, an imperative for fertility. Teffeteller (2001: 361, ns. 62–63) says her name 'appears to mean a

"spring" or spring-fed "pool" or "well"', and that the original site of Arinna contained a sacred spring. Rather than an actual 'war' goddess, she appears to be more of a giver of victory.

It is unclear if the Hittites had a war goddess that was strictly Indo-European. Ištar is certainly a Near Eastern goddess as her most prominent characteristics are clearly not Indo-European. Nevertheless, she has conflicting aspects such as healing/war, war/fertility, fertility/death (war), but like Arinna, this Ištar does not seem to have the propensity towards violent sex of her Near Eastern counterparts.

Because the Hittite goddesses appear to be the earliest of the Indo-European war goddesses, we might think of them as somewhat transitional, having absorbed some characteristics of the earlier Near Eastern goddesses, but in some respects changing or perhaps softening some of their features. The more violent sexual attributes appear to have been set aside while the affinity for water and fertility were maintained; the virginity characteristic does not seem to appear among the Hittites. It is not clear why the Hittites have taken this softer line – possibly because the earliest Indo-European gods are so strong that their female counterparts do not compare in strength, or perhaps just through the passage of time. What passes for a Hittite war goddess seems to be a fairly weak Indo-European goddess with a thin Near Eastern overlay.

The Iranian Goddesses

Arədvī Sūrā Anāhitā

The Iranian goddess Arədvī Sūrā Anāhitā, ('pure mighty moist one', 'faultless') 'goddess of the mythical world river' (Boyce 1984: 33), and most commonly considered the goddess of waters was, in fact, a multi-functional goddess. Her functions included fertility (verified by her epithets 'furthering creatures', 'furthering the land', 'furthering the herd' and 'furthering wealth') (Gray 1929: 56), women's affairs (purifying the womb, milk and male seed), and water (purifying all the waters). Nevertheless, Anāhitā, too, was a war goddess, and like so many of the Indo-European war goddesses she is a supplier to the warriors rather than a warrior herself. It is to her that warriors sacrifice and beg for the favours of victory.

Yašt V of the *Avesta*[5] is dedicated to Anāhitā and vividly describes her in detail as one who is dressed in a golden cloak, wearing a tiara made of either diamonds or gold, wearing a precious necklace, and driving a chariot. Although Anāhitā is sometimes known as Mithra's consort, she is also a virgin – again suggesting 'virgin' as a title. While thought to be Iranian, she appears in other Near Eastern connections as well. Gray considers her Iranian in origin but

'perhaps influenced by Ištar' (ibid.). Boyce (1982: 202) also speaks of a cult of Anāhiti(a)/Ishtar.

The Iranian heroes, including the main Zoroastrian god Ahura Mazda himself, worshiped her and asked her help, but it is not until §§131–32 of Yašt V that we see a real battle request:

> Here, O good, most beneficent Ardvi Sûra Anâhita! I beg of thee two gallant companions, one two-legged and one four-legged: one two-legged who is swift, quickly rushing, and clever in turning a chariot round in battle; and one four-legged, who can quickly turn towards either wing of the host with a wide front, towards the right wing or the left, towards the left wing or the right. §132 ... come down from those stars, towards the earth made by Ahura, ...; come to help him who is offering up libations, giving gifts, sacrificing, and entreating that thou wouldst grant him thy favours; that all those gallant warriors may be strong, like king Vîstâspa ['he who has many horses']. (Darmesteter 1882, Pt. 2: 84).

The Fravši

The Fravši are an Iranian winged group much like the Germanic Valkyries. They are warlike female beings that inhabit the air and not an earthly dwelling. They will fly quickly to the aid of a kinsman who has properly prayed. They are not easily defined but appear to be connected in some way to ancestor worship (Boyce 1996: 118–19). Yašt XIII.67–68 tells us that:

> (67) They fight in battles, each *for her own place and abode, where she had a place and abode to inhabit; even as a mighty chariot-warrior should fight, having girt on his sword belt, for his well-gotten treasure. (68) Then those of them who conquer drive off the water, each to her own family (Boyce 1984: 33).

The Greek Goddesses

The Greek war goddesses are more fully developed Indo-European deities than those of the Hittites or even the Iranians. They appear in the so-called *Homeric Hymns*,[6] some perhaps from the seventh century BC, therefore, possibly as early as Homer or Hesiod, and thus constitute some of our earliest Greek literary monuments. Although we often see that the violence of the Near Eastern goddesses has been carried over into the Greek goddesses, it is not usually as savage as seen in Hymn 11.

Of Pallas Athene, guardian of the city, I begin to sing. Dread is she, and with Ares she loves deeds of war, the sack of cities and the shouting and the battle. It is she who saves the people as they go out to war and come back

Hail, goddess, and give us good fortune with happiness!
<div style="text-align: right;">Hymn 11 (to Athena)</div>

The Erinyes
Before moving to the better-known goddesses with war aspects, the lesser mythological figures should be mentioned. The Erinyes (equated to the Roman Furies) are some of the more ancient goddesses within the Greek cosmological genealogy who were created from drops of blood that fell on Gaia when Cronus castrated Uranus (*Theogony* 182–85). They are mentioned in Linear B at Knossos (V 52) and again at (Fh 390) (J. Chadwick 1976: 98) thus dating back to the Bronze Age. While not officially war goddesses, they were quite violent and refused the authority of Zeus' generation of gods. They are goddesses of retribution and analogous with the Fates. They were thought of as three in number – Tisiphone, Megaera and Alecto – all of whom are repulsive creatures dressed in black, winged and often described as having snakes mixed in with their hair. They in the 'darkest pit of Hell' called Erebus, and caused misfortune such as occurred to Oedipus and Agamemnon's family. They avenged crimes, particularly against the family and murderers. They are also referred to as the Eumenides (see the Aeschylus play) as a form of flattery in order not to bring down their wrath (see Grimal 1996: 151; Price and Kearnes 2003).

Eris
The goddess Eris personified 'strife' or 'discord'. At *Iliad* 4.440–45 she is called 'the sister and comrade of man-slaying Ares'. It is she who 'bring[s] most woe upon human beings on the earth, whenever someone willfully swears a false oath'. (*Theogony* 231–32). These two worked in concert – she instigated war and he carried it out. She is somewhat like the Erinyes in that she is usually portrayed as a winged spirit but not having a warrior aspect. While not precisely a goddess of war, she delighted in creating conflict such as when she threw out the apple for the Judgement of Paris (Lucian, *Dialogues of the Sea-Gods* 7), which led to the Trojan War.

Enyo
The war goddess Enyo was the companion of Ares whom she accompanied into battle. She is also considered by some his daughter (some others say sister or mother). Enyo, who delighted in battle carnage, ranked with Athena in fighting and carried the epithet 'sacker of cities' (*Iliad* 5.333, 592). A statue of her stood

in the Temple of Ares (Bell 1991: 181), and she is portrayed as covered with blood, striking a violent pose.

The Erinyes, Eris and Enyo appear together at the beginning of the epic by the Roman Quintus Smyrnaeus' *The Trojan Epic* (Book V) when the meticulous description of Achilles' shield is given.

> Then there were scenes of devastating warfare
> And horrible fighting, with people killed on every side
> to be drenched with copious blood upon that solid shield.
> There were Panic and Fear and the ghastly goddess of war [Enyo],
> Their limbs all hideously bespattered with blood. There too was
> deadly Strife [Eris] and the fierce avenging spirits [Erinyes],
> Strife spurring men to engage in combat without restraint,
> The avenging spirits [Erinyes] breathing blasts of destructive fire
> (*The Trojan Epic*, Book V, ll. 25–33).

Athena

The most famous of the Greek goddesses to sustain a war aspect is, of course, Athena, the goddess of war, who was also protectress of cities – principally, Athens. In the hymn above we see this contradiction: 'she loves deeds of war' yet '[i]t is she who saves the people'. When she is worshipped in Athens one of her surnames is Areia 'warlike', and in the numerous stories that recounted her birth, one of the most frequently told is that she sprang from the head of Zeus 'in warlike arms of flashing gold', (*Homeric Hymn* 28 [to Athena]) which clearly accentuates her warrior aspect. At Hesiod's *Theogony* (318) she is called 'leader of the war-host' and at 925 she is described as 'terrible, battle-rouser, army-leader, indefatigable, queenly, who delights in din and wars and battles'.

Although her origins are somewhat obscure, her antiquity is considered great.[7] A Linear B tablet dating to about 1400 BC refers to 'A-ta-na-po-ti-ni-ja', 'the powerful female goddess of the place At[h]ana', which seems to refer to Athena. However, Deacy (2008: 95) is cautious of the Bronze Age claims because '[t]he tablet does not explicitly call the goddess Athena, but rather the goddess of a place called Athana. It cannot even be said with certainty that this Athana is consonant with Athens'. Nevertheless, this mention in the Linear B tablet does add credence to the suggestion of a Mycenaean 'warrior goddess' discussed in Rehak (1984) and again in 1998 in a possible attempt 'to trace the origins of the historical Athena back into the prehistoric period' (1998: 227). The figure in question is a painted plaque that 'shows a white skinned female figure wearing a figure-eight shield and possibly a boar's tusk helmet, and brandish a sword' (ibid.). Rehak connects a growing number of other figures to the plaque relating the three recurring elements: figure-eight shields,

boar's tusk helmets and swords. He suggests 'that an iconography of important women bearing weapons and wearing a figure-eight shield could represent such a divinity' (ibid.). Furthermore, he points out that the increasing number of these figures on Crete itself 'strengthens the notion that the Mycenaean Warrior Goddess was originally a Minoan divinity' (ibid., 236).

Athena does share a number of characteristics with older Near Eastern war goddesses and even with the Hittite Sun Goddess Arinna, but she is not considered a disguised Near Eastern goddess (Farnell 1896: 258–59). Some, however, say that her armour is a later embellishment and that her armed appearance signifies defence rather than aggression (Bell 1991: 84–85). Nevertheless, her warrior proclivities, be they offensive or defensive, are portrayed both on an exaleiptron housed in the Louvre, painted by the artist C. Painter, depicting her birth (ca. 570–560 BC), and on an Attic red-figure kylix showing Athena slaying the Gigante Enceladus (ca. 550–500 BC) also housed in the Louvre. Teffeteller (2001: 349) emphasises that Athena's first priorities are war and the protection of cities, their people, and their kings. In the battle between the gods and giants, she fought mightily on the side of the gods, but Crystal stresses that she was also a goddess of military strategy. As Athena Promachos she was 'the one who fights in the front', and as Athena Hippeia she was the inventor of the chariot. He further states that '[c]onflict and war were last options for Athena, deployed only when all diplomacy had proved unsuccessful' (Crystal 2017: 4). Nevertheless, this is at divergence with the words of Hymn 11 that, 'with Ares she loves deeds of war, the sack of cities and the shouting and the battle' and *Iliad* 5.838 where she is described as 'a goddess eager for battle'.

Some consider Athena more benevolent than warlike and point to her many non-warlike attributes, including her invention of the plough, numbers, several musical instruments and weaving. Indeed, in *Homeric Hymn* 5, addressed to Aphrodite, Athena's less warlike qualities are emphasised, but even here we are told she 'delights in wars and in the work of Ares'. In *Homeric Hymn* 28, Athena's 'warlike arms' – albeit made of 'flashing gold' – are mentioned. This is reinforced by Hymn 11 (to Athena) in which she is called 'dread', and, as we have seen, we are told she 'loves deeds of war, the sack of cities and the shouting and the battle', leaving no doubt that she is a war goddess. While she may be ἐρθσίτολιν 'guardian of the city', she is also 1) δεινήν 'terrible' and 2) coupled with Ares as one who is concerned with the deeds (or acts) of war ὀλεμήια ἔργα, which are specified as περθόμενά τε πόληες, 'the sacking of cities', ἀϋτή (the war cry) and πτόλεμοί (warfare). Furthermore, her cult titles and epithets affirmed her commitment to war Ἀλακαλκομένη, 'the helper in battle'; Προμαχόα, 'the one who fights in the forefront of the battle'; Ἄρεια, 'warlike'; Ἵππια, '[war-]horse-goddess', Ληῖτις, Ἀγελείν, 'the goddess who gives the [battle] spoil' (Farnell 1896: 1: 309). If no other, the epithet Νίκη, 'Victory', speaks to her warlike nature. A more charitable

conclusion might say that as a defender she would be interested in protection from the attacks of enemies, but as we have seen above, Hymn 11, to Athena, also envisions her guarding armies going and returning. All of which looks like a more aggressive Athena than she is usually acknowledged to be. In the *Iliad*, we see Athena most frequently in warrior garb, and she sides with the Greeks over the Trojans because she did not agree with the Judgement of Paris, despite the fact that the city of Troy was under her protection. She interferes in battles numerous times, working not only for the Greeks but also actively against the Trojans (*Iliad* 22). She made Laertes young in order that he could battle the Ithacans and protects her favourites such as Herakles and Diomedes. When she defends Diomedes against Sthenelus (*Iliad* 5.800–62), she is not only 'a goddess eager for battle' (*Iliad* 5.838), but also Ἀλκίδημος 'defender of the people', reminding us that one woman's defence is another's aggression. As such we might quote the poem of the early sixth-century BC Athenian statesman and lawgiver Solon, who praises Athena as the protector of Athens. 'Our city will never be destroyed by the destiny of Zeus or the intent of the blessed immortal gods. Such a great-spirited protectress, child of a mighty father, Pallas Athena, holds her hands out over it' (Teffeteller 2001: 350).

Another point about Athena which is pertinent and links her to other war goddesses is her avian association, but with Athena it is the predatory owl – although she is depicted with wings on a vessel by Olpe carrying a body over the sea (Boardman 1974, fig. 207). Also like many other war goddesses Athena has a clear horse relationship as seen above in the epithet Ἵππια, '[war-]horse-goddess'.

N.J. Allen (2001) considers Athena cognate with the Indic goddess Durgā, who, as we will see, was an extremely fierce warrior goddess. Athena was also a popular goddess among the Eastern nomads and her image is fairly common among them (Hiebert and Cambon 2008: 242, figs. 55, 56, 105).

Athena was a militant virgin who on occasion had to ward off male advances (Apollodorus 3.14.6). The Parthenon (*parthenos* 'virgin') was built on the acropolis as a temple to her, and while not using the word, Pomeroy describes Athena as a 'virago' in that she:

> is the archetype of the masculine woman who finds success in what is essentially a man's world by denying her own femininity and sexuality. Thus Athena is a virgin – and, what is more a virgin born not of woman but of man. While her mother was pregnant, Zeus swallowed her and, in time, at the stroke of the ax of Hephaestus, Athena was born, as befits a goddess of wisdom, out of the head of Zeus, fully armed and uttering her war cry (Pomeroy 1975: 4–5).

Because Athena is both a virgin and virago she has some characteristics of the Amazons, but she also engages in what is referred to as 'woman's work' as seen in the *Iliad*. Here we see her in both guises and her warrior aspect is in full force when she:

> let fall upon her father's floor her soft robe, richly broidered, that herself had wrought and her hands had fashioned, and put on her the tunic of Zeus, the cloud-gatherer, and arrayed her armour for tearful war. About her shoulders she flung the tasselled aegis, fraught with terror, all about which Rout is set as a crown, and therein is Strife, therein Valour, and therein Onset, that maketh the blood run cold, and therein is the head of the dread monster, the Gorgon, dread and awful, a portent of Zeus that beareth the aegis. And upon her head she set the helmet with two horns and with bosses four, wrought of gold, and fitted with the men-at-arms of an hundred cities. Then she stepped upon the flaming car and grasped her spear, heavy and huge and strong, wherewith she vanquisheth the ranks of men – of warriors with whom she is wroth, she, the daughter of the mighty sire (*Iliad* 5.735–51).

Aphrodite

The goddess Aphrodite is best known as the goddess of love and beauty, but when seen in full armour, as in Sparta, like Athena, she is called *Areia* 'warlike' (Pausanias 3.17.6, 3.15.10). Plato in his Symposium 180 said there were two Aphrodites: *Ourania* – 'heavenly', and *Pandemos* – 'all the people'.

While not a war goddess she does have military aspects and in her warlike persona, Aphrodite also has fertility associations like many war goddesses.[8]

Unlike most goddesses, Aphrodite had numerous lovers but appropriately the war god Ares was perhaps her favourite.

Aphrodite was credited with at least two sources of birth, but she also had several antecedents and there are several theories regarding her origins.[9] Homer gives her parents as Zeus and Dione (*Iliad* 5.370), but Hesiod has her rising from the foam that resulted from the blood of Uranus' castration (*Iliad* 5.370). She is generally not regarded as wholly Indo-European, but most importantly for our purpose, we can point to the ferocity of her Near Eastern antecedents, first Inanna followed by the Assyrian/Akkadian Ištar. Herodotus recognised this Eastern influence and claims the Phoenicians brought her from Askalon in Israel to the Greek islands. Aphrodite is also given a connection to Canaanite-Phoenician goddesses, chief of who are Astarte and the related Anat, the bloodthirsty goddess seen in the previous chapter. Frazer (1963: 381ff.) advocated for this connection, but Budin (2003), in her expansive study of the goddess and a history of the varying views, makes a credible case for her

emerging during the Late Bronze Age in Cyprus. Euripides showed the darker side of this Greek love goddess in the prologue of his play *Hippolytus* when Aphrodite seeks vengeance from Hippolytus for honouring Artemis above her. For this sin Aphrodite declares she will kill his stepmother, Phaedra, who loves Hippolytus due to Aphrodite's scheming. Although war is not an outcome of Aphrodite's actions, it does show that she is capable of the type of abhorrent acts characteristic of a number of the ancient Near Eastern war goddesses.

A fragment of an armed female found on the Acropolis is identified as Aphrodite herself. She holds a round shield in her left hand (the viewer sees the inside of the shield) and spear is shown above her, which she undoubtedly holds in her right hand (Budin 2003: 27, fig. 2e). The fragment is attributed to the painter Lydos and dates to 560–540 BC. Budin (ibid., 28) further reminds us of the later work of the Roman Pausanias (3.5.1, 3.15.10, 3.23.1) where he describes the no-longer-existing monuments where Aphrodite is represented as armed. She adds: '[n]evertheless, there is iconographic and literary evidence for both a link between Aphrodite and Ares in the early sources and portrayals of Aphrodite herself armed'.

Thus Aphrodite, too, despite the varying views of scholars as to the extent or even existence of her military aspect (see Cyrino 2010: 49–52) can be added to our catalogue of Greek goddesses with a war aspect. Nevertheless, she appears to have been less successful as a war goddess than as a love goddess. To this point, Zeus chides her, 'Not unto thee, my child, are given works of war; nay, follow thou after the lovely works of marriage, and all these things shall be the business of swift Ares and Athene' (*Iliad* 5.424–30).

We should also remember that different peoples often adopted local deities when their worship became more widespread. Dexter (1990: 112) points out that 'a Near-Eastern mother-goddess might be assimilated with the Greek virgin goddess, Artemis, or a local Laconian warrior-goddess might be synchronised to the Pan-Hellenic Aphrodite'. The Phoenician goddess Astarte is often considered the precursor of Aphrodite.

Pausanias (3.15.10–11) twice comments on Aphrodite's military aspects. First, he points out that on a small hill near Boetia where the Lacedaemonians (Spartans) built the only two-story temple known to him, a wooden statue of an armed Aphrodite surnamed '*Morpho*' had been placed. This statue of the goddess, veiled and with chains on her feet was meant to demonstrate, according to Pausanias, the faithfulness of the Lacedaemonian wives to their husbands. A second reference (3.17.1–6) tells us of another sanctuary of Aphrodite begun by Tyndareus but left unfinished. Years later the Lacedaemonians completed the sanctuary, building it and a statue of Aphrodite in bronze. Behind the Bronze House they built a temple to Aphrodite *Areia*. Graf (1984: 250), however, observes, 'In marked contrast to the Near Eastern goddesses Inanna, Ishtar, and Astarte, Aphrodite in Homer is absolutely alien to war and battle … Her world

is the world of women and love'. Graf overlooks her failed attempt to rescue her son Aeneas, only to be wounded by Diomedes (*Iliad* 5.335–39). Another interpretation comes from Parker Pearson (1999) who sees the depiction of deities in warrior aspect as a relic from primitive cult images while Pausanias himself refers to the wooden images in the temple of Aphrodite *Areia* 'as old as any in Greece' (Pausanias 3.17.5).

Aphrodite, like so many other goddesses with war characteristics, is frequently depicted with a bird, in her case, the dove, the same bird associated with the Near Eastern goddesses Ištar-Astarte and Anāhitā. We see this on an inscription dating to 284 BC in Athens that refers to the cult of Aphrodite *Pandemos*. Budin (2003: 29, fn. 60) suggests that the expression κατὰ τὰ πάτρια (forefathers) indicates that the inscription may be much earlier. She further proposes that Aphrodite's bird associations may also extend to swans and geese. We will see later that both doves and geese have a number of war connections, but less so swans.

Aphrodite was quite popular farther east in the Scythian world and Aphrodite's cult in this part of the world has been examined in detail by Yulia Ustinova (1999), using many Russian sources. Ustinova concludes that:

> The absolute preeminence of Aphrodite *Ourania* as a patroness of the king and his kingdom, attested by inscriptions and coins, her role as a grantor of military victory, her function as a guardian of the dead in the nether world, the idea of a communion between the goddess and a deified king, a general or a simple mortal – all these traits were borrowed by the Bosporan Aphrodite from her local counterparts. (Ustinova 1999: 173).

Artemis

Artemis, goddess of the hunt, moon,[10] virginity, childbirth and natural environment, is another of the major Greek deities to have not only war connections, but also some connection to the Near East.

Along with other Greek divinities, Artemis' name appears on Linear B tablets from Pylos specifically Eb 650.5 (J. Chadwick 1976: 99). She 'delights in arrows' (*Homeric Hymn* to Artemis 9) as one would expect from a goddess of the hunt, but this might also apply to war to which she also had connections. The Spartans, before a war or battle, would sacrifice a goat to her (*Hellenica* 4.2.20), and when the Persians were about to attack before the Battle of Marathon, the Athenians vowed to sacrifice as many goats to her as enemies killed (Xenophon, *Anabasis* 3.2.11–12). Bell (1991: 71) declares she 'was the most complex of the Olympian deities, paradoxically compassionate and vengeful, nurturing and destructive, pacific and bloody'. Although she is not specifically a goddess of war, these characteristics fit well with many of the other war goddesses;

her virginity is particularly noted, as are her midwifery skills that connect to fertility; at Ephesus she is especially famous for fertility. Dexter (1990: 162) says Artemis 'was a virgin by virtue of being independent and her chastity was secondary', therefore, her virginity was 'figurative'. Artemis is known for her vengefulness, particularly towards those who neglected sacrificing to her. Bell claims she favoured women over men, but women were also targets of her vengeance. Her most famous act of revenge came when Niobe disparaged Leto for having only two children while she, Niobe, had six. Artemis and Apollo worked in concert – he killed the boys and she the girls.

Spartans were noted for their stoicism and military prowess and therefore we should not be surprised that many of their gods, unlike their Athenian counterparts, were depicted with weapons. This also holds true of their female divinities. Where only Athena herself is armed in Athens, the Spartan goddesses Artemis *Orthia*, as well as Aphrodite *Morpho*, and Aphrodite *Areia*, are all dressed as warriors. Artemis *Orthia* wears a helmet and carries both a spear and bow. Nevertheless, Pomeroy (2002: 19) claims it would be 'naive to postulate that goddesses were invariably a direct reflection of their female worshippers ... [but] the Spartan evidence, with its intense focus on martial prowess, does seem to have implications for women'.

Despite these armed goddesses, there is little indication beyond the episode with the invading Messenians (seen in the Pomeroy quote above) that Spartan women took part in battle. They were, however, required to keep fit. Xenophon (*The Lacedaemonians* 1.4) tells us that Lycurgus 'believed motherhood to be the most important function of a freeborn woman. Therefore, in the first place, he insisted on physical training for the female no less than for the male sex ... believing that if both parents are strong they produce more vigorous offspring'. Plutarch tells us that 'maidens exercise their bodies in running, wrestling, casting the discus, and hurling the javelin' (*Lycurgus* 14.2), revealing that women had some training in weaponry; but in Plato (*Laws* [805E-806A]), the Athenian stranger points out that although girls partake in gymnastics, they do not engage in military service. Furthermore, because they do not know how to use weapons, they would be useless in defence of their city. Nevertheless, the gymnastic activity was, we are told, for the purpose that women would have healthy bodies in order to bear healthy sons. A consequence of their training, however, was the strength they acquired that allowed them to do heavy manual labour assisting the men on at least one occasion in 369 BC when the Thebans invaded Sparta (Pomeroy 2002: 16; see also Plutarch *Pyrrhus* 27.2–3).

Although clearly not as ferocious as the Near Eastern war goddesses, it is evident that the Greeks had war goddesses, or at least goddesses who dabbled in war. Nevertheless, it appears that the aggressiveness of the Greek war deities had been diluted, although traces of this ferocity can still be seen in some of the literary sources. The Erinyes, who are considered some of the

most primitive Greek goddesses, seem to have maintained the violence of the Near Eastern goddesses. It is also evident that many of the warlike aspects of both Athena and Aphrodite were greatly suppressed overtime, and although the cult of Aphrodite as a warrior did flourish primarily in Sparta, it also extended somewhat into other Greek cities.

The Armenian Goddess

Perhaps related to Athena, at least during the Hellenic period, is the Armenian goddess Nane who was the beautiful daughter of the Armenian supreme god Aramazd. She, too, dressed in armour and like Athena carried a spear and shield. In the Armenian pantheon she was the goddess of wisdom, motherhood and war. Furthermore, she had connections to the Iranian goddess Anāhitā. Her name is unclear but it has been given Indo-European origins including Phrygian Kybele (see Lurker 1987).

The Roman Goddesses

Because their army played such a dominant role in Roman society, it might be thought surprising that there are even fewer Roman goddesses with even fewer pronounced warrior attributes than the Greeks. We also see less influence from the Near East among the Roman goddesses, but there is overlap with Rome's Italic and Etruscan neighbours.

Minerva
While not primarily a warrior goddess, Minerva does take on a warrior goddess persona and is later worshipped in conjunction with Mars. The slightly earlier but non-Indo-European Etruscan goddess Menerva is very similar to Minerva, who has a greater war aspect and is, in fact, considered an actual war goddess. To women Minerva was the patroness of domestic skills, but to men her courage, cunning, prudence and particularly military knowledge, for which she wore a helmet, cuirass and carried a shield, were most notable (*New Larousse* 1959: 209). Although Bell (1991: 308–309) sees her warrior aspect as late, she is seen wearing a helmet already on the obverse of a coin dating to 240–225 BC. This would have been early in the Roman coinage system that began about the middle of the third century BC. Her image in warrior apparel continues periodically throughout Roman times but notably during the reign of Domitian (AD 81–96), when she is most frequently depicted on *denarii* and *ases*.[11]

Minerva's association with water is clearly seen in Britain where she became the goddess to oversee the curative waters at Bath, and her name

was combined with that of the Celtic goddess Sulis who had previously been worshipped there. A Roman temple dedicated to Sulis Minerva was erected at Bath in AD 60–70.

Juno

The goddess Juno is considered one of the oldest of Roman deities and part of the reigning triad of Roman gods, which also included Minerva and Jupiter. Although her exact history is not well known she has deep Italic roots. She was the chief deity of Lanuvium (a city south of Rome) and is found among other Italic people such as the Sabines, Oscans, Umbrians and Latins, as well as the non-IE Etruscans. The Etruscan Great Goddess Uni, who is also the wife of the Etruscan supreme god Tinia, is equated to the Greek Hera and Roman Juno. It is also via her Etruscan link that Juno's war association reaches back to a Near Eastern connection by way of her Phoenician ancestry and that society's brutal war goddess Astarte. This association is evidenced in the inscriptions on the Pyrgi gold tables written in Etruscan and Punic (Pallotino 1978: 111–12).[12]

Like Athena, Juno carries a spear and shield, but her warrior aspect is usually not emphasised. Nevertheless, in the first lines of the *Aeneid* we are told of 'cruel Juno's unforgiving wrath and much enduring in war' (*Aeneid* 1.4–5). A few lines later we are told that Carthage, which waged war fiercely, is her favourite land and where she kept her shield and chariot (*Aeneid* 1.12–18). Another military aspect which is rarely emphasised is that she is the mother of the war god Mars.

She had numerous attributes including being the protector of nearly everything female from child birth to death, as well as marriage and the sexual act, Prema and Pertunda, but she is most commonly known as Juno *Sospita* 'the Saviour'. Although Juno is often equated with the Greek Hera, the patroness of marriage and childbirth, both have some characteristics of a warrior goddess. Despite her warrior attributes, it was Juno's name that was invoked during the act of childbirth, which again gives us an example of the pairing of war and fertility in a single goddess.

One of Juno's earliest war links came in 390 BC under the name Juno *Moneta*,[13] at the time of the Celtic invasion of the Italic Peninsula (Plutarch, *Camillus* 27.2). Geese that were raised in her sanctuary sounded the alarm, and this early warning allowed Manlius Capitolinus enough time to gather his forces and repel the invaders (Grimal 1996: 243). While geese are neither predatory nor carrion birds, they can be belligerent and quite vicious particularly to strangers.

Bellona

The goddess Bellona's name comes from the earlier Duellona (Varro V.73, VII.49) and transparently derives from the Latin *bellum* – 'war'. Bellona, the Roman equivalent of the Greek Enyo, was the companion of Discordia,

the Furies, as well as Mars, and perhaps his wife; like Enyo, Bellona, who is usually dressed in armour or at least a helmet (typically plumed), delighted in the carnage of the battlefield. She is associated with Mars and Virtus (who embodied all types of military activities), and according to the *Corpus Inscriptionum Latinarum (CIL)*, thirty-three inscriptions are dedicated to her. A number of these inscriptions are geared toward the army in connection with Mars and Virtus (Lloyd-Morgan 1999: 124–27).

Dio Cassius (*Roman History* 50.4.5) tells us that Octavian's declaration of war on Cleopatra that culminated in the Battle of Actium was followed by a visit 'to the temple of Bellona, where they performed through Caesar as *fetialis*, all the rites preliminary to war in the customary fashion. These proceedings were nominally directed against Cleopatra, but really against Antony'. On a number of inscriptions in Alesia in eastern France and western Germany, Bellona was associated with military facilities and has been attributed to inspiring the invention of arms.

Nerio

Nerio, a little-known Roman goddess, was borrowed from Rome's Italic neighbours, the Sabines. She was another consort of Mars and her name may mean 'masculinity' from the IE root **hner-* meaning 'man'. Like Mars, spoils of war were dedicated to her (Fantham *et al.* 1994: 322).

Discordia

Despite Discordia being the Roman goddess of war and discord, she is mentioned only twice in the *Aeneid* (6.280 and 8.702). Her companions, Bellona, Mars and the Furies (see Greek Eris), all had war aspects and all were depicted in the centre of Aeneas' shield, which illustrates the Battle of Actium and was given to him by his mother, Venus. 'In the midst of the fray storms Mavors, embossed in steel, with the fell Furies from on high; and in rent robe Discord strides exultant, while Bellona follows her with bloody scourge' (*Aeneid* 8.700–703).

Bellona, Nerio and Discordia are minor figures in the Roman pantheon, deriving from Latin words for 'war' and 'manliness' and closely connected to the Greek Erinyes, Eris and Enyo. The figures Bellona and Discordia reinforce the idea that Romans did think in terms of one, or several, war goddesses. War was not solely in the realm of Mars.

The Celtic Goddesses

The Celts present us with two problems peculiar to them. While we have first-hand knowledge of many ancient peoples' religion (Sumerian, Egyptian, Greeks, Roman) written down by them, this does not hold true for the Celts,

who had a predisposition against writing down religious traditions. Therefore, our knowledge of Celtic religion comes from observations by outsiders – Caesar and other classical writers. A critical issue to consider with the Irish texts is the influence of Christianity. Many of the pre-Christian texts were edited and redacted by the early Christian monks who 'sanitised' or 'Christianised' them, resulting in texts that may vary greatly from the originals. Some of this early material can be retrieved, but undoubtedly much has been completely lost.

The second problem is that they are geographically divided, which is also reflected in the type of evidence we see. Because of this physical separation we might also think of the Celts as three entities in one. The Continental Celts are the oldest of the three groups, and the remaining two groups are made up of the insular Celts that are again divided into two parts, the British/Welsh group and the Irish. From the Continental Celts we mainly get the Gaulish inscriptions (see Meid 2010). From these inscriptions, we occasionally find a divine name that matches a name in one of the later Celtic tales that are found primarily in the insular groups (particular Welsh and Irish) that allows us to have some notion of the character of the Celtic divinities.

Our sources regarding Celtic goddesses are also split among the Celtic traditions. The Irish and Welsh provide the literature, but the Continental Celts supply most of the iconography, archaeology and epigraphy. We also have some iconographic support found on British monuments that date to the time of the Roman occupation (AD 43 to 410). The classical authors, from whom we have numerous accounts about the Celts, have provided much information in regard to their society and beliefs, but legends and Celtic law tracts also offer us insights.[14]

Another significant point to keep in mind for a general Indo-European view is that in many features of law and religion, as well as poetical phrasing, the early Irish texts show that the Irish are among the most conservative in regard to Indo-European traditions.

Amid the Celts we find figures that can most prominently be referred to as 'war goddesses' (or goddess analogues) within the Indo-European world. However, just as with the other war goddesses we have surveyed, they are never solely concerned with war. Often these goddesses have a triple aspect,[15] and perhaps the most usual trio is fertility (much like we have seen elsewhere), sovereignty and war, the latter of course, being our particular interest. This trio is more prevalent among the Irish, whose affinity for warrior goddesses sees them engaged in battle, albeit often in a metamorphosed form. Although the Irish had the greatest number of war goddesses, the Britons had at least two goddesses of war, as did the Continental Gauls.

Additionally, the goddesses frequently have equine and avian associations as we have seen elsewhere, and an association with the Underworld is also common. Although our interest is war, the primary trait of these goddesses was

fecundity. Some of these goddesses, as we will see, are clear triples such as the Irish Macha and Badb, but it is the Morrígan who is perhaps the principal war goddess for the Celts although Badb, who is closely connected to her, is also of great consequence – they are sometimes indistinguishable. The Morrígan is even more of a collective than Macha or Badb and quite complex as she can include Macha and Badb as well as another war goddess, Nemain, who also brings confusion. (See C. O'Rahilly 1967, l.2133 and 4149). Ross (1967: 206) notes, 'there is an overlapping of the various cults and symbols, so that complete segregation is impossible'. The reader must, therefore, be flexible with the following descriptions.

Continental and British Goddesses

Water is also closely associated with Celtic war goddesses, perhaps because many rivers, lakes, or sacred wells, are said to be curative. According to Ross (1967: 218) many of the wells and springs dedicated to these goddesses are found on tribal boundaries.[16] This association of goddesses and water, although not necessarily war goddesses, is found among the Continental Celts, as exemplified by Sequanna, goddess of the Seine.[17]

Epona
One of the most prominent of the Continental Celtic goddesses is Epona whose name transparently means 'horse' from the Latin *equus*.[18] She is not specifically a war goddess but has several war connections and was particularly popular among the ordinary soldiers of the Roman army (Linduff 1979).

Britannia
The goddess Britannia, goddess of sovereignty, who first appeared during the period of Roman occupation, has remained the symbol of Britain to this day. The image of Britannia leaning on her shield and holding a spear or trident, is first seen on a coin, ca. AD 161, during the reign of the Roman Emperor Antoninus Pius (P. Ellis 1996: 27). She has become the personification of Britain but does not seem to be a war goddess as such although her image becomes more prominent as a symbol during wartime.

Andraste
The British (Celtic) war goddess Andraste (Andrasta/Anderta) was probably the goddess Andrasta of the Voconces tribe (Dudley and Webster 1962: 67–68; Ross 1962: 151, n. 2; Green 1996: 32). It is to the goddess Andraste that Boudica (see Chapter 5), who may have been a priestess of Andrasta (Ross 1967: 360; P. Ellis 1996: 93), sacrificed her female prisoners, and it is to Andraste that

Boudica calls out before the battle, thanking her for the auspicious escape of the hare from under Boudica's dress (Dio Cassius 62.2). Boudica then speaks to Andrasta 'woman to woman'. It is in this speech that Boudica says that Briton's women have the same valour as its men and ridicules the Romans by saying that they 'sleep on soft couches with boys for bedfellows, – boys past their prime at that, – and are slaves to a lyre-player [Nero] and a poor one too' (Dio Cassius 62.6). Andraste was known as a goddess of victory, and she was also the only native Celtic war goddess whose name was used by Greco-Roman commentators who are more or less contemporary (Green 1996: 31). Rankin (1987: 222) suggests that it is the innate cruelty of the cult of Andraste that caused the Celtic warriors to impale female prisoners on stakes, cut off their breasts, and then stuff the breasts into the prisoners' mouth (see Dio Cassius 62.7). This streak of viciousness can be found in several of the Irish figures. Ross likens Andraste to the Irish Macha, Badb and the Morrígan, but it is because of her cruelty that Andraste reminds us of the Near Eastern goddesses discussed in Chapter 1. Ross[19] tells us that Andraste's name means 'the unconquerable' and that although her cult is not found elsewhere, this is fairly typical of Celtic deities as so many of the names seem to be confined to a single locality but their function is more widely spread. A further connection between Andraste and the Iceni is the possible appearance of the goddess on an Iceni coin (Ross 1967: 218).

The Irish Celts

It was, however, the Irish Celts who gave us the most colourful and numerous war goddesses. Compared to other groups of war goddesses the Irish divinities are well documented, as seen in the writings of Ross, Green, Epstein and others. The well-known Medb, who is often presented as a divinity, will appear in the next chapter, as she is generally believed to be more of a legendary figure. Nevertheless, beyond the problematic character of Medb, Ireland had several undisputed war goddesses, and we learn about these divinities exclusively from the Irish literature.

The Morrígan
The Morrígan,[20] 'Great Queen' or 'Phantom Queen',[21] seems to be not one, but 'a collective term for … [a number of goddesses] as well as being the name of one individual goddess' (Ross 1967: 219). Among her many names are Badb, Macha, Nemain, Anu/Danu, Bé Neít and daughter of Ernmas, Fea. She is very fierce in battle and is nearly a match for the powerful Irish hero Cú Chulainn as seen in the celebrated Irish epic *Táin Bó Cúalnge* (*The Cattle Raid of Cooley*, hereafter *Táin*) (C. O'Rahilly 1967, ll. 1989–2010).[22] She has the ability to

change her shape and can turn herself into a grey wolf, a hornless heifer, a great black eel, or carrion bird such as a crow or raven. She can also take on the roles of sorceress and prophetess. Equally, she can be a beautiful young girl or conversely an old hag. The Irish word for hag is *cailleach*, which not only has the connotation of goddess, but also has an association with curative wells (see Ross 1967: 219–20). As we have seen earlier in this chapter, according to Kapelrud (1969: 31) old goddesses are not goddesses but 'hags'.

The Morrígan, Badb and Badb's daughter are all associated with the motif of 'Washer at the Ford', in which a woman is seen washing away the blood-soaked and stained remains of war. These remains include not just garments but also weapons and limbs of the dead. The sighting of the 'Washer' is considered a sign of impending death as when the Irish hero Cormac witnessed such a scene prior to the battle in the tale of *Da Choca's Hostel*. (See Stokes 1900: 157–59.)[23]

The Morrígan is the most developed of the Irish war goddesses, and known from a number of tales. Like the other Irish war deities, she frequently engages in sex to achieve her goals. The Morrígan is a complex character that chooses the victorious side in a battle, but is known to promise victory to one side then give it to the other, as she did in the final battle of the Ulster Cycle (Green 1996: 43–45).

> It was on that night that the Morrígu daughter of Ernmas came and sowed strife and dissension between the two encampments on either side, and she spoke these words: *Crennait brain* etc.
> She whispered to the Érainn that they will not fight the battle which lies ahead. (C. O'Rahilly 1967: 263).

Her influence on the battlefield could be physical, usually in non-human form, but more often magical and/or psychological; her battle cry is said to have been as loud as the cries of 10,000 men. As we will see with the Valkyries, the Morrígan also has the ability to determine which soldier will die in battle.

Badb

Badb (originally 'battle', later 'hooded crow') is closely connected with the Morrígan, sometimes to the point of being indistinguishable.[24] She is noted for her fondness of death, being the harbinger of doom, and closely associated with, or seen as, a carrion bird. Badb is also known as *Badb Catha* – 'Battle Raven', and is known from an inscription at Haute-Savoie on the Continent *(C) athubodva* – 'Battle Raven' (Ross 1967: 219). In the tale *Da Derga's Hostel* (Stokes 1900), we see her connections with the Underworld. It is in this tale that King Conaire awaits his prophesised death and Badb appears as a hideous crow-like figure, bleeding, with a rope around her neck. When Conaire inquiries about her identity, she responds in riddles – a common devise of the Celts.[25]

In *Tochmarc Ferbe* (*The Courtship of Ferb*)[26] a prediction by a druid of Badb's destruction of Maev (Medb) comes early: 'Badb shall destroy! force wild and dread from Maev the field shall win' (Leahy 1902: 11).

Later, Badb comes to Maev in her sleep and tells her of the impending battle between Conor and Maev's son Mani (ibid., 25–26). Still later, in a song by Ferb, she sings 'Pale Badb have you feasted' (ibid., 41, ll. 830). This feeding of Badb is a reference to the death of the warriors.

Badb also appears in an episode of *The Táin* with Cú Chulainn, when he hears a terrible scream and finds a lone red horse[27] with only one leg pulling a chariot. A pole passes through the body of the horse and a red woman dressed in a red cloak (a war goddess) rides in the chariot; a man walks beside the chariot. Cú Chulainn asks who they are, and they answer, in true Irish fashion – in riddles. Cú Chulainn, enraged, jumps on the chariot, but the only one now there is Badb, in the form of a raven. In the guise of the Washer at the Ford, Badb (or her daughter) in human form washes the armour and weapons, in a form of prophecy, of those about to die in battle (Ross 1967: 245). In Irish translations of Latin texts Badb is often associated with the Roman goddess Bellona. (See Epstein 1998a: 245–70.)

Macha

Macha, who is also a part of the collective of the Morrígan, is herself a triple. We first know her as the wife of Nemed (Macalister 1940: 194 ¶¶ 249, 250; see also Stokes 1895: 45–46, §94; 279–83, §161; Ross 1967: 220, fn. 1), leader of the Bolgic invasion (T. O'Rahilly 1946: 75–84). It is this form of the triple that we know the least well, only that she died on the plain of Macha, which her husband named for her. *The Rennes Dindshenchas* tells us of the second Macha – Macha of the Ruddy Hair, *Macha Mongruad*. This Macha was the sole heir to Aed the Red, one of the three kings each of whom had ruled Ireland in turn. When Aed died, his daughter, Macha, was refused her turn by the other two kings, but she took them on in battle, defeated them, and then ruled for seven years. When a second king, Dithorba, died he left five sons who also refused Macha's turn as sovereign. She again went into battle and defeated the five sons. At last she married the remaining claimant, Cimbáeth, whom she made chief of her mercenaries. She then decided to visit the five defeated brothers in the guise of a leper. Despite her visible symptoms of leprosy (Macha had applied 'rye-dough and redbog-stuff' to create the effect), they decide to lie with her in turn. When she was alone with each, she bound them, enslaved them and ultimately had them build a *rath* (fortress), which we now know as Emain Macha, the boundaries of which she drew with her brooch (Stokes 1895: 281–82).

We see the third account of Macha as the wife of the peasant Cruinniuc. This Macha supplies the equine connection to the three Machas, and it is about

slain'. Earlier evidence comes from votive stones at Housesteads, 'Dedicated to the God Mars Tinesus and to the two Alaisiagae, Bede and Fimmilene', and another merely refers to 'Mars and the two Alaisiagis'. These names have been interpreted as 'ruler of battle' and 'giver of freedom' (Davidson 1964: 62), and are reminiscent of other Valkyrie names; Old English *Beadu* – 'battle', and *Baudi* – 'war', are not uncommon elements in Germanic names. We find these elements in some female names as well as Valkyrie names that connect them to war or battle: *Bothvild* – 'War-Maiden',[30] and cognate to *Beaduhild* – 'War-Maiden',[31] *Hlathguth* – 'the Necklace-Adorned Warrior-Maiden'.[32]

Davidson connects Valkyries[33] with spells that have survived in Germanic lore, one dealing with bonds or shackles applied by an enemy (she reminds us of the Valkyrie named Herfiǫturro – 'war-fetter') and the other, pain inflicted by weapons.

Turville-Petre (1964: 221) draws a connection between the *dísir* and the Valkyries. The *dísir* (sing. *dís*) are beings that are only vaguely defined. They may be 'tutelary goddesses attached to one neighbourhood, one family, perhaps even to one man ... [who] are hardly to be distinguished from the *fylgjur*, attendant spirits who protect an individual or a clan'. To add further to the confusion, Turville-Petre states that in poetry the word *dísir* 'is occasionally applied to valkyries, who are called *Herjans dísir* (Óðinn's *dísir*)' (ibid.). He then strengthens his case with two examples from Old Norse poetry. First from *Hamðismál* 28, when the brothers Hamðir and Sörli kill their bother and they say 'the *dísir* incited us to this' (ibid.). In this instance, Turville-Petre claims that '[f]or them the *dísir* can be no other than valkyries' (ibid.). The second example comes from *Krákumál* 29 when 'the dying hero says: *heim bjóða mér dísir* (the dísir invite me home).' Turville-Petre (ibid., 314, n. 10) believes '[t]he *dísir* appear in this context to be valkyries'. Shaw (2011: 61–62), however, simply leaves the *dísir* as an undisclosed collective possibly connected to *idisi* ('ladies') from the more general Continental Germanic area.

Stanza 30 of the first poem in Snorri's *Prose Edda*, *Vǫluspá* (*The Prophecy of the Seeress*), introduces the Valkyries. Hollander (1962: 1) suggests that this poem held the greatest significance because it was the 'most comprehensive and representative' of all the poems. Here we are not only told what the Valkyries do, but are also given some of their names.

[The valkyries flock ready to ride
Skuld held her shield,
Guth, Hild, Gondul,
for thus are hight
ready to ride

from afar she beholds,
to the realm of men:
Skogul likewise,
and Geirskogul:
Herjan's maidens,
o'er reddened battlefields.]
(Hollander 1962: 6.)[34]

Unlike the legend that Amazons did not do women's work, we see the Valkyries not only do the unusual weaving mentioned above but also, in *The Lay of Volund*, St. 1, three young valkyries are described as sitting by a lake spinning flax. Their names speak to their being valkyries: Halathguth the Swanwhite – 'the Necklace-Adorned Warrior-Maiden', Olrún – 'the One Knowing Ale Runes' and Hervor – 'the Warder of the Host'. It is in this tale that we meet the Swedish King Níthoth – 'Grim Warrior', and his daughter Bothvild – 'War-Maiden' (ibid., 160–61). In the story of Tyrfing, the magic sword, the Valkyrie Hervor disguises herself as a man and engages in combat. (See Tolkien 1960 and Clover 1986.)

Another major difference between the Valkyries and Amazons is that, according to Davidson, 'from early times the heathen Germans believed in fierce female spirits doing the command of the war god, stirring up disorder, taking part in battle, seizing and perhaps even devouring the slain' (1964: 62); the Amazons acted on their own without the direction of a god.

Freyja

Freyja was one of the race of Vanir gods, the daughter of Njörd (the sea god), sister of Freyr, and mother of Hnossa – 'jewel'. She is the only female Vanir named and is the Norse goddess of love, fertility, wealth, magic, prophecy, death and probably war. While she is not always called a war goddess, she has most of the characteristics of this type of deity, including engaging in frenzied and promiscuous sex and being associated with the boar and carrion birds – war symbols of both Germanic and Celtic people. In *Grímnismál* 14 we are told she received half of all those who died in battle (Oðinn took the other half), and she took them to her hall Fólkvangr – 'battlefield'. This action has caused her to be called 'the first Valkyrie'. Her sexual activities are infamous, and Loki accused her of lying not only with all the gods, dwarfs and giants but also engaging in incest with her brother Freyr (in *Lokasenna* 32). The *Flateyjarbók*[35] includes the story of her sleeping with all the dwarfs in order to acquire her necklace, the famous *Brísingamen*.

Freyja wore a feathered cloak called *falkhamn* – 'falcon coat', that allowed her to change into a bird, compounding her bird connection. A unique characteristic is that she drove a chariot pulled by cats,[36] and she also rode a boar with golden bristles, an activity not seen elsewhere except with her brother Freyr. Furthermore, she was also known by several names that indicate her characteristics and relationships: Mardöll – 'a sea connection', Hörn – 'flax', Gefn – 'giver', and Syr – 'sow'. (See Davidson 1964: 114–24; Lindow 2001: 126–28; Simek 1993: 90–91.) Aside from the Valkyries there are other Germanic female figures that have war connections.

The Alaisiagae

Davidson (1993: 48) tells us that Germanic female deities are divided into two main categories: The Mothers (Matres, Matronae), associated with giving, and the war goddesses or battle spirits. The latter include the Alaisiagae and the Valkyries. The Alaisiagae is a collective name for four goddesses: Baudihillie, Bede, Finnilene and Friagabi, about whom we know very little, and what we do know depends on archaeological finds. The Alaisiagae are mentioned on three monument stones found in the third-century Temple of Mars at the Roman fort of Housesteads on Hadrian's Wall in the north of England – two were found in 1883 (#s 1593, 1594), and the third in 1920 (#1576).[37] The names of these goddesses are recorded on one of the stones found in 1883 and the stone found in 1920 while the second 1883 stone simply uses the collective term; the two earlier stones both refer to the god Mars and the two Alaisiagis: the first stone (found in 1883) reads:

[#1593] Deo Marti Thincso et duabus Alaisiagis Bede et Fimmilene et N(umini)[38] Aug(usti) Germ(ani) cives Tuihanti v(otum) s(olverunt) l(ibentes) m(erito)

To the god Mars Thincsus and the two Alaisiagae, Beda and Fimmilena, and to the Divinity of the Emperor the Germans, being tribesmen of Twenthe, willingly and deservedly fulfilled their vow. (*Roman Inscriptions of Britain RIB* 1593).

The second reads:

[#1594] Deo Marti et duabus Alaisiagis et N(umini) Aug(usti) Ger(mani) cives Tuihanti cunei Frisiorum Ver(covicianorum). se(ve)r(iani). Alexandriani votum solverunt libent[es] m(erito)

To the god Mars and the two Alaisiagae and to the Divinity of the Emperor the Germans being tribesmen of Twenthe of the *cuneus* of Frisians of Vercovicium, styled Severus Alexander's, willingly and deservedly fulfilled their vow. (*RIB* 1594).

The 1920 inscription, which Bosanquet describes as 'less well cut' than the earlier finds, reads:

[#1576] Deabus Alaisiagis Baudihillie et Friagabi et N(umini) Aug(usti) n(umerus) Hnaudifridi v(otum) s(olvit) libens) m(erito)

To the goddesses the Alaisiagae, Baudihillia and Friagabis, and to the Divinity of the Emperor the unit of Hnaudifridus gladly and deservedly fulfilled its vow.

The linguistic peculiarities of the names are discussed in Bosanquet's article and determined to be German with meanings roughly Baudihillie – 'battle-commanding', and Friagabi – 'giver of freedom'. With the 1883 monuments was an additional monument on which was carved 'an armed god, evidently Mars, holding shield and spear and attended by a goose' (Bosanquet 1922: 188). The inscription confirms that the figure is Mars and the goose is characteristic of war divinities. However, Turville-Petre (1964: 181) points out that 'If, as is widely believed, Mars Thingsus is Týr, god of the Þing, or judicial assembly, the argument that Týr was god of justice, as well as of war, gains much support.'[39]

The inscriptions and the placement of the inscriptions makes it clear that these were goddesses connected to war.

Þorgerðr Hölgabrúðr and Irpa

The Old Norse figure Þorgerðr Hölgabrúðr (also Gerðr) is a somewhat mysterious character. Although she, along with her sister Irpa, may be regarded as trolls (N. Chadwick 1950: 408), Simek (1993: 176 and 326–27) regards them as goddesses. Here, I am placing them in the latter category of war goddesses because they seem to fall into this type in a number of instances. Little is known about Irpa, but she always appears to be connected with Þorgerðr Hölgabrúðr, who frequently appears on her own. Snorri refers to Þorgerðr Hölgabrúðr (Thorgerd Hölgabrudr) as King Helgi's daughter, but she is also referred to as the bride of Helgi. The skaldic poets further know her as Gerðr (N. Chadwick 1950: 400). Our knowledge of her is confusing, and here I will stay with those things that place her in our warrior category. In addition, Þorgerðr Hölgabrúðr is said to have been the deity worshipped by Jarl Hákon (ca. 937–995) of Lade in Trondheim, a fierce pagan and anti-Christian. It is to Hákon's aid during the Battle of Hjørungavágr against the Jómsvíkingar that Þorgerðr and Irpa appear, and where famously they cause hail storms and arrows to fly from their fingers.

The Slavic Goddess

Zroya (Zarya) seems to be the only Slavic war goddess. She is the virgin dawn goddess who is dressed as a warrior. She was not only the goddess of the day (*Utrennyaya*), but also the night (*Veckernyaya*). She is closely associated with Perun the thunder god. When found with him, she assumed the aspect of a well-armed virgin warrior, patroness of warriors whom she protected, and thus, we can find close similarities with the Greek Athena (*New Larousse* 1959: 294; Dexter 1990: 65; Dixon-Kennedy 1998).

The Indic Goddesses

Indic deities are complicated and often difficult to follow. Nowhere is this more evident than in the area of war goddesses. There are no Vedic goddesses that could be classed as a war deity, but there are later Hindu goddesses that have this aspect in one form or another.

Durgā

Perhaps the most fearful is the many-armed goddess Durgā (see Kinsley 1988: 95–115), which is only one name and form for 'the Goddess' Devī who appears in multiple forms much like the Irish Morrígan.

Durgā is the Hindu goddess of victory, has the body of a tiger and in one aspect is the slayer of the Buffalo Demon, Mahisha. Her most famous exploits are found in the *Devī-māhātmya* (see Kinsley 1988: 233, n. 3). She is able to change her shape and is often called upon to do this in order to restore order to the cosmos. Her primary function is to engage in battle with demons. Each of her many arms wield a weapon and the lion she rides is savage. In addition to her battle function, and like many other war goddesses we have seen, she has a fertility aspect. She is associated with the fertility of crops and one of India's greatest festivals, Durgā Pūjā, a ten-day event held in the fall at harvest time, highlights her fertility characteristics. The festival celebrates her victory over the demon king Mahishasura when she ran a trident through his chest. At the festival she appears in full warrior dress, 'slaying the demon Mahisha in order to restore order to the cosmos' (ibid., 110). During the periods of worship Durgā is anointed with 'sugarcane juice and sesame oil', is known to accept blood offerings of sheep and goats, and is prayed to in order to create life (ibid., 111–12). Like the Amazons, whom we will survey in Chapter 3, the area in which Durgā is associated lays beyond any civilised society, in her case particularly the mountainous areas of the Himalayas or the Vindhyas. Her disassociation with civilised society is emphasised by her desire for meat and blood.

She was known in the earlier indigenous Harappan civilisation predating the arrival of the Indo-European speaking people. Iconographically, she is often seen slaying a buffalo, but on one Harappan tablet the slaying of the water buffalo is carried out by a male figure (Kenoyer 1998: 114, fig. 6.24b). One version of her origins, perhaps the best known, is that she was created from parts of the bodies of male gods who also supplied each of her many arms with a weapon. In battle she creates female, never male, helpers from her own body, the best known is Kālī, who is described as wild, terrible in appearance and always depicted dark. Durgā is able to create a group of ferocious female deities that are usually seven in number and called Mātṛkās, the mothers. Durgā is the antithesis of the Hindu woman, being neither submissive nor subservient

to the male. Moreover, she can hold her own on the battlefield – traits she shares with the Irish goddesses and more human Amazon figures. Additionally, she does not give her power to a male but takes from him. In a dialogue between Durgā and the demon Mahisha, she is portrayed as delicate and too beautiful for anything except love. Nonetheless, she uses her beauty not to attract lovers but to snare men into battle and then overpower them (Kinsley 1988: 96–99). This reminds us of the Near Eastern goddesses, some of the Celtic goddesses and the description of the earliest Valkyries – all of whom can exhibit ferocious behaviour often connected to sex.

Durgā attends to the needs of her devotees and is associated with the philosophic ideas of *śakti, māyā* and *prakṛt.*

> *Śakti* is almost always understood to be the underlying power of the divine, the aspect of the divine that permits and provokes creative activity.
>
> *Māyā* has negative connotations ... [It] is that which impels individuals into self-centred, egotistical actions ... [It] is the sense of ego, personal identity, and individuality which clouds the underlying unity of reality and masks one's essential identity with *brahman* or some exalted being such as Visnu, Śiva, or Durgā ... [It] may also be understood as a positive, creative force not unlike *sakti.*
>
> *Prakṛt* is the physical world as well as the inherent rhythms within this world that impel nature to gratify and produce itself in its manifold species (ibid., 104–105).

Durgā is the battle queen, particularly when associated with *śakti* where she personifies action. Although not original to the great Indic epics of the *Mahābhārata* or *Rāmāyana*,[40] Durgā has come to be a connection to military deeds of the heroes of the epics the Pāndava brothers and Rāma respectively (ibid., 106–107).

Originally Durgā was known as *Chandika* – 'the Fierce' and only later Durgā – 'hard to get [to]'. According to Doniger (2009: 388), Chandika 'burst onto the Sanskrit scene full grown (much as Athena did from the head of Zeus) in a complex myth that includes a hymn of a thousand names'.[41] She was formed by the energies (*tejas*) of the male gods after Mahisha 'Buffalo' defeated them. They gave this extremely beautiful goddess her weapons, jewellery, garlands of lotuses and a lion to ride upon. The king of snakes gave her gems and necklaces of snakes. When Mahisha saw her, he chided her, and she defeats him in battle cutting off his head with her sword. She is an unmarried tooth goddess. The tooth goddesses were fierce, out-of-control killers and 'generally

barren of children' but also called 'celibate mothers' (ibid., 390). This places them undoubtedly in the category of viragos, reminiscent of the Near Eastern goddesses – but perhaps also another type of virgin. Chandika's own *śakti* belongs only to her and is not controlled by a male deity – she is clearly a virago. This is not necessarily good for women as men need *śakti* and get it from controlling women (ibid., 389–92). The anti-god Shumbha fell in love with Chandika, but she would only marry someone who defeated her in battle – he did not, so she killed him (ibid., 416).

Allen (2001) considers Durgā mythologically, but not linguistically, cognate with Athena, although she is less interfering than the Greek goddess; Durgā only intervenes twice in the leviathan epic poem *Mahābhārata*,[42] while Athena frequently appears in the *Iliad*. Nevertheless, it is Durgā that Yudisthira, the King of Righteousness, calls upon for advice (Miller 2012: 6).

In a later period, the image of Durgā and her actions are somewhat softened. She becomes the wife of Śiva and has many children.

Parpola (1999: 102) reminds us that Durgā is connected with the Near Eastern goddesses of love and war Inanna-Ištar, but she does not appear in India before the Christian era. Like other scholars, he puts her origins in South Asia at a much earlier period during Harappan times, having her arrive by way of Afghanistan and Iran. As a starting point for his research, Parpola looks to a cylinder seal from Kalibangan that shows two soldiers spearing each other. The soldiers are holding the hands of a skirted goddess who has the body of a tiger. The seal, carved in Harappan style, is characteristic of the Indus Civilization,[43] but the shape of the cylinder is reminiscent of the more westerly Bactria-Margiana culture (BMAC).[44] Kenoyer (1998: 117) interprets this action as 'fighting over a woman', but Parpola claims this to be a war goddess and that:

> [h]er action can be understood from the Vedic text Jaiminīya-Brāhmaṇa [2,115] which tells us of the goddess Vāc. Angered, she became a lioness with a mouth at either end of her body. Standing between the gods and demons who were fighting with each other, she grabbed whomever she could reach on either side. In other words, both sides lose warriors as victims to the goddess of war. On the Kalibangan seal, the two men both wear their hair in the 'double-bun': Kenoyer does not tell us that this hairstyle comes from Mesopotamia and that hair worn in such a 'double-bun' constitutes part of a Sumerian electrum helmet excavated by the Royal Cemetery of Ur (Parpola 1999: 103, n. 4).

Many Western Asiatic goddesses are associated with a citadel or defensive walls (Durgā < *durga* – 'fortress') (ibid., 105) as well as felines. The names of both Aryan and Dravidian goddesses can be associated with fortresses and felines;

in the ritual text Agni-Purāṇa, for example, the goddess Cāmundā is referred to as *koṭa-rākṣī* – 'protector of the fortress', the Kālikā-Purāṇa refers to a goddess as *koṭeśvarī* – 'mistress of the fort', and in Nepal, Durgā's temples are called 'fortresses' (ibid., 105). Another form of Durgā is the goddess Tripurā, or Tripura-sundarī, that Parpola argues is because she was originally the guardian of the *Tripura*, the three walls of the Asuras' (the demon enemies of the Aryans) stronghold. This tripleness reminds us of the triple Irish goddesses.

Vāc

It is, however, to the goddess Vāc – 'speech', that Parpola (1999: 113) makes the greatest case for being a war goddess and a form of Durgā who 'is associated both with battle and with blood sacrifice'. Vāc is also associated with the Rigvedic goddess Sarasvatī, who originally is a river goddess. In fact, Lal (1980: 167) comments that '[h]er personality as a female divinity does not become clear unless she merges herself in another important Vedic deity, namely, Sarasvatī'. This again brings us to a water link with a war goddess. Although Parpola states that Vāc is a war goddess, his view is not generally accepted and Kinsley (1988: 11–13) does not place Vāc into the category of war goddess; still Parpola states that she is a form of Durgā. She is the sound of the war drum. However, it is Lal (1980: 166, n. 45) who tells us how Vāc (Vāk) in *Atharva-Veda Samhitā* (*AVS*) 5.20 incites the people to battle. Verse 1 tells us, 'The Loud-noised drum, warrior-like, of forest-tree, brought together ... with the ruddy [kine], whetting the voice, dominating our rivals; thunder thou loudly against [them] like a lion, about to conquer.' Parpola (1999: 124–26) presents both *AVS* 5.20 and *AVS* 5.21 emphasising important passages, and later shows how in *AVS* 5.21 the battle drum induces terror into the enemy. In *RV* X.125.6, Parpola finds additional proof of Vāc's militancy: 'I stretch the bow for Rudra, for his arrow to smash the hater of the sacred formulation. I make combat for the people. I have entered Heaven and Earth.' However, Jamison and Brereton state that Vāc is rarely seen as a 'clear personage' and consider this late hymn 'a 1st-person self-praise ... [hymn] spoken by Vāc herself.' (2014: 53).

Kālī

Kālī, whom we also saw earlier connected with Durgā, is an extremely fearsome goddess with a frightening countenance and whose earliest reference does not appear until about AD 600. She is a destabilising goddess usually found on the battlefield and described as very dark with wild hair, naked except for severed arms that act as a girdle and garlands of corpses or skulls. She has sharp fang-like teeth, claw-like fingers and blood is often on her lips. She is a furious combatant often intoxicated from drinking the blood of her victims. If she is in a cremation area, she sits on a corpse surrounded by jackals and goblins. Although often treated alone, she, like Durgā, is associated with Śiva as her

consort, and iconographically, Kālī is nearly always shown as dominant. In this capacity she incites Śiva to wild destructive behaviour that unbalances the cosmos. Kālī shares the epithet Canṇḍī (Kinsley 1988: 117) with Durgā in her most famous appearance in the *Devī-māhātmya* and during battle she springs from Durgā's forehead. Kālī makes a second appearance later in the battle to defeat the demon Raktabīja and his many duplicates. It is in these episodes that she 'appears to represent Durgā's personified wrath'. Kālī is worshipped on the periphery of Hindu society most frequently with uncivilised tribal or low-class people who perform exotic self-mutilating acts (ibid., 116–20).

Nirṛti

Nirṛti – 'Black Bird', 'destruction', 'decease', 'dissolution', 'chaos', is not a war goddess but is worth mentioning due to her similarities to war goddesses. She is a death goddess and death is found in her lap (Dexter 1990: 77). She is found about twelve times in the *Rigveda* but in only one hymn (*RV* X.59) is she mentioned several times (vs. 1–4).[45] Unlike the usual view of the female, she personifies the dark side and represents destruction, decay, old age, anger, need and death (Kinsley 1988: 13). She is often invoked by magic (Hillebrandt 1980 II: 249). This is evocative of the Irish Morrígan, who is also identified with black carrion birds – crows and ravens. Lal (1980: 114) tells us that 'a crow is said to be the mouth of Nirṛti', but the dove and owl are her ominous messengers. We have come across these birds earlier – the dove in association with the Iranian Anāhitā, and the owl with the Greek Athena. Nirṛti is associated with night and the two cannot quite be separated (Hillebrandt 1980 II: 296, n. 78). She is further explained as the Underworld or Hell (Hillebrandt, quoting Arbman 1980 II: 374, n. 491).

Devī

Devī – 'goddess' is something of an umbrella term for all Hindu goddesses who are expressions of Mahādevī – 'great goddess'. Kinsley (1988: 133) tells us that her 'essential nature is *śakti*, or "power" ... the active dimension of the godhead'. She is, therefore, a multi-functional goddess who is 'creator and queen of the cosmos' (ibid., 137). While pictured as an aloof figure, she is motherly and quick to respond to the needs of children as well as gracious and 'surpassingly beautiful'. She has many roles, but the role that interests us is the one in which she is armed with many weapons and wears a tiger skin. Connected to this role are other descriptions of her that include her sitting 'on a throne of five corpses'. She is referred to as 'the terrible one' and 'a great devourer'. Moreover, she is denoted as 'victory', 'night of death', 'is fond of violence and quarrelling', and 'she who is death'. Like a number of other goddesses, she is praised for her beauty and as an 'exciter of desire', noted for fertility and a giver of food (ibid., 140–41). Nevertheless, the counterpart of her

being a giver of food, in return she demands the blood and finally the lives of all creatures. Although she has weapons, she is more inclined to use her sharp teeth as weapons to rip apart her prey as this satiates her intoxicating thirst for blood. Her concern is not in the art of war but the satisfaction of her lust for blood (ibid., 144). In these gruesome acts we might compare Devī to the early description of the Valkyries.

Summary of Chapters 1 and 2

As we have seen in this chapter and Chapter 1, ancient people sought divine protection or support for those aspects of life that were important to them and affected their lives. The ubiquity of war was a fact of life that would account for the deification of war, and we see this from our earliest writings in the Near East and later in the Indo-European evidence. While we cannot postulate a direct connection between the Near Eastern and Indo-European evidence, there are comparisons. Both groups had war goddesses although the aspect of war was rarely if ever the sole facet of any of these deities. Among the Indo-European goddesses, war was usually subordinate to their other characteristics, particularly fertility. This may well be attributable to the fact that although war was a major factor in the lives of women, fertility was even more important and something women dealt with on a daily basis – with or without war.

The earliest extant evidence for a war goddess is the Sumerian Inanna, whose ferocity was formidable, and she intimidated even the greatest of the male deities. Inanna, and other goddesses linked to her, are found under a variety of names throughout the Near East and share a number of characteristics.

A direct connection between a warrior and a war goddess is more representative of the Indo-European goddesses while the Near Eastern figures depended more on rage and violence. We see this direct connection between warrior and goddess among the Iranians, Germanic, Celtic peoples and in Homer, but not so much among the Indic people whose war goddesses cast a wider net. Dexter (1990: 157) claims that 'the majority of Indo-European female warrior-figures played the role *of giving energy and encouragement to the male warriors*' [original italics] acting 'as strategists and endowers of martial energy'. She further equates the strategist/endower role with the nurturing function frequently seen in the Indo-European war goddess. I would agree only in part with this analysis, particularly the part of strategist. The Indo-European war goddesses do encourage males in both the training process and on the battlefield, often taking up a single warrior as her protégé or being 'cheerleaders' for an army. If this is what Dexter means in giving energy, I agree; but if it is something such as a life force endowing males in general, I would not take it that far.

Because males were (and are) the default participants in war, it is natural that most war deities are male. Nevertheless, war affected women as much as men despite their more usual status as non-combatants. Perhaps because the lives of women were less involved with actual battle, the war goddesses were not confined to that one aspect, but a woman's status in society was intimately linked with that of her male relatives, therefore the behaviour or fate of her father, brothers, sons or husband determined the course of her life. This situation would explain the seemingly odd pairing of fertility and warfare seen in so many of the goddesses that can be associated with warfare. Because war affected women's lives, it should not seem strange that war goddesses were paired with other features of their lives that affected them most – fertility and sex. Fertility is obvious, sex less so – despite sex being essential for fertility. However, when paired with war it does become obvious. Even today rape is a weapon used against women during war and there is no reason to believe that this would have been less prevalent in ancient times. Women may be skilled in weaponry, though less likely to be champions when matched with men, but when they are, they are heralded and become the subject of myth and legend – they are viragos. This might also account for the number of myths/legends that point to women who will only marry a man who can defeat her in battle or some sort of contest, and explicate the retelling and fame of the Amazons who were women that lived their lives apart from men.

While the linkage of sex and virginity is not immediately obvious, Kapelrud's definition and suggestion that 'virgin' can be something of an honorific title does make sense. Furthermore, Kapelrud's definition of old goddesses being 'hags' fits well with the Irish evidence. The idea that the word 'virgin' can mean something other than an anatomical state also has validity. Barber's definition of virginity (see Introduction) meaning never having conceived also has merit. Because the English word 'virgin' may be used in a broader sense than an anatomical virgin, it would be wise to qualify its use and to heed Hastrup's caution to keep in mind the social context in which it is used.

The attribute of violent sex is diminished in Indo-European goddesses. Violent sex is neither universal nor even common among Indo-European war goddesses, but is seen primarily on the periphery among the Celtic and Indic goddesses. The Greeks show evidence of love of violence, but not sexual violence. The Erinyes, who are among the most primeval of Greek war goddesses, show the greatest ferocity among them. It does, however, appear that the ferocious characteristics found in the Near East does not completely die out as it can be found in a diluted form in the Roman Juno but in a less diluted form among the Celts and Indic figures. It can also appear in some early stories or legends as with the Valkyries weaving.

Although it is clear that war goddesses did not begin with the Indo-Europeans, there are a number of characteristics that we see in the Indo-European female

war figures that are not in evidence in the earlier Near Eastern goddesses. Perhaps most prominent is their plurality; frequently, martial goddesses, particularly the Celtic triple goddesses, Germanic Valkyries and Indic figures, do not act alone but behave in concert, the group acting together as a unit.

Indo-European war goddesses have maintained a strong association with fertility and water. While the Near Eastern goddesses have an early but not strong association with birds, the Indo-European goddesses amplify this association and attach themselves primarily to carrion or predatory birds. In some societies lions are seen as the associated animal of war goddesses, but they are noticeably absent where lions do not occur, as in Ireland, and their presence is less prominent over time, perhaps because of the reduction of the lion population over time in the areas of IE speakers. These goddesses also have a broad equine association, an association found throughout IE societies as seen from both female and male names. Three of the Amazon queens had horse elements in their names: Lysippe, Hippo, as well as the more famous Hippolyte, and a number of Greek male names (e.g., Hippocrates) also have horse elements, some of which are still commonly used today – including Eric and Philip.

When it comes to actual battle, females are less likely to engage in it but they do. In lieu of authentic combat, female figures were more likely to be instigators of war, as with the case of the goddess Eris who personified strife and discord but was considered the sister of Ares, the god of war. Eris can be contrasted with Enyo, who not only delighted in destruction, but also bore a carnage epithet, 'sacker of cities'. Even Athena, 'guardian of the city', who is so often treated as a benevolent deity (despite her warrior garb) 'loves deeds of war, the sack of cities and the shouting and the battle' (*Homeric Hymn* 11).

It would be reckless to assume that the roles carried out by the mythical figures reviewed in this chapter and the last have a direct correlation to actual women, and that has not been the intent. What Chapters 1 and 2 do show is that early people in cultures throughout the world (both in and outside the Indo-European sphere) were quite adept at envisioning women as warriors, capable of not only fighting, but of engaging in acts of horrific cruelty. In the following chapter we will see the next step on the road to reality by examining legendary figures that are closer to actual women who subsume military roles.

Chapter 3

Legendary Figures – Mortal and Supernatural

Aside from deities who have war connections, legendary female figures appear in ancient stories that fall between the lines of myth and reality. In fact, the line separating some 'legendary' figures from goddesses can be so very thin as to be sometimes imperceptible. Consequently, a number of the female figures in this chapter are neither goddesses, nor myths, nor historical figures but fall somewhere in between. This leaves the category of legend. Still, these legendary figures do have war associations that require our attention. The connections these figures have to war are more closely tied to the warriors themselves, and while the war connections sometimes appear a bit tenuous, I believe they should, all the same, be considered.

Perhaps the oldest of the legendary Indo-European female warrior figures is found in the *Rigveda*, the date of which is not known for certain but as mentioned in Chapter 1, is generally placed at ca. 1500–1000 BC. This would, of course, put it earlier than any of the Greek literature. Few females are mentioned in the *Rigveda*, but Viśpalā is one (*RV* I.112.10, I.116.15; I.117.11, I.118.8, and X.37.8). Appropriately, she was an ally of the Aśvins, the twin horse gods, and thereby continuing the connection between female war figures and horses. According to Griffith's translation (1889) of the Rigvedic hymns Viśpalā was 'a lady' whose leg was cut off while she was engaged in battle with the twin gods 'in Khela's battle' (*RV* I.112.10 and I.116.15). The Aśvins, who have curative powers, fit her with a metal prosthetic leg. The difficulty with Viśpalā is that it is not clear if she was in fact a human woman. A completely different interpretation is held by a number of other scholars – that Viśpalā is not a human but the name of a horse and thus the metal leg was placed on a horse. Macdonell rejected this theory as 'improbable conjecture' (Macdonell and Keith 1912: I: 308–309; Macdonell 1897: 52), but Bloomfield (1908: 113), says that the leg is made of iron, more importantly refers to Viśpalā as a 'racing mare', and O'Flaherty (1981: 183 and 185; see also 1980: 179) follows suit, as does Geldner 'Die Rennstute Viśpalā' (1951: 155). Neither Bloomfield nor O'Flaherty mention the possibility of her being a human woman, and in the most recent translation of these hymns, Viśpalā is treated as a racehorse.

'Because her foot was cut away like the wing of a bird, in the contest of Khela, at the decisive turn, right away you [Aśvins] inserted a metal shank for Viśpalā to run, when the stake had been set' (Jamison and Brereton 2014: I: 268–71).

As a consequence of these two interpretations, Viśpalā is either a racehorse or a woman who goes into battle.[1] Although I leave the interpretation to the Vedic scholars, I include her here on the possibility that Griffith and Macdonell are correct.

The Amazons

Nothing says 'warrior woman' like the word 'Amazon'. Amazons are without doubt the best known of all legendary warrior women. Few words conjure a more immediate or specific picture of a battle-ready woman than the word Amazon.[2] Both Greeks and Romans had innumerable tales of Amazons ranging from their skill on the battlefield to their love interests. A modern audience sees the Amazon as Wonder Woman – champion of justice and civilization.[3] The ancient Greeks, from whom we get the term, saw Amazons as beautiful well-built women dressed in a variety of warrior garb wielding a sword, axe or other weapon, and perhaps lacking a breast. To the Greeks, the thought of Amazons brought fear of chaos. Amazons were a symbol of female aggression and this was no way for a woman to behave. (See Tyrell 1984; duBois 1991.) Women belonged at home bearing and caring for children. They were the mothers of soldiers or the mothers of mothers of soldiers – this was the natural order.[4] Women taking on the role of warriors were beyond the pale, and there are those who suggest that the Greeks even invented the Amazons as a kind of socio-political boogey man.[5] But if the Amazons were a figment of Greek imagination, they gave them a remarkable number of names: Bell (1991) lists upwards of sixty names of Amazons, at least sixteen names are firmly established from Greek vessels.[6] Due to this plethora of evidence, it is, therefore, difficult to believe Amazons were made-up out of whole cloth. They must have had a prototype, and the evidence suggests they did. Moreover, there was most likely more than one prototype. Amazons have been associated with a number of steppe people including Sauromatians, Sarmatians, Scythians, Saka and Sargat.

A great deal of scholarly (and popular) ink has been spilt on the subject of Amazons, particularly on the question of whether or not there really were Amazons. Even in the ancient world, we have an array of literature that compares Amazons with queens who went into battle, such as Artemisia I of Halicarnassus, and reports of classical historians. Furthermore, literary evidence comes from distant sources beyond the Greeks as mentioned in the Introduction. Even the great Irish hero Cú Chulainn does battle with Amazons in *The Feast of Bricriu* (Henderson 1899: §§66–67).[7] It is, however, inappropriate

to apply the term Amazon to more modern examples of women who have gone into battle, as some authors would have it. Because of their military abilities and lack of reticence in achieving their goals, we might say the Amazons were viragos personified.

While Amazons have been treated as both myth and legend, we have three different types of sources that provide us with evidence for their existence, ancient authors, iconography and archaeology. Chief among the ancient authors are Herodotus, Diodorus Siculus and Strabo, who provide descriptions and legendary accounts of Amazons that are remarkably uniform – the latter two undoubtedly drawing from the former. In the following funeral oration, the Greek speechwriter, Lysias, in the early fourth century BC, provides us with advantages, achievements and follies of the Amazons.

> Well, of old there were Amazons, daughters of Ares, dwelling beside the river Thermodon; they alone of the people around about were *armed with iron*, and they were *first of all to mount horses*, with which, owing to the inexperience of their foes, they surprised them and either caught those who fled, or outstripped those who pursued. They were *accounted as men for their high courage, rather than as women* for their sex; so much more did they seem to excel men in their spirit than to be at a disadvantage in their form. *Ruling over many nations, they had in fact achieved the enslavement of those around them*; yet, *hearing by report concerning this our country how great was its renown, they were moved by increase of glory and high ambition to muster the most warlike of the nations and march with them against this city.* But having met with valiant men they found their spirit now was like to their sex; the repute that they got was the reverse of the former, and by their perils rather than by their bodies they were deemed to be women. *They stood alone in failing to learn from their mistakes*, and so to be better advised in their future actions; they would not return home and report their own misfortune and our ancestors' valour: for *they perished on the spot, and were punished for their folly, thus making our city's memory imperishable for its valour*; while owing to their disaster in this region they rendered their own country nameless. *And so those women, by their unjust greed for others' land, justly lost their own.* (Lysias, *Funeral Oration* II.4–6.) [Emphasis added.])

This passage from Lysias also provides us with the earliest possible date for Amazons – that of ca. 1200 BC – as this is the earliest known date for iron weapons. The Amazons had the advantage of horses, excelled in courage and by ruling over other nations had enslaved other peoples. But by their hubris

and not learning from their mistakes, the Amazons lost their own land while the Greeks benefited from their virtue and defeated these viragos. This lesson was one that the Greeks could not forget and was used in a number of forms to keep Greek society under control. Reminders of the Greek victory over the Amazons were found repeatedly in mythology, e.g., battles between Bellerophon and Herakles against the Amazons, and we should remember that the Amazons were on the side of the losing Trojans. The Amazons may have conquered other more inferior peoples, but not the Athenians. We should, however, also remember that it was the Greeks not the Amazons who wrote the accounts of the Amazons. These same themes and stories are found repeatedly on the iconography. Perhaps the most important example was the placement on the west metopes of the Parthenon that prominently displayed one-on-one fighting between the Athenians and the Amazons. Here, these badly damaged sculptures portray Amazons fighting on foot or on horseback.

Graeco-Roman iconography consistently shows Amazons to be well built and beautiful. More recently, archaeological material offers some artefactual evidence of ancient women who engaged in warfare. The archaeology gives us burials of women with not only weapons, but also wounds indicative of battle wounds that we will see later in Chapter 4. This is particularly true of Sarmatian women about whom we also have descriptive accounts from Herodotus. However, current archaeological evidence has revealed similar evidence for some Scythian women, as well as other women from Steppe cultural groups.

Until quite recently many scholars believed the Amazons were just a Greek myth, having little if anything to do with reality. This lack of reality can be seen in depictions of Amazon attire. At times the Amazons were dressed in Greek chitons of various lengths, but the wardrobe of the Amazons is not consistent and changes through time (Shapiro 1983). While we have numerous depictions of Amazons in male dress, i.e., trousers,[8] the Greek vase painters did not confine the Amazon wardrobe to trousers. They were frequently depicted in a variety of other dress such as that of Thracians, Scythians or Persians – all of whom were, in the eyes of the Greeks, Barbarians. The short *chiton* was sometimes worn over what appear to be long stockings or leggings that would have facilitated riding astride.[9] In the earliest period of vase painting, the Amazons appear as Hoplites,[10] but they are also presented in the dress of Persians (Fantham *et al.* 1994, fig. 4.3), Scythians and Thracians. The Phrygian hat is often seen (Carpenter 1991, figs. 196 and 198) and helmet styles vary including Corinthian and Attic styles (von Brothmer 1957: 92–93). Other articles of clothing include corselets, short tunics, oriental dress with sleeves and trousers, caps with laurel wreaths, animal skins (associated with Thracians) and some items that indicate battle gear such as skullcap helmets with high crests, greaves, pelta and armour.

Despite this change in clothing and the firm belief that the Amazons were non-Greeks, the individual names of the Amazons are all Greek. Moreover, as Blok (1994: 25) points out, no Greek writer suggests that the word Amazon 'might not be Greek'.

Herodotus was not alone in his accounts of the Amazons, other classical authors contributed to the Amazon legends as well. Homer made the Amazons allies of the Trojans, suggesting either an Anatolian or Thracian location for them.

Herodotus first records the Amazons in Book 4 of his *Histories*:

> When the Greeks warred with the Amazons (whom the Scythians call Oiorpata, a name signifying in our [Greek] tongue killers of men, for in Scythian a man is *oior*, and to kill is *pata*) the story runs that after their victory on the Thermodon they sailed away carrying in three ships as many Amazons as they had been able to take alive; and out to sea the Amazons set upon the crews and slew them.

But because the Amazons did not know how to handle the boats, they were left to the vagaries of the sea until:

> they came to the Cliffs by the Maeetian lake; this place is in the country of the free Scythians. There the Amazons landed, and set forth on their journey to the inhabited country, and seized the first troop of horses they met, and mounted on them they raided the Scythian lands (Herodotus 4.110).

At first the two groups engaged in battle, but when it became clear to the Scythians that the Amazons were women, they decided to end the fighting. Because the Amazons and Scythians did not understand each other's language they resorted to sign language. Eventually the two groups engaged in friendly relations and the Scythians 'desired that children should be born of the women' (ibid., 4.112). After this, the two groups travelled to a new territory where they lived. Herodotus now refers to them as Sauromatae, and he reports that it is the law that a girl cannot marry until she has slain a man of their enemy (ibid., 4.116–17).

Diodorus Siculus (ca. 80–20 BC) wrote of Scythians and Amazons in Books 2 and 3 in his *The Library of History*. He, too, wrote at length about the Amazons reporting that:

> in Scythia ... the sovereigns were women endowed with exceptional valour. For among these peoples the women train for war just as do the men and in acts of manly valour are in no

wise inferior to the men ... [This] nation of the Amazons, after it was once organised, was so distinguished for its manly prowess that it not only overran much of the neighbouring territory but even subdued a large part of Europe and Asia' (Diodorus Siculus 2.44.1–2).

Because he lived 400 years after Herodotus, we should not be surprised that Diodorus often repeats what Herodotus wrote, as well as repeating the work of some other authors. Still, he presents us with additional material. Strabo (ca. 64 BC – AD 21), more-or-less a contemporary of Diodorus, is yet another source, and again relates the Amazons to the Scythians, deriving the Sarmatians from an earlier mating between Amazons and Scythian warriors.

All these things were presented to the Greeks (here read Athenians) as abnormal and aberrations. At least one scholar (Tyrell 1984) has written that the myth itself was designed to keep Athenian society (or perhaps just Athenian women) under control and that the myth was used to show what happened in society when women did not keep their places as wives and mothers. In other words, in a world where women behaved like men the result is a world of chaos – this, despite the fact that the deity who watched over Athens was the helmeted, spear- and shield-bearing Athena herself. This obvious contradiction, between official misogyny and a patron goddess who appears as a warrior, has been rationalised as 'her warlike attributes were geared more to protectiveness than to aggression' (Bell 1991: 85). This begs the issue as few aggressors see their actions as aggressive. Furthermore, Athena's actions and interference in the *Iliad* cannot be termed defensive (see *Iliad* 5, and 20.41–53), and as we saw in Chapter 2, her aggressive behaviour is quite evident. Seymour (1963: 126) is even more forthright as he forgoes Ares or even Apollo and calls Athena the chief divinity of war. The Greeks, we will remember, were horrified at the thought of women behaving like men and thus their view of the Amazons. The knowledge of these women warriors may well have extended to the East as the Chinese seem to have held a similar view of women who behaved like men as they imagined a group of women, the Nürenguo, who lived far to the west in 'women's countries' (Mallory and Mair 2000: 41).

Legends frequently contain some grain of truth, and in this case, it is becoming increasingly evident that there was at least some validity in the Amazon stories.[11] The contradictions and inconsistencies within these legends, however, serve to strengthen the unreal status of the Amazons. One point in the Amazon legend which I believe can be dispelled is the suggestion that they had only one breast. Diodorus Siculus said their right breast was seared off while the girls were infants (3:53.3). The much later (early fifth century AD) Orosius (Bk. 1.15), follows Diodorus, while Apollodorus tells us that 'they pinched off the right breasts, that they might not be trammelled by them in throwing

the javelin, but they kept the left breasts, that they might suckle' (*The Library* II.5.9). Philostratus (*On Heroes* §57.5),[12] however, said they fed their children horse milk in order to keep their breasts from enlarging, while Virgil draws attention to Penthesilea's bare breasts (*Aeneid* 1.492).

Despite the assertion by Timothy Taylor (1994: 395) that 'Amazons are depicted in Greek sculpture and painting with the right side of the chest draped to cover this missing breast,' they are never depicted as having only one breast, and the right breast is fully formed under the draping.[13] In 1996, Taylor gave a plausible explanation for the removal of the left (as opposed to his earlier discussion of the right) breast. Here he suggests that the left nipple would have been in danger when using a 'composite reflex bow fired from horseback [where] the draw is short and across the body' (T. Taylor 1996: 200).

Still another view is taken by Marazov (1996: 94), who interprets the draping of the right breast as 'some specific semiotic value of this attribute ... [that] ... denotes the Amazon as a sexless creature'. Marazov further claims that to ancient people the breast signified a social, not erotic, function, which connects with the etymology of Amazon as the 'non-breast feeding one'. This claim, however, is contradicted by numerous Greek epigrams regarding breasts such as:

> Eluding her mother's apprehensive eyes, the charming girl gave me a pair of rosy apples. I think she had secretly ensorcelled those red apples with the torch of love, for I, alack! am wrapped in flame, and instead of two breasts, ye gods, my purposeless hands grasp two apples. (Paulus Silentiarius, *The Greek Anthology* 1916: 281, No. 290).

> Oh, would I were the wind, that walking on the shore thou mightest bare thy bosom and take me to thee as I blow. (Anonymous, *The Greek Anthology* 1916: 169, No. 83. See also 169, No. 84.)

Clearly the Greeks, like so many others, found erotic pleasure in women's breasts. Furthermore, the lack of one breast does not preclude breast-feeding, and as we have seen, according to Apollodorus the left was used specifically for this function. It might also be noted that although Athena wielded a spear and Artemis a bow, there is never a suggestion that they were deprived of a part of their female anatomy in order to improve their skill with these weapons.

Although the Greeks, with their emphasis on physical human beauty, may just have been reticent to represent this abnormality visibly, a more likely reason in support of the two-breasted Amazon is an etymological one, namely the one breast interpretation purported some later scholars is actually

a late folk-etymology while the Greek's own understanding of Amazon is 'un-breasted'. This cultural mastectomy would have left the Amazons 'one-breasted', *monomazones*; thus, it is likely that Amazons had another, different meaning. Blok's comprehensive work *The Early Amazons* devotes much of the first chapter to the etymology of Amazon, summarising many of the nineteenth- and twentieth-century viewpoints on this subject, but none of these are particularly convincing. Another etymology would be 'she who has no husband', from Proto-Indo-European *ņ-mņgwįon-es* (Huld 2002). This linguistic suggestion of 'without husband' follows Aeschylus' assumption that Amazons were 'mateless and flesh-devouring' (Aeschylus, *Suppliant Women* ll. 284–87). Furthermore, if Amazons were without husbands, it would support the idea that they were virgins and did not engage in sex (at least not with the benefit of 'clergy'). For the second element of the compound, compare Old Church Slavic *mǫžĭ*, which becomes Russian *muzh* – 'husband'. We should also remember that the Russian adverb to signify that a woman is married has a collective prefix 'with' affixed to the word for husband. Thus, the word for a woman to marry is *zamuzh* – literally to be with husband – something Amazons were strongly believed not to have.

The implication of the Amazon's life to the Greeks may have been that Amazons lived in a world of nature and thus to the nature taming Greek, unnatural chaos. This unnaturalness seems to be emphasised by the fact that their sexual activity was random and conducted outdoors. There is, however, nothing to indicate that the Amazons lived in a state of chaos. Indeed, the Amazons had queens (e.g., Thalestria, Penthesilea, Antope, Hippolyta and Andromache), were organised enough to go to war, founded cities – Ephesus, Smyrna, Cyme, Themiscyra and Myrina are attributed to them (Strabo 11.5.4), and according to Lysias (*Funeral Oration* 2.4–6), ruled over many nations and enslaved those around them.

Herodotus (4.114) tells us that these women warriors did not engage in, or even know how to do, women's work, and they lived without men – being with them only to beget children. Later, when men agreed to live with the Sauromatians, they continued to follow their own ways, went 'to war, and [wore] the same dress as men' (ibid., 4.116). They rode horses, shot bows, threw spears and hunted. He further tells us that no girl married before she had killed an enemy. If this was not fulfilled, the woman died a spinster (ibid., 4.117).[14] Strabo (11.5.1) gives the occupations of the Amazons as ploughing, planting, tending cattle and particularly training horses. Iconographically, he clothes them in animal skins. For weapons he gives them the bow, javelin, the sagaris (a single-edged weapon) and shield. We also see them with swords and driving chariots.

Diodorus Siculus tells us that the Scythians were closely connected with the Amazons and that in Scythia women were trained for war much like men.

Moreover, there was a time when women 'endowed with great valour' ruled over Scythia. He goes on to say (2.44.2) that this 'nation of Amazons, after it was once organised, was so distinguished for its manly prowess that it not only overran much of the neighbouring territory but even subdued a large part of Europe and Asia'. Furthermore, he points out that along the Thermodon River, women held sway and that women as well as men went to war. He singles out a particular queen who 'made war upon people after people of neighbouring lands' and she took for herself the designation Daughter of Ares. While doing this she put men to spinning wool and other domestic duties. This queen, who goes unnamed, was highly intelligent and skilled as a general. Moreover, she built a great palace and died heroically. Her daughter, also unnamed, followed her mother's path, had girls train in the military arts and rule continued through the female line. They ruled with distinction and 'women have been the authors of many great deeds, not in Scythia alone, but also in the territory bordering upon it'. The line of queens 'ruled with distinction and advanced the nation of the Amazons in both power and fame' until Herakles conquered Hippolyte while pursuing her girdle. From this time, the neighbouring people rose up against the Amazons. The final queen to be distinguished was Penthesilea, daughter of Ares, who fought as an ally of the Trojans and died at the hands of Achilles (ibid., 2.45–46).

The earliest depiction of an Amazon appears on a terracotta shield, found at Tiryns dating to about 700 BC, fighting a warrior whose identity is unclear.[15] Later, Amazons appear on dozens, if not hundreds, of black and red figure vessels with Herakles, Achilles or Theseus among others.

The location of the Amazons is generally placed in the area north of the Black Sea based on Herodotus, but a case can be made for placing their homeland in Thrace (Shapiro 1983). Although Homer implies that the Amazons came from Anatolia (*Iliad* 3.184–89 and 6.173–87) – there is little if any evidence for this. However, the noted Indo-Europeanist Calvert Watkins (1986: 53–55) mentions female archers within a Hittite passage, suggesting a fairly archaic use of weapons by women.[16]

Strabo (11.5.1) comments that the Amazons lived not only in Albania (this one located in the Caucasus), but also in the foothills north of the Caucasus. This may well be the most accurate as it is in the lower Volga region were the largest number of graves of armed women have been found – accounting for about 20 per cent in the Sauromatian area. In Scythian graves of southeastern Europe, it has been calculated that during the fourth–third centuries BC, 27–29 per cent of female burials contained some sort of armament (Melyukova 1995: 43). Although the ancient authors place the Amazonian homeland in various places, they generally agree that it was on the borders of the civilized world. Despite the literary evidence for the North Pontic location, there are female warrior burials further east. Given the many Scythian ornaments made by Greek artisans, there

must have been substantial contact between the Greeks and Scythians. Guliaev (2003) suggests that these artisans carried back to Greece the stories of armed women who would most likely have been young and in the full flower of youthful beauty, and that this led to stories of the Amazons.

Amazons and Amazonomachy, 'Amazon-battle', were favourite subjects for Greek artists, and depictions of them can be found on many vases and in sculpture. According to Wace and Stubbings (1962: 306–307) '[t]he Amazons ... are so firmly implanted in Greek literature that it is hard to believe these female warriors do not represent a real people of central Anatolia; the theory which identified them with the Hittites, romanticised by legend, has met with little favour, but deserves serious consideration'.

Various clay vessels are particularly useful in that a number of them provide names of the characters depicted. For example, the black-figure amphora by the potter Exekias gives us the names of both Achilles and Penthesilea.[17] Additionally, it is extremely helpful that the Greeks used conventions to illustrate the Amazons; their skin tones are light in colour and breasts are depicted but are not always prominent. Their weapons, spears, swords, bows and arrows (von Brothmer pls. XL-1-2, LXI-4, LXXV) are typical, except their battle-axes, which are non-Greek (Boardman 1974: 231).[18] The shields, or pelta, of Amazons are a distinctive crescent-shape.[19]

Although the Amazons have frequently been portrayed merely as myth or legend, the ancient authors have provided us with a fair amount of information about individual Amazons, and, as noted, a number of names. As would be expected, we know most about the leaders, several of whom are referred to as queens. Three of the best known are presented below; some have names connected to horses.

Hippolyte – 'she who releases [her] horses', has several legends concerning her (e.g., Euripides' *Hippolytus*) and, as with many mythical and legendary figures, there is some confusion. Although she was queen, her two sisters, Antiope and Melanippe, shared the running of the government. Her parents were Ares and Otrera. She ruled the city of Themiscyra, located on the Thermodon River, a place where men were not welcome. Hippolyte (who Apollonius Rhodius calls 'warlike') owned the famous girdle sought by Herakles for his ninth labour, and it was the girdle that symbolised her primacy in governance. One story says that after Herakles took the girdle from her, he killed her. Another story has Theseus abducting her. Still another, found in Euripides' *Hippolytus*, suggests she (Hippolyte) is the mother of Hippolytus. Even yet another story has her leading her army on the march into Attica and the Peloponnese, but Theseus conquered them and 'Hippolyte fled to Megra, where she died in grief and was buried' (Bell 1991: 246). Her tomb was built in the shape of an Amazon's shield.[20] The Castellani Painter, ca. 560 BC, illustrates the siege of Themiscyra on an amphora. (See von Brothmer 1957: 7–8 #19, pl. X.)

Legendary Figures – Mortal and Supernatural

Antiope – The stories about her, like those of her sister Hippolyte, are somewhat confusing, but what does standout is that she is the only Amazon known to marry – perhaps. The most frequent story is that Theseus captured her (or she was given to him as a gift by Herakles) after she, as an Amazon queen, came aboard his ship bearing gifts. Once she was aboard, he set sail for Athens. It was this event that precipitated the attack by the Amazons on Athens. Antiope's sisters, Hippolyte and Melanippe, along with their armies, followed Theseus' ship. During this journey (of unknown duration) Antiope fell in love with Theseus and bore him a son, Hippolytus, who was sent to his grandmother in Troezen for safekeeping. However, at about line 305 in Euripides' play *Hippolytus*, the Nurse calls Hippolytus a 'bastard' of the horse-loving Amazon, suggesting they were not married. The 'abduction' of Antiope was the subject of a red-figure cup by Late Archaic Athenian vase painter Oltos (ca. 525–500 BC) and part of a marble pediment group at the Temple of Apollo at Eretria (Carpenter 1991, figs. 251 and 250). Meanwhile, the Amazons arrived in Athens and did battle with the Athenians for three months. During this time Molpadia killed Antiope, either while she was fighting at the side of Theseus, her (perhaps) husband, or by Theseus himself. Although Euripides suggests Hippolyte as Hippolytus' mother, when he refers to Hippolytus' mother as 'the horse-loving Amazon' his mother might have been Antiope, but Apollodorus also states she is Hippolytus' mother.[21]

Penthesilea – The stories of her are also mixed and confused although Bell (1991: 351–52) relates them in an abbreviated but amusing way. She, too, is said to have been the daughter of Ares and Otrera, which would make her the sister of Hippolyte, Melanippe, Antiope and probably others. Quintus Smyrnaeus (1.657–74) describes the moment in which Achilles simultaneously kills and falls in love with her. This moment has been immortalised on a number of vessels, particularly well-known is the black-figure amphora signed by Exekias dating to ca. 530 BC (Figure 2). The theme of an Amazon being killed, particularly Penthesilea, was widely used after what may have been its first appearance on a terracotta shield. Penthesilea is arguably the most famous of the Amazons, no doubt for the number of times she was memorialised on vessels, but also for her descriptions by Homer, Virgil and Quintus Smyrnaeus. She was known to be a fierce warrior, and it was she who led the Amazons on the side of the Trojans. She is described as a maiden carrying a Scythian-type bow and wearing a leopard's skin on her shoulders.[22] It is, however, the post-Homeric Quintus Smyrnaeus in the first book of his *Trojan Epic* who gives the most exhaustive description of Penthesilea. She is 'clothed in godlike beauty' (19), 'stood out from all her dashing followers' (41), and she looked

> like one of the blessed immortals; in her face
> There was a beauty that frightened and dazzled at once.
> Her smile was ravishing, and from beneath her brows

> Her love-enkindling eyes like sunbeams flashed.
> Her cheeks were flushed with modesty, and over them
> A wondrous grace was spread, all clothed with valor. (56–57).

The Trojans were overjoyed to see her as '[h]er promise was a deed for which no mortal had hoped – To kill Achilles' (93–94). Penthesilea was herself 'eager for battle' (71), 'filled with courage' (139), and urged 'the Trojans to go and win glory in combat' (162).

Virgil's description of this warrior queen is a bit more evocative but equally praiseworthy. 'Penthesilea in fury leads the crescent-shielded ranks of the Amazons and flames amid her thousands; a golden belt she binds below her naked breast,[23] and, as a warrior queen, dares battle, a maid clashing with men' (*Aeneid* 1.491–93).

The views of what the Amazons were are wide ranging. From these brief outlines, it is clear that Amazons did not live in nature and had a somewhat sophisticated governmental structure. What is most germane is that the Amazons are here to stay in the human psyche, whether or not they were in fact a real group of women.

In addition to the Amazons, we have several examples of women who were not warriors but who had the same type of independent spirit seen in the Amazons – although I would not link the two. The first of these independent women has a strong war association, but she herself neither took up arms nor, in fact, did she have any close war context except to watch from the battlements of Troy.

The Greeks

Helen of Troy
Helen of Troy (who was in fact Greek) was herself neither warrior-like nor any type of military advisor, but she is, of course, given credit for being the cause of the Trojan War and exemplifies Keegan's point on wife stealing (see Introduction), thus her inclusion here.

While not a warrior herself Helen brings together two elements that we have seen are intimately connected to a female involved in war – war and sex. According to Blondell (2013: ix), Helen:

> is the mythical incarnation of an ancient Greek obsession: the control of female sexuality and of women's sexual power over men … When she escapes male oversight by absconding to Troy with her lover … [with no evidence that she was forced] she triggers … the war … The war is caused not only by their

[the men who pursue her] inability to control the beautiful Helen but their equal inability to dismiss or destroy her.

It is, therefore, her act of independence that drives men into what can arguably be called the greatest war in Western literature. One might equate this to the horror the Greeks felt towards the Amazons who also acted on their independent nature.

Helen's legend(s) is/are complicated (see Edmunds 2002–2003). She is considered the daughter of Zeus, but her mother varies depending on which legend one pursues. Her brothers were Castor and Pollux, who are equated with the Vedic twin horse gods, the Aśvins, and she was, of course, the wife of the Greek Menelaus and lover of the Trojan Paris.

Hippodameia

Returning to women who take up the sword, it is Roman author Quintus of Smyrna who gives us the greatest Trojan example. In his *Trojan Epic*, the women of Troy take heart from seeing the Amazons fighting and dying for Troy against the Achaians. It is Hippodameia, 'she who masters horses', daughter of Antimachos and wife of Tisiphononos, who calls the women of Troy to battle.

> With a brave and eager heart
> She used bold words to encourage those as young as herself
> To join the bitter fighting; her boldness gave her strength:
> Friends, let the hearts within your breasts be brave,
> No less than those of our husbands, who for the fatherland
> Are fighting the foe on behalf of our children and ourselves
> With no relief from suffering. Let us also fill
> Our hearts with courage and take an equal share of fighting.
> We are not far removed from the strength of men.
> The vigour that there is in them is also in us.
> Eyes and knees are the same, and everything is alike.
> The light and the liquid air are common to us all.
> Our food is the same. So what advantage is given to men
> By heaven? Let us then not shrink from battle.
> Don't you see a woman far excelling men
> In close combat? And yet her [Penthesilea] family and her city
> Are nowhere near. It's on behalf of a foreign king
> That she is fighting with such spirit, heedless of men,
> Possessed by boldness and the will to destroy.
> But we have various causes for sorrow close at hand.
> Some have sons or husbands fallen before the city;
> Some of us mourn our parents no longer living;

Others grieve for the deaths of brothers or kinsmen.
Not one is without a share of sorrow and suffering.
Our expectation is to see our day of bondage.
Our affliction is such that we can delay no longer
The joining of battle. Better by far to die in the fighting
Than afterward to be led with our helpless children
By foreign masters under painful compulsion
Our city in flames and our men no longer living (Quintus Smyrnaeus, *The Trojan Epic*, Bk. 1, ll. 406–35).

The Romans

Camilla

The war connections of the Roman Camilla began when she was only an infant. Her father, Metabus, king of the Volscian town Privernum, was expelled ('through hatred of his tyrant might' *Aeneid* 11.542), and he was forced to flee with the baby Camilla. When he came to the river Amasenus he knew he could not swim with her in his arms, so he tied her to a spear and threw her across the river where she landed unharmed. The king fed his child with milk from a wild mare and armed her as soon as she could stand and hold a pointed lance. He taught her warlike activities, and dedicated her to the goddess Diana. This was:

> Camilla, of Volscian race, leading her troop of horse, and squadrons gay with brass, – a warrior-maid, never having trained her woman's hands to Minerva's distaff or basket of wool, but hardy to bear the battle-brunt and in speed of foot to outstrip the winds ... All the youth, streaming from house and field, and thronging matrons marvel, and gaze at her as she goes; agape with wonder how the glory of royal purple drapes her smooth shoulder; how the clasp entwines her hair with gold; how her own hands bear a Lycian quiver and the pastoral myrtle tipped with steel (*Aeneid* 7.803–17).

Early in the *Aeneid*, Virgil reminds us of Penthesilea, 'a warrior queen, dares battle, a maid clashing with men' (ibid., 1.492–93), and near the end of the epic in the war between Aeneas and Turnus, Virgil compares Camilla to the Amazons:

> like an Amazon, one breast bared for the fray and quiver-girt, rages Camilla; and now tough javelins she showers thick from her hand, now a stout battle-axe she snatches with unwearied grasp;

> the golden bow, armour of Diana, clangs from her shoulders. And even if, back pressed, she withdraws, she turns her bow and aims darts in her flight. But around her are her chosen comrades, maiden Larina and Tulla, and Tarpeia,[24] shaking an axe of bronze, daughters of Italy, whom godlike Camilla herself chose to be her pride, good handmaids both in peace and war. Such are the Amazons of Thrace, when they tramp over Thermodon's streams and war in blazoned armour, whether round Hippolyte, or when Penthesilea, child of Mars, returns in her chariot, and amid loud tumultuous cries, the woman-host exault with crescent shields (ibid., 11.648–63).

Virgil goes on to describe the battle and has Camilla, who sided with Turnus, shout to Ornytus as she is about to slay him: 'The day is come that with woman's weapons shall refute the vaunts of thee and thine. Yet no slight renown is this thou shalt carry to thy father's shades – to have fallen by the spear of Camilla!' (ibid., 11.687–89). Camilla is eventually slain by Arruns who flees the battle.

While we might, and some have, considered Camilla (and the whole of the *Aeneid* for that matter) myth, I have chosen to place her in the same legendary category as the Amazons due to the frequency with which they are compared.

Juturna
Another interesting figure from the *Aeneid* (Book 12) is Juturna, the supernatural sister of Turnus who is described as '*virago*' – 'warlike woman', but also a water nymph. When she sees the resolve of her brother's soldiers' wane, she takes to the field disguised as Turnus' charioteer, Metisus (in every way, down to his voice and arms), and returns Turnus' lost sword that had been made by Vulcan. In the end, Jupiter, who had earlier taken her maidenhood, sends a fury instructing her to leave her brother and return to her spring. L'hoir (1994: 9, fn. 15) compares the later Iceni queen Boudica (see Chapter 5) to Juturna, calling Boudica 'another chariot-driving virago who acts as a *dux*'.

The Persians

Gordafarid
Shahnameh, The Persian Book of Kings,[25] gives us two stories of women warriors. The first of these stories is of Gordafarid,[26] daughter of the warrior Gazhdaham. She is described as having hair 'worthy of a diadem' and rosy cheeks which 'became as black as pitch with rage'. She was in the White Fortress when Sohrab, the son of Rostam the great Persian hero, attacked it. When Hejir, the leader of the Fortress, 'had allowed himself to be taken' she

was greatly shamed. Gordafarid dressed herself in a knight's armour, tucked her hair under a Rumi helmet, and rode out of the fortress like 'a lion eager for battle'. She taunted the enemy soldiers until Sohrab himself came out to her, and he laughed at her. She was an expert with bow and arrows – 'no bird could escape her well-aimed arrows'. When Sohrab caught her in his lariat, he was greatly surprised to find his opponent to be a woman. Because she could not escape by strength, she pointed out to him that two armies were watching, and he would be a laughing stock if his army saw that she was a girl. She then promised him her army, wealth and fortress. While she was promising these things, Sohrab was struck by her appearance:

> her shining teeth and bright red lips and heavenly face were like a paradise … ; no gardener ever grew so straight and tall a cypress as she seemed to be; her eyes were liquid as a deer's, her brows were two bent bows, you'd say her body was a bud about to blossom

But still he warned her not to go back on her word. Sohrab returned her to the fortress, and he returned to his army. Once back inside the fortress, Gordafarid shouted to him that she would not fulfil her promise and that Rostam would destroy him. Her words were filled with taunts ending with, 'The fatted calf knows nothing of the knife' (Ferdowsi 2006: 191–94). Her actions show her to be a virago while she retained her physical virginity.

Gordyeh

The second female warrior in the *Shahnameh* is Gordyeh, sister of Bahram Chubineh usurper of the Persian throne held by Khosrow II. The usurper ruled as Bahram VI for a year (590–591) but was reconquered by Khosrow II. Eventually Bahram was killed while in China. After her brother was killed, Gordyeh, who was noted for her wisdom, received an elaborate marriage proposal from the emperor of China, but she also was asked by her brother's followers to lead them from the Chinese. She chose an army of 1,160 men and selected 3,000 camels to carry supplies:

> When night fell Gordyeh mounted her horse; she sat like a proud warrior, grasping a mace in her hand. Her horse was covered with splendid barding, and she wore armor and a helmet and a sword at her side. Her army rode forward like the wind, through the dark night and the bright day (Ferdowsi 2006: 801).

When faced with the Chinese army she took Tovorg, their leader and a brother of the emperor of China, aside in an attempt to negotiate. Failing this, she killed

him, a great battle ensued, and she was victorious. It was, however, Yalan-Sineh who led her troops into battle. Gordyeh then wrote of these events to her other brother, Gerdui, who was King Khosrow II's advisor.

At this time Gostahm, who had been responsible for the blinding of King Khosrow's father, was a commander of the king's troops, but he now decided to turn against the king. At the same time Gerdui went to the king and informed him of his sister's exploits. Gostahm went to meet Gordyeh and her army. Yalan-Sineh was with her and he, along with Gostahm, had been involved in the blinding of the old king. Gostahm reminded Gordyeh of this and warned her that Khosrow would not welcome her. As a consequence, Gordyeh's army joined Gostahm's. Gostahm now decided it would be a good idea if Gordyeh would marry him and she did.

As time passed Gostahm became more worrisome to King Khosrow, after Khosrow turned to Gerdui for advice. Khosrow remembered that despite her brother Bahram's actions, Gordyeh had always supported him. The king decided to write to her, as did her brother Gerdui; the letters were sent via the king's wife. As a result of the king's missive, Gordyeh, with the help of five of her friends, killed Gostahm while he was in bed. She again put on her armour and was acclaimed by one and all – clearly Gostahm was not held in high regard. King Khosrow was so pleased with her action that he called her 'the moon's diadem', and placed her in his harem where she ranked above all others (ibid., 800–807).

The Celts

Medb
As mentioned in Chapter 2, the line between Celtic mythical and legendary female figures with warrior associations is often difficult to determine. Keeping this in mind, the legendary figures, like those referred to as war goddesses, are prominent and fairly numerous: several are standouts, many we have already addressed, still others are less well known. As with the goddesses, the Irish and Welsh stories provide us with a number of these legendary women with warrior connections. We need go no further than the first few lines of the great Irish epic, the *Táin Bó Cúalnge*, to find the quintessential example of the female Celtic warrior, possible goddess, but certainly queen, Medb. Medb, the legendary queen of Connacht, was both a warrior and a woman of great power, straddling the real world and the shadowy world of myth and legend. As *The Táin* begins, Queen Medb is having a conversation in bed with her current husband, Ailill, who is somewhat younger and a complacent cuckold. He tells her how much better off she is now that she is married to him. Medb protests, claiming that she

was well enough off without him. She then goes on to list all the things she had; he counters with his possessions. In the end, their possessions are equal except that Ailill has a large brown bull the equal of which Medb does not have. In order to solve this inequity, Medb sets out with her army to capture the Brown Bull of Cooley that resides in Ulster.

Medb differs from most Irish war figures in that she takes part in battles in her own form, not resorting to shape changing as others do. The healer Fingin describes her when he examines the wound of the hero Cethern. 'A vain, arrogant woman gave you that wound' (Kinsella 1970: 208) – which further justifies her placement in the category of legend rather than goddess. Nevertheless, Egeler (2012: 72) considers her warlike aspect a sign of divinity, particularly because she calms her army after the fright the war-goddess Nemain had caused.

Medb is as comfortable on the battlefield as she is in the bedchamber as evidenced repeatedly in *The Táin*. *The Táin* tells us that she leads an army that consists of a third of the men in Ireland (C. O'Rahilly 1967, l. 1756). Not only does she lead her men in battle against male armies, but Medb also goes into battle against an army led by another female, Findmór wife of Celtchair, whom she slays and then lays waste to Dún Sobairche (ibid., ll. 1792–93). Medb is a woman of great confidence as demonstrated when she speaks of conflict with Cú Chulainn. '"We make but little account of him,",…"He has but one body. He shuns wounding who evades capture. His age is reckoned as but that of a nubile girl nor will that youthful beardless sprite ye speak of hole out against resolute men"' (ibid., ll. 733–37).

Although Medb may have been a towering figure in the mythical political and military spheres, the Irish annals give her no historical counterpart (F. Kelly 1988: 71). Moreover, her lover Fergus decries the leadership of women when he tells her, 'This host has been plundered and despoiled today. As when a mare goes before her band of foals into unknown territory, with none to lead or counsel them so this host has perished today.'[27] Kelly points out that '[t]he implication is that a "stallion" would have been a more suitable choice of leader', i.e. Fergus (mac Róich) 'son of great horse' – Medb's own lover. This suggests that if there were Irish female political or military leaders, and there doesn't seem to be any hard evidence for them, they were not held in high regard.[28] The view that society balances on the edge of devastation when women take the lead is also mirrored in the Celtic literature. Despite what is generally thought to be a more liberal view of women by the Celts, O'Connor (1967: 32) states that the original purpose of the author of *The Táin* was to 'warn his readers against women, particularly women in position of authority. Look at what happens to people and armies when they are in a woman's power!' Nevertheless, it was not uncommon both in the Irish literature and in actual fact of other societies, as we will see in Chapters 5 and 6, that the wives of kings

did, indeed, lead armies into battle or at least to it. Soon after the period of this volume we can point to two examples of English queens, most famously Margaret of Anjou, wife of Henry VI, and less famously Catherine of Aragon, wife of Henry VIII, who did this very thing.

Medb is noted for her sexuality and promiscuity. She has numerous husbands and lovers, several of which have horse connections, particularly her lover Fergus mac Róich. T. O'Rahilly (1946: 16) characterises her not as a goddess 'but a masterful woman, with the inevitable result that her character has sadly degenerated, so much so that at times she is no better than a strong-willed virago.' Patricia Kelly takes it further and suggests 'O'Rahilly's view of Medb's "degeneracy" is shared by her literary creator, and that it is a central purpose of *The Táin* to depict her in a thoroughly unflattering light' (1992: 78).

The Irish stories do, however, make it clear that women taught the great Irish heroes not only wisdom but also feats of arms. The two best-known instructors were also sisters (often called doubles) – Scáthach and Aife. Scáthach is usually thought of as the most renowned teacher of the legendary Irish hero Cú Chulainn, but she was not his first. This position goes to Domnall Míldemail, 'the war-like', who was found in the land of Alba. From Domnall, Cú Chulainn learned 'craft of arms', and when she was finished with him, she told him that he must continue his training with Scáthach (Kinsella 1970: 28–29).

Scáthach

Scáthach, 'the Shadowy one', was the daughter of the Morrígan. Some see her as a war goddess but others skip over this point suggesting that her divinity is not firm. Scáthach was said to be the greatest warrior in the world, although we are never told with whom she does battle other than her students and sister. Moreover, her sister was a superior warrior. Scáthach was also a *fáith*, i.e., 'a seeress', expert in supernatural wisdom. She had a school for training warriors and because of her greatness and fame, all warriors wanted to attend. The journey to her military academy was very difficult as it was within a solid fortress (Dún Scaith) on the Island of Shadows (Isle of Skye), and one had to cross through black forests, desert plains, great bogs, a glen with terrible beasts and a bridge that rose up when someone stepped on it. Cú Chulainn came to her in order that she would train him, which she did, and it was Scáthach who instructs Cú Chulainn in the use of the *ga bulga* (his famous spear), taught him his famous leap, and Torannchles 'thunder feat'. During his training period of a year and a day Scáthach's daughter, Uathach, shares Cú Chulainn's bed. Once he had finished his training, Cú Chulainn and Scáthach engage in single combat that ends in a draw and afterwards Scáthach and Cú Chulainn also bed. Scáthach's sister, Aife, learning of the new champion challenges him.[29]

Aife

Aife has many similarities to her sister. Like Scáthach, Aife was a great warrior and thought of as even greater than her sister. She is known to ride alone in her chariot (Ross 1986: 125), but unlike her sister, was defeated in battle by Cú Chulainn – not by strength, but by stealth. Interestingly, in Kinsella's Introduction to *The Táin*, he groups Aife with Medb and Macha as a 'goddess-figure', but he does not include Scáthach (Kinsella 1970: xv).

Búanann

Another, although less famous, school for young warriors was run by Búanann, 'the lasting one', 'mother of heroes', 'the nurse of warriors', in Britain (MacCana 1983: 86). She taught the famous hero of the *Fenian Cycle* Finn mac Cumall as well as Cú Chulainn, who made the trip to Britain just to train with her. She is also connected to the Morrígan in that the Morrígan is given the patronymic Buan in *The Táin*. MacKillop (1998: 56) suggests that Búanann may be a counterpart of the Roman goddess Minerva.

The Nine Witches of Gloucester

The Welsh stories produce another group of trainers, The Nine Witches of Gloucester (Caer Loyw), who were known to lay waste to land and seem only to engage in evil deeds. In one of the three Arthurian tales, *Peredur Son of Efrawg* (Jones and Jones 1974: 183–227), we are presented with the story of the Welsh hero, Peredur, who meets one of the Nine Witches as she is doing her worst. Peredur engages her in battle and bests her. She calls him by name and says she not only knows who he is, but knew he would defeat her. She then suggests he come with her and she and her sister witches will train him in the warrior arts. These witches wore helmets and armour, instructed Peredur in chivalry, feats of arms, and supplied him with horse and armour. These women also trained other young men who lived with them in a *llys* or court.

Peter Ellis (1996: 71–72) discusses lesser-known figures when he 'turn[s] to women in a rather unusual role'. These include a number of less well-known Irish female figures who take up arms. He begins with the earliest warrior heroine (as opposed to warrior goddess), Am, who is found in *Lebor Gabála Érenn*[30] and is the wife of the warrior Golamh (*nom de guerre* Míl [Milesius of Spain]) and daughter of the Pharaoh. Míl took refuge in Egypt and married Scota. Scota had seven or eight sons. When Golamh heard that the Tuatha Dé Danann in Ireland had killed his nephew, he rushed there to avenge him. Míl was killed before they reached Ireland, but Scota fought beside her sons and was killed. (See P. Ellis 1996: 71–72 and 110.)

> §64. When the sons of Mil reached their landing-place they made no delay until they reached Sliab Mis; and the battle of Sliab

Mis was fought between them and the Tuatha De Danann, and the victory was with the sons of Mil. Many of the Tuatha De Dannan were killed in that battle. It is there that Fas wife of Un son of Uicce fell, from whom is named Glen Faise. Scota, wife of Mil, fell in the same valley; from her is named 'Scota's Grave', between Sliab Mis and the sea.[31]

§74. At the end of three days and three nights thereafter the Sons of Míl broke the battle of Sliab Mis against demons and Fomoraig, that is, against the Túatha Dé Danann [sic]. It is there that Fás [sic lege] fell, the wife of Ún s. Uicce, after whom 'the grave of Fás' is named, between Sliab Mis and the sea.

Scota d. Pharao king of Egypt, also died in that battle – the wife of Érimón s. Míl. For Míl s. Bile went a-voyaging into Egypt, four ships' companies strong, and he took Scota to wife, and Érimón took her after him. In that night on which the sons of Míl came into Ireland, was the burst of Loch Luigdech in Iar-Mumu (Macalister 1941, §74).[32]

Another woman with an unusual role is Erni, who was Medb's personal warrior and who guarded Medb's treasure (P. Ellis 1996: 73).

In '*The Wooing of Emer*', before eloping with Emer, his greatest love, Cú Chulainn had to do battle with Emer's sister, Scenn Menn, who was against the match. Scenn Menn raised an army against him, but Cú Chulainn was triumphant (Cross and Slover 1936: 170–71).

'*The Wooing of Emer*' also presents us with an obscure female who is not precisely a warrior, but behaves in a warrior-like manner and is also the mother of three warriors. It is for vengeance of her three sons (Ciri, Biri and Blaicne) that Éis Énchenn (Ess Enchenn), the bird-headed, seeks to kill Cú Chulainn. Cú Chulainn had killed her sons who fought on Aife's side in her battle against Scáthach. After Cú Chulainn bested Aife, impregnated her and went on his way, he came across a hag on the narrow path of the sea cliff. She tells him to get out of the way, which he does – except for clinging on by his toes. She goes to push him off, but Cú Chulainn sees her and strikes off her head (ibid., 168).[33]

The Irish tale *The Adventure of Art Son of Conn* (*Echtrae Airt meic Cuinn*) gives us yet another example of a female who does not shy away from violence to achieve her purpose. Although she is called a warrior woman, we are not told of her warrior activities, except in the protection of her daughter and her own life. *Coinchend Cendfada* (Irish 'dog-headed'), the daughter of Conchruth king of the Coinchind and wife of Morgán, king of the Land of Wonder, is referred to as an amazon. She is said to have been a monstrous warrior woman,

a virago (in the extreme), who had the strength of a hundred in battle, but the Druids had foretold that she would die if her daughter, Delbchaem, were ever wooed. She therefore built a stronghold to keep her daughter confined. Around the stronghold was a palisade of bronze, and on every stake was placed the head of a man slain by Coinchend, save on one stake alone. Art, son of Conn, slays Coinchend, places her head on the empty spike, and takes Delbchaem to Ireland (Best 1907: 167-71; Rees and Rees 1961: 261–62).

Germanic Legends

Veleda

Among the Germanic tribes there are a number of female figures with war connections that seem to straddle the line between myth and legend.

Tacitus tells us that the Germanic tribes greatly esteemed women with prophetic powers. This applied to the virgin prophetess Veleda of the Bructeri tribe who was held in extremely high regard and treated nearly as a deity. Her only (or at least most important) war connection was that she foretold the victory of the Germans and destruction of Roman legions during the Batavi war of AD 69. She was esteemed so highly that for a long period she lived in a high tower and only specially chosen people were allowed to talk to her (Tacitus, *Histories* 4.61, 65). Furthermore, she seems to have been not only a prophetess but also a political figure, as she was chosen as an arbiter along with Civilis[34] in a dispute between the Germans and Romans. In AD 77 the Romans took her captive (ibid., 4.65).

There is some confusion as to whether Veleda was a German or a Celt; P. Ellis states that her name is clearly Celtic (the root *gwel* – 'to see' cognate with Irish *fili*) (1996: 93; see also Davidson 1988: 159). However, Simek (1993: 357) points out that although Veleda phonically suggests the Old Norse *vǫlva* – 'seeress' it is more likely linked to Celtic *fili(d)* – 'poet, scholar', and she is frequently connected with the Celtic prophetess Fedelm.

Tacitus has several references to Veleda, but Dio Cassius mentions her only in passing: 'Ganna, a virgin who was priestess in Germany, having succeeded Veleda' (67.12.5). More modern authors also give her short shrift: Green (1992: 148) speaks of her (Valenda [Veleda]) only in a Germanic context and MacKillop (1998) does not mention her in his *Dictionary of Celtic Mythology*, but Simek (1993) in his *Dictionary of Northern Mythology* is more generous.

Senoni

Simek refers to another Germanic seeress in quite a surprising context – a second-century AD list of Roman and Greco-Egyptian soldiers found on the

Egyptian island of Elephantine. Senoni is listed in Greek on the penultimate line of what appears to be a payroll list. Not only is her name given, but also her occupation and origin: '*Waluburg. Se[m]noni Sibylla*' ('Waluburg, sibyl from the tribe of the Semnoni').' Simek contends that Senoni is spelled incorrectly and should be Semnoni, thus making her Germanic (as is her name) rather than what initially appears to be Celtic. How she arrived in Egypt is unknown but Simek gives three possibilities: she may have been a slave, she may have been in service to a Roman officer or lastly, she may have been deported, given the importance seeresses held for the Germans (Simek 1993: 370–71). Other than being on a list of soldiers, however, she does not seem to have any military connections.

The Scandinavians

Although one might think the Scandinavian women who were involved in war, should be categorised as Germanic, Scandinavians stand apart from their Continental and British cousins not only culturally and geographically, but ecologically as well. It is best, therefore, to treat them separately. Moreover, the sources differ chronologically and to some extent culturally. Nevertheless, before we move on a few words must be said about sources. First, we will look at Saxo Grammaticus, whose *History of the Danes* put down a number of stories pertinent to our study of women and warfare, and then we will comment on Snorri Sturluson, who recounts the *Icelandic Sagas*.

Problems abound with both Saxo and Snorri, not the least of which is whether the tales they have passed down to us are fact or fiction. Saxo was not only a Christian but also a cleric who wrote in Latin and took the typical Christian view that women were simply sexual beings. The first nine books of his *magnus opus* are a discussion of pre-Christian times, and the subject of women as warriors only appears in these books. What is important to remember is that Saxo is not always clear as to who is an actual person and who is legendary. Several reasons could account for this: his desire to play up the more Christian qualities of a character and emphasis the evil of the pagan qualities; he didn't really know the difference between legendary and actual subjects; and his aim was simply to convey a good story. Whatever his intentions, however, women are found only in traditional roles in Books X–XVI. It is in the earlier books that women are portrayed outside traditional roles, and it is thought that he drew these earlier books from classical sources, Norse legends, and his imagination. Keeping this in mind, it is difficult to categorise Saxo's women – are they legendary or historical? The choice is not always clear, but I have placed them in one category or the other depending on where I deemed the evidence most persuasive.

Snorri Sturluson, our second great source, was much more than a man of letters. In his lifetime he acquired great wealth as a man of business who travelled widely, a diplomat, and twice held the highest office in Iceland (Nordal 1954: 17). Snorri's *Prose Edda* and *Poetic Edda* (see Sturluson 1954 and Hollander 1962), also have women who go into battle. Still another important Norse work, the *Íslendingasögur*, consists of a group of Icelandic sagas and is generally considered fiction, but is still a picture of Viking life in the ninth–eleventh century (Jesch 1991: 182).

Shieldmaidens

Among the Scandinavian-speaking people we have a group often referred to as shieldmaidens to whom Saxo refers in the early books of his work. The shieldmaidens[35] (*skjaldmær*) appear in Scandinavian mythology and folklore as young women who choose to fight as warriors. A shieldmaiden is said to keep men at spear's length, approaching them only when she is armed with a spear or axe. These shieldmaidens are females (it is not completely clear if they were maidens in the chaste sense) who chose to go into battle. Some are said to wear armour, preferring the spear to the needle.

In Book VII of Saxo Grammaticus' great work, he digresses from his narrative to explain the nature of these shieldmaidens as:

> women in Denmark who dressed themselves to look like men and spent almost every minute cultivating soldiers' skills; they did not want the sinews of their valour to lose tautness and be infected by self-indulgence. Loathing a dainty style of living, they would harden body and mind with toil and endurance, rejecting the fickle pliancy of girls and compelling their womanish spirits to act with a virile ruthlessness. They courted military celebrity so earnestly that you would have guessed they had unsexed themselves. Those especially who had forceful personalities or were tall and elegant embarked on this way of life. As if they were forgetful of their true selves they put toughness before allure, aimed at conflicts instead of kisses, tasted blood, not lips, sought the clash of arms rather than the arm's embrace, fitted to weapons hands which should have been weaving, desired not the couch but the kill, and those they could have appeased with looks they attacked with lances (Saxo VII: 212).

This explanation is helpful but not always useful. Saxo and Snorri both occasionally use the term shieldmaiden, but other than their sex little if anything distinguishes them from male warriors. Commentators and even Saxo sometimes equate them with Amazons (ibid., 227) while both Saxo and Snorri

are also known to compare them with Valkyries. Usually, however, only their fighting abilities are mentioned.

A number of times a woman or girl is actually called a shieldmaiden, such as in the case of Vebiorg, but at other times we are simply told that a girl took up arms without being given any specific designation.

The Battle of Bråvalla (probably eighth century but could have been as early as the sixth century) is one of the great battles of Norse legend and is repeatedly referenced in the sources. In it, the Danish king Harald Wartooth was pitted against, and lost to, his much younger Swedish nephew, Ring. Saxo calls our attention to a number of women who fought in this battle, two women he refers to as Slavs. They were leaders of the army from Schleswig during the Battle of Bråvalla and are described as women 'whose female bodies Nature had endowed with manly courage' (ibid., VIII: 238 and n. 11). First is Visna,[36] 'a woman hard through and through and a highly expert warrior' (ibid., 214–15), and the second woman, Hetha, brought a hundred men into combat. Both of these women led their men into battle. Hetha was later appointed to rule over part of the land of the Danes, but the Sjællanders thought it a disgrace to be ruled by a woman.

Hervör

We are given the names of a number of shieldmaidens, but perhaps the most famous is Hervör, a figure in the cycle of the magic sword Tyrfing in *The Saga of King Heidrek the Wise* (Tolkien 1960). Hervör is the only child of Angantyr who owns the sword Tyrfing, but he dies in battle before his daughter is born. Hervör lives with her maternal grandfather and as she grows, she becomes more adept with the sword, shield and bow than with a needle. As a young girl she dresses as a boy and behaves as a young thug, mugging people for their money. Using the name Hervarðr, she joins a Viking group and becomes their leader. In time she seeks out her father's grave and demands from her dead father the sword Tyrfing, which had been buried with him. He insists (although he is dead) that it has never gone to a woman, but ultimately she overcomes his objections. Taking the sword, she re-enters the world of the living where she continues her 'masculine' life until one-day she returns to the life of a woman, marries, and has two sons.[37]

Although Saxo gives us the names of shieldmaidens, each is mentioned only once or twice, e.g., Sela, Lathgertha, Rusila, Stikla, Vebiorg, Alvild, Gurith (daughter of Alvild). According to Saxo, these Danish women took part in the great Battle of Bråvalla or engaged in piracy. Some of these women are often thought of as legendary, while others appear to have historical connections. Such is the case of Lathgertha, who is said to have been the lover of Ragnar Lothbrok, probable father of Ivar the Boneless and Halfdan, who were involved in the Danish attack against England in the ninth century.

Despite the numerous women who fought bravely, in these stories, the women ultimately were typically defeated in battle because the male warriors 'thought it a disgrace to be subject to a woman's laws' (Jesch 1991: 177). A short reference is made to Sela, 'a warring amazon and accomplished pirate' who was the sister of Koller of Norway. After Orvendil slays Koller, Orvendil 'hounded [Sela] down and slew [her]' for a reason that is not made clear (Saxo III: 83). Perhaps because Orvendil was a pirate of great renown he did not want to see a woman as his rival.

The shieldmaiden Vebiorg (*Webiorga, Weghbiorg*), found in Book VIII of Saxo, is mentioned twice, and both times she is clearly a secondary player with nothing said of her except that she was in the skirmish and died in battle (Saxo VIII: 238, 242). We are told in the commentary that Vebiorg appears in the oldest skaldic poems[38] and belongs to the long complex history of Valkyries and shieldmaidens (ibid., II: 7).

Rusila (*Rusla*) is mentioned three times by Saxo. The first reference to her states that she had great 'military ardour' but was overthrown by Fridlef 'the Swift', for which he 'collected manly fame from his female adversary' (ibid., IV: 110). It is also suggested that Rusila is the same woman known as Inghen Ruaidh (Red Daughter), who was a Viking leader in the attack against Munster in *The War of the Gaedhil with the Gaill* (ibid., n. 48 and VII, n. 114). In Book VII we are told of a struggle for the kingdom between 'Olaf, king of the Thronds and two women, Stikla and Rusila', but Harald Wartooth defeats the two 'amazons' (ibid., VII: 227).

Rusila also reappears in Book VIII at the Battle of Bråvalla (ibid., Vol. II: 123, n. 114) and in what seems to be the same, or a later part of the story that we saw in Book VII, this time without the interference of Harald Wartooth. Now Rusila does battle with her brother Olaf, defeats him, and attempts to take over the sovereignty of Denmark, but she is rejected by the populace, no doubt another instance of men not wanting a woman as their leader. She then flees, encounters her brother again, who kills her (ibid., VIII: 246; see also Vol. II: 135, n. 77).

Princess Alvild was discouraged from marriage by her mother as well as being guarded by two snakes; despite this, Prince Alf still pursued her. She ran away to live the life of a pirate gathering a group of girls with her, and they all joined a band of pirates. Alvild ('[b]ecause of her beauty') was elected as pirate chief. Prince Alf, however, continued his pursuit of Alvild; eventually he tracks her down and convinces her to return to the feminine life, which she does. Subsequently she bears a daughter, Gurith, who takes the same path as her mother to the point that when Gurith was involved in a war in Sjælland and her son, Harald, needed help, she dressed in 'male attire', flung him over her shoulder and carried him off the field of battle. During her retreat an opponent shot an arrow into her son's buttocks causing Harald

to reckon that 'his mother's aid had brought him more embarrassment than assistance' (ibid., VII: 198, 210-12, 225).

Queen Olǫf

The Story of Helgi in the saga of *King Hrolf and his Champions* (G. Jones 1961) introduces us to Queen Olǫf who ruled over Germany.[39] The description of her is one of a true virago:

> [E]very inch the war-king in her ways, wearing shield and corslet, a sword at her side, and a helm on her head ... [she was] lovely of countenance, but fierce-hearted and haughty. By common consent she was the best match men had ever heard tell of in those days in the Northlands, yet she would not take a husband (ibid., 234).

A considerable body of men also describes her as arrogant, tyrannical and avaricious. Although she greatly humiliates him, Olǫf and King Helgi ultimately sleep together, she becomes pregnant and gives birth to a girl, whom she names Yrsa, the name of her dog, which indicates her contempt for the child (or perhaps affection for the dog). Yrsa is given to a peasant to be raised. In the course of time King Helgi, who does not know he has a daughter, comes upon Yrsa – who is of course beautiful – marries her, has a son, and they live happily ever after – or until Olǫf comes back into the picture.

After some time, the queen hears of Helgi and Yrsa's life together and she goes to visit Yrsa. Despite Yrsa being Olǫf's daughter, Olǫf never had any fondness for her and now cruelly tells Yrsa that she, Olǫf, is her mother and that King Helgi is her father. Olǫf offers to take Yrsa back with her to Germany, and because Yrsa knows she can no longer live with her husband/father, she agrees. Soon after, the king of Sweden, knowing the situation, offers to marry Yrsa and she consents. We are then told that Olǫf is no longer to be heard from (G. Jones 1961: 234–46). Although Olǫf is described as a 'war-king' and she is given the trappings of a warrior king, we hear little of her actual battle activities – just of her unpleasant disposition.

A final example from the sagas of women who take up arms is from *Hrólfr Gautreksson Saga* (*Hrólfs saga Gautrekssonar*). In this saga Þornbjörg, the only child of King Eirekr of Sweden, has a very independent spirit and prefers to spend her life engaging in martial arts rather than more feminine arts and swears she will not marry, defeating or killing all her suitors. Finally, her father provides her with men and land and she adopts both male clothing and a male name, Þórbergr. Ultimately, she accedes to Hrólfr Gautreksson (Clover 1986: 40–41).

The Balkans

Vile

In the area of the Balkans, the Slavs provide us with a group of supernatural female figures that are not well understood (Jurić 2010), but in part resemble the Valkyries and are associated with warriors. These are the *vile* (singular *vila*), a group of maidens largely known from heroic songs among the Slovaks, Croats, Serbs and Bosnians. These *vile* have a number of forms. They are beautiful, strong and naked; they possess arrowheads, and can take the form of a number of animals including swans, snakes and falcons. When they are in the form of horses, wolves, falcons or whirlwinds they are, like the Valkyries, battle-maidens who befriend heroes. They are associated with the god Svarog, who is 'the generator of the sun', and can be compared to the Vedic war god Indra and the Iranian war god Vṛtagna. When the *vile* 'are dancing on mountain tops or meadows they shoot at anyone who approaches, or blind him or pull him into the ring and dance him to death' (Gimbutas 1971: 162–64). Similar figures are found with the Albanian *zana* and Bulgarian *samovila*. Miller (2012: 7) points out that they are 'neither clearly divine nor completely human' and that they have powers, which they 'may use to aid or to harm the human hero-warriors with whom [they] can be closely associated'. Most importantly for our purposes, they are said to have warrior attributes. The *zana* are said to be extremely courageous and are compared to Athena in that they protect warriors but will attack them if the warrior observes them bathing. They are also known to watch Albanian tribes in battle and intervene when they find it necessary (Gimbutas 1971: 162–64). Barber (1997; 2013) has also studied the *vile,* associates them with Russian *rusalki,* and emphasises their fertility aspects. They have further similarities to other legendary groups in that they live outside urban areas – usually mentioned are mountain lakes – which provides another connection to the figures we have already discussed. Jurić (2010: 172) attempts to make 'a case for the understanding and study of the *vila* as one distinct figure divided into two typological facets – one mythological in nature, the other a product of folk custom'. Within the context of the mythological facet, he states that '*vile* are seen as powerful, supernatural warriors whose might is only rivalled by the bravest of heroes', furthermore, they wear armour, and their choice of weapons are bow and arrow (ibid., 182).

An Indic Legend

The Indian epic *Rāmāyana* provides us with a somewhat elusive warrior figure, Kaiyeyi. She was the second and favourite wife of King Dasaratha and again she might fall into the category of either myth or legend. Her activities as a warrior are confined to her going into battle with her husband against his enemy Samhasura.

During the battle the wheel of Dasaratha's chariot breaks and he is shot with an arrow. It is Kaiyeyi who saves his life. After she saves his life, he grants her two boons which she saves for later and thus follows the story of the *Rāmāyana* (2004).

Back to Britain and a Segue to History

The last of the legendary figures we will consider takes us back to Britain and provides a segue into the chapters on historical figures. These final legendary figures can be thought of as qusai-historical due to our source, Geoffrey of Monmouth, whose *History of the Kings of Britain* some consider more legendary than historical. Geoffrey writes of the time before the Romans came to Britain and of two queens who took to the battlefield.

Gwendolen

The first of these queens is Gwendolen, daughter of Corineus, who was in the service of Locrinus the first son of Brutus who, according to Geoffrey, was the first king of Britain. Locrinus, now king of a third of Britain, had promised to marry Gwendolen. However, while Locrinus was off fighting he had captured the very beautiful daughter of the king of Germany, Estrildis, and wanted to marry her. When Corineus heard this, he went mad with fury and threatened Locrinus, who backed down and married Gwendolen, but set up a home for Estrildis in a cave, where she stayed for seven years until Corineus died. After Corineus' death Locrinus deserted Gwendolen and married Estrildis, making her his queen. But we need to remember that Gwendolen had been, and perhaps still was in some people's eyes, queen. She raised an army and set out against Locrinus who was eventually killed by an arrow. She then had Estrildis and her daughter, who had been born during her seven years in the cave, drowned in the river Habren, which was also the girl's name. Gwendolen reigned for fifteen years until her son was old enough to take the throne, and then she retired to Cornwall (Geoffrey of Monmouth 1966: 75–78).

Cordelia

The second queen that Geoffrey of Monmouth presents to us who went into battle is quite famous thanks not to Geoffrey, but to Shakespeare and his play *King Lear*. Monmouth's king was Leir and he, like Lear, had three daughters, the youngest being Cordelia[40] and the older, less pleasant sisters Goneril and Regan, all of whom the king loved dearly. The story is much the same as Shakespeare's and was likely the inspiration. In both cases Cordelia marries Aganippus, the king of the Franks, and becomes queen of France; in both cases she leads an army but under slightly different circumstances. Ultimately, she reconciled with Leir and after his death, she inherited the crown of Britain, where she reigned

for five years when her sisters' sons challenged her, and it was against them that she went into battle. Eventually she was captured and placed in prison where she committed suicide (Geoffrey of Monmouth 1966: 81–87). In both Geoffrey's rendition and Shakespeare's, it ends badly for Cordelia.

Summary

In this chapter we have seen numerous legendary women leading their armies into battle, or at least being their commander; women who take up arms to go into battle, and women who just take up arms. The chief example of these women is, of course, the Amazons – the archetypical women of war. The Amazon tales are numerous and told with great (but often conflicting) detail. In the category of warrior women, Amazons have no equal. Still, there are individual legendary women who lead armies, such as Camilla and Cordelia, who find their way into more modern literature. Armies are not just men, as in the case of Hippodameia of Troy who led an army of women. The Celts also have women who do actual battle, as with Scenn Menn who fought for her sister against the hero Cú Chulainn. Although not as well-known as the Amazons, the Scandinavian people had their shieldmaidens who volunteered to go into battle, a number of whom are said to have fought at the great Battle of Bråvalla.

We have thus far looked at war goddesses and legendary figures that are involved in war or have military connections. There are also small groups of females who do not fall easily into either of these two designations but are more like prophetesses and seeresses.

What should be clear from this chapter is that women, or female figures, engaged in warlike activities – not only individually but also in concert alongside each other. As evidence of this, we can point to the legends, the literature and the reported activities as set down by classical authors. These mythical and legendary women bring us one step closer to reality. It is impossible to believe that the legends that grew up about these women were all imagination, but it is equally impossible to believe that once the legendary seed had been planted, many embellishments did not branch off from the original story.

While most of the examples in this chapter fall into the category of 'legendary', we will see in Chapters 5 and 6 that flesh and blood women also commanded armies and went into battle. These historic women were not 'legendary', although legends about them often developed over time. What is important to keep in mind is that all of these female figures contribute to the fact that societies did not have difficulty envisioning women combatants, or at least women involved in military activities.

Before we move on to historical women, however, it is essential to examine some of the archaeological evidence for women and warfare.

Chapter 4

Archaeological Evidence

The previous chapters have intermittently pointed out archaeological evidence, but now we will look at the archaeology in greater depth.

When excavating a grave, the items placed in the grave with the body give us important information, as it is largely through the grave goods that we determine the cultural context of the person in the grave. Other factors that are useful, particularly if grave goods are absent, are whether the grave is flat or under a mound, and the position of the body. One of the first questions an archaeologist asks of the material in a grave is whether the remains are of a male or a female. A complicating factor of the archaeological evidence is the long-standing bias to designate a skeleton male if the grave contained weapons. However, typical warrior items including bows and arrows, iron knives, armour and lances have been found in graves that were otherwise thought of as female (Rice 1957; Rolle 1989; Melyukova 1995; Barbarunova 1995; Davis-Kimball 1997/1998).

Until about the beginning of the twenty-first century, most ancient graves in which weapons appeared were nearly always said to be that of a male. Even in the Eurasian Steppe region where the majority of female warriors (and of course Amazons) have been claimed, there were obvious problems. If weapons were found in what was otherwise considered a female grave, it was suggested that these items were placed there as ritual items, or offerings from a grieving relative. However, some of the women just referenced have also shown evidence of head and body wounds typical of battle (Rolle 1989: 88; Davis-Kimball 1997/1998: 48; Murphy 2003) and this fact complicated the designation of their sex.

While graves containing weapons were designated male, typically it was believed that women were buried with jewellery, pottery, clay spindle-whorls and mirrors. Despite this generalisation, pottery is commonly found in male graves, spindle-whorls have been found in male graves that also contained weapons, and it is not uncommon for men to also have jewellery (see Parker Pearson 1999: 108; Berseneva 2008). Depending on the cultural context, male graves are also known to contain mirrors, for example in Scythian graves (Bokovenko 1995: 278). Nevertheless, all the bronze mirrors in a Saka context from Kazakhstan are from female graves (Yablonsky 1995: 205). We can thus

see that mirrors are not a reliable sex marker in all societies, and that grave goods alone are precarious as sex indicators.

Until the very early years of the twenty-first century when the use of DNA testing became possible, the most accurate sexing was done by a physical anthropologist who had a large sample of skeletons from the area under investigation that could be used for comparison.

However, even this was not fool proof, particularly if a skeleton was in a degraded condition. Adding to the male-centric bias is the fact that the skeletal remains of an immature male and a young female are very similar, and while there can be differences in the cranial structure – males generally having thicker brow ridges – this development may not appear until the male is well into his twenties. The pelvic areas of the two sexes also have a somewhat different shape in mature individuals, but it is not until a woman has children and the pelvis becomes pitted that sex becomes easier to determine. Moreover, with only a few specimens for the physical anthropologist to examine, the female/male differences may not appear obvious and may be overlooked. Better sexing techniques and more open minds regarding gender roles improved this stilted sexing problem but did not completely eliminate it. With DNA testing things have been made much easier and greater certainty can be had in the area of sex identification, but until DNA testing is more prevalent, we are left with a great number of excavation reports where the sex of the remains is questionable. Despite these caveats, we do have some evidence about which we can speak. This evidence is again found primarily on the periphery of the Indo-European world, particularly in the east.

Prior to the use of DNA testing, there was tangential but tantalising evidence that has suggested the existence of women warriors. Before moving on to the more current archaeological studies, we can consider some of this marginal evidence.

The numismatic evidence is of particular interest. Coins are ideal for dating purposes, particularly if a known person is embossed on the coin. Coins are less useful when they are embossed with unknown personages or abstract figures, but they may be represented in an abstract form as myth, actual beliefs or views of a group. Abstract figures are not unusual on Celtic coins where the combination of a corvid bird, a horse, and sometimes a nude female can be found (see Allen 1980: 142, #526; Meid 2010, fig. 14). Some of these coins are struck in gold. The Redones, a Celtic tribe from northwest France dating to the first century BC, provide some evidence in the way of coins that allows us to think of women involved in battle. One such coin shows a nude woman warrior riding astride a horse and holding a shield in one hand and a lyre in the other (Megaw 1989: 180). Another coin depicts a horsewoman, also astride, which Duval describes as dressed and riding as an Amazon. This second female holds a shield in one hand and a severed head in the other (Duval 1977: 173,

figs. 389 and 390). It is most likely that these figures are mythological or symbolic (we know the Celts kept the heads of their enemies), but they may also represent real female leaders for whom we have historical parallels such as Boudica. Although this is less direct evidence than that found in graves, it does suggest that the women of this Celtic tribe may have engaged in the activities shown (although perhaps unlikely in the nude) and that this activity was valued enough to relate it on coins.

A Warrior's Grave

Before we turn to the actual graves, we should first lay out what in fact represents evidence for a warrior's grave. We are, of course dependent on grave goods that have been preserved, as organic material, in most cases, does not survive. Ideally a warrior's grave should contain weapons made of stone or metal and/or armour. Even here, however, preservation can present a problem in that arrowheads are sometimes made of wood (see Graham-Campbell 1981, #13) and are not always preserved; the same can be said for bows made solely of wood. Although it should be noted that wooden arrowheads are generally used for hunting birds, they could be used as weapons against humans. Smaller bronze items such as arrowheads and knives may also decompose leaving only a green stain where the item lay, and in some areas iron does not preserve well. Perhaps the best indication of a warrior's grave is visible battle wounds on the skeleton such as broken bones – particularly skull and arm wounds – combined with weapons.

Turning first to the weapons, most of what we consider a weapon, as was pointed out earlier, has dual usage (Huld 1993). A knife can be used to kill someone but can also be used for eating and other non-lethal purposes. Spears, bows and arrows, slings and shot can be used in battle but also for hunting. Swords are one of only a very few objects designed primarily as a weapon or for warfare – they were the ultimate status weapon; mace heads might fall into this category too, but they also can be seen as symbols of power while still inflicting a deadly blow. Spears, another hunting tool, are more often labelled instruments of war. Armour and shields have only the purpose of protection in battle. We are, therefore, left with objects that are ambiguously weapons or tools. Shields and armour would have been very costly and therefore might only be found in an elite warrior's grave. Swords would also have been costly and are not common finds, but more common than shields and armour. From iconographic evidence and the ancient authors, legendary female fighters (i.e., Amazons) seem to have preferred bows and arrows, spears, darts and double battle-axes. They carried crescent-shaped shields (Erol 2008) and sometimes wore battle-belts[1] and Hellenic bronze helmets (Guliaev 2003: 113).

Even with the recognition of dual usage for most weapons, we need to be cautious. Instances from old as well as recent excavations can present a number of questions. Most of the burial evidence that suggests female warriors comes from the Eurasian Steppe area, but some is found in the western part of Europe. We will first look at the western area, much of which dates to a later time period, particularly the Viking period.

Modern Evidence from the West

The storerooms of museums are filled with old, and often unpublished, remains and notes of excavations. Using modern methods, particularly DNA, it can be worthwhile to go back into these archives and re-examine questionable, or just old, material. The Scandinavian area itself has produced a number of graves that are of interest.

The archives from the site of Birka in Southern Sweden, excavated in the nineteenth century by Hjalmar Stolpe, is one such case, but before we get to the site of Birka, it is informative to review some newer excavations.

A number of burials of interest come from the Viking Age, which can be dated quite precisely for England because the first Viking attack destroyed the abbey at Lindisfarne, an island off the northeast coast of Northumbria (Map 3), on 8 June AD 793; Viking occupation continued until not long before the time of the Norman Conquest in 1066. For the rest of Europe, the Viking Age is less precise, but roughly covers the period from about 800 to the eleventh century.

From Denmark there are three graves of note, all excavated post 1980: a grave from Gerdrup (Sjælland) (Christensen 1981; 1997), Grave BB from Bogøvej (Langeland) (Grøn *et al.* 1994) and Grave A505 from Trekroner-Grydehøj (Sjælland). Each grave had some type of weapon associated with a female skeleton.

The first burial of interest to us is Grave B found in 1981 at Gerdrup (Sjælland) in Denmark and dates to the early ninth century (Christensen 1981; 1997; see also Jesch 1991: 21, 25). This was a large and deep grave pit that held the skeletal remains of two adults. The main occupant was a female, first described as about 40 years old, who at death had been missing a number of teeth for several years and her pelvis indicated she had given birth to at least one child. A later description of her included that she 'must have had the appearance of an old woman with a receding mouth' (Kastholm and Margaryan 2021: 6). She had as grave goods a needle case and an iron knife, both found at her waist. The most significant object to accompany her was a 37cm iron lance that laid along her right side, the tip facing south. The socket of the spear is ornamented with grooved parallel lines, is a Petersen type E (Petersen 1951),[2] and dates to the ninth century. While the needle case is a typical female item, a

spear, as already mentioned, is usually classified as a weapon, although hunting with it cannot be ruled out. The excavator notes that weapons were 'normally the sole prerogative of male warriors' (Christensen 1997: 34). Still, here we have a real possibility of a woman being buried with a weapon – although other suggestions have been that the spear functioned as a sign of status (Gardeła 2013: 280).

A further surprise in this grave came in the form of a second skeleton that had been carelessly put in the grave; this skeleton was found to be a male of 30–40 years old. The legs of the man had probably been tied together due to their unusual position, and the twisted cervical vertebrae suggest he died by hanging. Only one object, an iron knife, which lay on his chest, was associated with him. Both bodies were buried in supine position and orientated N-S.

The woman showed no signs of violence except for the three large stones that had been placed on top of her – one on her chest, one on her right leg and one on her left side at her hip. Christensen (1997: 34) associates her with the shieldmaidens but also suggests she may have been a sorceress or priestess. The stones, however, indicate those who buried her did not want her returning from the grave.

Several questions were raised about this second body. Was he a sacrifice to the woman, or perhaps a religious sacrifice? Was he a defeated enemy? Did he symbolise a military triumph? This was a unique grave for the area, but one that is initially reminiscent of the Steppe burial at Cholodny Yar in Ukraine, which will be discussed further below. We should also keep in mind, despite comments by classical authors to the contrary, that women might not have given up their more 'feminine' activities just because they also engaged in fighting.

In 2021 a surprise result of the DNA analyses published by Kastholm and Margaryan showed that the grave 'clearly indicated a parent-offspring relationship', and that 'the female (sk1) was the mother of the male (sk2)' – the two bodies were mother and son (ibid., 9). The age similarity (the male said to be 30–40 and female in her 40s) was not addressed, but it was clear that the woman was older than the man, and apparently old enough to be his mother.

A second grave of interest from Denmark is Grave BB from Bogøvej (Langeland), (Grøn, *et al.* 1994). The skeletons from Langeland were anthropologically sexed and Grave BB contained a 'positively identified' 16–18-year-old female lying in supine position in a chamber grave (ibid., 136). A late-type axe was found near her right knee, a strike-a-light and a piece of a silver Arabic dirham coin dating to AD 945. Axes are usually considered male items and, during the period just after the introduction of Christianity, usually status symbols. However, the authors also suggest 'the possibility cannot be excluded that this grave represents the inhumation of a young woman and the symbolic cremation of an absent man'. Traces of charcoal were also found, but no burnt bone (ibid.). This unusual grave was the only grave in the cemetery

to contain a weapon. Furthermore, because of the unusualness of some of the burial items and the construction of the grave itself, the occupant of the grave may well have been a foreigner (Gardeła 2021: 73-74). However, this also casts doubt on the gender identification of the occupant of this grave; see Gardeła (2021: 80, n.149).

From the Kaupang cemeteries in Norway come a number of female burials with weapons. Three graves from Nordre Kaupang cemetery produced brooches and axes. Grave Ka.3, a cremation burial, revealed two oval brooches[3] and two beads, along with an axe (Petersen type H), as well as two sickles, a spindle-whorl, horse bit, rivet and several iron objects including a rod, rattle, frying pan, saucepan and a possible cauldron. Grave Ka.16 also produced a Petersen type H axe, two oval brooches, as well as a sickle, scissors, spindle whorl of burnt clay, textiles, an iron sword-beater, horse bit and harness mount. Grave Ka.10 yielded a Petersen type K axe, two oval brooches, a sickle, soapstone vessel, spindle-whorl, horse bit, casket handle, iron hook, rod, rectangular iron mount and 2-3 rivets (Stylegar 2007: 83–84).

In Gardeła's review of these graves from Nordre Kaupang (2021: 60–61), he points out that sex in these three cases were all determined by grave goods and may possibly have held more than one person, that is a male in addition to a female.

The Bikjholberget cemetery at Kaupang contained a meaningful number of female graves: twenty-two (50 per cent) from the ninth century, and thirty-eight (25 per cent) from the tenth century (Stylegar 2007: 82). Of these, at least two female graves each revealed a spear and two graves contained a shield-boss, suggesting a possibility of Valkyrie symbolism (Stylegar 2007: 84).

The inclusion of arrowheads and small axes in female graves can present confusion as to their use. Were they used as tools or weapons? Again, the arrowheads could be used for hunting and the axes could be tools – chopping wood was a task usually performed by women. Despite the possibility of these weapons (spear and arrowheads) being used by the woman in whose graves they were found, the well-known Viking scholar Judith Jesch (1991: 21–22) took the view that 'even burial with a real weapon does not necessarily imply that the woman knew how to use it in real life – we should again recall the possible symbolic functions of grave goods'. Although Jesch has conceded that there may be weapons in some female burials, she has been hesitant to say these females are themselves fighting women (2014: 106). This is, of course, an area that requires examination of the skeletal remains to determine the types of wounds the person sustained. We will turn to this subject below.

Recently, a number of these Viking Age burials have been re-examined in regard to whether or not they were women with weapons. Leszek Gardeła (2013) surveyed a number of female graves from sites in Denmark, Norway and southern Sweden, including Birka, that had 'war-gear' in order to determine if these women were deceased warriors or if the weapons had another meaning.

His results had several conclusions. He found that in the corpus of graves, axes, which are rare finds in female graves, were, in fact, the most common weapon in female graves that contained weapons. He does admit that rather than weapons the axes could have been used as tools for a variety of household uses. Gardeła showed that the axes were all of the same type – Petersen's type H – a fairly common type of axe during the Viking Age (Petersen 1951). He also speculates that the axes may indicate a connection with the god Þórr and his hammer *Mjöllnir*. Of the two spears found in his survey, Gardeła argues that they could be connected to Old Norse magic (*seiðr*)[4] and not used as practical weapons. Two swords (that elevated the graves to a more aristocratic level) were found in graves that held both a male and a female. Gardeła points out that in both instances the female appears to be the more important of the deceased and speculates that the sword might be regarded as an object 'additionally strengthening their status and authority' (2013: 298–300). Another possibility that he does not entertain is that if the female was of higher status, perhaps the male with the sword was there to protect her in the afterlife.

The strongest case for a female warrior in Gardeła's 2013 survey was found at Birka, in grave Bj.834 (ibid., 294). This, again, was a double grave of a man and woman. Due to the elaborate grave goods (including two horses, a sword in a wooden sheath, a shield, an iron staff, battle-knife and fifteen arrows) this grave can also be placed in the category of elite or aristocratic. According to Gardeła, some of the weapons 'should' be associated with the female, as the majority of iron staffs have been found in female burials. Accordingly, he believes it possible that the female was the dominant person in the grave, perhaps as a 'ritual specialist'. Unfortunately for his case, this does not make the female a warrior. However, if Gardeła's hypothesis is accepted, it could put the female in the category of 'warrior-priestess' as proposed by Davis-Kimball (1997/1998; 2012). Gardeła concludes that '[i]n my view, at the current stage of research it is perhaps too early to offer any definite answers to the question' (2013: 306) of whether or not there were warrior-women in Viking Scandinavia. His conclusion was understandably cautious, but as we will see with the next grave (also from Birka), perhaps too cautious.

This next grave from the site of Birka (which is a UNESCO World Heritage Site) brings us to some very recent and widely discussed research. A Swedish team of researchers headed by Charlotte Hedenstierna-Jonson re-examined grave Bj.581 from Birka that had originally been excavated in 1889 by Hjalmar Stolpe.[5] This grave had stood out from surrounding graves even to Stolpe due to its completeness of weapons, elite finds and prominence of place.

> The grave goods include a sword, an axe, a spear, armour-piercing arrows, a battle knife, two shields, and two horses, one mare and one stallion; thus, the complete equipment of a

professional warrior. Furthermore, a full set of gaming pieces indicates knowledge of tactics and strategy (van Hamel, 1934; Whittaker, 2006), stressing the buried individual's role as a high-ranking officer. As suggested from the material and historical records (Hedenstierna-Jonson *et al.* 2017: 2).[6]

Because of the grave goods, the occupant of the grave had, since its excavation by Stolpe, been considered male. It was not until the 1970s that the first osteological analysis was done, and it was then said to be a female. This notion was disregarded, much as other cases of females with weapons, and had also been disregarded on the grounds that the weapons were heirlooms or symbolic items. Nevertheless, in a 2014 conference paper Anna Kjellström noted the female characteristics of the skeleton. Her work was expanded in a group paper in 2017 headed by Charlotte Hedenstierna-Jonson. In this paper (Hedenstierna-Jonson *et al.* 2017: 3) it was stated that:

> [t]he greater sciatic notch of the hip bone was broad, and a wide preauricular sulcus was present ... [as well as] the lack of projection of the mental eminence on the mandible ... Additionally, the long bones are thin, slender and gracile which provide further indirect support for the assessment.

In order to test the DNA of the skeleton, samples were taken from the left canine and the left humerus and previously accepted procedures were followed. The results concluded that the skeleton of the Birka warrior in grave Bj.581 was, indeed, that of a female, establishing her as 'the first confirmed female high-ranking Viking warrior', and that she also has a genetic affinity to the population of what we can consider the Viking world (ibid., 5). An additional finding of this research showed her to be mobile, as the historical sources imply the elite Viking population to be. Moreover, she had not grown up in Birka but had come there (ibid., 6).

This 2017 paper created something of a firestorm in the community of people interested in fighting women, particularly Viking fighting women, and immediately produced headlines in multiple well-regarded newspapers and magazines worldwide, as well as journals and a number of blogs (e.g., *Daily Mail* 8/9/17; *Newsweek* 11/9/17; *National Geographic* 12/9/17 *New York Times* 14/9/17; *Washington Post* 14/9/17; *The Guardian* 15/9/17).

The authors of the paper were both lauded and criticised on a number of grounds including race, gender and whether there was an additional skeleton now lost. I will not repeat all the comments but give a review of the results of the 2017 paper and an even more current paper (Price *et al.* 2019) that addresses a number of critics.

Of the many comments and commentators on this female Viking warrior little was said about her lacking any evidence of war wounds, but in an article by Paula Cocozza on 12 September 2017 in *The Guardian*, Rebecca Gowland from Durham University pointed out that the 'burial is clearly of a high-status woman. The fact that she's buried with weapons indiciate [*sic*] this. It doesn't indicate that she's a warrior, but if we interpret [male graves] in that way, why not women as well?'

In 2019 a second paper, produced by the same team as the 2017 paper, noted that from the time of Stolpe's excavation, grave Bj.581 was considered extraordinary. Stolpe himself described it in his unpaginated report to the Royal Academy as:

> perhaps the most remarkable of all the graves in this field (1879, translated by N. Price). In an underground wooden chamber, a body had been interred, dressed in clothing with details evoking the fashions of the Eurasian Steppe; two horses, one of which was bridled for riding, had been arranged on a platform at the chamber's edge ... The deceased individual was surrounded by a large number of weapons; a bag of gaming pieces was placed in the person's lap and a gaming board was propped up beside them. The burial was located at the extreme perimeter of the grave-field, outside the hillfort's northern gate and adjacent to the road leading from the fortress into the town. Bj.581 is, in fact, the westernmost grave at Birka, situated high on the rocky promontory overlooking the lake and originally marked by a large boulder, which would have been visible from both the settlement and the water below. (N. Price *et al.* 2019: 184).

Again, this new paper caused a flurry of articles and caused even Jesch to moderate her views saying, 'Price's work more generally ... improves on the previous study with a better-reasoned argument and by toning down the original rather sensationalist claims' (historyextra.com 4 March 2019).

In other parts of Western Europe there have been a few female burials in which weapons have been found. DNA testing has been the major contributing factor in finding females in graves that earlier, because of the weapons they contained, were labelled as male. None, however, have caused the tumult of the Bj.581 burial. Perhaps the only other Viking burial to create such attention is the Oseberg ship burial, which contained two women but no actual weapons, although among the many objects found in the burial were two axes.

Since Price *et al.* (2019) was published, other publications have appeared, two of the more important, Jeresh (2021) and Gardeła (2021), have expanded

on the 2019 paper. What is quite evident is that, Bj.581 is clearly a woman – and just as clearly, an important leader.

The Steppe Evidence

Despite the latest Viking data, most of the evidence for women engaging in battle has come from the east, particularly the Eurasian Steppe. Burials of women equipped as warriors have been found from Ukraine eastward across the Steppe, as far as the Altai Mountains into central Siberia (Rolle 1989; Melyukova 1995; Davis-Kimball 1997; Berseneva 2008; 2012; Ražev and Šarapova 2014) as well as the Caucasus (Rice 1957: 48–49; Khudaverdyan *et al.* 2019). Within these female burials a wide range of weapons have been found including daggers, lances, spears and pebbles (possibly for slings), but the bow and arrow seems to have been the favourite weapon of women and bronze arrowheads seem to appear more often than iron. Sometimes the only remaining evidence of weapons in these graves is that of a quiver hook. The choice of the bow and arrow may have been to compensate for the lesser upper body strength of women, or because they could be used from horseback, or both.

The Steppe has also provided some very recent finds, some of which are both surprising and spectacular. Before presenting the newest finds, however, a review of earlier finds will show that the new material really follows and expands on what was known, or at least suspected, earlier.

The earliest report of these eastern female warrior graves comes from the nineteenth century when Count A.A. Bobrinskoi (1887–1901) excavated in the area of Smela in Ukraine and found several female graves that included weapons. Rolle (1989: 87) tells us that he was one of the first to use anthropological sexing of skeletons and his analysis caused him to conclude that these women were connected with the legendary Amazons.

A 1928 report from Zemo-Avchala, an area about 8 miles from Tbilisi, the capital of Georgia, tells of a female grave that was uncovered by farmers (Nikoradze 1928). She was buried in a crouched position with weapons near her. The date of the burial is third century BC, based on the artefacts that are more similar to Sarmatian than Scythian. She was undoubtedly identified as a Scythian due to the warrior woman connection between Scythians and Amazons. Rice, however, connected her with the Sarmatians (1957: 48–49) another Eastern Iranian speaking people related to the Scythians.

In 1970, the Polish-born archaeologist Tadeusz Sulimirski commented that there were a 'relatively large number of graves of armed women, especially in Sauromatian cemeteries' (Sulimirski 1970: 34). He further noted that many of these women were priestesses based on the portable altars found in their graves.

That women not only engaged in battle but were buried with their warrior equipment can be seen from burials of Scythian, Sauromatian, Sarmatian, Saka, Sargat[7] and other peoples across the Steppe.[8] These burials, mostly discovered since the 1950s, give us undisputed evidence of women buried as warriors and also give new meaning to the stories of Amazons told by Herodotus and others. The key has been the anthropological sexing of skeletons. With the use of DNA testing, more female warrior burials will undoubtedly be identified.

We are fortunate that in the past few decades a number of Russian and Ukrainian archaeologists have turned their interests to the social structure of steppe peoples, particularly in regard to the male/female division of labour. In 1983, A. Terenozhkin and V. Ilinskaya recognised ambiguity in Scythian burials, where armour and weapons were present in some female burials. By 1991, Elena Fialko had examined over 112 graves that contained females with weapons from the Ukrainian area of the steppe and forest-steppe between the Danube and the Don rivers. Of these graves, 70 per cent were of females between the ages of 16 and 30 according to anthropological examination, although one grave contained a girl as young as 7–10 years old – she had two spearheads and iron armour. In these graves Fialko found many arrowheads (mostly bronze), iron spear points, darts, the rare sword but never battle-axes. Swords are not frequent finds in women's graves and battle-axes not at all; defensive armour is also rarely found (Fialko 1991: 8–13 quoted in Guliaev 2003: 115). Excavating in the Trans-Ural area of Western Siberia in the early twenty-first century Russian archaeologists Dimitrij Ražev and Svetlana Šarapova (2014) report on the frequently found war equipment in female graves – arrowheads, daggers and parts of horse harnesses – but no heavy armaments. The percentage of females with weapons depends on the area, but Berseneva (2012: 56) finds that female burials with weapons 'constitute 10 to 25 per cent in the "kurgan" cultures of the Early Iron Age of Eurasia'.

One of the most interesting examples of a female warrior grave comes from Cholodny Yar in central Ukraine southeast of Kiev first mentioned by Sulimirski in 1970 (see Bobrinskoi 1887–1901). In the central burial of kurgan 20, which dates to the fourth century BC, under a timber ceiling lay two skeletons (both anthropologically sexed). Like the Viking grave at Gerdrup, the main skeleton was clearly a female – Rolle referred to her as 'the oldest known Amazon find' (Rolle 1989: 88). She wore large silver earrings, bronze arm rings and a necklace of beads made of bone and glass. Arranged around her were a bronze mirror, pottery, a clay spindle-whorl, two iron knives and food offerings. Near her head were what could most likely be weapons – two iron lance points (56cm and 48cm), a wooden quiver brightly painted with forty-seven bronze arrowheads, and five 'pebble' missiles near her skull. There is, of course, the possibility that these were used for a hunting purpose. The second skeleton, (probably) a male about 18 years old, lay at her feet and had only

'two small bronze bells, two ornamented pipes and an iron armring' (ibid.). He might well be thought of as another of her grave goods or perhaps a sacrifice. Unfortunately, unlike the Gerdrup burial, we do not have any DNA information that might enlighten us further and reveal as to whether or not there was any familial relationship between the two.

Although swords and armour are not commonly found in female graves, they do occasionally appear such as at Volnaya, Ukraine, in the northern part of kurgan 22, where a sword was found in a Scythian woman's grave (Melyukova 1995: 46). At Akkermen I, in kurgan 16, a female skeleton was found in a secondary grave not only with the usual female items, but also weaponry. She lay supine, wore bronze and silver arm rings, a pearl bracelet and a necklace of glass beads. She also had a bronze mirror, a decorated lead spindle-whorl, and food offerings in wooden vessels. Her weapons included a quiver containing twenty arrows, two lances lying near the skeleton, plus two additional lances plunged into the ground near the entrance of the grave. Additionally, she had armour that consisted of a heavy fighting belt covered in strips of iron. Most revealing, she had 'severe head injuries from blows and stabs, and a bent bronze arrowhead still embedded in the knee' that attest to her role in combat (Rolle 1989: 88–89). The fighting belt reminds us that it was the belt of the Amazon queen Hippolyte that was the ninth labour of Herakles. Fialko reported three additional battle belts in female graves, one in the surprising context of the 7–10-year-old girl mentioned above (Fialko 1991: 8–13 quoted in Guliaev 2003: 115).

In 2003 V.I. Guliaev gathered together a number of Russian and Ukrainian reports concerning graves of women buried in a warrior context. These reports confirm the existence of female fighters. At Ordzhonikidze, in kurgan 13, the remains of a woman with a bronze arrowhead embedded in her knee were found. Her weapons included an iron spearhead and seven bronze arrowheads. The grave also contained more 'feminine' items, including a bronze mirror, some ornaments and a bronze awl. The most surprising finds in the grave were two children, an infant, and a 7–10-year-old, said to be a boy[9] (Terenozhkin and Illynskaya 1983: 179 in Guliaev 2003: 115). A burial discovered in 1967 on the lower Don River of a woman approximately 40 years old was unearthed with 'an iron spearhead, an iron sword, bronze and iron arrowheads, two bronze bracelets, a necklace of glass and golden beads, a bronze mirror, a clay spindle-whorl, one Greek amphora, a hand-made bowl, and sacrificial food' (Brashinsky 1973: 60–61 quoted in Guliaev 2003: 116–17). These finds were not only rich, the weapons included a sword – as we have noted a rare item in a female grave. During the period 1993–2001, five rich and well-appointed graves of women with military equipment were found in the middle Don area, not far from the town of Voronezh in southeast Russia. All the women were between 20–30 years old and the tombs with the kurgans were large and elaborate. According to Guliaev (2003: 120), they were from the Scythian

elite and 'were, according to all indications, the true Amazons of the classical written tradition'.

Within the Scythian context, from the Danube to the Don, all of the known female warrior graves were in the primary central position of their respective kurgans and in some cases show signs of feasting including remains of sheep, cows and horses, which parallel male warriors' graves (Fialko 1991: 9 in Guliaev 2003: 115). This contrasts with other female Scythian graves and gives these female warriors a social status equal to male warriors (Illynskaya 1966: 169 in Guliaev 2003: 115).

In the past it was believed that Scythian female graves contained few weapons, contrasting with Sauromatian and Sarmatian female graves that were relatively rich in weapons.[10] Nevertheless, E.P. Bunyatyan (1981) calculated that during the fourth–third centuries BC, 27–29 per cent of female burials contained some sort of armament (in Melyukova 1995: 43). Smirnov (1982: 120-31) reported that among the Sauromatian female graves, 20 per cent contained weapons, mostly arrowheads, but also daggers and occasionally even swords and spearheads. Barbarunova (1995: 124) points out that included in the burial ritual, during the fourth century BC in the southern Urals, the Sauromatians placed cultic ritual vessels, such as small portable stone or clay altars, in some female graves. In the Early Sarmatian period (third–second centuries BC) these altars were replaced with stone or clay censers (ibid., figs. 10 and 11). These rituals also included the ancient one, in which arrowheads and occasionally swords were buried with females.

In the steppe zone of the Orenburg oblast in the southern Urals, south of the city of Orenburg near the village of Pokrovka, the American archaeologist Jeannine Davis-Kimball joined the Russian archaeologist Leonid Yablonsky. Together they excavated a number of cemeteries that date to the Sarmatian period. Among these graves was a young girl, 12–13 years old, who was found with 'a quiver with many bronze arrowheads and an iron dagger', as well as a leather bag on her chest that contained a bronze arrowhead (Davis-Kimball and Yablonsky 1995/96: 8). While some might place this girl in the category of warrior woman, Davis-Kimball (2001: 247) puts her in the category of 'warrior' based on the large number of bronze arrowheads and the iron dagger, but she also classified her as a 'priestess', based on a boar's tusk amulet, two oyster shells and a pink translucent stone. Nevertheless, Davis-Kimball (1997/1998: 8–9, 16) reported that at Pokrovka, 15 per cent (Davis-Kimball and Yablonsky 1995) of the female graves had weapons, and at another cemetery within the Orenburg oblast the rare sword and spear were found in female graves.

In 2004, Petrenko *et al.* reported on Scythian female graves with heavy weaponry. It should be noted that the prevailing view of Russian scholars who specialise in the Iron Age of the steppe and forest-steppe areas that arrowheads are considered weapons of war rather than for hunting due to their construction.

Prior to the third century BC, 'Sargat burials contained small bronze arrowheads for bows of the Scythian type and bone armor' (Berseneva 2008: 139). It was the large (about 1.5m) composite bow which appeared in the third century that used long arrowheads made of bone and iron, making for a much more powerful weapon. The composite bow was strengthened with bone plaques that, unlike the wood of the bow (and to the advantage of the archaeologists), did not decompose in the grave (ibid., 139–40). These parts of the bow are fairly frequent finds in the grave.

Hanks (2008: 19) writes about 'direct' and 'indirect' evidence for women who lived on the Steppe engaging in battle. For direct evidence he turns to biological indicators such as 'asymmetry in muscle development and attachment and the osteoarthritis and other pathologies that may be induced by particular repetitive physical activities connected with martial activities ... [including] archery, sword fighting, and intensive horseback riding from a young age'. However, only sword fighting (and perhaps archery) can be directly connected to warfare. Moreover, horseback riding is a skill that both boys and girls of the Steppe (and undoubtedly other areas) would have learned at a young age. Although we think of women as riding side-saddle (and there is abundant evidence for this), we also know they rode astride, as seen on numerous depictions of Amazons and discussed in Chapter 3.[11] In addition to riding astride, which is a more warrior-like position, we have depictions of women holding lances and shields. Proficiency with bow and arrow also appears to be shared by both sexes. Because the bow and arrow can just as easily be used for hunting as in battle, it is difficult to determine their specific use.

The Physical Evidence

The best evidence for women engaging in battle comes from the skeletons themselves, such as the wounds of the head and limbs as those reported by Murphy and Davis-Kimbal [sic] (2001). Determining if a woman was involved in battle requires a careful look at the skeletal remains, though this must be done with a cautious eye because a skeleton can show signs of trauma but simply be a victim (or possibly a sacrifice) and not a fighter. Wounds, particularly on the arms and skull, are the most revealing and most frequently considered battle wounds, but here again wounds alone can be interpreted more than one way. Murphy and Davis-Kimbal [sic] (ibid.) examined photographs of four skulls from the Chowhougou cemetery complex in Western China that showed evidence of trauma. Up to about 300 BC, Caucasoids, who are thought to have arrived during the Bronze Age, inhabited this area. The inhabitants of the Chowhougou cemetery do

not show characteristics of Han Chinese, but resemble the more Caucasoid mummies found in the Ürümchi and Korla Museums in Xinjiang, China. These mummies are frequently associated with Indo-European speaking people (Barber 1999; Mallory and Mair 2000) and therefore may have been part of the 'Scythian World'.[12] Of the four skulls, examined by Murphy and Davis-Kimbal [*sic*] (ibid., 31) there were three adults and one subadult. One adult (Individual 3) is most likely a female and showed injuries that were probably inflicted by a large 'axe or mace-like implement'. Another injury resulted from '[a] pointed battle axe ... on the left parietal, adjacent to the midpoint area of the sagittal suture'. A third perforation is 'present on the margin between the temporal and parietal' area and 'was probably caused by an arrowhead' (ibid.). Although there has been speculation that the wounds from these four skulls may have resulted from trepanation, Murphy and Davis-Kimball believe they were trauma induced.

In a separate study, Murphy examined the cemetery complex of Aymyrlyg in south Siberia. The majority of these burials are considered Scythian, dating to the late period during the third–second century BC (Murphy 2003: 26).[13]

In her general comments Murphy states that the presence of 'female warriors in the steppes during the Iron Age is heavily supported by evidence from the archaeological record', that 'a significant number of burials of definite female warriors have now been identified in the funerary record', and '[t]he majority of burials of armed females have been recovered among those of the ordinary classes of the population, rather than in tombs of the upper strata of society'. She also states that in some cemeteries, 'as much as 37 per cent of the burials' are female (ibid., 11). Within her study she found fractures of long bones, clavicles, metacarpals and crania that indicate interpersonal violence (ibid., 65–66). Of the fractures of the cranial vault during the Scythian period, 38 per cent were male, 24 per cent female and 38 per cent subadults. The majority of these injuries occurred on the left side of the crania indicating a blow by a right-handed person. Examination of cranial trauma showed that the majority of these injuries were inflicted with a pointed axe and that 75 per cent of these victims were male, 17 per cent subadults and 8 per cent were female. Trauma inflicted by swords during the Hunno-Sarmatian period showed a slightly different frequency: 75 per cent male, 17 per cent female and 8 per cent subadults (ibid., 94–95). Although it is clear that males were the primary victims of these injuries and therefore most likely the main participants, women (as well as subadults) were involved in the battles that produced these injuries.

An even more recent case – and a clear example of battle trauma on a female – comes from a Pazyryk[14] kurgan in the Mongolian Altai. Here a group of fourteen traumatic injuries on seven individuals were carefully studied by an international team (Jordana *et al.* 2009). The individuals under study included

five males, a female and a child. The female (Skeleton BTG-VI/T10B) is described as:

> between 25 and 30 years old, exhibited two V-shaped cut marks at the angle of two contiguous right ribs, involving the inferior aspect of the eighth and the superior aspect of the ninth rib, just below it ... This injury is indicative of the action of a sharp double-edged weapon that could be compatible with the Scythian dagger ... The analysis of the compressed area of the edges of both V-shaped cuts allows us to suggest that the sharp force penetrated the thorax in an ascending dorsoventral direction from left to right. We suggest that the clinical consequence of this injury would be related with fatal lung compromise, caused by hemopneumothorax (ibid., 1324).

The authors conclude that these injuries, due to their location and distribution, appear to have come from a number of directions indicating that they were sustained during a violent altercation indicative of battle and not by ritual or sacrifice (ibid., 1325).

In a study carried out by Ražev and Šarapova of Sargat graves, weapons were found in both male and female biologically sexed graves, with arrowheads and sections of composite bows being the most frequently found. Approximately 25 per cent of the female graves contained these items, and all graves, male and female, contained handmade ceramics indicative of the Sargat culture. While female graves also had weapons, such as daggers, arrowheads and parts of horse harnesses, they lacked swords and protective armour (Ražev and Šarapova 2014: 161).

Ražev and Šarapova have conducted some revealing research concerning violence, warfare and gender among the Iron Age Sargat culture located in the forest-steppe area in the Trans-Ural region of Western Siberia. Out of forty-three burials, nineteen were in sufficiently good preservation to examine. They point out that evidence of trauma on male skeletons has usually been thought of as resulting from combat and that wounds on female skeletons have been put down to the women being victims of violence either domestic or as a result of raiders. Nevertheless, some research has pointed to these female wounds being a result of combat. Although Ražev and Šarapova were handicapped by not having some information, they concentrated on cranial traumas among the aristocracy of these Sargat people. These subjects were chosen because of their placement in central position in kurgans (ibid.). The majority of centrally placed burials were male (males are three times more likely to be in central position than females),[15] while most female graves were on the periphery; it was only the exceptional female that was found in the central, high status,

1. Akkadian cylinder seal impression of the goddess Ishtar in her warrior aspect with her lion. (Photo Number 064706) (Courtesy of the Oriental Institute of the University of Chicago)

Left: 2. Death of Penthesilea at the hands of Achilles. Black-figure amphora signed by Exekias with names included. (Museum number 1836,0224.127) (Courtesy of the British Museum)

Below: 3. Sketch of archaeological grave found and labelled 'Bj.581' by Hjalmar Stolpe. Birka, Sweden. Drawn by Evald Hansen, 1889.

4. Marble Relief of Two Female Gladiators from Halicarnassus. (Museum number 1847,0424.19) (Courtesy of the British Museum)

5. The Wedding Feast of the Empress Matilda and Henry V. (Courtesy of The Parker Library, Corpus Christi College Cambridge, MS 373, fo. 95b: by courtesy of the Master and Fellows of Corpus Christi College Cambridge)

6. Queen Isabella I of Spain, Queen of Castille (1451–1504) ca. 1470–1520. (RCIN 403445) (Courtesy of the Royal Collection Trust)

Map 1. The Ancient Near East: Generalised Areas, Various Time Periods. (Bley Geographics)

Map 2. Early Distribution of Major Indo-European Language Groups. (Bley Geographics)

Map 3. Britain: Circa AD 900 to 918. (Bley Geographics)

Map 4. Iberia Generalised Regions: Circa AD 1150 to 1492. (Bley Geographics)

position of the kurgan. All types of artefacts were found in male graves, with 60 per cent of these graves containing various types of weapons. The wealthiest graves contained armour and were also interpreted as male. Among the adults, 24.9 per cent were under the age of 20. Mortality among the males was highest between 35–39 years old, and among the females 20–29 years old. The central graves are also larger and more architecturally elaborate. It needs to be said that these 'aristocrats' had been selected from the general Sargat population by an unknown process, as the kurgan population was too small to be representative of the overall Sargat population. From thirty-three Sargat cemeteries from various chronological periods and geographical areas, 173 adult crania (109 males and 64 females) were examined. Of these, eleven crania from ten cemeteries exhibited trauma (seven males and four females).

> In ten cases fractures were found on the cranial vault, while there is one case with a fracture of the lower jaw. All studied traumas were identified as deliberate and were inflicted during violent conflicts ... Thus, of eleven injured Sargat crania, six were injured in violent conflicts – only 3 per cent of the total (Ražev and Šarapova 2012: 151–52).
>
> The wealthiest tombs with a full set of weaponry, including a complete set of defensive and offensive weapons, have been anthropologically and archeologically identified as male. A minimum of 60 per cent of Sargat male burials were found with some kind of armour, and 20 per cent of the women were accompanied by weapons. The archaeological context – chiefly the grave goods in Sargat burials (both male and female) – indicated the social status of a mounted warrior: iron swords and daggers, horse harnesses, iron and bone arrowheads, bone shoulder plates, and pottery were present in various combinations.
>
> On the basis of this general mortuary context and in analogy with other Eurasian Iron Age societies, it was suggested that the life of the Sargat population was militarised to a significant degree. However, 30 per cent of male graves and more than half of the female ones do not contain any weapons or elaborate jewellery at all; their grave goods can be described as gender-neutral and include pottery, animal bones, iron knives, and individual beads or ornaments. It was also suggested that weaponry in burials is the main gender marker. In this context, it seems interesting to analyse the character of known injuries (Ražev and Šarapova 2012: 150–51).

Ražev and Šarapova hypothesised, based on the Sargat sample of crania trauma (5 of 109 males and 2 of 64 females), that 31 per cent of the females could

have been injured on the battlefield (ibid., 153). An additional finding in their analysis was that a number of the individuals with cranial wounds who also had deformed skulls that the researchers determined were an indication that these were high status individuals. In addition to the deformed skulls these individuals[16] were provided with defensive and offensive weapons and their graves contain a substantial amount of meat (ibid.).

Recent Finds

Although archaeology is the study of the past, it is not static and new finds continue to be made. The past few years have presented a number of new finds both through very recent excavations and a review of previous excavations much as we saw in the Viking area. While the excavations have been carried out by well-thought-of scholars, all of their results have not, as of this writing, been published in peer-reviewed journals. Some partial reports have, however, found their way into the popular press. I have selected three of these new discoveries to illustrate some of the more notable finds and to point out how new methods, particularly DNA analysis, are changing the study of women in warfare in the ancient world.

Writing in the mid-fifth century BC, Herodotus identified the Amazons of Greek legend with the Scythian and Sarmatian cultures north of the Black Sea. Although we have seen a number of female graves from this area with weapons, they date to the later Sargat period. This fact suggests that if Herodotus learned of women warriors from this region in the fifth century BC, the tradition of women fighting, or at the very least putting weapons in female graves, continued long after the lifetimes of those women referred to as Amazons by Herodotus. These Sargat graves should be classed as female warrior graves, but not what might be called the 'classic' Amazons.

Strabo (ca. 64 BC – ca. AD 24), the Greek geographer and historian who wrote much later than Herodotus, comments that the Amazons lived not only in Albania (located in the Caucasus), but also in the foothills north of the Caucasus. Recently a new excavation has come to light from this region, but not from Strabo's era. In 2017 a team of Armenian archaeologists, excavating in the north of Armenia in the Lori Province that borders Georgia near the village of Shnogh at the necropolis of Bover I, uncovered a female labelled a warrior. The grave in question dates to the time of the Urartu (Bianili) Kingdom during the ninth century BC to 585 BC, a time period that more or less corresponds with the Amazons. With the collapse of the kingdom, the area suffered intrusions from the northern steppe tribes such as the Cimmerians and Scythians. (See Herodotus Book 4 and Diodorus Siculus Book 2).

Artefacts in the grave included bracelets and ceramic vessels that allowed the excavators to date the grave to the Early Armenian Period (eighth–sixth century BC) (Khudaverdyan *et al.* 2019) and to label the woman as high status. Unlike the other female warrior graves we have examined, however, the only weapon mentioned in the grave is the iron arrowhead embedded in the femur of the skeleton of the grave's occupant. The details of the wounds inflicted on the woman, however, are given in detail and showed that she had, over time, suffered multiple wounds including sword and hatchet blows, as well as projectile trauma from arrows.

The skeletal remains in the grave in question, Burial N 17, was, like most skeletons in this area, badly preserved, but some analysis was possible and carried out on the remains that were available; the analysis was carried out by the standard modern methods (see Khudaverdyan *et al.* 2019: 122). Sex and age were based on the morphological characteristics of the skull, teeth and pelvis, showing the skeleton to be a 20–29-year-old female. The limb bones were long and narrow with narrow epiphyses, and her height was of 163.32 ± 3.36 cm calculated by long bone length' but with strong muscular attachments. 'Both upper limbs were mechanically loaded. …The pectoralis major and deltoid muscles…had been used in flexing and adducting the hand (at the shoulder) and drawing the bow via the chest (medial rotation; Lieverse, Bazaliiskii, Goriiunova, & Weber, 2009: 468)' (Khudaverdyan *et al.* 2019: 122). Perimortem trauma was evidenced 'mainly on pelvis, femur, and tibia bones most often were comminuted bones resulting from cut/stab fractures' (ibid.). There was also indication of an active inflammation on the left proximal tibia and right femur, suggesting that the individual was in poor health at the time of her death. 'The number of skeletal fractures (one antemortem and three perimortem) emphasises the fact that for this early Armenian female from Bover I, interpersonal violence was an ever-present aspect of life' (ibid., 124). Analysis of the wounds showed that different weapons had inflicted them.

Despite the lack of weapons in her grave, but taking into account the build of this woman and the injuries she had suffered, there seems little doubt that she was a fighter and not a victim.

Even more recently a new excavation has come to light from the area north of the Black Sea near the Middle Don River in the Voronezh Oblast in southwest Russia. At a press conference on 6 December 2019, Valerii Guliaev of the Russian Academy of Sciences Institute of Archaeology announced that in the last decade his expedition group had recovered about eleven armed women – but that a unique find had come to light during their 2019 season. In Kurgan 9 from the Devitsa V cemetery, four female graves were found under a kurgan measuring 1.1m high and 40m in diameter. The graves were identified as Scythian, but unfortunately, two of the graves (a 12–13-year-old girl and a woman in her mid-twenties) had been robbed in antiquity, but the remaining two

graves that were under the same mound were intact and in very good condition. These two women had been laid on wooden pallets that had been covered with grass. The younger of the women, 20–25 years old, had two spears next to her, a glass bead bracelet, and a bronze mirror under her shoulder as well as thirty iron arrowheads, knives, pieces of horse harnesses and bridle hooks – items usually considered belonging to men. In addition to the weapons, animal bones – probably horse and the bones of a 6–8-month-old lamb – that were green, indicating they had been in a bronze pot that had been robbed. There were also ceramic vessels that date to the second half of the fourth century BC. The oldest women (40–50 years old) wore a well-preserved beautifully engraved gold headdress called a *calathos*. The gold (approximately 65 per cent) was alloyed with copper, silver and a small amount of iron. Although this type of headdress is known, they have usually been found accidentally by a non-archaeologist and are not in the excellent condition of this one. Next to this woman was an iron knife wrapped in cloth and an unusual tanged iron arrowhead.

The younger woman was in a 'position of a horseman'. It had been determined that the tendons of her legs had been cut in order for the legs to fall in this position.

The burial was determined to have occurred during the late autumn due to the age of the lamb, which would likely have been born in March-April.[17]

This is an intriguing set of burials and like the Birka burial has created much attention, resulting in articles that have appeared in *The Washington Post* (Derek Hawkins December 31, 2019), and *Archaeology* (Eric A. Powell May/June 2020). Due to the ages of these women, they have been interpreted as four generations, but further analysis will be necessary to confirm this. Because of the recentness of this find, a great deal of work is needed to unveil the many components of this discovery.

A third burial of interest was excavated in 1988 by M.E. Kilunovskaya and V.A. Semenov of the Tuvan Archaeological Expedition, located at Saryg-Bulun in the Tuva republic in south central Siberia, just north of Mongolia. They then announced the discovery of two kurgans containing seven burials belonging to the Aldy-Bel culture dating to the seventh–sixth century BC (Early Scythian). Burial 5 was the standout of the graves. The burial was in a larch coffin about a half-metre deep with a 'tightly closed lid'. Larch is noted for its preservation qualities and the coffin contained the extremely well-preserved mummy of a child, which still retained some facial skin, including a wart. A cut in the abdomen appeared to be an attempt at artificial mummification.

The occupant of the grave was clearly a warrior as the coffin also contained a battle pick and a birch bow one-metre in length, a quiver made of leather and horse hair attached to the belt and ten 70cm arrows. The shafts of the arrows had painted decoration. Two arrows were made of wood, one with a bone tip, and the remaining arrowheads were bronze.

The clothing included a leather cap covered with red spiral decoration and a double-breasted fur coat made of jerboa that fell below the knees. The coat with long straight sleeves was closed by a leather belt that had bronze ornaments and a buckle. A shirt that did not survive was under the coat and there were also possibly trousers. Because there were no items that suggested a female, the burial was classified as male.

Over thirty years later genetic testing was carried out at the Moscow Institute of Physics and Technology at the Laboratory of Historical Genetics, Radiocarbon Analysis, and Applied Physics by Dr Kharis Mustafin, Dr Irina Alborova and postgraduate Alina Matsvai. The results were surprising. The skeleton that had always been assumed was a male, tested genetically to be a female. Moreover, while it was clear the warrior was young, it was unexpected to find she was not yet 13. (M.E. Kilunovskaya, V.A. Semenov, et al. 2020.)

Wheeled Vehicles

The wheeled vehicle is an important piece of equipment that is commonly considered a weapon of war, but here again there can be confusion, so a brief discussion is useful before we turn to women and vehicles. The literature is replete with references to chariots in general and war chariots specifically. We are told that at the Battle of Kadesh fought between the Egyptians and Hittites in 1274 BC, 5,000 chariots were involved; Caesar talks of war chariots that engaged in 'hit and run' attacks during the mid-first century BC (*The Gallic War*), and *The Táin* refers to many chariots that were used both as transport and as battle equipment. Most of these references to war chariots, however, involve only men. In Chapter 2 we learned of references to war chariots in the *Rigveda* and the *Avesta*. But with Vedic evidence one needs to be cautious, as the Vedas are not always what they seem (the reader will remember Viśpalā in Chapter 3). In *RV* 10.102, Mudgalānī is said to be her husband's charioteer during a race. This would seem to allow us to have a female charioteer in a sacred text. However, analysis of this opaque hymn by two excellent Vedic scholars concludes that the hymn is a description of a ritual in which an impotent husband is replaced in order that he can have sons (Jamison 1996: 99–110; Brereton 2002). In other words, here we are dealing with sex and fertility.

Nevertheless, in the category of general knowledge of women in warfare, Herodotus (4.193) tells us that the women of the Zauekes (in modern day Libya) participated by driving their husbands' chariots. Furthermore, we have literary examples of women being charioteers, which would place them in the category of warrior women. In the tale of Cú Chulainn's birth we are told that, Deichtine, Conchobar's daughter, is also his charioteer (Gantz 1981: 131), and

the reader will recall from Chapter 3 that Juturna disguises herself as Turnus' charioteer. Thus, we can see that at least in literary texts, and possibly in history, women have taken the military role of charioteer.

Wagons are almost universally described as having four wheels (Jones-Bley 2000; 2006a)[18] and two-wheeled vehicles are frequently described as chariots, although carts also have only two wheels. These terms, cart and chariot, are often used loosely and sometimes interchangeably. Technically the axle of the chariot is placed at the back of the platform, while the axle of the cart is placed medially. The rear placement of the axle allows for ease of entering and exiting the vehicle. Nevertheless, although the medial placement of the axle is less efficient as a war vehicle, it can still be used for military purposes. Although chariots are most regularly thought of as war related, they can also serve as parade vehicles and as transport to the Otherworld (Gening 1979; Jones-Bley 2006b).[19] Although the *Oxford English Dictionary* defines a chariot as a conveyance of goods and persons and as a vehicle used in ancient warfare, it neither designates the number of wheels nor the placement of the axle. Littaurer and Crouwel (1979: 4-5) take the definition further and give it some specificity: 'A light, fast, two-wheeled, usually horse-drawn, vehicle with spoked wheels; used for warfare, hunting, racing and ceremonial purposes. Its crew usually stood.' Examples from the Near East can easily be seen in Littaurer and Crouwel (1979). Carts usually have heavier frames, a medially placed axle, solid or spoked wheels and is suitable for a seated occupant.

Once a two-wheeled vehicle is recognised as a chariot its function needs to be established, and here lies another problem. Chariots are most frequently thought of as war vehicles,[20] but can this be justified when there is no other weapon or indication of warfare? When found in a grave this designation should perhaps be reserved for those instances when weapons are included in the burial – an occurrence that is fairly rare.

Although we think of war chariots being used as platforms for spear throwing and archers, there is another war use for chariots as set out by Caesar in the mid-first century:

> First of all they drive in all directions and hurl missiles, and so by the mere terror that the teams inspire and by the noise of the wheels they generally throw ranks into confusion. When they have worked their way in between the troops of cavalry, they leap down from the chariots and fight on foot. Meanwhile the charioteers retire gradually from the combat, and dispose the chariots in such fashion that, if the warriors are hard pressed by the host of the enemy, they may have a ready means of retirement to their own side. (Caesar, *The Gallic War* 4:33).

Although men are usually associated with chariots, we have a number of burials with women buried with vehicles dating to the Early Iron Age, Hallstatt period, and there are also a few two-wheeled vehicles from the Late Iron Age La Tène period. While we think of chariots as war vehicles, and they are often referred to as such, there are other cultural uses aside from war, such as funerary vehicles. This suggestion is based on the two-wheeled vehicles found in women's graves such as two at Wetwang, one at Besseringen (Megaw 1989: 90) and the one at Bad Dürkheim (Megaw 1989: 70, 73).

The two chariot burials from Wetwang in northeast England held the remains of females, and although nearby there were male chariot burials that contained swords, the female burials did not (Dent 1985). Both of the female graves contained mirrors and the remains of the chariots; additionally, pig bones were found in one grave. Did these women go into battle? It seems unlikely because they did not have weapons, but then there may have been some cultural reason for them not to have weapons. Weapons, swords in particular, were expensive to produce and were often passed down to heirs, but obviously this was not the case for the swords in the male graves. If these women were not warriors, why were they buried in such close proximity to what may be male warrior burials with war chariots? Were they leaders or supporters of the warriors?[21] Again why did they not have weapons? Thus far we are unable to answer these questions. One factor is clear. Because of the rarity of chariots, these women were of very high status. Because of the obvious status of these graves, we might think of them in the same terms as the Viking burial, Bj.581, at Birka discussed earlier – that is some kind of leader.

The area of North Yorkshire in northeast England has large cemeteries that have produced hundreds of Iron Age graves dating from about 400 to 100 BC. Of the over 700 burials known, only about 21 have held two-wheeled vehicles (frequently referred to as cart burials) and of these 21, 3 of the burials are known to be of females. The first of these was found in 1877; a second in 1984 at the cemetery of Wetwang Slack (Dent 1985), and a third was excavated in 2001 at Wetwang Village (Hill 2002). This latter burial has produced dates of 210–195 and 215–180 cal BC (Jay *et al.* 2012: Table 2). The grave goods in all the cart burials were considered gender specific, with weapons in the male graves and articles such as mirrors and spindle-whorls in the female graves. All of the female graves contained iron horse trappings, the remains of a pig and other high-status items, but nothing that suggests a weapon. Sex appears to have been determined by grave goods.

The Wetwang Slack cart burial is of particular interest. Here, three cart burials were found in a row and shared a number of features.[22] Two burials contained swords and one, without a sword, contained a mirror. This latter is said to be a female (Dent 1985) and was without doubt the wealthiest of the three. The actual method of determining sex is not clear. About fifteen mirrors have been found in England associated with burials, both cremations and inhumations, and when sex

could be determined, all were females (Megaw 1989: 210). With people other than Celts, however, the mirror is far less a sexual determinate; mirrors have been found in burials said to be male in Egypt, Crete, Mycenae, in Tarquina (de Grummond 1982: 166), and as we have seen in some Scythian burials. The purpose of the mirror is unclear, but it is clearly a luxury good; they could have been used for magic, ritual, religion or simply a display of wealth.

The carts alone speak to prestige, but there were neither weapons nor any other indication that they were used as war vehicles found in the female cart burials. We, therefore, cannot suggest that these women buried with carts were combatants. Nevertheless, we should not underestimate the status these women would have had, as evidenced by their being buried with a cart. It does not seem an exaggeration to suggest that if they were not combatants, and I see no evidence to suggest they were, they may well have been commanders or leaders. It is, of course, also possible that the three women, or at least the Wetwang Slack woman, held a position of leadership, given the latter's proximity to the other two vehicles that might be labelled war vehicles due to the inclusion of swords and other weapons. It is also possible that these women were some sort of nobility either secular, religious or both.

Unlike the burial of the woman at Wetwang Slack (burial 2), burials 1 and 3 were both designated as male graves and contained (aside from the swords) scabbards, spearheads and shield fittings (Dent 1985). Lacking weapons, it seems much more likely that the cart in a grave represents either a display of wealth, indicating status, or a mode of transport to the Otherworld – but again exhibiting wealth and status. It should, however, be remembered that the sex of these burials was determined by grave goods as DNA analysis was not yet available.

The third female cart grave was found in a nearby area of Wetwang in 2001 and can be dated to about 300 BC. However, unlike the earlier finds that have been associated with the Arras culture, the later find is associated with the Parisi tribe. The woman, 25–35 years old, was in a crouched position[23] and her torso covered with pig bones – a feature known from this type of burial in the area and could indicate a sacrifice, or food for the afterlife. Her vehicle was dismantled and the platform covered her. The horses were not in the grave and although the wood had long since rotted, the remains of the harness and beautifully made metal fittings survived. The bits contained glass or enamel and the other fittings had inlays of what may be coral – a very rare item. Like the woman in Wetwang Slack, this woman had a mirror, made of iron, which lay over her ankles. The mirror may have had a tassel from which hung over a hundred tiny blue beads as well as metal and possibly coral beads. A low mound covered the grave and a square ditch surrounded it.

The reconstruction of the Wetwang vehicles puts the axle medially, but the decoration puts them beyond what one thinks of as an ordinary cart. These vehicles can be contrasted to the earlier two-wheeled 'chariots' from

the Sintashta graves found just east of the Urals in Siberia dating to a much earlier time ca. 2100–1800 BC. In the Sintashta graves the vehicles were placed whole into the graves, giving us a better idea of what they actually looked like, as opposed to the Wetwang vehicles which were dismantled. The Sintashta vehicles had near medial-placed axles (Gening *et al.* 1992, figs. 80, 108), but none of the Sintashta vehicle burials are suggested to have contained women.

On the Continent a number of females were buried with wheeled vehicles. During the Hallstatt period these vehicles were four-wheeled, but in the later La Tène period two-wheeled. Nevertheless, none of these have confirmed weapons except perhaps at Stuttgart-Bad Cannstatt (Kimmig 1988). Here, a female burial with three spearheads was found.[24] This is a rare, if not unique, example of a burial containing weapons that is attributed to a female in this area. We have seen that contemporary women on the Steppe not only engaged in battle (again, how sex was determined is unclear) but were also buried with their warrior equipment. We do know, however, due to the time of the excavations, DNA analysis was not an option.

Nevertheless, the literary support is compelling. Plutarch (*Gaius Marius* 11.2–5) tells us that in 104 BC, the claim of 300,000-armed fighting troops from the Teutones and Cimbri tribes came to the attention of the Romans. With them were said to be hordes of women and children searching for land. But the most warlike of these tribes were the 30,000 Ambrones (*Gaius Marius* 19.2). Plutarch (ibid., 19.7) reports that once the battle began:

> the women met them, swords and axes in their hands, and with hideous shrieks of rage tried to drive back fugitives and pursuers alike, the fugitives as traitors, and the pursuers as foes; they mixed themselves up with combatants, with bare hands tore away the shields of the Romans or grasped their swords, and endured wounds and mutilations, their fierce spirits unvanquished to the end.

Despite the writings of classical authors and the mythological evidence, the fact remains we have little archaeological evidence of women combat warriors in Western Europe. Where are the graves of these women? Did they die and remain on the battlefield, maintaining their anonymity? Perhaps because they were part of a battle there were no individual graves.

In the western area of Europe, however, it is in the Viking period that we begin to uncover some evidence for women on the battlefield, but there is nothing as substantial as that found in the Steppe area. Nevertheless, with more open minds in regard to what constitutes items in female graves and the advancement in DNA techniques, it seems inevitable that additional graves of women who went into battle will be found. The most recent finds in the Steppe area speaks to this inevitability.

Chapter 5

Historical Women Through the Roman Period

We now turn to historical women and see how they fit into the scenario of Women and Warfare in the Ancient World. Again, we need to return to our definitions of our three types of women: virgins, viragos and amazons. Although this chapter and the next in general follow each other chronologically, the subject matter is intermingled and examples from both chapters will be used where necessary.

In the Introduction and Chapter 1 we saw that in some societies, virginity could have meaning other than never having engaged in sexual intercourse; it can mean never having given birth, one who has youth, beauty and potential for fertility, or it can be used merely as something of an honorific title, as in the case of Elizabeth I. In this and the next chapter we will see that virginity, particularly in its most narrow anatomical sense, does not play much, if any, role in the lives of these historical women, but sex itself may have taken over this role. We will see in Chapter 6 that in at least two cases, Æthelflæd of Mercia and Matilda of Tuscany, sex may have just faded from their lives. While this did not turn them into virgins, sex seems to have been eliminated as an important factor in their lives. In this chapter we will see that some women have used sex to pursue their ends, perhaps most famously Cleopatra VII. Thus, we might alter the term 'virgin' (in the anatomical sense) by turning it on its head to incorporate both sex as used as a tool and fertility, which was of great importance to most women, particularly noble women, as a means of maintaining power. Women were frequently used as pawns to forge alliances for their families, but later being the mother of the heir, particularly the male heir, secured a woman's position of power.

The role of virago, however, was a prerequisite for all the women we will meet in this chapter and the next. These historic viragos were not shy at taking on leadership, be it as a planner or even on to the battlefield. Furthermore, the comparison of these leaders to Amazons becomes a cliché. In the cases that can be documented, female leaders, like the Amazons to whom they were compared, showed themselves to be the peers of men and displayed the same traits seen in male leaders: bravery, intelligence, ruthlessness and, on more than one occasion, cruelty that rivalled that of any man.

In the previous chapters, we saw that the women (or female figures) who were involved in military matters did so often, not just as actual combatants but also as advisors or mentors. Having said this, there were still women who took up the sword and engaged in actual combat. These chapters in which we are dealing with real women precludes, however, some of the earlier options, such as shape changing, given to the mythical or legendary females. Still, like the goddesses and legendary figures, the involvement of these real women is more in strategy than in the tactical implementation of war. This point, however, touches on a subject that could use more clarity.

We will encounter women who we are told take to the battlefield, but in many instances, these acts should not be taken too literally. In this, I follow the lead of McLaughlin who points out that many of these women might better be called 'generals' rather than actual 'warriors', but the same might be said for many male war leaders of this and other periods (McLaughlin 1990: 196). There are also women who, while they engaged in the planning stages of battles, never went near the battlefield. These strategicians might well be excluded from both warrior and general categories, but placed in a category of their own. Nevertheless, these planners played an important role and often provided the leadership that caused the military action to happen. On those terms they were not physical warriors, but they did engage in an essential military activity. Such was the case of Catherine of Aragon in 1513 who, while acting as Governor of the Realm and Captain-General of the Forces for Henry VIII (who was engaged fighting the French), gathered an army in order to put down a Scottish uprising headed by James IV at Flodden in Northumberland. Thomas Howard, Earl of Surrey, led the English troops, but it was Catherine's victory as Henry had appointed her to act in his stead (Scarisbrick 1997: 37). The difference between female and male generals and commanders would probably have been that men who had engaged in actual battle before they reached a position of leadership; this was less likely with female commanders. In ancient times, it was important for a leader or king to be on the battlefield, even in the front lines, and thus we do hear of female leaders who donned hauberks causing the reader to envision them on the battlefield. While we will see this is sometimes true, for example Illyria's Cynane and Mercia's Æthelflæd, we will also see that it is not always true, or is suspect at best. At times this need for the leader on the battlefield resulted in the death of the leader, as in the well-known cases of King Harold at the Battle of Hastings in 1066, and Richard III at the Battle of Bosworth Field in 1485. In both of these instances, the death of the leader changed the course of history. We should not imagine that female commanders were any less involved in the battles over which they presided than their male counterparts, but they may have been less likely to be in the thick of a battle.

As one might expect, the names of historic women occupied in warfare belonged, for the most part, to queens – or at least women from the nobility. A few women from the ancient period who were involved in war are celebrated for their military activities, but as Fraser correctly points out, the same names appear repeatedly (Fraser 1988: 10). These names begin with Semiramis of Babylonia but include Queen Septima Zenobia of Palmyra, Boudica of the Iceni tribe in Britain, and the Empress Matilda of England, all of whom are distinguished in this regard as are their stories.

Women from the earliest historic period often fall into a semi-legendary category, but as we move further along in time, the legendary accounts dwindle in size and completeness, slipping further and further away as factual details become more abundant. Nevertheless, legend often creeps into the most documented lives – much as it does into family histories – leaving the difficulty of disentangling fact from fiction.

It really is not until more recent times, that is, the period that abuts the time of this work, that we know extensive details of the lives of the women in this chapter and the next. Elizabeth I of England is perhaps the first queen about whom we know a great deal, and even here many of the details are still controversial. The farther back in time we go, the sketchier the details become and legend inextricably melds with reality.

Most queens achieved their high royal status by marriage or by what Fraser refers to as the 'Appendage Syndrome' (see Introduction). Even the few women who were queens in their own right by legitimate inheritance – most prominently Elizabeth I – often reminded their people of their male connection. Elizabeth frequently reminded her people and councillors that her father was the 'Great Henry', and although she was queen, she referred to herself as a 'prince' – by which she was referring to herself as an independent ruler, but the 'maleness' of the word undoubtedly did not escape her.[1]

'Manliness' in a queen was, indeed, looked upon with favour and was explicitly encouraged by the abbot Bernard of Clairvaux, who wrote to Queen Melisende of Jerusalem after her husband's death that 'although [you are] a woman, you must act as a man by doing everything you have to do "in a spirit prudent and strong." You must arrange all things prudently and discreetly so that all may judge you from your actions to be a king rather than a queen' (Huneycutt 1998: 199). During the struggle between Stephen and the Empress Matilda, both Matilda the Empress and Stephen's wife Queen Matilda, were referred to in 'manly' terms such as the queen being a woman with 'a man's resolution', and having 'the valour of a man' (*Gesta Stephani* §§61, 63). As one might expect, the Empress does not fair well in the *Gesta*, but Chibnall (1993: 194) quotes Ralph of Diss,[2] who said the empress had 'masculine courage in a female body'. Not only were the images of Egypt's Queen Hatshepsut that of a man,[3] but inscriptions referring to her used the

masculine pronoun. In some instances, terms used for ruling 'queens' were masculine because the languages lacked a feminine word for ruler. Such was the case of Tamara of Georgia who was called 'king' in Georgian.[4] The Byzantine empress Irene, however, simply dropped the feminine form, *basilissa*, for the masculine form *basileus*.

Frequently biographies of these exceptional women are more an account of their fathers, husbands, brothers or other men around them rather than of the women themselves; all too often when a woman is mentioned, it is only in the context of being a wife, mother, daughter or sister to some husband, father, son or brother, validating the 'Appendage Syndrome'. Æthelflæd of Mercia is an excellent example of this. Despite Æthelflæd having ruled Mercia for a number of years and leading her armies into battle against the Danes, being the daughter, wife and sister of kings has reduced her prominence in history. The victors may write history, but men have been the primary writers of history, usually at the expense of the female participants.

As one approaches more recent periods, more names of female leaders are certainly better known. Here, in linguistic/cultural and roughly chronological order, I present brief accounts of some of those women who are distinguished for their military activities, some who are less renowned but who deserve greater prominence. Through these sketches, we will see that there were a number of characteristics that many of these women had in common, chief among them are the traits described by the terms used in earlier chapters – those of virgins, viragos and amazons.

The Near East

What may be the earliest military evidence for real, but unnamed, women comes from the Egyptian Pre-dynastic period (ca. 6000–3150 BC). This evidence was found in graves at the cemetery at Naqada. In at least three graves, 1488, 1401 and 1417, weapons were found, including mace heads and flint knives. These graves, excavated by the well-known Egyptologist Flinders Petrie, were all considered female graves and none of the items were considered votive (Petrie 1896: 28). Mace heads and a flint dagger were also found somewhat later, dating from the 12th Dynasty, in the tomb of a woman at the site of Lisht (Mace and Winlock 1916: 102–103, pl. XXXII A–C; Dean 2013). Unfortunately, we know little else about these women.

Queen Ahhotep

What seems to be the earliest evidence we have for a queen who took to the battlefield was also found in Egypt and relates to Queen Ahhotep who may, in fact, have been two queens.[5] Notwithstanding the language and cultural

difference, Ahhotep greatly resembles her Indo-European sisters in that she is known as a male appendage. Ahhotep's titles were: King's Daughter, King's Sister, King's Great Wife, King's Mother and God's Wife. More specifically, she was the daughter of Senakhtenre Taa I and the wife of Seqenenre Taa II, successive kings of the 17th Dynasty (1630–1539 BC). It is through her son, Ahmose, who succeeded his father, Seqenenre Taa II, that we know of Ahhotep's battle experience. Ahhotep ruled as Regent for her son Ahmose for about a decade before he came of age, and it was Ahmose who had carved on a stela at Karnak in a temple dedicated to the god Amun-Re, that the people should revere his mother because of her efforts in driving out the Hyksos from Egypt. Ahmose's praise of his mother is quite specific: 'She has looked after her Egypt's soldiers, she has guarded Egypt, she has brought back her fugitives and gathered together her deserters, and she has pacified Upper Egypt and expelled her rebels' (Tyldesley 2006: 84). As if to confirm her courageousness, included in her grave goods were three golden flies of valour – the medal awarded to high-ranking Egyptian soldiers (ibid., 83–84).

Hatchepsut

Aside from the last of the Cleopatras, (Cleopatra VII of Caesar and Marc Antony fame) Hatshepsut (1479–1478 BC, early 18th Dynasty [1539–1292 BC]) is the most famous of Egyptian queens. She ruled Egypt as regent for her stepson Thutmosis III, who was heir to his father, Thutmosis II, who was also Hatchepsut's half-brother. Her titles included: King's Daughter, King's Sister, King's Great Wife and God's Wife of Amun – she preferred the latter title. Thutmosis III was only an infant when his father died, and his mother was an inconsequential queen, Isis, considered unsuitable to be regent. This succession is related in the biography of the architect Ineni, written in his tomb (Dorman 2005: 87; see also Dziobek 1992, pls. 34, 63).

Throughout her twenty-two-year reign, Hatchepsut neither denied nor formally displaced her stepson – they reigned as co-rulers – but by the seventh year she was crowned king of Egypt and acquired the titles that went with the crown. Furthermore, she had herself declared the heir to the great Thutmosis I and had images of herself made to look like a man – appropriate for one who was no longer a queen but now a king (ibid., 88).

As to Hatchepsut's war record, it is somewhat difficult to assess. Her reign was book-ended between two of Egypt's greatest warrior pharaohs, and many of her monuments and inscriptions were defaced or destroyed by her stepson, Thutmosis III. Moreover, many scholars have considered her reign to be one without serious war. Despite this, evidence gathered from her mortuary temple at Deir el-Bahri shows that in the late nineteenth century BC it was necessary for her to put down the usual uprisings that occurred by vassals at the beginning of a new reign. Additionally, there is evidence – such as Hatchepsut appearing

as a sphinx crushing Egypt's traditional enemies – indicating that she took on the role of suppressor of rebellions. At the same temple there is also a damaged inscription that seems to make this clear:

> as was done by her victorious father, the King of Upper and Lower Egypt, Aakheperkare [Thutmosis I] who seized all lands ... a slaughter was made among them, the number [of dead] being unknown; their hands were cut off ... she overthrew [gap in text] the gods [gap in text] (Tyldesley 1996: 142).

Another inscription by a bureaucrat named Ti also places her on the battlefield:

> I followed the good god, the King of Upper and Lower Egypt Maatkare, may she live! I saw him [i.e., Hatchepsut] overthrowing the Nubian nomads, their chiefs being brought to him as prisoners. I saw him destroying the land of Nubia while I was in the following of His Majesty ... (ibid., 143).

While her actual battle experience has been questioned, it is clear that throughout her reign she maintained her army in ready condition to the point that when Thutmosis III came to his full reign, he was quickly able to dispatch the army on his numerous campaigns.

The Greek historian Herodotus is frequently our chief informant for some of the earliest historic queens as he is the first to write, as he puts it, *ta genomena* – 'the facts' (see Dewald 1981).

Semiramis

The earliest of these historic queens to be memorialised by Herodotus is Semiramis, a somewhat mythical ninth-century BC queen of Babylonia, who, although again not part of the Indo-European world, sets out a pattern seen frequently among the Indo-Europeans and elsewhere. It is generally believed that Semiramis is based on the true-life figure of Sammu-ramāt, wife of the Assyrian (not Babylonian) King Šamši-Adad V (d. 811 BC), who like so many other queens, both warrior and otherwise, came to the throne as regent for her young son, in this case Adad-nerari III (810–783 BC), after the death of her husband (Siddall 2009).

We first hear of Semiramis in Herodotus (1.184) when he tells us that it was she who built dykes on the plain in order to prevent flooding by the Euphrates, but it is Diodorus Siculus (1.56, 2.4–11, 13–14, 16–20),[6] writing at a later time, who tells us how Semiramis rose from 'lowly fortune' to fame. Like many other early queens, her legend outstrips what we actually know of her, which

is surprisingly little considering the fame of her reputation. Diodorus describes Semiramis as 'the most renowned of all women of whom we have any record'.[7] Thus the Greek world hears of this amazing 'Babylonian' queen. Bernbeck (2008) summarises this legend, which conflates stories of Alexander, Darius and Nebuchadnezzar II. Bernbeck goes on to say, 'none of the exploits of the Semiramis of Diodorus can be attributed to Šammuramat' (ibid., 354).

Although our knowledge of Sammu-ramāt is not as extensive as that of Semiramis, Sammu-ramāt was still remarkable for several reasons. Assyrian queens were usually known not by their names, but merely by the word *sēgallu* (MÍ.É.GAL, lit. woman of the palace) (Svärd 2015: 39). These women would also have titles that presented their relationship to the king. Sammu-ramāt was unusual in that she had relationships with three kings and these were spelled out in her titles Sammu-ramāt, queen of Šamši-Adad, mother of Adad-nerari, daughter-in-law of Shalmaneser (ibid., 48).

In the 1970s the question of Sammu-ramāt relationship to her son came into question. Was she the mother to a grown son, or was she regent for an underage son? (Schramm 1972) Siddall took up this question first in 2009 at a conference, then in 2013 and more specifically in 2014 in the proceedings of the 2009 conference.

The three sources regarding the queen 'are the Pazarcik stele and the Nabû statues dedicated by the Assyrian official, Bēl-tarṣi-ilumma, and her own stele found at Aššur' (Siddall 2014: 497). The stele is a boundary marker signifying the beginning of a western campaign and the queen's title is prominently linked with her son's, indicating her involvement in the military campaign – an unprecedented action. Siddall states the most plausible reason for Sammu-ramāt partaking in a military expedition was the continued problems associated with the rebellion from 827–821 that plagued the end of the reign of Shalmaneser III, and the beginning of Šamšī-Adad V's (ibid., 498). He further says the location of the stele is important because, being in the open, it can be inferred that she was recognised throughout the empire.

The Nabû statues provide a dedication for the lives of the mother and son. This unique inscription indicates, that Sammu-ramāt was recognised by the central administration (ibid.). 'For the life of Adad-nīrārī, king of Assyria, his lord, and (for) the life of Sammuramāt, the palace woman, his lady, Bēl-tarṣi-ilumma, governor of Calah … had [this statue] made and dedicated [it] for his life…' (ibid., 499). Because someone outside the royal family made the dedications, Siddall says, 'A dedication made to two members of the royal family is without parallel and taken together, the stele and the statues indicate that Sammu-ramāt held political power during the early years of her son's reign' (ibid.).

While the statues are significant and clearly demonstrate her importance, it is the stele that is for us the greatest interest, as it clearly lays out in Assyrian terms

that Sammu-ramāt was involved in military activities. It is not unreasonable to assume that Sammu-ramāt was a woman of strength of character, a virago in our terms. If, as we assume, the king was young, a strong person was needed both to guide him and to send the message to his enemies that he had a person of strength guiding him and to ensure the continuation of his dynasty.

The Iranian Speakers

Tomyris

Tomyris is the first figure we can refer to as an Indo-European speaker (see Map 2). In the first half of the sixth century BC, she was queen of the Massagetae, most probably an Iranian speaking, Scythian people living in what is today eastern Iran. As noted in Chapter 3, Scythian women were said, like men, to train in weaponry. Tomyris came to the throne upon the death of her husband, and as she was now a widow ruling a large group of people, Cyrus the Great of Persia attempted to court her. Because she knew his passion was for the land she controlled, not herself, she rejected his advances. Since Cyrus could not have her and her territory by means of marriage, he prepared to take her country by war (Herodotus 1.205–207). He advanced his army into the Massagetae territory where the Persians killed and captured many in her army, including Tomyris' son, Spargapises. Tomyris warned Cyrus that if he did not return her son, she would not allow Cyrus and his army to go unpunished. Subsequently, we learn that Spargapises escaped, but hear nothing more about him. Cyrus, however, did not heed Tomyris' warning which caused her, in 529 BC, to attack the Persian army killing many, including Cyrus himself. Tomyris then put Cyrus' head in a sack made of skin that had been filled with human blood and declared this insult to the dead man: 'Though I live and conquer thee, thou has undone me, overcoming my son by guile; but even as I threatened, so will I do, and give thee thy fill of blood' (ibid., 208–15). Thus, Tomyris carried out her warning to both Cyrus and the Persians.[8]

Amage

The Sarmatians were also an Iranian-speaking people closely connected to the Scythians and another steppe people, the Chersonesians; they all occupied an area around the Black Sea. The *Strategemata* of Polyænus[9] (8.56) tells us of Amage whose husband, Medosaccos, the Sarmatian king, had fallen into drunkenness and debauchery. As a consequence of her husband's behaviour, Amage took charge, defending her territory against enemies, built alliances with her neighbours and gained a powerful reputation. It was to her that the Chersonesians, who occupied the area of Taurica (modern-day Crimea), appealed when the Scythians bothered them.

Apparently, her power was such that she, at first, felt it only necessary to send word to the Scythian king that he should stop harassing the Chersonesians. When this failed, she led a lightning raid with only a small cavalry of 120 soldiers with three horses apiece on to the Scythian royal palace, killed the guards at the gate, the king, friends and kinsmen – all except the king's son, whom she placed on the throne. Amage ordered her new client king to live peacefully with his neighbours. It is his promise, which seems to have been kept, that tells us how powerful and important a leader Amage was, and makes the point that when her commands were not obeyed, she did not hesitate to carry them out by force. Although the date of this story is in question (it seemingly centres around the fourth century BC), it does signify that the Sarmatian queen held considerable power over the Scythians and Greeks in the Crimean area and that both the Scythians and Chersonesians were clearly her vassals (Harmatta 1950: 9).

Zarinaea

Like the Sarmatians and Scythians, Saka women, according to Ctesias, fought 'alongside the men … [and] from horseback' (Llewelyn-Jones and Robson 2013: 156).[10] Ctesias further tells us that the Saka (Saces) were at one time ruled by a woman named Zarinaea (Zaromaea, Zarina) who was not only a great beauty but was 'devoted to warfare'. She was considered the most courageous of the Saka women who were known for their courage and accompanied their husbands into battle. Zarinaea was the wife and sister of King Cydraeus of the Saka, and upon his death she married Mermerus, king of the Parthians. She fought against neighbouring tribes who would have enslaved her people and 'introduced civilized life, founded not a few cities, and in a word, made the life of her people happier' (ibid., 150–51, 156).

Sparethre

Another Saka queen, Sparethre, proved her ability to lead an army when Cyrus the Great captured her husband King Amorges in the sixth century BC. In order to free him, Sparethre continued the war against Cyrus, gathering an army said to number 300,000 men and 200,000 women. She defeated Cyrus and took captives including Cyrus's brother, Parmises, and three of his sons, who were later exchanged for Amorges. (Llewellyn-Jones and Robson 2013: 171).[11]

Anatolia

Artemisia (1)

We move from the Iranian world to Anatolia and the realm of the Carians that gave us at least three women of war, two of whom were sisters and two

were both named Artemisia, a situation that at times has caused confusion. Herodotus evinces amazement at the audacity of the first Artemisia (r. 484–460 BC), Caria's queen, daughter of Lygdamis of Halicarnassus and a Cretan mother. Upon the death of Artemisia's husband, she, like the Egyptian queen Ahhotep, assumed the throne for her young son, Pisindelis. She allied with the Persian king Xerxes during the Persian Wars against the Greeks, and Herodotus speaks not only of her 'manly spirit', but that she 'moves me to marvel greatly that a woman should have gone with the armament against Hellas' (7.99). Artemisia is best known for her actions during the Battle of Salamis in 480 BC.

When Xerxes gathered his leaders about him according to rank, the leaders were questioned as to whether or not the Persian ships should go into battle. All of the leaders agreed they should – all but Artemisia, who led men not only from Halicarnassus but also Cos, Nisyrus and Calydnos. She commanded five ships, which were said to be the best in the fleet after those of Sidon. When it came to her turn, she spoke with no false modesty and reminded the men of the defeat at Euboea:

> I who say this have not been the hindmost in courage or in feats of arms in the fights near Euboea. Nay, master, but it is right that I should declare my opinion, even that which I deem best for your cause. And this I say to you – Spare your ships, and offer no battle at sea; for their men are as much stronger fighting battles on the sea than yours, as men are stronger than women. And why must you at all costs imperil yourself by fighting battles on the sea? have you not possession of Athens, for the sake of which you set out on this march, and the rest of Hellas? no man stands in your path; they that resisted you have come off in such plight as beseemed them. I will show you now what I think will be the course of your enemies' doings. If you make no haste to fight at sea, but keep your ships here and abide near the land, or even go forward into the Peloponnese, then, my master, you will easily gain that end wherefor you have come (Herodotus 8.68).

As a consequence of her speech, Xerxes 'was greatly pleased by the opinion of Artemisia; he had ever deemed her a woman of worth and now held her in much higher esteem'. Nevertheless, despite his view of her he chose to follow the advice of the majority of leaders and prepared for the Battle of Salamis that took place in 480 BC (ibid., 8.69).

Artemisia's bravery during the Battle of Salamis is legend, despite her tactics which included sinking a ship of an ally in order to save herself and her own ship. Seeing only her success and not her manoeuvre caused Xerxes

to announce, 'My men have become women, my women men' (Herodotus 8.88), and he sent a complete set of Greek armour to Artemisia (Polyænus, *Stratagems* 8.53.2).[12]

After the Battle of Salamis, which was a humiliating defeat for the Persians, Xerxes again asked her advice, which this time conflicted with that of his other councillors but coincided with his own 'panic-stricken' thoughts. Consequently, he followed her advice and returned to Persia (Herodotus 8.101–103).

Artemisia's military tactics went beyond weaponry. On her ship she carried flags of a number of her enemies, and she would hoist whatever flag suited her advantage. On another occasion, when in opposition to the city of Latmus, she planted soldiers in ambush while she and a group of women, eunuchs and musicians, celebrated a sacrifice outside the city. When the people of Latmus came out to watch the sacrificial procession, the soldiers took possession of the city. 'Thus did Artemisia, by flutes and cymbals, possess herself of what she had in vain endeavoured to obtain by force of arms' (Polyænus, *Stratagems* 8.53.4).

Artemisia (2)

The second Artemisia (d. 350 BC) was also queen of Halicarnassus and sister to our third warrior, queen of Caria, Ada. These sisters were daughters of King Hecatomnus of the Carians and a Cretan wife. In addition to the two daughters, the king also sired three sons, Mausolus, Idrieus and Pixodarus. The two daughters married the first two sons. This Artemisia can be added to the list of female rulers who took up arms, but she is also well known as the builder of the great tomb at Halicarnassus dedicated to her husband, Mausolus,[13] who was also her brother (Strabo 14.2.16–17). After the death of her husband in 353 BC, this second Artemisia ruled the territory of Caria a mountainous Persian dependency in southwestern Anatolia.[14] This area also held the Greek city of Halicarnassus that lay opposite the Greek island of Rhodes, which at the time was controlled by the Carians. Soon after Mausolus' death, the Rhodians attacked Halicarnassus, assuming the weakness of a female ruler. Artemisia rose above their low expectations and devised a surprise strategy in which she hid her fleet and, without warning, put down the Rhodian attack. The great orator Demosthenes had encouraged the Rhodians and although he gave Artemisia full marks for her military and political abilities, he questioned the Athenian's bravery when they were up against a barbarian, and stressed the shame of being subjugated by a woman – and a woman barbarian at that (Demosthenes 15; Cuchet 2015).

Artemisia only lived about two years after the death of her husband/brother, but it is said she loved him with such passion and was grief stricken at Mausolus' death, so much so that she mixed his bones and ashes with spices, ground them, and placed the powder in water and drank them (Aulus Gellius, *The Attic Nights* 10.18.1).

Ada

After Artemisia's death the Carian throne was passed to her second brother Idrieus, who was married to their sister Ada, our third warrior queen from Caria. Idrieus also died and Ada (r. 344–340 BC) took the throne as sole ruler. Nevertheless, no evidence exists to show that she was formerly recognised as a Persian satrap (Carney 2005: 68), and her remaining brother Pixodarus soon deposed her.

Although Ada controlled the military facilities, the sources for Ada's military activities are conflicting and written after the events, with Strabo taking the strongest stand for her military role. Cuchet (2015) attempts to bring clarity to what remains an unclear chapter in Caria's history.

The Greeks

Archidamia

The Greeks are not known for their female leaders but there are historical accounts of Spartan women, as given to us by Plutarch, who points out that they were not actually trained for combat but were said to be more athletic than most women.[15] Still, Plutarch tells us that they did not shirk from battle when it was necessary and we have reports of their courage and bravery. About 273–272 BC when the Spartans (also referred to as Lacedaemonians) anticipated an attack from Pyrrhus, the Molossian king, the Lacedaemonian counsel made plans to prepare the camp for invasion and to send their women to Crete, but this plan was stopped by Queen Archidamia (ca. 340–241 BC), grandmother of the Spartan King Agis IV (ca. 265–241 BC), who 'came with a sword in her hand to the senators and upbraided them on behalf of the women for thinking it meet that they should live after Sparta had perished' (Plutarch, *Pyrrhus* 27.2–3). The women ordered the fighting men to rest for the battle and the women dug much of the trench meant to keep out Pyrrhus and his elephants. Furthermore, Chilonis, wife of the Spartan King Cleonymus, is said to have kept a halter about her own neck in order that she might not be taken alive (ibid., 27.4–5).

These examples do not speak of Spartan women taking up arms themselves, but it is clear that they held a strong warrior spirit for which they believed their sons (and one might reason their most beloved possessions) should die.

Telesilla

A surprising combination of poet and female warrior comes from an equally surprising non-Spartan area of Greece in the mortal character of Telesilla of Argos. The Argives had suffered a great defeat led by the Spartan king Cleomenes (r. ca. 519 – ca. 490 BC) and no men were left to defend the walls of the city. Telesilla took the initiative; she placed slaves along the walls,

collected the available arms found in the temples, armed the women, posted them where she thought Cleomenes' army would attack, and they fought off the Lacedaemonians. The Lacedaemonians now found themselves in a difficult position as they believed a victory over women would be an odious one and a defeat a humiliation. It is said Telesilla read her poetry to the women and worked them into a state, causing them to fight so furiously they drove out the enemy. An image of her is seen on a slab at a sanctuary of Aphrodite. She is portrayed with books scattered at her feet looking down at the helmet she holds, and seems about to put it on. In memory of this event at the beginning of the month of Hermaeus, the Festival of Impudence is held where the men wear women's robes and women wear men's (Pausanias 2.20.8–10; Polyænus, *Stratagems* 8.33; Plutarch, *Moralia* 223 B–D, 245 C–D).

What is often overlooked is the point that the populace – both young and old, slave and free – came together to fight the common enemy. The common threat caused the common response to resist the enemy with any means necessary. Women were needed, and they reacted for the common good, as did the Messenians and the people of Plataea under similar circumstances.[16]

Macedonia

The reigns of Philip II of Macedonia and his son Alexander the Great saw a number of queens with military connections and at least three queens take up arms and lead troops into battle. Most of these were connected in some way to Philip II, but only two of Philip's wives are of particular interest to us – his first wife, Audata, and his last, Olympias, the latter of whom was perhaps, the best known of Philip's seven wives. Their stories and some of their descendants must be told together.

Audata-Eurydice
Philip's first foreign wife, Audata, was an Illyrian princess, perhaps given to Philip by the Illyrian prince Bardylis to cement a treaty between them in 358 BC.[17] Audata may have changed her name to the Greek Eurydice (Audata-Eurydice), which, like Cleopatra in Egypt, seems to have become something of a dynastic name and may indicate that this made her the 'legitimate' wife whose children could inherit (Macurdy 1932: 25, 48), but Carney (2000: 58, n. 30) questions this.

Cynane
Although Audata-Eurydice took the Greek name, she did not take the more submissive ways of Greek woman as she passed on to her only child, a daughter, Cynane (Cynnane or Cynna), a more Illyrian attitude toward royalty.

Cynane also inherited the fighting nature known among generations of Illyrian women (Pomeroy 1984: 6). Audata-Eurydice seems to have been the one to teach her daughter military skills. Cynane is known to have gone into battle with her father, and Polyænus (8.60) tells us that Cynane went into the field with her own armies and charged at the head of them. She engaged in great slaughter against the Illyrians defeating them in 344 BC and in one battle she even cut down the Illyrian queen, Caeria,[18] with a blow to her throat. (See also Carney 2004; Loman 2004: esp. 45–48.) Cynane married Amyntas, son of Philip II's brother Perdiccas III, and thus her cousin; soon after the marriage and the murder of Philip in 336 BC, Alexander had Amyntas (also his own cousin) killed (*FGrHist* 156 F 22). After her husband's death, the still young Cynane refused all marriage proposals, devoting herself to the military education of her daughter, Adea (Polyænus 8.60; Carney 1987: 498; 2013: 89).

When Alexander died in Babylon in 323 BC, Cynane took her young daughter, Adea, and dashed to Babylon, not only in an attempt to seize the throne by reminding the army that she was Philip's daughter and half-sister to Alexander, but she also had the aim of marrying her daughter to Philip Arrhidaeus, who subsequently inherited Alexander's throne and became Philip III, thereby making her daughter queen.

After Alexander's death his generals divided up his territories among themselves excluding the royal family.

> But Cynane crossed the Strymon, forcing her way in the face of Antipater, who disputed her passage over it. She then passed the Hellespont, to meet the Macedonian army, and Alcetas with a powerful force advanced to give her battle. The Macedonians at first paused at the sight of Philippus' daughter, and the sister of Alexander; but after reproaching Alcetas with ingratitude, undaunted at the number of his forces, and his formidable preparations for battle, she bravely advanced to fight against him (Polyænus 8.60).

The regent's brother Alcetas, however, murdered Cynane in Aegae (Diodorus Siculus 19.52.5), thus apparently thwarting her plans. Despite her death, Cynane's plan ultimately succeeded because her murder so enraged the army that to pacify them, the marriage between Cynane's daughter Adea and Philip Arrhidaeus was carried out (*FGrHist* 156 F 9.22–23; Carney 1987: 498).

With Alexander dead, Cynane's daughter Adea (ca. 337–316 BC), now Philip III's wife, changed her name to Eurydice (Adea-Eurydice) (Pomeroy 1984: 6; see Macurdy 1932: 40ff., 48–52), following in her mother's footsteps she consolidated power into her own hands. Philip III was not mentally sound (the precise cause of this is unknown), but it is safe to say he was never fit to

rule and was in a state of perpetual childhood. This put Adea-Eurydice in the position of gathering power for herself, which she quickly did by wooing the army (Macurdy 1932: 41).

Diodorus (19.11) tells us that this attempt by Adea-Eurydice to gather power for herself put her at odds with Olympias, Philip II's last wife, who had political aspirations of her own. Olympias, who Carney (1993: 35) calls 'a genuine virago', was not only Philip II's widow but also the mother of Alexander the Great; moreover, Olympias had royal roots of her own.

Olympias was the daughter of Neoptolemus, ruler of Molossia in Epirus in northwestern Greece and had married Philip in 357 BC. She had learned to ride, hunt and use weapons, ultimately giving birth to Philip's son Alexander (later the Great), and a daughter, Cleopatra, who, like her mother, learned the arts of riding, hunting and weaponry. It was at Cleopatra's wedding in 336 BC that Philip was murdered – perhaps plotted by Olympias herself (Macurdy 1932: 31).

While both Adea-Eurydice and Olympias were each powerful in their own right, Eurydice had a seeming advantage in that in her flowed the blood of both Philip II and his brother Perdiccas – moreover, she was married to the actual ruler of the Macedonian Empire. Unfortunately for her, she lacked the all-important bonus of being mother to the heir. She made great promises to many powerful Macedonians and sent to Cassander, the son of the powerful regent Antipater, for help (Diodorus Siculus 19.11.1–2; Carney 1987: 499). Olympias' advantage came with her ties to the regent Antipater and after his death, the succeeding regent Polyperchon, plus, the not to be forgotten fact that she had been Philip II's wife and was the mother of Alexander the Great. In 317 BC at Euia (in what is said to be the first war between women [Carney 2004: 185]), both sides prepared for battle with both women participating – Eurydice wearing the armour of the Macedonian infantry and Olympias said to be dressed as a Bacchant, marching to the beat of tympanum (Carney 2004: 188). But the Macedonians refused to fight out of respect for Olympias, who took the day with a bloodless victory (Diodorus Siculus 19.11.2).

Olympias was not, however, benevolent in her victory and placed Eurydice and her husband Philip in a little room, walled it up, and had their food handed through a small space. This was not looked upon favourably by the Macedonians, but Olympias then went further and had the feeble-minded Philip stabbed. Still, Eurydice showed neither repentance nor contrition, causing Olympias to hold her out for greater punishment. Without consideration of Eurydice's previous position or pity, Olympias sent to Eurydice a sword, a rope and a cup of hemlock, in order that she might choose her own method of death. In a final gesture of defiance, Eurydice chose to reject the methods of death she had been offered and instead hanged herself with her own girdle that was soiled with the blood of her husband (ibid., 19.11.5–7).

This, however, was not the end of Olympias'[19] activities, and the sweet taste of victory did not last long. Before his death the regent, Antipater, had given his son, Cassander, the position of second in command, and on his deathbed, Antipater warned against women ruling the country (ibid., 19.11.9). When Cassander heard of Olympias' return to Macedonia, he abandoned his plans in the Peloponnesus and also returned to Macedonia (ibid., 19.35.1–2).

Once Olympias was in power, she felt herself secure enough to kill Cassander's brother. Not satisfied with this, she then chose a hundred of Cassander's closest Macedonian friends and had them executed. These vicious acts finally caused the Macedonians to turn against her (ibid., 19.11.8–9). When Olympias learned of Cassander's return, she sent her army to fight and gathered around her personal friends who were useless in battle. Not only was her group of friends incompetent in battle, they had not foreseen the long siege that Cassander waged by land and sea, causing them to lack food and supplies (ibid., 19.35–36). The siege was so severe and lasted so long that there was mass starvation among both the people and animals, resulting in incidents of cannibalism. Olympias' end came in 316 BC. Once she surrendered, Cassander urged on the Macedonian assembly who condemned her, and relatives of her victims subsequently killed her (ibid., 19.49–51).

Cratesipolis

Not all capable and ambitious Hellenistic women were as successful in their pursuits. Loman (2004) relates some of the 'military blunders' by women, including Cynane's daughter Eurydice. One of the most interesting of these unsuccessful women was Cratesipolis ('conqueror of the city') of Sicyon, and the wife of another Alexander, son of the Macedonian regent Polyperchon (Macurdy 1929: 273). Remarkably, we do not hear of her until after the assassination of her husband in 314 BC. Nonetheless, she was much admired by her husband's army, because, it was said, of her kindness to them, and we do not have any name of a male commander associated with her (Carney 2004: 188).

After her husband's death, she took command of the army. She then put down a rebellion in Sicyon but now, instead of her previous display of kindness, she showed great cruelty to the defeated army. Nevertheless, she is clearly admired by Diodorus who said, 'She had a grasp of politics and a courage beyond that of women' (Diodorus Siculus 19.67.2). She also controlled Corinth, which she turned over to Ptolemy for a reason that is not clear (ibid., 19.67.1, n. 1). This may, however, have been an attempt at marriage to Ptolemy that would have been extremely advantageous to the ambitious Cratesipolis. Unhappily for her, she was neither a blood relative to Philip II nor Alexander the Great, as Ptolemy was interested in a blood tie to

these great leaders. Moreover, the princess Cleopatra, daughter of Philip II and sister to Alexander, was pursued by all the ambitious men of the time, and she accepted Ptolemy:

> Clearly the advantages of a marriage with the princess Cleopatra would tip the scale against Cratesipolis. A Ptolemy would never hesitate to prefer the lady who might bring the throne of Macedon as her dower to one whose prestige depended on her beauty, her personal influence, and power of charming her mercenaries (Macurdy 1929: 276).

It is unfortunate that we do not know the end of Cratesipolis as she just disappears from the record. Surely, she came from a noble family – as attested by her marriage to a man from a noble family. Moreover, had she remained on the scene she might have succeeded in marrying Ptolemy after all, as Cleopatra was killed under the order of Antigonus I 'the One-eyed' (ca. 382–301 BC)[20] prior to her marriage to Ptolemy (see Diodorus Siculus 20.37.1).

The Romans

Agrippina the Elder

Roman women are not famous for their military activities, but there are a few notable exceptions, perhaps the best recognised is Julia Vipsania Agrippina, known as Agrippina the Elder or Maior (14 BC– AD 33). She was the daughter of Marcus Agrippa and Julia, daughter of the Emperor Augustus and his second wife Scribonia. Agrippina was, in addition, the wife of Germanicus,[21] for whom she bore nine children, including Caligula; unlike her mother Julia, she was greatly admired for her virtue, courage and devotion to her children. Once she and Germanicus were married, they became a celebrated couple for their abilities and devotion to one another. She was renowned for her 'Roman' virtues – chiefly fertility – and went with her husband, Germanicus, on his military campaigns into Gaul and Germania, despite the fact that Roman society did not look with favour upon women in the field.

Agrippina's note in military matters was most evident at a battle to prevent the demolition of the Rhine Bridge where she took command as a general and prevented the demolition of the bridge. Tacitus, no lover of women as leaders, was even more appalled when the woman was Roman – barbarians were one thing, Roman women another – nonetheless, he portrays Agrippina with admiration tempered by suspicion:[22]

had not Agrippina prevented the demolition of the Rhine bridge, there were those who in their panic would have braved that infamy. But it was a great-hearted woman who assumed the duties of a general throughout those days; who, if a soldier was in need, clothed him, and if he was wounded gave him dressings. Pliny ... assets that she stood at the head of the bridge, offering her praises and her thanks to the returning legions ... Agrippina counted more with the armies than any general or generalissimo, and a woman had suppressed a mutiny which the imperial name had failed to check (ibid., *Annals* 1.69).[23]

In AD 29 her long-time nemesis, the Emperor Tiberius, sent Agrippina to Pandatería, an island in the Bay of Naples and the place of her mother's exile. Agrippina died in AD 33 of self-inflicted starvation.

Agrippina was quite unusual for a Roman woman and difficult to classify. She held firm to her beliefs and was determined to have her own way, be it accompanying her husband on his military campaigns, taking charge of a military situation when necessary or defying the emperor, all the while still carrying out the role of the ideal Roman woman by giving birth to a multitude of children. To call her a warrior may be stretching her military activity, but strength of character and her ability to take control of a situation would surely place her in the category of virago.

Agrippina was neither the only Roman woman said to be involved in military matters, nor was she the most infamous. This infamy was left to another prominent Roman matron.

Fulvia Flacca Bambula

Rarely do we come across a woman who seems to have been so universally disliked (should I say despised) as Fulvia Flacca Bambula (ca. 83–40 BC), a woman of great wealth, twice a widow, part of the circle of power in Rome, including being Julius Caesar's mother-in-law and wife of Marc Antony. Moreover, she had a flare for the dramatic. Her first two husbands had both been politically well placed. Her first husband the demagogue Publius Clodius Pulcher, by whom she had two children (including the daughter who married Caesar in 43 BC), had been murdered, and her second husband, the tribune Gaius Scribonius Curio, died in the Civil War of 49 BC (Babcock 1965: 18). Fulvia was neither a woman to sit by and play the role of dutiful and obedient wife, nor did she shirk from being in the public eye – something considered improper for a Roman matron. Marc Antony seems to have encouraged this improper behaviour as he had used her as the model for 'Victory' on coins minted in Cisalpine and Transalpine Gaul in 43/42 BC. Shortly after, the city of

Eumenia in Phrygia was renamed 'Fulviana', but this evidently did not please all its citizens (Brennan 2015: 358).

According to Plutarch, Fulvia did not, as was likewise said of the Amazons, engage in domestic activities such as 'spinning and housekeeping' (Plutarch, *Antony* 10.6.3). She had greater ambitions, desiring to 'rule a ruler and command a commander',[24] preferring to accompany her husbands into army camps. She is described as 'meddlesome and headstrong', and her ambition created hatred towards her (Pomeroy 1975: 185). Cicero vilified her, along with Marc Antony, in his *Philippics*, and Dio Cassius gives us examples of her outright cruelty as seen from an incident in 43 BC:

> And even Fulvia also caused the death of many, both to satisfy her enmity and to gain their wealth, in some cases men with whom her husband was not even acquainted ... When, however, the head of Cicero also was brought to them one day ... Antony uttered many bitter reproaches against it and ...Fulvia took the head into her hands before it was removed, and after abusing it spitefully and spitting upon it, set it on her knees, opened the mouth, and pulled out the tongue, which she pierced with the pins that she used for her hair, at the same time uttering many brutal jests. (Dio Cassius 47.8).

Dio also tells us of her taking power for herself, as in 41 BC when:

> Publius Servilius and Lucius Antonius nominally became consuls, but in reality it was Antonius and Fulvia. She, the mother-in-law of Caesar and wife of Antony, had no respect for Lepidus [a close ally of Caesar's] because of his slothfulness, and managed affairs herself, so that neither the senate nor the people transacted any business contrary to her pleasure. (ibid., 48.4).

Later he goes on to tell us that 'she would gird herself with a sword, give out the watchword to the soldiers, and in many instances harangue them' (ibid., 48.10).

Livy, in his *History of Rome*, tells us that in 41 BC:

> Caesar, leaving Antonius to take care of the provinces beyond the sea, returned to Italy, and made a distribution of lands among the veterans. He represses, with great risk, a mutiny among his soldiers, who, being bribed by Fulvia, the wife of Marcus Antonius, conspired against their general. Lucius Antonius, the consul, influenced by Fulvia, made war upon Caesar, having taken to his assistance those whose lands Caesar had distributed

among his veteran soldiers: and having overthrown Lepidus, who, with an army, had charge of the defence of the city, he entered it in a hostile manner (Book 125, http://www.perseus.tufts.edu, accessed 29 July 2017).

In Frag. 127 of his great work, Livy relates that Fulvia's interference did not always work to her benefit:

> The Parthians, who had joined the Pompeian party, under the command of Labienus, invaded Syria, and having beaten Decidius Saxa, a lieutenant-general under Antonius, seized that whole province. Marcus Antonius, was excited to dispute with Caesar by his wife Fulvia, having dismissed her, lest she should mar the concord of the generals, and having concluded a treaty of peace with Caesar, he married his sister Octavia (Book 127, http://www.perseus.tufts.edu). Accessed 24 May 2018.

The Roman historian Velleius Paterculus, writing fifty years after her death, penned in his *Roman History* (2.74) that she bore 'nothing female about her except for her body', and Hallett (2015) provides a survey of many of her exploits and various contemporary views of her.

Once Antony's affair with Cleopatra began, Fulvia hoped to win him back (Plutarch, *Antony* 28, 30, 31.2) and in what may have been an attempt to retrieve Antony's affections, Fulvia took the unorthodox action of going to war *not* against him, but *for* him. Plutarch (28.1) tells us that while Antony was involved with Cleopatra, Fulvia acted for Antony's interests, gathering troops on the Perusian plains and engaging in war (known as the Perusine War, 41–40 BC). She took this action alongside Antony's brother Lucius (but without Antony's knowledge) against Octavius in Rome. This military escapade was a catastrophe for Fulvia and Octavian drove her out of Italy. It was while she was sailing to Antony that she became ill and died.

Recent archaeological finds confirm Fulvia's place on the battlefield and sentiments that were felt towards her. Slingshots with rude messages have been unearthed that name Fulvia and show the low opinion in which she was held. 'I'm aiming for Fulvia's cunt', and 'Baldy Lucius Antonius and Fulvia, open yur arses', leave little doubt as to the battle and who the opponents were (Freisenbruch 2010: 9; *Inscriptiones Latinae Liberae Rei Publicae*, 1106, 1112, in P. Jones 2006: 98). In Delia's (1991) 'Reconsidered' view of Fulvia she is presented in a less strident less manipulative light, but the archaeological finds seem to speak to the earlier views of her. Even the Roman poet Martial gives us a poem (10.20), which he attributes to Octavian that is quite lewd and insults both Fulvia and Octavian (Hallett 2015: 249–50).

Gladiators

A revealing piece of iconography from Halicarnassus in the form of a marble carving now housed in the British Museum renders some evidence for what might be considered 'semi-military' and have a more sensational nature. The relief shows two women gladiators in armed combat and the inscription below the figures reads 'ΑΜΑΖΩΝ ΑΧΙΛΛΙΑ'. Above the two women is the Greek word ΑΠΕΛΥΘΗΣΑΝ that Coleman (2000: 488) (Figure 3) renders into Latin as *missae sunt*, meaning 'both these combatants have received *missio*', which 'represents discharge from the authority of the *editor* who has sponsored the spectacle, so that a gladiator who is *missus* will return to his barracks to train for future engagements; it does not mean discharge from service as a gladiator'. The relief is Greek, dating to the second century AD (ibid., 487). The second example is a Roman bronze parade mask (BM Cat. Bronzes 877) of a woman dating to the second century AD. Most surprisingly of all was the announcement in 2000 by the Museum of London that the remains of a woman found in a Roman cemetery south of the Thames was believed to be that of the first female gladiator ever found. Despite several pieces of circumstantial evidence, however, confirmation that this woman was a gladiator has not been generally accepted (Murray 2003) and McCullough (2016) detail the argument against acceptance.

Despite the lack of evidence to suggest Roman women had much involvement in the military, there does seem to be a fair amount of evidence that some women were at least interested in more violent activities, such as being gladiators. The earliest reference to women engaging in this activity comes from a senatorial edict of AD 11 that bars women from the arena and a later, AD 19, edict that 'banned the descendants of senators and equestrians (as well as the wives of the latter) from fighting in the arena as gladiators' (ibid., 956). Additional evidence comes from ancient authors such as Tacitus who states in his *Annals* (15.32) that in the year AD 63, 'a number of gladiatorial shows, equal in magnificence to their predecessors, though more women of rank and senators disgraced themselves in the arena'. Suetonius confirms these 'gladiatorial shows', reporting that during the reign of the emperor Domitian (81–96) the emperor had gladiatorial displays at night which included both men and women gladiators, (*The Lives of the Caesars*, Domitian 4).

The upper-class women who volunteered as gladiators were undoubtedly mostly thrill-seekers, while the women pressed into the gladiatorial service were more likely slaves trying to save their own lives or desperate for the money they might earn. I suspect that the women who engaged in these violent pursuits were neither virgin, nor viragos nor amazons – but certainly adventurous.

Busa

An additional point, which is not usually mentioned in regard to women and the military, is their financial contribution. Livy (22.52.7) tells us that during the war with Hannibal (219–202 BC), Busa, a wealthy Apulian lady, gave provisions to soldiers, which caused the senate to vote her honours at the end of the war. In the Hellenistic world specifically, women who held public office were particularly involved in contributions to military causes (as well as public works). While it may have been that the women could sometimes designate where their money was to be spent, this was not always the case (Bielman 2015: 239–40).

Cleopatra

Returning to Cleopatra (full name Cleopatra VII Thea Philopator) (69–30 BC), we come to arguably the most famous women in Western civilization. While certainly not Roman, I include her here because of her important connection to Rome. Stories of her liaisons with Julius Caesar and Marc Antony have entertained audiences for centuries, and gossip about them undoubtedly entertained people at the time they occurred. She has been called an extraordinary beauty and has been portrayed on the screen by some astonishingly beautiful women.[25] She was, however, more than a great beauty, and her representations on coins reveal that of a strong, rather than exceptionally beautiful, face. Plutarch gives a glowing account of her charm, presence, even her voice and specifically her linguistic abilities. Rather than her beauty it seems more likely that she depended on her intelligence to gain her objectives. Although we have few primary sources for Cleopatra and know little of her actual education, it seems from Plutarch's description[26] that she was well educated, particularly in languages that must have been especially useful:

> For her beauty, as we are told was in itself not altogether incomparable, nor such as to strike those who saw her; but converse with her had an irresistible charm, and her presence, and the character which was somehow diffused about her behaviour towards others, had something stimulating about it. There was sweetness also in the tones of her voice; and her tongue, like an instrument of many strings, she could readily turn to whatever language she pleased, so that in her interviews with Barbarians she very seldom had need of an interpreter, but made her replies to most of them herself and unassisted, whether they were Ethiopians, Troglodytes, Hebrews, Arabians, Syrians, Medes or Parthians (Plutarch, *Antony* 27.2–4).

Although she was queen of Egypt, Cleopatra, like all the Ptolemies,[27] was in fact much more Macedonian by blood than Egyptian, but culturally even more Greek. Cleopatra's mother is unknown, making her maternal bloodline difficult to access (see Tyldesley 2008: 28–32).

We first hear of Cleopatra's military activities about 49 BC, when her brother/husband, Ptolemy XIII, backdated his reign by two years, thereby eliminating her from the throne and claiming sole rule for himself. She responded by raising a mercenary army to respond to Ptolemy's power grab. These Egyptian problems were happening during the height of the Roman Civil War in which Pompey and Julius Caesar were two of the major players and were vying for Egypt's (read Ptolemy's) loyalty. Although the Egyptians were not directly involved, they came to be after Ptolemy's supporters put Pompey to death in a particularly gruesome manner (Tyldesley 2008: 50–53).

It is impossible to write about Cleopatra without including the two most famous men in her life, the first of whom was Caesar, whose fame during his lifetime spread across the known world and remains even today. After Pompey's death, Caesar remained in Egypt and took it upon himself to settle the quarrel between brother and sister.

In theory, Ptolemy XIII had the upper hand as he controlled Alexandra, but Ptolemy was still only 13 years old, and it was in fact his advisors who were in control. Nevertheless, Cleopatra had advantages Ptolemy did not possess, and once again sex enters the picture. This time, sex arrived by way of the famous entrance of Cleopatra in the bed sack described by Plutarch (*Caesar* 49.1–2). As a result of Caesar taking sides with Cleopatra, what has been called the Alexandrian War (48–47 BC) broke out, pitting the forces of Caesar and Cleopatra (who kept a very low profile during all of this) against her brother. Although outnumbered, Caesar was ultimately triumphant and Ptolemy XIII was drowned in the Nile. Ptolemy XIII's younger brother, Ptolemy XIV, was placed on the throne next to Cleopatra, and they ruled jointly but in name only as Cleopatra had Caesar's backing along with his Roman legions. Thus, her desire to be sole ruler was never quite realised and what was recognised came about only with the help of Caesar who, although thirty-one years her senior, had become her lover and Egypt essentially became a Roman province.

In terms of Cleopatra's involvement in war, the Battle of Actium (2 September 31 BC), which took place in the Ionian Sea off the peninsula of Actium on the west coast of Greece, is by far the most prominent. The background to this battle is complicated and involved friendship, deceit, a marriage alliance, bigamy and besotted love, not to mention civil war, greed, betrayal, a weak man and a strong woman, all obfuscated by political propaganda – in other words: all the makings of a spectacular Hollywood movie.

Certainly, Antony's role was that of the commanding general, and he had had great success with land battles, but it was Cleopatra's decision to carry out the

battle at sea. Moreover, Cleopatra's contribution was anything but insignificant as she commanded a fleet of sixty ships. Additionally, she gave 200 of the 800 ships on their side, as well as 20,000 talents and resources for the entire army. Furthermore, it was the queen who gathered the Eastern allies that made the battle itself possible. It should also be remembered that it was on Cleopatra that Octavian declared war, not Antony, and although this was clearly a political move on Octavian's part, it was she who was declared the enemy (Dio Cassius 50.4.3–6). Despite Antony's attempts at sending her to safety, she insisted on remaining on the war ground (Plutarch, *Antony* 56).

Nevertheless, when it was nearly certain that the battle was lost, both Antony and Cleopatra left the scene and that has generally been equated with cowardice, but Jones suggests it may have been a strategy to break out of Octavian's blockade (P. Jones 2006: 154).

Cleopatra's life has been the subject of countless books and articles, both scholarly and frivolous. The theatrical presentations alone have obscured her true contributions, but there should be no question that she was an extremely capable woman and leader. A recent biography of her (Schiff 2010) presents the many sides of this mesmerising woman, warts and all. She was a woman who fought for the throne she believed was rightfully hers, and who is arguably, if not the most beautiful, the most famous of all women in Western history.

The Celts

Celtic women stand in stark contrast to their Roman sisters. The classical authors attest that women are closely connected with warfare in the Celtic world, and the fighting spirit and ferocity of Celtic women is noted on numerous occasions. Ammianus Marcellinus describes how difficult it would be to defeat a Celt, particularly if he called in the aid of his wife, as she was stronger than he was. His physical description of fighting Celtic women is quite dramatic: 'with flashing eyes; least of all when she swells her neck and gnashes her teeth, and poising her huge white arms, proceeds to rain punches mingled with kicks, like shots discharged by the twisted cords of a catapult' (Ammianus Marcellinus 15.12.1); Strabo tells us the entire race was 'war-mad' (4.4.2); and, according to Diodorus Siculus, 'The women of the Gauls are not only like the men in their great stature but they are a match for them in courage as well' (5.32). We should also remember that among the Celts warfare, sport and ritual were closely related. We can see aspects of ritual in warfare in their penchant to go into battle naked, painting their bodies with woad for a blue affect, liming their hair, perhaps in the wearing of torcs, and the great noise made by the women who stood on the side lines of a battle encouraging their men and thereby, to some degree, participating in the battle.

Queen Teuta

In 231 BC Agon, king of Illyria, who ruled a number of tribes (some perhaps Celtic) that lived along the Illyrian coast, died – according to Polybius (2.3–12) – of an attack of pleurisy brought on by 'carousals and other convivial excesses' that occurred following a successful attack against the Aetolians (a Greek people).[28] This was an area of some Celtic influence mixed with Illyrian (a people about whom we know little and what we do know is muddled),[29] and Agron's name may represent the masculine version of the goddess Agroná. Agron's widow, Queen Teuta, became regent not for her own son but for Agron's infant son, Pinnes, by his first marriage (Wilkes 1992: 167). P. Ellis (1996: 81) suggests Teuta was either of the Celtic ruling class or a Celto-Illyrian, but she does seem to be the first even semi-Celtic woman to whom we can give a name. She may have had a Celtic name or title that meant 'the people's queen', from *teutates* – 'people'.[30]

Teuta took over as ruler and commander of the army and allowed individual ships to engage in universal plunder, which had been their long-time habit (Polybius 2.4, 8).

Teuta put down a number of uprisings by her own Illyrians, attacked Greek settlements and extended her holdings by attacking Epirus but later made a truce with the Epirots. When some Roman citizens were harmed, Rome sent out an ambassador who, in an arrogant manner, told her to rein back her aggression. As the ambassador was boarding his boat to return home, Teuta had him killed. Rome in turn sent 200 ships and ground troops who summarily destroyed her cities. She gave way, agreed to pay reparations, promised to behave and cease her attacks on Epirus. With that and the Roman victory celebration in 228 BC, Teuta falls into obscurity (Polybius 2.8–9, 11–12).

We find many reports among the Celts of women involved but not actually fighting. Nevertheless, Celtic literature and mythology are replete with examples of the powerful woman and the female warrior. Tacitus was appalled at women on the battlefield, but he did recognise the strength of non-Roman women:

> Tradition relates that some lost or losing battles have been restored by the women, by the incessance of their prayers and by opposing their breast; for so it brought home to the men that captivity, which they dread much more intolerably on their women's account, is close at hand: it follows that the loyalty of those tribes is more effectually guaranteed from whom, among other hostages, maids of high birth have been extracted.
>
> Further, they conceive that in woman is a certain uncanny and prophetic sense: and so they neither scorn to consult them nor slight their answers. (Tacitus, *Germania* 8).

Surely there would be no reason to outlaw the practice of women going into battle if they did not go into battle. As we will soon see, evidence suggests that lower-class women, most likely slaves and war captives, were used in battle either as soldiers or servants of warriors, and it was the visit of St Adomnan in AD 697 to Ireland, and the law tract *Cáin Adomnáin* (Law of Adamnán) attributed to him, that outlawed this practice (Ryan 1936). It was not until the Law of Adamnán, probably written in the ninth century but based on seventh- or eighth-century documents, where we are told that women warriors were no longer known in Celtic countries.

Queen Cartimandua

A great deal has been written (much of it fantasy) about Boudica, the best-known Celtic queen of Britain, but less has been written about her near contemporary and the less dramatic Queen Cartimandua. Although Cartimandua was not the military leader Boudica was, both deserve attention as each played roles that were not only historic, but also point to the levels to which women could rise in the Celtic world. Moreover, each woman dealt with military activities in their own way. Tacitus is our major source for both of these women.

Unlike Boudica, who occupied the throne for her young daughters at the death of her husband, Prasutagus, about AD 60, Cartimandua was, in her own right, queen of the Brigantes (one of the largest of the British tribes) from at least AD 43 to 69. The Brigantes tribe was located in northern Britain, which probably included five of the northern counties; these counties were, still even in the middle of the last century, thought of as distinctive. In 1954 Richmond said this area 'is in a marked degree prone to regionalism. No one well acquainted with its people can for one moment mistake the local accents' (Richmond 1954: 44), and this regionalism was recognised even in ancient times. The northeastern occupation of the Brigantes provided a buffer zone between Roman Britain and the Picts of Scotland.

Cartimandua came from a noble family described by Tacitus as *pollens nobilitate*. Adding to her power was her capture, through treachery, of King Caratacus of the Silure tribe in AD 47, apparently after he had come to her for assistance. Tacitus describes her as having the 'wanton spirit which success breeds' (*Histories* 3.45). The Brigantes had become a client state of the Romans during the early days of the Roman occupation of Britain, and she was a loyal ally – most likely because it was to her benefit rather than for a love of Rome. This gave her an advantage over other tribes as she had the power of Rome to back her when disputes arose. Perhaps because of this relationship with Rome, Cartimandua never seems to have actually gone into battle herself – she depended on the Roman army to do her fighting. Nevertheless, she, along with her husband, Venutius, was in command.

Although Venutius was Cartimandua's consort, he did not hold the title of king but may have been the ruler of a tribe north of the Brigantes (Webster

1985: 14). Tacitus tells us that Venutius, who greatly disliked the Romans, had the best military knowledge second only to Caratacus among the British leaders (Tacitus, *Annals* 12.40). It was Caratacus' military prowess that had given him notable success against the Romans and had placed him at the pinnacle of British leadership (ibid., 12.33). Cartimandua's reputation with the Romans was also quite high, particularly after AD 47 when she captured Caratacus and then turned him over to the Romans.

There was great enmity between Cartimandua and Venutius, who seems to have had a personal resentment towards her – and for her part she seems to have despised him. In AD 53, Cartimandua divorced Venutius in favour of his squire Vellocatus, with whom she shared her throne, something she had not done with Venutius. The result of this scandalous act caused Venutius to gain the support of the Brigantes and required Cartimandua to turn to the Romans for protection. Ultimately, she had to be rescued and her throne passed to Venutius (Tacitus, *Histories* 3.45).

Although Venutius did not hold the title of king during his marriage to Cartimandua, he probably was recognised as such. Evidence for this may come from coins marked 'Carti-Ve' that were thought to belong to the reign of Cartimandua. Allen (1944: 42–43) suggested that the Ve stands for Vellocatus, however, Richmond (1954, fn. 32) disagreed and believed that Ve must have stood for Venutius on the grounds of the early dates. More recently, both theories have been questioned (Howarth 2008: 46).

The recognition of Cartimandua's position may not have lasted too long as she did not long appear on coins, and her image on coins may have only coincided with the time before she became a Roman client. It does not appear that Rome allowed this coin privilege to its clients (Richmond 1954: 47). The full story of her ascendancy to power is lost to us, but was most likely set down by Tacitus in a book of his *Annals* that is no longer extant.

The Roman alliance with Cartimandua was advantageous to both sides. For Rome, it had a powerful ally to the north that held back a war on two fronts once unrest in the south by the Druids had taken on momentum. For her, Roman assistance allowed her to prevail over quarrels within the Brigantes themselves (ibid., 48).

The case of Cartimandua presents us with two difficult questions that can only be answered with conjecture. The first is why did she not side with Caratacus, and the second, why did she divorce her husband and place her lover, who seems to have had not much more than his body to recommend him, on the throne?

The first question is perhaps the easiest to answer. Webster (1985: 32) reminds us that at this time there was no sense of nationhood, and that among the British tribes there was as much hatred against each other as against the Romans. Ruling over the many Brigantian tribes could not have been easy, but she did. Had she

allied herself with Caratacus her position might well have been diminished, but remaining as Rome's ally she maintained her position as queen.

As to the reason for her placing Vellocatus on the throne, no satisfactory answer can be found. Cartimandua's earlier decisions show her to be a woman of great ability and political shrewdness, but this decision makes her appear silly and foolish, playing into the hands of male leaders who believed women lack the judgement that it takes to be a leader. But love (or perhaps just lust) has caused more than one leader (both male and female) to act injudiciously. Perhaps Tacitus' assessment that 'the queen's passion for him and by her savage spirit', (Tacitus, *Histories* 3.45) was correct.

In assessing Cartimandua, she does not fall into the more usual categories that we have seen or will see. She was neither the typical virago engaging in dramatic actions, nor did she engage in amazonian type actions. She has no claim to virginity, but it does appear that sex played a role in her actions. Nevertheless, she was queen in her own right and seems to have worked for her people even when it meant aligning with the subjugating Romans and not with the most powerful of the local kings, Caratacus.

Boudica

Turning to Boudica,[31] it must be admitted that our knowledge of the woman herself is not extensive. Miranda Green has suggested that 'We cannot even be certain that Boudica existed at all; she could have been an imaginary figure, invented by classical historians as a means of exploring ideas of barbarism and its antidote' (2006: xvi–xvii). Based on what we do know, I cannot give credence to this suggestion.

According to Roman historians, we know that early in the occupation of Britain by Rome, the Iceni tribe, under its king Prasutagus, became a client state. After the death of Prasutagus, his wife, Boudica, became regent for their two daughters to whom Prasutagus had left as rulers of the Iceni jointly with Rome – a common practice since the Iceni were already a client state. When the Romans abused Boudica and ravished her young daughters, Boudica, in AD 61, gathered an army that consisted of not only the Iceni, but also the Trinovantes, (Tacitus, *Annals* 14.31) and led a rebellion the likes of which the Romans had never experienced. During one battle of the rebellion, Tacitus tells us that Suetonius Paulinius admonished his troops to take heart and to ignore the din made by the barbarians and their empty threats, and that there were more women than men in the enemy ranks (ibid., 14.36). Conversely, Boudica, while gathering troops, shouted that 'it was customary … with Britons to fight under female captaincy' (ibid., 14.35). Tacitus, no admirer of women leading men into battle – or even ruling over them, acknowledged her as the one in command and that she was 'a woman of royal blood – they recognise no distinction of sex among their rulers' (Tacitus, *Agricola* 16).

Boudica led her army in a number of battles and dealt savagely with her captives. It is said that she sacrificed her captives to the goddess Andraste (see Chapter 2 and Dio Cassius 62.6). Dio Cassius (62.2) claims Boudica raised an army of 120,000 men, but later raises the number to 230,000 (62.9). He describes Boudica as 'a Briton woman of the royal family and possessed of greater intelligence than often belongs to women'. While Dio's numbers may be inflated,[32] it surely indicates that those who saw her army saw it as immense. At the battles of Camulodunum, Verlamium and Londinium, Boudica's army is said to have killed 70,000 Romans, but in the final battle of the uprising 80,000 Britons were killed (Rankin 1987: 222–23). She was ruthless, showed no mercy, and was willing to die for her cause. Boudica was the personification of a virago! If, as Green has suggested, Boudica was an invention of the classical authors, they went into great detail to justify their account of her. What does give credence to Green's suggestion is the fact that later historians of Britain, the Venerable Bede and Nennius, mention neither her nor any of the British leaders in their works, but do refer to the uprising for which she was responsible. Geoffrey of Monmouth is also silent on the subject of Boudica.

Two variants of Boudica's death, which are not necessarily exclusive, have come down to us. Tacitus (*Annals* 37) tells us that she 'ended her days by Poison', but Dio Cassius says she 'fell sick and died'. He goes on to say: 'The Britons mourned her deeply and gave her a costly burial' (62.12). Tacitus is uncommunicative on the point of her burial.

The last word on Boudica comes from the sixth-century British writer and monk Gildas (ca. AD 500–570), who pre-dates both Nennius and Bede, and who wrote *De Excidio Britanniae* (*On the Ruin of Britain*), in which he addresses secular and ecclesiastical abuses. As so few texts from this time have survived, it is considered a very important work. In Part One of the work, Gildas refers to a rebellion led by a 'treacherous lioness', which has frequently been considered to be Boudica and her uprising. However, Professor Hugh Williams, in the notes to his 1899 translation of Gildas' treatise, refutes this contention. He bases his objection on the dates, which conflict with other events and that 'Gildas shows a fondness elsewhere for the term "lioness", as applied to a country' (1899: 20, fn. 1). It is unfortunate that we have nothing with which to compare Gildas on this point, but to reject the point based on a 'fondness' for words seems rather weak.

Chiomara

There are a number of stories related to the ill-treatment by the Romans, but one of the most telling of both sides is that of Chiomara wife of Ortiagon, a Celtic chief of the Tolistobogii tribe located in Anatolia. After her capture during a battle between the Romans and Galatians in 189 BC, a Roman centurion raped

her. Upon learning of her high position, the centurion demanded ransom for her. The sum was agreed upon and he returned her. But as he was picking up the gold, Chiomara gave a nod to one of her soldiers who then cut off the centurion's head. She then wrapped up his head in her cloak (it was the custom of Celts to keep the heads of their enemies), and she brought it to her husband. Plutarch relates some of their conversation that Rankin (1987:247) points out fits well into Celtic directness and the brevity of the Irish as seen in the Irish sagas:

> 'A noble thing, dear wife, is fidelity.'
>
> 'Yes,' said she 'but it is a nobler thing that only one man be alive who has been intimate with me.' (Plutarch, *Bravery of Women* 258).

Onomaris

Onomaris is another woman among the Celts about whom we know captivatingly little. She is said to have been a leader of the Galatians (a Gaulish-Celtic tribe, perhaps more specifically the Scordisci who Ammianus Marcellinus reports were savage and cruel).[33] The brief and only reference of her comes from the anonymous and little known *Tractatus De Mulieribus*:

> Onomaris, one of the distinguished Galatians. Her fellow tribesmen were oppressed by scarcity and sought to flee their land. They offered to obey whoever wanted to lead them, and when none of the men was willing, Onomaris placed all their property in common and led the emigration, with many people, approximately ... She crossed the Ister and after defeating the local inhabitants in battle, ruled over the land (Gera 1997: 10–11).

Even her name is problematic. The second element *maris*, which appears to be Greek, could also be the common and well-established Gaulish meaning 'great' (Gera 1997: 22), but according to D. Ellis Evans (1999: 32) there are similar forms in Thracian and the first element also has more than one option. Evans gives us a number of possibilities but fails to give a conclusive one and ends his discussion of the name with, 'It *is* idle speculation to try to perceive both the origin and, worse, the etymological "meaning" of this particular proper name' [original emphasis] (ibid., 33).

If there is no definitive etymology for the name, what can we conclude about the story itself? Koch (2006: 4: 1396) says this is possibly a true story, and if it is true implies a time when Celtic women held political leadership much as we saw with Boudica, Cartimandua, Veleda and even the legendary Medb.

Evans (1999: 36–37) takes the view that the *Tractatus De Mulieribus* is itself a relating of heroic deeds carried out by Celtic women, and he associates it with heroic storytelling in the fashion of *Táin Bó Cúalnge*. Gera (1997: 223) rejects the view put forth by the early twentieth-century scholar Camille Jullian, who wrote (1906: 123–24) that Onomaris was:

> *simplement la transformation en femme de quelque fétiche, de quelque virago mythique du peuple, ou même, plutôt, de sa grand déesse, la Victoire ou la Bellone des Scordisques.* [simply the transformation into a woman of some kind of fetish, a kind of mythical virago of the people, or even, rather, of the great goddess of Victory or War of the Scordisci. Translation KJB]

Moreover, because none of the other women in *De Mulieribus* has supernatural powers, Gera rejects the idea that Onomaris did. Although Gera suggests she may have risen in social status, I suspect this is only a theory as the passage clearly states she was a 'distinguished Galatian'. From the short passage we can, however, discern two possibilities. First, Galatian was the name given to the Celts that crossed the Danube River (Ister being the old name) into Greece and Asia Minor about the third century BC. Second Galatian was probably also the name of the tribe that invaded Italy and the Balkans in the fourth century. (See Gera 1997: 219–21.)

We do not know with confidence the source of this story – Timaeus, Posidonius and Phlegon have all been suggested. However, all of this leaves us with a tiny sampling of what seems like an intriguing story, but not enough to make anything substantial of it. Nevertheless, Onomaris is different from other women we have seen, and will see, in that she does not become a leader because of the loss of her husband, or to temporarily take power while her son grows to maturity, *she takes power because no man will*. Her tribe follows her *because no one else will lead*. Jullian was correct when he referred to her as 'some kind of virago' – mythical or not.

Although Boudica is by far the best known of Celtic fighting women, women going into battle alongside men may, in fact, have been the norm much as they followed men in their wanderings around southeastern Europe. But most women had much less glorious roles than what we know of Boudica or the legendary Medb. Ammianus Marcellinus (fourth century AD) spent time among the Gauls and gives us a first-hand description of them, commenting on the aggressiveness of the women (15.12.1). Still judging from the text of the later *Cáin Adomnáin*, mentioned earlier, which came out of the Synod of Biri in AD 697,[34] it was not until after the birth of Christ and the time of Adamnán that women were freed from bondage and slavery as well as forbidding the employment of women in battle. Paragraph 2 of the

Cáin Adomnáin uses the word *cumalach* 'female bond servants', and their lives are then described (Meyer 1905: 2). Paragraph 3 of the same document reveals to us how women were used in battle prior the prohibition set down by Adamnán:

> The work which the best of women had to do, was to go to battle and battlefield, encounter and camping, fighting and hosting, wounding and slaying. On one side of her she would carry her bag of provisions, on the other her babe. Her wooden pole upon her back. Thirty feet long it was, and had at one end an iron hook, which she would thrust into the tress of some woman in the opposite battalion. Her husband behind her, carrying a fence-stake in his hand, and flogging her on to battle. (*Cáin Adomnáin* §3, Meyer 1905: 2).

Even in *The Táin*, when Fergus is calculating all that are in their war camp, he adds, 'not counting the general rabble or the young or the women' (Kinsella 1970: 67). This passage also seems to place women at the bottom of the social order. Ryan (1936: 271) concluded that most of the women on the battlefield were quite likely slaves forced into battle, Paragraph 52 of *Cáin Adomnáin* states it is a crime '[i]f women be employed in an assault or in a host or fight' (Meyer 1905: 33).

Despite this, there is little doubt that a higher class of women had military obligations as noted in the Laws. First, we must note that there were several circumstances in which Irish women could inherit property as set down in the *Annals of Ulster*. Of interest for us here is that:

> women may inherit as *banchomarbai* from a woman, namely when the land is hers by right of 'hand and thigh', and she has no sons. Given the right of a daughter to inherit from her father, this is a further privilege ... The limitations are as usual. She inherits only a life-interest, and only half the land, unless she accepts liability for military service (Dillon 1936: 140).

While still on the subject of Celts, let us return to *Macha Mongruad* the second of the three Machas discussed in Chapter 2. As we saw, she was the sole heir to Aed one of the three kings who at one time ruled Ireland in turn. The reader will remember that after Aed died, his daughter, Macha, was refused her turn by the other two kings. She defeated them in battle, and she then ruled for seven years. When the sons of the second king, Dithorba, all refused Macha's turn as sovereign, she again took to the battlefield and defeated all five sons. Finally, she married the remaining claimant, Cimbáeth, whom she made chief

of her mercenaries. She then decided to visit the five defeated brothers in the guise of a leper. They in turn decide to lie with her, but she binds each of them, enslaves them, and has them build a ramp for the fortress of Emain Macha. I have returned to her because F. Kelly (1988: 71) has stated that there is no historical parallel to a sovereign queen in Ireland such as Medb. P. Ellis (1996: 79), however, states that Kelly has 'ignor[ed] the annals which record that in 377 BC Macha Mong Ruadh (Macha of the Red Hair) became queen of all Ireland. She is said to have reigned for seven years.' Ellis admits that few historians like to rely on such early chronicles and most consider this evidence mythical. Nevertheless, he believes it should be considered and because so much of the Irish evidence is confusing, I include it here for contemplation.

The Germanic People

Although we have no specific Germanic women to consider, we do know, particularly from Roman authors, that women took part in battles and engaged in divinations that predicted the result of battles.

In 102 BC the Roman general Caius Marius engaged in battle with the Ambrones, a Teutonic tribe, at Aquae Sextiae (modern Aix-en-Provence). The Romans cut down the Ambrones until the river was filled with blood and the Romans reached the Ambrones camp (Plutarch, *Caius Marius* 19).

> Here the women met them, swords and axes in their hands, and with hideous shrieks of rage tried to drive back fugitives and pursuers alike, the fugitives as traitors, and the pursuers as foes; they mixed themselves up with the combatants, with bare hands tore away the shields of the Romans or grasped their swords, and endured wounds and mutilations, their fierce spirits unvanquished to the end (ibid., 19.7).

Co-general and co-consul with Caius Marius, Quintus Lutatius Catulus relates another encounter between Marius' army and the Cimbri, in which he tells of the great ability of the Roman soldiers and the reaction of women at the defeat of their men:

> The women, in black garments, stood at the waggons and slew the fugitives – their husbands or brothers or fathers, they strangled their little children and cast them beneath the wheels of the waggons or the feet of the cattle, and then cut their own throats. It is said that one woman hung dangling from the tip of a waggon-pole, with her children tied to either ankle (ibid., 27.2).

From another source, Strabo, we learn that the Cimbri tribe had priestesses who contributed to what was undoubtedly encouragement to the troops by their prophecies. These women:

> were grey-haired, clad in white, with flaxen cloaks fastened on with clasps, girt with girdles of bronze, and bare-footed; now sword in hand these priestesses would meet with the prisoners of war throughout the camp, and having first crowned them with wreaths would lead them to a brazen vessel of about twenty amphorae; and they had a raised platform which the priestess would mount, and then, bending over the kettle, would cut the throat of each prisoner after he had been lifted up; and from the blood that poured forth into the vessel some of the priestesses would draw a prophecy, while still others would split open the body and from an inspection of the entrails would utter a prophecy of victory for their own people; and during the battles they would beat on the hides that were stretched over the wicker-bodies of the wagons and in this way produce an unearthly noise (Strabo, *Geography* 7.2.3).

We thus see that both priestesses and even ordinary women were able to take up arms and perform the most repugnant deeds.

Palmyra

By the beginning of the first millennium AD the Roman Empire was so vast that one would expect problems to arise within its borders. While part of the Empire during the third century AD, Palmyra, an Arab country, technically was just outside the Indo-European-speaking world in what is today Syria. It became part of the Indo-European world around AD 114, when Palmyra was annexed by Rome. Because of its strategic location between Rome and the Persian Empire, the city had grown quite large and developed into a very significant trading city, as well as being a vital part of what came to be known as the Silk Road. Furthermore, it had annexed large swaths of territory in the East, including Egypt, and perhaps because of this Palmyra was given considerable autonomy by the Emperor Hadrian.

Zenobia

It is in Palmyra that we find another powerful female warrior leader who took power at the death of her husband. Our knowledge of Zenobia, ruler of Palmyra (267 – ca. 275), comes primarily from the *Scriptores Historiae Augustae* (*SHA*).

Latin inscriptions call her Septimia Zenobia, while she is known as Bat Zabbi in Aramaic (with the usual variety of spellings). In the *SHA* her physical appearance is described in great detail, and she is said to have held power for her sons Herennianus and Timolaus.

The problem with the description is that due to the general consensus of some current scholarship, the *SHA* is now considered a work of fiction by a single author as opposed to the work of several authors who wrote biographies of prominent personages as has previously been believed (see, e.g., Syme 1983; Rohrbacher 2013). Should we then throw out this work completely, or attempt to use what at least seems possibly true? I have chosen the latter course despite the thinness of the material that is left to us. Unfortunately, because of the dependency on the *SHA*, all other descriptions of Zenobia, including that of Gibbon (1882:1: 350–58), are clearly derivative of this earlier description. Nevertheless, there are a few things about this woman that can be said definitely (or almost) that allows us to outline an image of her.

Although we know little of her early life, she was most likely of Arabic descent, possibly Nabataean. Because of her Aramaic name, Aramaic was undoubtedly her native language (Vaughan 1967). Her life does not really come into focus until she became the second wife of Odaenathus, a man of distinction and note in Palmyra. He came from an aristocratic family, was held in high regard by Rome, and one of his ancestors had been made a citizen of Rome by Emperor Septimius Severus before blanket citizenship was given to all the freeborn inhabitants in the empire in AD 212 by the Edict of Caracalla. Although we know nothing of Zenobia's family, she is said to have come from a wealthy Arab merchant family, and she claimed ancestry through the Ptolemies and many other notable rulers. Still, it seems unlikely that a man of Odaenathus' position would have married someone outside his prominent circle. Before his death, she held her husband's confidence and seems to have ruled with him. Therefore, her taking up the reins of power in AD 267 – a year after the murder of her husband and his son, Herodianus, by his first marriage – did not seem extraordinary or unusual for the Arab world at this period.[35] Nevertheless, there are those who felt she was responsible for the deaths of her husband and his son Herodianus. Soon after their deaths, in AD 268 Zenobia granted her own son, Vabalathus, the title *Rex Regum*, and three years later she took the title *Augusta* for herself, placing herself on a par with that of the Roman emperor and, stressing her political agenda, declared the independence of Palmyra (Senden 2009).

Zenobia governed Syria from about AD 267 to 275. She led her armies against the Roman armies of emperors Claudius and Aurelian, but her first step was to consolidate her power and expand Palmyra's borders towards Persia and northwest into Asia Minor, while at that time maintaining good Roman relations.

Fantham *et al.* (1994: 389) write that because she was a woman (a foreign woman at that) and had managed to defeat Roman forces before she was captured, it was necessary for her to be made into a worthy opponent, and thus Aurelian brought her to Rome in chains. While this may be true, the fact that she *was* a worthy opponent is de-emphasised. But in a supposed letter from Aurelian to the Senate he protests that he should not be faulted for taking a woman captive, as his detractors should 'know what manner of woman she is, how wise in counsels, how steadfast in plans, how firm toward the soldiers, how generous when necessity calls, and how stern when discipline demands' (*SHA: Thirty Pretenders* 30.5).

The Zenobian coinage is a source that puts us on firmer ground, at least for establishing her as an actual person. Her coins are rare, only ten to fifteen are known, because her coins seem to have been recast, but we do know that her coins, 'Antoniniani', were originally cast at mints in Antioch, Alexandria and Emesa. On some coins she appears in profile, facing to the right on the obverse, with S ZENOBIA AUG engraved. On the reverse, the goddess Juno appears with a peacock and JUNO REGINA. On other coins she appears with her son Vabalathus and the inscription is AUGG, referring to the two Augusti – Zenobia and Vabalathus (Senden 2009: 139). The last of the Zenobian coins seem to have been struck no later than AD 272, and it was soon after that Zenobia and her son were paraded through Rome (supposedly in gold chains) at the triumph of Aurelian. Thereafter, the beautiful and audacious Zenobia passed into historic oblivion.

Coinage establishes Zenobia as an actual person and clearly a leader of Palmyra in the last quarter of the third century AD. However, beyond this we need to be extremely cautious when using other sources.

The Goths

Before we move on to the post-Roman period, one last group should be mentioned. About AD 551 the Roman bureaucrat Jordanes, now residing in Constantinople, wrote *De origine actibusque Getarum* (*The Origin and Deeds of the Goths*) in which he (who was a Goth himself) tells us of the bravery of the Gothic women after the death of the Gothic king Tanausis (see Mierow 1915). This was a period of turmoil and while his successors were involved in battle, a neighbouring tribe attempted to carry off some of the Gothic women. Their husbands, however, had trained these women in resistance. Of particular note were their leaders Marpesia and Lampeto:

> When they had won this victory, they were inspired with great daring. Mutually encouraging each other, they took up arms and

chose two of the bolder, Lampeto and Marpesia to act as their leaders. While they were in command, they cast lots both for the defence of their own country and the devastation of other lands. So Lampeto remained to guard their native land and Marpesia took a company of women and led this novel army into Asia. After conquering various tribes in war and making others their allies by treaties, she came to the Caucasus. There she remained for some time and gave the place the name Rock of Marpesia (Mierow 1915: 63–64).

Zenobia and the Goths take us through the Roman period and through the time when we are heavily dependent on the classical authors for our source material. In the next chapter sources for women's military actions are more prevalent, we will be less dependent on legend and classical authors but more dependent on Christian sources that often sanitise events and redact the written record. We will see, however, that the reasons the women profiled take up the sword are most often the same as those women in earlier antiquity.

Chapter 6

Historical Women from the Roman Period to 1492

For our purposes we will use, as is commonly done, the date of AD 476 as the fall of Rome, but this does not take into account the splitting of the Empire into Western and Eastern parts around AD 330, from which time the Eastern portion was known as the Byzantine Empire. The Byzantine Empire lasted for nearly a thousand years after the 'fall of Rome', until 1453 when Constantinople fell to the Ottoman Turks. Nevertheless, we cannot overlook the eastern portion of the empire, which was initially ruled by Constantine I. Constantine, a man of no small abilities (or ego), had not only moved the capital of the empire east to the city of Byzantium on the Bosporus, but also renamed it for himself. Prior to this grand gesture, Constantine had already secured his place in history with another grand gesture – his conversion to Christianity and the issuance of the Edict of Milan in 313. This edict made the empire neutral on the subject of religion, but later in 380 the Edict of Thessalonica made the Roman Empire a Christian state by declaring Nicene Christianity the official religion. These two events – the conversion of Rome to Christianity and the fall of Rome – provide a suitable division in the record of women we will consider in this study.

As something of a segue from the fall of the Roman Empire to Byzantium and the early Middle Ages, often referred to as the Dark Ages, we should cast an eye to the Middle East where another empire was now developing. This, of course, was the rise of Islam. Quite briefly, Muhammad (ca. 570–632) was presented with revelations, beginning in 610, from the archangel Gabriel. These revelations were set down and codified in the Qur'an, which became the Muslim holy book, and Muhammad set out to spread its message. After his death in 632, his followers continued Muhammad's efforts proselytising the Arab world. By the year 1000 Islam had become not only the dominant religion of the Arab Peninsula, but had spread well beyond it. Islam brought with it Islamic culture that included a flourishing of literature, art and architecture. Along with the cultural aspects that enriched both the Middle East and Europe came a good deal of conflict between the new Islamic world and the newly established Christian world. Not surprisingly, women were involved even from the earliest days. The great Muslim biographer, Abu Abdullah Muhammad

Ibn Sa'd, tells us of one such woman, Nusayba bint Ka'b (Umm 'Umara), who, along with a number of others, joined a *jihad*, or holy war, to fight for Muhammad. Most notably she fought with her husband and two sons at the Battle of Uhud in 625 where she was wounded many times. Earlier in 632 at the Battle of Yamama, her hand was cut off in battle (Ibn Sa'd 1995: 270–73).

Byzantium

Unlike the empresses of the Western Roman Empire, many of the empresses of Byzantium are well known and a number of them appear on coins. Several of these empresses ruled in their own right, and we will see that the reasons they came to the throne were much like what we have seen previously. On a number of occasions, it was an empress who selected the next emperor, but because it was generally believed that women were incapable of commanding an army, none took to the battlefield or even led the army as its leader. Nevertheless, the Empress Irene (753–802), also known as Irene Sarantapechaina, dealt with the military in a manner that stands out from her sister empresses.

Empress Irene
At the death of her husband, the Emperor Leo IV (775–780), from unclear causes, although carbuncles on his head due to wearing a heavy crown have been claimed (Herrin 2001: 75), the Empress Irene ('peace'), who was at the time only about 25 years old, followed a familiar pattern and became regent for her 9-year-old son Constantine VI. As was the Byzantine custom, his father had already crowned the boy emperor, and now he and his mother reigned as joint rulers. Owing to an attempted revolt by Leo's younger half-brothers, it was essential that Irene firmly establish her authority, leading her to choose a number of military commanders from her own household that consisted largely of eunuchs.

A major issue at this time in Byzantium was the worship of icons. In 754 Constantine V, Irene's father-in-law, had outlawed this practice, establishing what was referred to as iconoclasm. There were, however, a substantial number of iconodules (as the supporters of icon worship were called) remaining in the empire and Irene numbered among them. In 784 Irene organised an ecumenical council to eliminate iconoclasm. Unfortunately, she did not do the necessary groundwork and found significant opposition from within the army. The council was a disaster, and she had to retreat. Not to be overpowered in her efforts, she removed the professional army and had the troops sent home. She then appointed military leaders loyal to her. By 787 she felt secure enough in her position to organise a second meeting of the Seventh Ecumenical Council at Nicaea, perhaps choosing this venue in an attempt to remind the attendees of the council of 325 organised by Constantine I. At this second meeting, she was

successful; the worship of icons was once again allowed, and Irene was praised for her victory (Herrin 2001).

Irene never led an army and, moreover, she was seriously disliked by much of the army. Her method of dealing with this institution essential to the empire was to eliminate those units she considered unfaithful and appoint military commanders she reasoned loyal – unfortunately this did not always bring about the desired results. After a disastrous intervention in Sicily ending with her appointed governor defecting to the Arabs, she sent a sizeable navy commanded by one of her eunuch aides to re-establish order. She seems to have mistrusted the army as a whole, resulting in her paying a great amount of tribute to the Arabs (ibid., 79). Nevertheless, because of this tribute, the outer provinces were able to avoid invasion by the Arabs (Runciman 1974: 11). In 788 she found her empire under siege on three sides – a basic military blunder that highlighted her limitations. Because the army needed a visible leader, she allowed her son Constantine, now 19, to step into his rightful position as emperor; but the empress was not yet outdone. In 790 a large earthquake required the administration to move out of Constantinople into a country palace, and this gave Irene the opportunity to arrest and imprison Constantine's advisors. She had both the advisors and her son, the emperor, flogged. This situation made the support of the army imperative and although Irene had appointed commanders she believed she could trust, the army itself took sides with the young emperor. Unfortunately for Constantine he proved to be incompetent as a leader, and his mother again resumed power.

There is little question that her actions both militarily and politically were for her own benefit and not for her son's. This was ultimately made clear by having her son's eyes gouged out resulting in his death shortly after. Further pressing the point of her reigning without her son as co-emperor was made by the minting of a gold solidus with Irene's portrait on both sides holding both the orb and sceptre, in Constantinople in 797–802 (the period of her singular rule). She is identified on the coin as *basileus* (emperor) not *basilissa* or *basilis* (empress). This is in contrast to earlier coins that show her with her son and Leo III, Constantine V and Leo IV (Herrin 2001, figs. 1a, b, c).

Many, if not most, of the queens who became regents for their sons worked to maintain authority for the benefit of their sons, but this was not the case with this virago empress. Irene was ultimately deposed by her son's successor, the Emperor Nicephorus, and she ended her days on the island of Lesbos – it is said, spinning wool to earn her living. Although she did not lead the army, by dent of her position she controlled it much of the time and manipulated it almost all the time. The payment of tribute to the Arabs and Bulgars kept the troops out of the field of battle and was probably cheaper than maintaining an army. Despite her deeds that many would consider reprehensible, the Orthodox Church canonised her for restoring the worship of icons (Runciman 1974: 11).

The Slavs

Princess Olga

From the neighbouring Slavic people, we are fortunate to have the *Primary Chronicle* (Cross ans Sherbowitz-Wetzor 1953) that places the entry of Russians into history during the time of the Byzantine Emperor Meihad III (842). It is from this chronicle that we are given the major example of a Slavic woman who took up arms in Russia – the Princess Olga. As with other figures of this period, the sources for Olga (ca. 890–969) do not always agree. Olga may have been a Slav with a Scandinavian name, or a Varangian (Scandinavian). What we do know is that in about 903 she married Prince Igor (ca. 913–945) the son of Rurik, the founder of Russia. Nora Chadwick (1946: 21–22) concludes that based on Olga's name and the fact that Rurik had given his son Igor to Oleg for fosterage; she may also have been the daughter of Oleg, Rurik's successor. Because of this, a marriage of Igor to Oleg's daughter would not have been out of the question.

In 945 the Derevlyanins, an East Slavic tribe, murdered Olga's husband Prince Igor, and predictably she took power in the name of their young son Svyatoslav. The Derevlyanins sent a delegation of twenty to Olga in order to persuade her to marry their Prince Mal. In defence of the murder of Prince Igor, the Derevlyanins told Olga that they had killed Igor because of the excessive tribute he had exacted from them. Olga received the delegation, but rather than accept the proposal, she exacted her revenge in a particularly savage manner – she had them buried alive in a pit. When the Derevlyanins foolishly sent a second delegation, she had them enclosed in a hut and set fire to it. She then took her army and laid siege to the town of Iskorostan, where Igor had been killed. Here she said to the town's people: 'Give me three pigeons ... and three sparrows from each house. I do not desire to impose a heavy tribute, like my husband, but I require only this small gift from you, for you are impoverished by the siege.' (Cross and Sherbowitz-Wetzor 1953: 81). After she received this tribute, she told them to return to the town and she would leave the next day. She had tinder and sulphur wrapped in cloth and tied to each bird. In the night the tinder was lit and the birds released. When the birds returned to their nests in the dovecotes and eaves of the houses the result was fires throughout the town. She then gathered all the elders, killed some captives and gave others as slaves.[1]

Later, around 957, when she was about 60 years old, she went to Tsar'gard (Constantinople) where she was baptised taking the name Helena (Yelena, Helen). Because of her actions in bringing Christianity to Russia, and despite her earlier most un-Christian actions, she was canonised after her death at about the age of 80. After Olga became a Christian, she tried without success to persuade her son Svyatoslav to convert; he died a pagan (Cross and Sherbowitz-Wetzor 1953: 83–84).

Nora Chadwick described Olga's later life as 'an Orthodox Christian, and a highly intellectual woman with a sense of the importance of statecraft and the

value of political institutions' (1946: 30–31). This latter description contrasts sharply with her earlier actions. The Empress Irene and Princess Olga have few if any equals when it comes to cruelty.

The Anglo-Saxons

After the Romans abandoned Britain in the early fifth century, the islands were invaded by Germanic tribes, some of which consolidated over the next 300–400 years into small kingdoms, among which Mercia, Wessex and Northumbria became three of the most influential (Map 3). Fortunately, we have another chronicle from this period that provides us with a fundamental source of information for this Anglo-Saxon period.

The several versions of the *Anglo-Saxon Chronicle* (*ASC*) are a major source for this period until after the Norman Conquest in 1066. Each of the several versions was compiled at different places and emphasised different events.[2] Although the *ASC* ostensibly begins with the year 1, the year of Christ's birth, they were not really set down until the ninth century, and even then they were based on other documents. It is not until 604 that the first female is mentioned, 'there the [East Saxon] king was called Sæberht, whom Æthelberht set as king – son of Ricola, Æthelberyht's sister' (Swanton 1996:20).

Seaxburh

The first reigning queen appears in the year 672 when the *ASC* reports that queen Seaxburh (Sexburh), wife of king Cenwalh (Kenwalk) of Wessex, ruled for a year after his death. While brief, the mere mention of Seaxburh speaks to her importance, and the fact that she ruled for a year speaks volumes as to her abilities and the regard to which she must have been held. Unfortunately, there is no mention of her actual activities, and although William of Malmesbury (1847: 30), who wrote in the late eleventh–early twelfth centuries, states that she died 'having scarcely reigned a year', he nevertheless praises her abilities and states that she 'overawed her enemies'. Sadly, for us, it is not clear what he meant by 'overawed'; did he mean in battle, or simply that it was surprising that a woman could conduct the affairs of state so ably?

Thanks to the *ASC* we know of a number of queens that are mentioned, but most only fleetingly, rarely more than once and very few who led armies. There are some hints that queens held positions of prestige and perhaps military hints as with Bebbe, a Northumbrian queen for whom Bamburgh ('Bebbe's fort') was named (D. Stenton 1957: 2).

What may be the most unusual military (although certainly very attenuated) connection of a female came in 626 when an assassin arrived from the king of Wessex to kill King Edwin of Northumbria. The king

was only wounded but two others were stabbed. That very night the king's daughter, Eanflæd, was born. The non-Christian Edwin promised Paulinus, bishop of Northumbria, that he would give his daughter to God if Paulinus, always eager for converts, would pray that Edwin would strike down King Cwichelm of Wessex who had sent the assassin. Paulinus seems to have prayed, Edwin was successful and Paulinus baptised Eanflæd. Within a year Edwin, too, was baptised.

Æthelburh (Ethelburga)[3]

Prior to the tenth century the *ASC* mentions about fifteen women by name, but they are of little consequence to us except for the listing of 722 that reads, 'Here Queen Æthelburh threw down Taunton, which Ine [her husband the king of Wessex 688–726] built earlier'. An explanation for this is given by Henry, Archdeacon of Huntingdon, in his *History of the English*, when he tells us that 'Eadbert ... who was the king's enemy had got possession of the castle, but Ina's Queen Ethelburga (Æthelburh) stormed and razed it to the ground, compelling Eadbert to escape into Surrey' (Henry of Huntington 1853: 120; Swanton 1996: 43, n. 12). This explanation tells us that Queen Æthelburh (ca. 673–ca. 740) not only took to the battlefield, but was also involved with the politics of the time. William of Malmesbury does not mention Taunton, but tells of her influence over Ine and calls her 'a woman of royal race and disposition' (1847: 35–36).

Æthelflæd (Ethelfleda)

Not since AD 61 had there been a woman in Britain comparable to Boudica, which brings us to Æthelflæd undoubtedly the most powerful and important woman in all of Anglo-Saxon England. Historically, she is the best-documented Anglo-Saxon woman of war (or any other topic), although it is clear that in the West Saxon version of the *ASC* she was pointedly ignored.[4] Not only was Æthelflæd the daughter of the Wessex king, Alfred the Great (871–899), sister of King Edward the Elder (899–924) and wife of Ealdorman Æthelræd of Mercia (d. 910/911), her mother was Ealhswith, 'daughter of Æthelræd, ealdeorman of the Gaini, and of Eadburh, a member of the royal house of Mercia'. All of this made Æthelflæd half Mercian, which leads Wainwright (1975: 307) to believe this contributed to the ease with which she took over rule from her husband at his death.

Although the exact year of her birth is unknown (most likely ca. 869 or 870), Æthelflæd was perhaps about 16 at the time of her marriage to Æthelræd (Wainwright 1990: 45), who was probably a good deal older as he was already ruler of Mercia in 885. Their marriage, according to the *Handbook of British Chronology*, must have been about 886/887 (Fryde *et al.* 1996: 17). A few years before this marriage, Alfred had taken London from the Danes[5] and

had installed Æthelræd as its keeper. The marriage between Æthelræd and Æthelflæd was no doubt arranged to seal the bond between the Ealdorman of Mercia and his overlord King Alfred of Wessex.

While Æthelflæd had a first-rate linage, it is her actions for which she is rightly regarded. Her importance during her lifetime can be seen by the fact that she is mentioned for her deeds at least six times in the *ASC*. Her first mention is in 910 when she built the borough (fortress) of Bremesbyrig. Her additional exploits, which included taking both towns and hostages are recorded for the years 912, 913, 916, 917 and 918, the same year she peacefully took the borough at Leicester under her rule.[6] She herself ruled Mercia alone for eight years after Æthelræd's death (ca. 910), but the evidence strongly suggests that she governed Mercia for some time prior to this due to his protracted but unknown illness. Upon Æthelræd's death she became known as *hlæfdige Myrcena*, 'Lady of the Mercians', a title that was the equivalent of her husband's *hlaford Myrcena*, 'Lord of the Mercians', and ruled over Mercia until her death.

In 793, according to the Peterborough version of the *ASC*, 'the raiding of heathen men miserably devastated God's church in Lindisfarne Island by looting and slaughter', thus announcing the first documented invasion of the Vikings into England. After this initial raid into Northumbria, England was subjected to periodic raids from the Norsemen for several decades. Then in 866 the Winchester manuscript of the *ASC* tells us that a great raiding-army entered England and wintered in East Anglia. This Viking army was given horses and peace was made, but the next year the army went again into Northumbria and into York itself, where the raiding-army created great havoc and many people on both sides were killed, including the opposing kings. The raids had now clearly intensified. The next year, 868, the raiding-army went into Mercia and wintered there. At this point King Burhred of Mercia turned to Æthelræd, king of Wessex, and his brother, the future King Alfred, for help. Battles between these two armies continued for a number of years, as did the policy of paying off the Viking leaders with the despised Danegeld, payments collected from the local nobility and religious institutions. It was into this military and political situation that Æthelflæd was born.

After the death of King Alfred in 899, his son Edward the Elder, now king of Wessex, with the cooperation of his brother-in-law, Æthelræd of Mercia, continued the campaign against the Danes, who had controlled a large portion of eastern England (known as the Danelaw) since 878, when King Alfred and the Viking leader Guthrum accepted the terms of the Treaty of Wedmore (see Map 3). King Edward's campaign commenced in full force about 909, and his sister, Æthelflæd, played a formidable role in the rebuilding of the base at Chester, which had been a Roman fortress. During her reign, beginning sometime before Æthelræd's death ca. 910, she built fortresses, kept the loyalty

of the military, planned expeditions, invaded northern territories, obtained a formal promise of allegiance from leaders around York, and led the Mercian army against the Danes (F. Stenton 1968: 324). In other words, she performed in the manner one would expect of a male leader. Nevertheless, she is distressingly neglected in the history of this period. This is no doubt because of the very powerful and well-documented men around her. Still, even with the few entries that we have of her, it is abundantly evident that she held extraordinary power.

That she was a force to be reckoned with but practically ignored by the English chronicles is seen in the story of the Norseman Ingimund. Ingimund had established a settlement in Wirral (a peninsula in northwest England bounded by the Irish Sea and the Mersey and Dee rivers) after he was expelled from Ireland about the year 902. According to the *Annals of Ireland, Three Fragments*:

> Hingamund [Ingimund] was asking lands of the queen [Æthelflæd], in which he would settle, and on which he would erect stalls and houses for he was at this time wearied of war. Ethelfrida [Æthelflæd] afterwards gave him lands near Chester, and he remained there for some time. What resulted from this was: as he saw that the city was very wealthy, and the land around it was choice, he coveted to appropriate them. After this, Hingamund came to meet the chieftains of the Lochlanns and Danes; he made great complaints before them, and said that they were not well off without having good lands, and that they all ought to come to take Chester, and to possess themselves of its wealth and lands. From this many and great battles and wars arose … Though they held this consultation secretly, the queen received intelligence of it. The queen collected great hosts about her from every direction, and the city of Chester was filled with her hosts. (O'Donovan 1860: 229).

What immediately stands out from this passage is that Hingamund, a powerful Norseman, applied to 'the queen' for lands. Although the illness of her husband was known, the extent of her power must also have been known.

In the *Fragmentary Annals of Ireland,* the story of Hingamund is similarly told, but in this version the people of Chester, when they saw the hosts of the Danes and Norwegians coming to attack, 'sent messengers to the King of the Saxons [Æthelræd], who was sick and on the verge of death at that time, to ask his advice and the advice of the Queen [Æthelflæd]' (Radner 1978: 171, frg. 429). Later in the same fragment when the town was under great siege, we are told explicitly that she is in authority. The king, who was near death, and the queen sent messages to the pagan Irish who fought with the Danes.

The message began: 'Life and health to you from the King of the Saxons, who is ill, and from the Queen, who holds all authority over the Saxons and they are certain that you are true and trustworthy friends to them. Therefore, you should take their side'. The Saxons and the Irish prevailed, but later fighting resumed.

In a later fragment for 914, the Vikings again challenged the Saxons. The Queen (Æthelflæd) was in command and:

> [t]he pagans [Vikings] were slaughtered by the Queen like that, so that her fame spread in all directions.
>
> Aethelflaed, through her own cleverness, made peace with the men of Alba [Scotland] and with the Britons, so that whenever the same race should come to attack her, they would rise to help her. If it were against them that they came, she would take arms with them. While this continued, the men of Alba and Britain overcame the settlements of the Norwegians and destroyed and sacked them (Radner 1978: 181, frg. 459).

Despite her achievements, she is nearly ignored in the West Saxon version of the *ASC*; a fragment of the mostly lost Mercian chronicle survives in the form of *The Mercian Register* (Wainwright 1990: 44). This fragment, which was added to other versions of the *ASC*, tells us that in 909 she built a stronghold at Bremesburh (Swanton 1996: 95), and in 912 she built strongholds at Scergeat[7] and Bridgnorth; in 913, taking the Mercians with her, she built strongholds at Tamworth and Stafford, then later in 914 at Eddisbury and Warwick. The next year, 915, saw the building of fortresses at Chirbury, Weardbyrig and Runcorn (ibid., 96, 98–99). All of this fortress building seems to have been integral to a plan by Æthelflæd and her brother, King Edward, to wear down the Danes, who were more successful at quick raids (Wainwright 1990: 47). Stafford claims their military campaigns 'were defensive as much as expansionary', but the ultimate goal was to pave the way for the complete ouster of the Danes. In addition to the fortress building, Æthelflæd was also concerned about her defences against the Welsh, whose territory contained a Viking settlement (Stafford 1989: 28 and 32).

While this more southerly plan combined the strategies of both Æthelflæd and Edward, according to the *Annals of Ireland, Three Fragments*,[8] she alone seems to have carried out a plan against the Norwegians in the north where her allies were Picts, Scots, Angles, Britons of Strathclyde and even the Danish settlers in Northumbria.[9]

In 916 the *Abingdon Chronicle* tells us that Æthelflæd 'sent an army into Wales broke down Brecon Mere, and there took the wife of the king as one of thirty-four others' (Swanton 1996: 100). This action was taken against the

king of Brycheiniog as punishment for the murder of Abbot Egbert and his associates (Wainwright 1990: 34). She took Derby in 917 from the Vikings and in 918 she took control of Leicester peacefully; only a year previous Leicester had repulsed an attack by Æthelflæd's brother, King Edward. Soon after the peaceful surrender of the Vikings, 'she departed, 12 days before midsummer, inside Tamworth, the eighth year that she held control of Mercia with rightful lordship; and her body lies inside Gloucester in the east side-chapel of St Peter's Church' (Swanton 1996: 105).[10] In all, she is known to have built or rebuilt Chester, Scergeat, Bridgnorth, Tamworth, Eddisbury, Warwick, Chirbury, Weardbyrig, Runcorn, and taken the castles at Brecknock, Leicester and York, the latter two peaceably.

Æthelflæd was well known to both the Welsh and Irish chroniclers, and the *Annals of Ulster* notes Æthelflæd's death, calling her 'the most famous Queen of the Saxons' all the while failing to note the passing of her brother or even her father, the Great Alfred (Hennessy 1887: 437) from whom she may well have learned her ideas of kingship. Her story impressed two of the best-known post-Conquest historians, Henry of Huntingdon and William of Malmesbury, both of whom refer to her as *virago*.[11] Only her death caused her pledges to be broken as they were not transferred to King Edward or the English army, thus resulting in the establishment of Norse control over the kingdom of York (F. Stenton 1968: 324–29):

> 918. Here in the early part of this year, with God's help, she peaceably got in her control the stronghold at Leicester, and the most part of the raiding-armies that belonged to it were subjected. And also the York-folk had promised her – and some of them granted so by pledge, some confirmed with oaths – that they would be at her disposition. But very quickly after they had done that, she departed, 12 days before midsummer, inside Tamworth, the eighth year that she held control of Mercia with rightful lordship; and her body lies inside Gloucester in the east side-chapel of St Peter's Church. (Swanton 1996: 105).

The *Florence Chronicle* said upon her death that 'Ethelfleda, the lady of the Mercians, a woman of incomparable prudence, and eminent for her just and virtuous life, died, eight years after the sole government of the Mercians fell to her, during which she ruled them with firmness and equity' (*Florence Chronicle*, 1854: 95). More than a hundred years after Æthelflæd's death, the English historian, Henry of Huntingdon (born between 1080 and 1090), paid tribute to Æthelflæd when he wrote, 'This princess is said to have been

so powerful that she was sometimes called not only lady, or queen, but king ... Some have thought and said that if she had not been suddenly snatched away by death, she would have surpassed the most valiant of men' (Henry of Huntingdon 1853: 168).

We know nothing of how she died but the esteem to which she was held may be presumed as we do know she was carried 100km from the West Midlands to Gloucester, where she was buried in a church that she and her husband had built and dedicated first to St Peter and, once the relics of St Oswald were added in 909, so was he added to the dedication. She had invested in this church for twenty years (V. Thompson 2004).

Our knowledge of Æthelflæd is almost exclusively drawn from the various chronicle manuscripts and these primarily give us an account of her military activities – fortresses that she either took or established. The entries in the *ASC* are usually brief, consisting of: 'In such a year Æthelflæd took such a place'. Her military career was certainly greater than any other Anglo-Saxon woman and at least as distinguished as her brother Edward the Elder. Her business was war and ruling Mercia, both of which she did with great accomplishment. William of Malmesbury says she was '*virago potentissima multum fratrem consiliis iuvare* ['a most powerful man-woman who aided her brother much with advice]' and later adds (perhaps at her brother's expense) '*fortuna an virtute ut mulier viros domesticos protegeret, alienos terreret*' [by fortune or by manliness that a woman would protect her male retainers, terrify her enemies'] (Szarmach 1998: 120–21).

This was a time when women had many children, but we know of only one child to whom Æthelflæd gave birth, a daughter Ælfwynn; thus, she was not an anatomical virgin. A number of reasons could account for her lack of procreation. We know that her husband was ill for several years and that her military activities (with which we are primarily concerned) seem to have monopolised much of her life, leaving little time for a lover or the business of motherhood. It is, however, from William of Malmesbury that we hear another version of Æthelflæd's 'regenerating virginity'. According to him she had such difficulty in childbirth that she 'ever after refused the embraces of her husband; protesting that it was unbecoming the daughter of a king to give way to a delight which, after a time, produced such painful consequences' (William of Malmesbury 1847: 123). Arman (2017: 112) suggests Æthelflæd may have had miscarriages that went unrecorded (as undoubtedly would have been the case) or that she may have had gynaecological difficulties. Walker (2000: 98), on the other hand, suggests that her remaining an unattached widow was an important factor in her retaining her position as leader of Mercia. The noted Scottish historian David Hume, while taking his cue from William of Malmesbury, gives a slightly different view in his *History of England*. His initial comment

concerns Æthelflæd's brother Edward the Elder, but then goes on to comment on Æthelflæd:

> In all these fortunate achievements, he was assisted by the activity and prudence of his sister Ethelfleda, who was widow of Ethelbert, earl of Mercia, and who after her husband's death, retained the government of that province. This princess, who had been reduced to extremity in childbed, refused afterwards all commerce with her husband; not from any weak superstition, as was common in that age, but because she deemed all domestic occupations unworthy of her masculine and ambitious spirit (Hume 1860: 258–50).

By having no male to complicate her life, she maintained political control of Mercia and thus was able to hand the reins of power over to her daughter. Whatever the reason for her 'renewed virginity', Ælfwynn seems to have been Æthelflæd's only child.

Ælfwynn

Ælfwynn, was, after her mother's death, 'chosen by a section of the Mercian nobility as her mother's successor in preference to her West Saxon uncle, Edward the Elder' (Stafford (1990: 57 and n. 11). The *ASC* reports to us that in 919 Ælfwynn, daughter of 'Æthelred, lord of the Mercians, was deprived of all control in Mercia, and was led into Wessex three weeks before Christmas' (Swanton 1996: 105). She then all but disappears from history. (See Bailey 2001.)

Despite her removal by her uncle, the fact that the Mercian nobility selected her as her mother's successor, particularly over her uncle, is extraordinary on its own. Æthelflæd must have raised her daughter to fill the role of leader and the Mercians must have recognised her abilities. We know that when she was about 16 years old, she was involved in a 'lease granted by Bishop Wærferth and the community of Worcester Cathedral for the term of three lives, i.e., Æthelred, Æthelflæd and Ælfwynn' (Bailey 2001: 117). It is, however, difficult to reconcile this seeming faith in Ælfwynn's abilities and the fact that at the time of her mother's death Ælfwynn would have been about 30 and unmarried. One can only speculate as to the reason. This is another moment in history when more knowledge of a female figure would prove to be beneficial.

It is Æthelflæd's prominence in the *ASC*, particularly when compared to other women, that make it evident that she was enormously important, and perhaps it was this prominence that caused Edward to see Æthelflæd's daughter as a threat to his supremacy, thus causing his actions toward her. It is unfortunate that we know so little about Æthelflæd's life outside her military campaigns.

Arman's recent biography of Æthelflæd (2017) speculates on other aspects of her life but there is no evidence for much of the speculation. Nevertheless, it is her military campaigns that set her apart not only from other Anglo-Saxon noble women but also from most other women. She was not just the wife of a king or other leader who took up the sword when necessary; she spent years leading an army, going into combat, and all the while ruling her territory.

It is difficult to imagine how formidable Æthelflæd must have been. This was a time when women were barely mentioned in any history. But yet, she ruled completely what was one of the two strongest and most important regions in Britain at the time, garnering the respect and loyalty of not only her allies and underlings, but her enemies as well. She clearly meant to pass on these duties to her daughter, but this was too much even for this most extraordinary of women.

Post-Conquest Britain

During the early Middle Ages, the principle of primogeniture was not fully established and inheritance of a crown was, even by the twelfth century, still somewhat fluid – when it came to women, a very watery fluid. Wars were common, which required a leader for the army as a prerequisite for ruling over a people – women were, of course, assumed unfit for this task. Nevertheless, because the king was frequently off in battle, it was left to the queen to rule as regent for an underage son if there was one. This, however, was not always the situation and occasionally a woman had the legitimate claim to a throne (Chibnall 1993: 1).

Empress Matilda

Such was the case of the Empress Matilda. If ever a woman had a legitimate claim to a throne, it was the daughter of Henry I of England. Matilda (b. ca. 1102), was also known as, Empress Consort of the Holy Roman Empire, Countess of Anjou, *Domina Anglorum* (Lady of the English), Matilda Augusta, Matilda the Good, and often referred to as Maud. Not only was she the daughter of King Henry I of England (and Normandy), but also the granddaughter of William the Conqueror, and niece of William Rufus. Her mother, also named Matilda, was the daughter of King Malcolm III (Canmore) of Scotland (1058–1093), and could trace her lineage back to Egbert, king of Wessex (802–839) to Alfred the Great and on through several generations that included Æthelred the Unready (978–1016). Despite the nobility of her linage and governance experience, Matilda was said to be haughty, arrogant and tactless, all traits that would probably not have been a problem had she been a man. Undoubtedly the worst strike against her was being female.

Little is known of her early childhood, but Matilda assuredly learned to read (evidenced by her signing charters) due to her mother's desire to have learned men in her court, and they undoubtedly influenced Matilda as well. In October 1109, she made her first appearance at a royal council to witness a royal charter. Because she was already betrothed to the German Emperor Henry V, she signed the document Matilda *'sponsa regis Romanorum'*, 'the betrothed wife of the king of the Romans' – she was 7 years old (Chibnall 1993: 16).

In 1114, now just 12 years old, Matilda was sent to Germany to marry Emperor Henry V, who was twenty years her senior, and thereby she became the Empress Matilda. Consequently, she was raised by Germans, which resulted in her outlook becoming in many respects more German than English. She, like several other of William the Conqueror's female descendants, had a strong character and showed great vigour, perhaps contributing to the haughtiness of which she was frequently accused. She was crowned 'Queen of the Romans' before she entered her teens and was well regarded by her German subjects. In 1117 she helped govern the Matilidine lands and sat in judgement in a property case brought against the church (ibid., 33). In 1118, Matilda was left with the army in Italy to act as regent gaining additional political and governing experience. She was at this time 15 or 16 years old.

Matilda came to be the heir to the English throne through two accidents, political manoeuvring and fast action. On 2 August 1100, her uncle, William II (William Rufus), was killed in a hunting accident. His brother Henry, who was a member of the hunting party, moved quickly, secured the treasury then the throne and was crowned Henry I on August 5 – this despite the existence of an older brother, Robert, who had gone off on a crusade (ibid., 6). This placed the Empress Matilda's younger brother, William, next in line to the English throne. In 1120 William drowned in what came to be known as the tragedy of the White Ship, and left Henry I without a male heir.

In 1119 Henry had married his second wife Adeliza of Louvain, who was still in her teens, following the death of the empress' mother the year before, but the marriage was without issue. When Matilda's husband, Henry V of Germany, died in 1125 leaving her childless, and thus with no claim to the German throne, her father moved to have the now Empress Matilda returned to England, recognising her as his heir. Henry I of England had the barons pledge allegiance to her first on Christmas day 1125 as 'Lady of England and Normandy'; in September 1131 at a council in Northampton, he again had the barons pledge their allegiance to her. On both of these occasions her cousin, Stephen of Blois, third son of Adela (daughter of William the Conqueror), was one of the first to pledge his allegiance to the empress. Heritage, education and dignity made Henry's daughter an ideal candidate for the throne. She was, however, a woman, and the precedent for a ruling female monarch in England

was extremely weak. The reader will remember from Chapter 5 that Gildas had written of '*leaena dolsa* [the treacherous lioness]' (Williams 1899: 20, [21]), which has been taken to be Boudica. If, indeed, he was writing about her, his words were unflattering and unpropitious for later would-be queens.

Now that the Empress Matilda had been declared her father's heir, it was necessary for Henry to find his daughter a second husband. With her second husband the empress' position was reversed from her first marriage. Henry chose for her the Count of Anjou a boy of 15 – nearly ten years her junior. Despite the very real importance of the Angevin alliance,[12] in terms of status, Matilda went from being the empress of Germany to the countess of a French province, albeit a large and greatly significant province. She may have been the heir to the English throne, but despite her protests, reluctance and previous position, she was still a pawn in her father's political machinations (Chibnall 1993: 55–56).[13]

Notwithstanding her father's efforts to secure the throne for Maud, her cousin Stephen de Blois also had a claim, and perhaps more importantly he held the trump card of being male. Moreover, Matilda and Stephen were not the only candidates for the throne. In a period when heredity and legitimacy was less important than it later became, Robert Earl of Gloucester (Henry I's illegitimate son), and Stephen's older brother, Theobald, Count of Blois, Chartres and Champagne, were also considered possibilities (Davis 1990: 14–15). Yet another claimant, William Clito, son of the Conqueror's oldest son Robert Curthose, had an even stronger claim than Stephen, but Robert had earlier been set aside as Henry I had also ignored William Clito's claim.

Unfortunately for the empress, she was in Anjou when her father died in Normandy on 1 December 1135. Before she could get to England, Stephen, who had been on the coast in Boulogne when he heard the news of the king's death, immediately set off for England, arrived in London, was quickly accepted by the barons (who had previously pledged fealty to the empress), and with the help of his brother, the powerful bishop of Winchester, was anointed king by the Archbishop of Canterbury on 22 December 1135 (Davis 1990: 16). The archbishop conveniently absolved the barons of their pledge of allegiance to Matilda.

The empress raised an army and invaded England. This was *her* crown for which she fought, not to be regent as she had no children, and she was the rightful heir. Matilda's battle to become queen regnant resulted in a nineteen-year-long civil war. Stephen was not a strong leader and at one point a rival group of barons had Matilda crowned not as queen, but as 'Lady of England', for which there was precedent. Stephen, however, never abdicated, and even Stephen's wife, Matilda of Boulogne (to whom we will turn next), conducted sieges and defended castles that contributed to Stephen's maintaining the crown. Power moved back and forth between the empress and Stephen making

this a catastrophic period in English history. The memory of this held no small part later in Henry VIII's desire for a male heir. The noted historian Marjorie Chibnall claims the empress had two great disadvantages: first the reluctance by the knights to have a woman as monarch, notwithstanding their previous oaths, and even though 'Matilda certainly tried to show the man in the woman; unfortunately, the comments of hostile chroniclers make plain that what might in a man have passed for dignity, resolution and firm control were condemned in her as arrogance, obstinacy and anger' (Chibnall 1993: 97). The second disadvantage was, according to Chibnall, that '[w]e never hear of her donning a hauberk and riding as a knight among the knights' (ibid.). Although we know she gathered armies, she apparently did not lead them into battle, which, for the time, gave Stephen the distinct advantage.

Despite this 'joint' rule Stephen ultimately held sway, but by the Treaty of Wallingford (1153), the empress' son Henry (II) became Stephen's heir, as his own son, Eustace, had died.[14] Henry II succeeded in 1154 upon Stephen's death and before the empress' death. During her days as Dowager Queen, Matilda became beloved by the English, displaying qualities of piety and grace. She died in Normandy in 1167.

Matilda of Boulogne

Greatly overshadowed by the Empress Matilda but with many of the same attributes and much of the same bloodline, Matilda of Boulogne (1105–1152)[15] was, like the empress, a woman of no small abilities. She, too, came from a regal line, being the granddaughter of King Malcolm III of Scotland and his wife, Saint Margaret of Scotland. Her mother was Mary of Scotland and her father Eustace III, Count of Boulogne. Through her mother she was not only a first cousin to the empress, but also a descendent from Anglo-Saxon kings including Æthelred the Unready. This Matilda's father, however, preferred the church to ruling Boulogne and retired to the spiritual life, thus causing Matilda to become Countess of Boulogne in her own right, but Eustace also invested his future son-in-law Stephen with Boulogne and the lands he, Eustace, controlled in England. It was the Countess Matilda's uncle, King Henry I (father of the empress), who chose Stephen to be her husband. When Henry died in 1135 Stephen, as we have seen, moved quickly and gained the crown, making Matilda of Boulogne queen of England. Stephen's coronation was held on 22 December 1135, but Matilda's was delayed until 22 March 1136. Her being pregnant may have caused the delay, but this is somewhat unclear; it is known that she and Stephen had five children – three boys and two girls.

Queen Matilda's first excursion into military matters came in 1138 when a rebellion broke out in Kent while Stephen was busy putting down another uprising in the Welsh marches. Although the commander of her army seems to have been her cousin, she is, through diplomacy and military, given credit

for the resolution (Hilton 2010: 77). Subsequently we are told that she had campaigns near the Surrey shore, this under the command of Flemish captain William of Ypres, and London (ibid., 83).

Gesta Stephani [Deeds of Stephen] describes the queen as 'a woman of subtlety and a man's resolution' (61). It further provides us with an account of the queen's siege of London after she attempted to negotiate the release of her husband but was abused with insulting language for her efforts. Although she was:

> expecting to obtain by arms what she could not by supplication, brought a magnificent body of troops across in front of London from the other side of the river and gave orders that they should rage most furiously around the city with plunder and arson, violence and the sword, in sight of the countess [Empress Matilda] and her men (*Gesta Stephani* 61).

The harshness of these actions caused the people of London to abandon the empress and make peace with the queen. After the empress fled to Oxford:

> The queen was admitted into the city by the Londoners and forgetting the weakness of her sex and a woman's softness she bore herself with the valour of a man; everywhere by prayer or price she won over invincible allies; the king's lieges, wherever they were scattered throughout England, she urged persistently to demand their lord back with her (ibid., 63).

Over the next years a number of battles ensued and the chronicler Orderic Vitalis recognised her not only as a strategist but the leader of her own armies as well as those of Stephen. Because of her esteemed position, when Robert of Gloucester, the empress' half-brother who became the leader of her forces, turned against Stephen in 1138, she had her men in Boulogne blockade Dover to prevent supplies getting through to Robert (Chibnall 1990: 113). When in February 1141 Stephen was captured at Lincoln, Queen Matilda raised an army, attacked the empress' forces and captured Robert, Earl of Gloucester. On 1 November the two prisoners were exchanged.

Matilda's military activities were not confined to the support she gave in her husband's struggle to keep the throne. Early in her marriage and throughout, she took charge of the army to put down what in comparison were minor rebellions and also engaged in acts of diplomacy. Her position as the Countess of Boulogne (which brought with it the English Honour of Boulogne that included vast land holdings centred on Essex) combined with her station as Queen Consort allowed her to wield considerable power (Dark 2007: 148). The marriage of Matilda and Stephen seems to have been strong, no doubt partly

based on its symbiotic nature, and her patrimony may well have added to the strength of the connubial relationship as well as to Stephen's power base.

Although the Empress Matilda spent much of her life fighting for her crown and inheritance, the times were such that there are many accounts of noble women who were put in the position of defending their lands and castles either because their husbands were away doing battle elsewhere, were in exile or had been killed.

Emma, Countess of Norfolk

Soon after the Conquest in 1066, and even before the Empress Matilda was fighting for her crown, women needed to defend their castles. In 1075 the Earl of Norfolk, who had rebelled against William the Conqueror, fled into exile while his wife Emma, Countess of Norfolk, remained to defend the castle at Norwich until she was given safe conduct to leave. During the reign of William II, the king captured the Earl of Northumbria, also a rebel, but his wife continued to fight for Bamburgh Castle until the king threatened to blind her husband (D. Stenton 1957: 37).

Although the civil war between the Empress Matilda and King Stephen created strife throughout Britain, Gerald of Wales tells us of another prominent woman who took up the defence of her castle, but with a less happy ending than that of Emma's.

Gwenllian verch Gruffydd

Gwenllian (ca. 1097 – ca. 1136), wife of Gruffydd ap Rhys ap Tewdwr, Prince of South Wales, was the daughter of Gruffydd ap Cynan, king of Gwynedd in Wales and his wife Angharad – the youngest of eight children. In 1136, Kidwelly (Cydweli) Castle was under siege by the Normans and Gwenllian's husband went off seeking reinforcements from her father. Not a woman to sit back waiting for rescue, Gwenllian raised an army and attacked the Norman ruler of the area, Maurice of London, causing Gerald of Wales to compare her to Penthesilea, queen of the Amazons. Confident of victory, she took two of her sons into battle with her; unfortunately, her confidence seems to have been greater than her army's ability as one of her sons was captured and the other killed. Gwenllian herself was treated as an equal with her soldiers as no consideration was given for her sex – she, along with a number of her soldiers, was captured and beheaded on the battlefield that is even today called Maes Gwenllian. Gwenllian is the only known Welsh woman to have entered the military arena (Gerald of Wales 1978: 136–37, fn. 210).

Nicolaa de la Haye

Still another woman of particular interest during the same general period is Nicolaa de la Haye (Haia) (1160?–1230) who inherited, along with the small Barony of Brattleby in Lincolnshire, two offices which would have

normally gone to a male heir had there been one. On her father's death she became sheriff of Lincolnshire (the first woman to hold this post) and castellan (governor) of Lincoln Castle; Richard I confirmed this by charter in 1189 when he became king. Nicolaa was married first to William fitz Erneis in 1178, and for a second time about 1185 to Gerard de Camville. Little is known about her first marriage, but her second marriage appears to have been advantageous to both parties. Probably due to Nicolaa's connections, de Camville was appointed sheriff and additionally administered Nicolaa's duties[16] although she remained heavily involved. During King Richard's absence from England, Gerard paid fealty to Prince John even though the castle was held by King Richard causing William Longchamp, King Richard's regent, to place the castle under siege in 1191; he also removed Gerard as sheriff. Gerard went off to be with John, which left Nicolaa, 'whose heart was not that of a woman', to take charge of the castle's defence 'manfully' (Appleby 1963: 31). Gerard died about 1215 and Nicolaa was able to regain fully her inheritance, which had been compromised in the dispute between Richard and John. In 1216–1217 England was in near civil war due in the occurrence of King John's dispute with the barons, which had resulted in Magna Carta and provided an opportunity for Prince Louis of France to attempt to seize power. Nicolaa, now in her fifties, again took charge of the castle's defences, repelling Louis' advances and contributing to his defeat at the Battle of Lincoln on 20 May 1217. Within days of this victory and despite her clear abilities, the new king, Henry III, (John had died in 1216) removed her from her offices and gave them to his uncle William Longespee, the Earl of Salisbury. Ultimately, after her protesting to the king, she regained control of the castle but not the shrievalty. She resigned as castellan in 1226 and died in 1230 (Pennington 2003: 314–15; Poole 1993: 485, fn. 1).[17]

Countess Agnes Randolph Dunbar

During the reign of Edward III of England, we hear of another woman, this time in Scotland, to whom her husband, the 4th Earl of March and 9th Earl of Dunbar, left the defence of Dunbar Castle. Although the account may seem apocryphal, Countess Agnes Randolph Dunbar, who famously came to be known as Black Agnes, personally took charge of the castle's defences against the well-equipped English troops led by the well-known William Montague, Earl of Salisbury. No matter the time of day, she was seen at the castle gate much to the chagrin and frustration of the English commander. Agnes was not a woman to be intimidated, and after each bombardment, she is said to have sent her maids out to dust the debris off the walls with their handkerchiefs (R. Marshall 1983: 48). The siege lasted five months from 13 January 1338 to 11 June 1338, during which time Salisbury bombarded the castle with catapults and other large weapons. Agnes fired back with the weapons she had and at

every opportunity mocked him. In the end Salisbury accepted a truce and marched away (Harrower-Gray 2009).

For her deeds Agnes is remembered not only in history, but also in a folksong attributed to the Earl of Salisbury himself.

> She makes a stir in tower and
> trench,
> That brawling, boisterous, Scottish wench;
> Came I early, came I late.
> I found Agnes at the gate. (H. Marshall 2017: 50)

Religious fervour was high during the Middle Ages resulting in tremendous enthusiasm for capturing Jerusalem for Christianity and the consequence was a series of Crusades. Numerous women went off to the Crusades until the Papal Bull in 1189 prohibited women from joining the Third Crusade – the Bull was widely ignored. Queens Eleanor of Aquitaine (who is said to have dressed as an 'Amazon' and rode bare-breasted before the troops), Eleanor of Castile, Marguerite de Provence, Florine of Denmark and Berengaria of Navarre are all known to have gone on Crusade, but admittedly it is not clear how much, if any, fighting they did. Matilda of Boulogne supported the Knights Templars believing that if she could not fight against the enemies of the Church, she could provision those who did (Hilton 2010: 75).

The role women played in the Crusades has been argued over, but little actual study has been made. An analysis of this very problem, however, is the subject of a work by Helen Nicholson (1997), who examined the Christian and Muslim sources and concludes that many women of all classes accompanied the male crusaders. Some of the women were themselves pilgrims, though most were only there to perform mundane but essential jobs, from building siege works to doing laundry.[18] Nevertheless, since some women in Europe did fight in 'urgent situations', they may have fought in the Holy Land, 'given that the crusade itself was the most urgent situation in all Christendom', but then only in emergencies (Nicholson 1997: 349).

J.F. Verbruggen has also reviewed women (primarily French women) who joined medieval armies, and notes that women fought as early as July 1097 during the First Crusade at the Battle of Dorylaeum (2006: 119). Although women were frequently found in armies engaging in the particularly dreary, but crucial, work of cleaning, cooking and carrying water, they were also known to use heavy weapons such as the trebuchet constructed by the people of Toulouse during the siege of that city (October 1217 – June 1218) during the Albigensian Crusade (Verbruggen 2006: 122).

Happily, we know of two letters written by Pope Boniface VIII (1294–1303) in which he praises 'ladies who had taken the cross', and uses them as examples to encourage men to take up the cause. In the mid-nineteenth century, Joseph Francois Michaud wrote in *The History of the Crusades* that:

> We are still in possession of a brief of the Pope's, in which the holy father felicitates the ladies who had taken the cross, upon their following the steps of Cazan, the emperor of the Tartars, *who, although a pagan, had conceived the generous resolution of delivering the Holy Land*. History has preserved two other letters of the Pope, one addressed to Porchetto, archbishop of Genoa, and the other to four Genoese nobles, who had undertaken to direct the expedition. 'Oh, prodigy! oh, miracle!' says he to Porchetto; 'a weak and timid sex takes the advance of warriors in this great enterprise, in this war against the enemies of Christ, in this fight against the workers of iniquity. The kings and princes of the earth, regardless of all the solicitations that have been made to them, refuse to send succours to the Christians banished from the Holy Land, and here are women who come forward without being called! Whence can this magnanimous resolution come, if not from God, the source of all strength and all virtue!!!' The Pope terminated his letter by directing the archbishop to call together the clergy and the people, and proclaim the devotion of the noble Genoese ladies, in order that their example may cast seeds of good works into the hearts of the people.
>
> This crusade, notwithstanding, never took place; it was doubtless only preached to rouse the emulation of the knights, and the Pope only directed his attention to it to give a lesson to the princes of Christendom, by which they did not at all profit. The letters written upon this occasion by Boniface VIII were preserved in the archives of the republic of Genoa for a long time. Even in the last century, the helmets and cuirasses which were to have been worn by the Genoese ladies in this expedition were exhibited in the arsenal of that city (Michaud 1891: III: 96). [Original emphasis.] https://ia800303.us.archive.org/24/items/HistoryOfTheCrusadesV3/HistoryOfTheCrusadesV3.pdf

While this crusade never took place, we are again reminded that women were willing to go into battle and that even the Pope encouraged them. This, again, points to the fact that women were not strangers to military activity.

Eleanor of Aquitaine

Much has been written of Eleanor of Aquitaine's (1122/1124–1204) actions in regard to the Second Crusade. Supposedly, on Easter Sunday 1146, Eleanor was so moved by the reading of the Papal Bull calling for the Second Crusade by the Abbé Bernard of Clairvaux at Vézelay, that she received the sign of the cross from the hands of the Abbé himself (Michaud 1881: I: 335). The bull forbade 'concubines'. This would not have discouraged Eleanor from joining the Crusade herself as she was certainly not a concubine – she was queen of France, and she took up the cross along with her husband King Louis VII. Aside from offering up her many vassals that swelled the ranks of the crusaders, it is said, she encouraged a number of other noble ladies to follow her lead and take up the cross. These included, among others, the 'countess of Thoulouse, the countess of Blois, Sibylla of Flanders, Maurille countess de Koussy, Talquery duchess de Bouillon and several other ladies celebrated for their birth or their beauty' (Michaud ibid., 360). Michaud further reports these women were in Antioch when King Louis arrived after having lost three-fourths of his army (ibid.). Whether or not any of these ladies took to the battlefield is never set out and is questionable at best, but Eleanor providing large numbers of crusaders is well established.

The chronicler Richard of Devizes described Eleanor as 'an incomparable woman, beautiful yet virtuous, powerful yet gentle, humble yet keen-witted, qualities which are most rarely found in a woman' (Appleby 1963: 25). She was the well-educated daughter of Duke William X of Aquitaine and the countess of Poitou. She would become queen of France (wife of Louie VII), queen of England (wife of Henry II) as well as being Duchess of Aquitaine in her own right, not to mention the mother of two kings of England, Richard I and John. Eleanor was not, however, the first noble woman to go on crusade. Even in her own family she was preceded in 1096 at the beginning of the First Crusade by Elvira, wife of the Count Raymond of Toulouse, uncle of Phillipa, Eleanor's grandmother. Elvira had not only gone with her husband but also carried her infant son with her. The First Crusade had begun in 1095 at Clermont when Pope Urban II called for those fit to take up arms for the church to do so; it seems unlikely that women would have fallen into the category, but it is certain that infants did not. The Papal Bull of 1189 calling for the Third Crusade expressly forbade all women.

The Aquitaine, where women could inherit and had freedoms – or at least tolerances – not found in many other parts of France, was Eleanor's outright and had been since 1137 when she inherited it upon the death of her father. She had brought the Aquitaine (Map 4), a very large and critical area of southern France, to her first marriage to Louis VII of France, and it remained hers after the marriage was dissolved by annulment following the birth of two daughters, fifteen years of marriage but no sons. She continued as the Duchess

of Aquitaine when she married Henry II of England; it then became important in maintaining the English king's foothold on the Continent. Eleanor remained its sovereign and throughout much of her life she struggled to keep it under her control. Aside from Joan of Arc, Eleanor was, and has remained, perhaps the best-known European woman of the Middle Ages. Nevertheless, despite her powerful holdings, being the wife of two reigning kings, the mother of two kings, raising rebellion against her king husband, reigning for her king son, and a flair for the dramatic as demonstrated by her departure to the Crusade,[19] she does not seem to have actually taken to the battlefield until perhaps after the death of her favourite son, Richard the Lionheart, in order – ironically – to bolster the claim of her least favourite son John – when she was 75 years old. This she did, not as the leader of the army, but at the side of Richard's mercenary captain, Mercadier. The sources are unclear as to whether or not she actually went into battle.

Less than a hundred years later, another royal French bride arrived in England and was placed in a position to fight very different battles.

Jeanne de Champagne and Isabella of France

Jeanne de Champagne, queen of Navarre and Brie (1273–1305) inherited her throne from her father, Henry I of Navarre and Count of Champagne. Jeanne was only 13 at the time of her marriage to Philippe IV (the Fair) of France (r. 1285–1314), who was arguably the most powerful monarch in Europe at the time. Jeanne was strong-willed and capable of leading her own army into battle, which she did twice: once against the Count of Bar, who had rebelled against her, and later against the kingdoms of Aragon and Castile.

Jeanne de Champagne's daughter Isabella was born in 1295. Being the daughter of two strong monarchs, Isabella grew up in a world of politics and almost immediately became a pawn in the diplomatic affairs of France and England. By the time Isabella was 12 in 1308, she was the bride of the new king of England, Edward II – he was 23. Unhappily for Isabella, Edward had a greater attachment than his new bride, one that was evident immediately following the wedding. Edward's favourite was Piers Gaveston, and it was on him that Edward showered gifts and position – even to the point of slighting Isabella. Gaveston's importance to Edward became even more evident a month after the wedding at the king and queen's coronation, where Gaveston played a role rivalling that of the royal couple's (Earenfight 2013: 148). Against this backdrop, and with a king later considered the least able of all English monarchs, Isabella began her life as queen of England – a life that would, at the least, be considered challenging. However, Isabella had come from stern stock.

For the first four years of marriage Isabella remained the dutiful wife and queen, but by 1312 it was the nobility of England that could no longer put up with the influence Gaveston had over the king. In June of that year Gaveston

was captured and executed by a group of England's greatest lords, headed by the earls of Warwick and Lancaster, the king's own cousins (*Vita Edwardi Secundi* [VES] 23–27). Edward was grief-stricken. In November of the same year Isabella gave birth to her first child, the future Edward III (ibid., 36), thereby cementing her position of power.

Despite being only 17 years old, Isabella was mother of the heir to the throne, intelligent and a keen observer of politics, which she had seen from the inside beginning at a very early age. With Gaveston no longer usurping her position, she was able to provide the king with shrewd and prudent advice – something he genuinely needed, given his relationship with the lords. She was also able to guide him in his dealings with France.

For the next ten years Edward struggled with the lords and Isabella stood by him using her not inconsiderable skills to maintain harmony between them. Nevertheless, during this time Edward attached himself to his new favourites – Hugh Despenser and his father. Like Piers Gaveston before them, the Despensers used their intimacy with the king to acquire influence and wealth (ibid., 108–09). Their advice to the king was usually disastrous and the king became embroiled in catastrophic military campaigns in Scotland. The country suffered famine and the king's foreign policy was detrimental to both the kingdom and the king himself. Fortresses were filled with those who were considered rebellious. All the while, Isabella remained in the background.

In the Fall of 1324, when relations with France were at a desperate low, Despenser took advantage of the queen's French birth and confiscated her lands, removed all her French retainers, and perhaps most foolishly of all, took her three youngest children from her care, placing them in the Despenser's household.

The situation with the French king was at a crisis and needed personal attention. Edward would have risked outright rebellion if he had gone to France, and Despenser was decidedly unwelcome there. The obvious solution was to send Isabella, who was King Charles IV's sister. Believing she would be his loyal messenger, she was sent off in March 1325 to pay homage to her brother in the name of her husband (ibid., 134–35). Once this was done, Isabella remained in France, entertaining and being entertained. There remained but one component that required attention – the need for Edward to pay homage to Charles for the Aquitaine. The Despensers convinced Edward that he should not cross the channel, instead it was decided to invest Edward's eldest son, the 12-year-old Prince Edward, with the duchy of Aquitaine, and thus the prince could fulfil the task. With the sending of the prince to France, the king also ordered the queen to return to England (ibid., 141–42).

Once Prince Edward arrived in France, the heir to the English throne was under the power of his mother, the queen of England. This now gave Isabella a

way to outmanoeuvre her husband and the Despensers. With this new position of power Isabella publicly announced:

> I feel that marriage is a joining together of man and woman ... and someone has come between my husband and myself trying to break this bond; I protest that I will not return until this intruder is removed, but, discarding my marriage garment, shall assume the robes of widowhood and mourning until I am avenged of this Pharisee (ibid., 143).

The king could not believe Isabella had planned this herself and ordered the king's council to write a letter imploring her to return. She did not (ibid., 144–45).

Up to this point Isabella had shown herself to be politically astute, and she continued in this vein as she gathered forces and allies enough to return to England. Her ability to do this was facilitated by the dowry of Philippa, the daughter of her cousin Count Guillaume of Hainaut, to whom Isabella's son was now betrothed. Isabella was able to put together an army of perhaps 2,500 men, but she also had powerful lords such as the earls of Norfolk and Leicester on her side (Hilton 2010: 236). Once in England Isabella engaged in a number of battles, including in 1326 the Siege of Bristol, where Edward II and the Despensers had taken refuge. This battle was memorialised in a fifteenth-century miniature portraying her among her troops. She and her now close advisor Roger Mortimer were able to capture first the Despensers and then the king in the name of her son Prince Edward. Despenser was quickly dispatched in a horrific manner, but the king was a greater problem.

In January 1327 a parliament was called. King Edward II, now imprisoned, was accused of following bad counsel, neglecting his people and causing members of the nobility to be slain. With careful staging the king's son, now 14, was declared king. Because he had not yet reached his majority, it was clear that the queen would be the regent and with her came Roger Mortimer. At this point Isabella took leave of her political shrewdness and discretion. She abused her power and amassed great wealth. Her affair with Mortimer was an open secret – she and Mortimer had taken on the mantel of Gaveston and the Despensers.

The actions of the Dowager Queen and her lover continued until the Fall of 1330 when the 17-year-old king and a few of his closest companions captured the queen and Mortimer. Like Despenser, Mortimer was quickly dealt with and hanged. The queen, however, was kept in close quarters for a while but eventually allowed to live – not only freely, but in great comfort. She had wisely seen that she had had her turn at power and that her son was ready to take the command that rightfully belonged to him. She died in 1358 at the age of 63.

For most of Isabella's life she had shown herself to be a woman of great strength and sagacity. What caused her to take leave of the perspicacity that had served her so well must be left to speculation.

The marriage Isabella had arranged for her son Edward and Philippa of Hainaut (ca. 1314–1369) proved to be a judicious and a fruitful one. Philippa was noted for her gentle character but, despite giving birth to twelve or thirteen children, she still found time to raise an army against the invading army of Scotland's King David Bruce in 1346 at Neville's Cross near Durham, where the Scottish army was defeated. After reviewing the army, however, she is said to have retired to pray for the army's success (Strickland 1886: 108).

The Continent and Beyond

Matilda of Tuscany and Beatrice of Lorraine
Moving to the Continent (and a slightly earlier time), we come to yet another Matilda, Matilda of Tuscany (ca. 1046–1115), also known as Countess Matilda of Canossa, who was truly an extraordinary woman and one of the outstanding personages of this period, male or female. If not unique, she was certainly a rare example of a woman with military interests, but equally well known for her formation of churches, monasteries and other religious establishments. Although she did not shy away from the battlefield, she is said to have frequently resorted to a Fabian strategy. There are few, if any, other works that place a woman's military leadership in the title, as does David Hay's *The Military Leadership of Matilda of Canossa, 1045–1115*. In the first sentence of his work, Hay calls her 'the most powerful woman of her time' (2008: 1). But it is the opinion of the noted historian Cosmas of Prague that gives us a more complete assessment of her position in the medieval world:

> In those days the most powerful lady had come to Rome: Matilda, who governed all of Lombardy together with Burgundy after the death of her father, Boniface, and had power over 120 bishops, whether to be elected and enthroned or removed. The whole senatorial order was arranged according to her will, as if she were their own lord, and Pope Gregory himself handled both divine and human business through her, because she was a most wise counsellor and the greatest supporter of the Roman church in all its troubles and needs (Cosmas of Prague 2.31).

Notwithstanding her repeated military pursuits, she engaged in important diplomatic and political efforts as well. Her cause was neither personal, as was

the Empress Matilda's, nor in defence of her castle, as was Nicolaa de la Haye's, but a holy cause. Furthermore, unlike most women who took up the sword, she did not do so for her heirs as she had no surviving children and, therefore, was never a regent. She is often called the 'Daughter of Peter' in reference to her ties to the pope, particularly Pope Gregory VII, the former monk Hildebrand, who was well known as a great reformer of the church.

Matilda was the daughter of Margrave Boniface II of Canossa and his second wife Beatrice, daughter of the Duke of Upper Lorraine. Boniface came from a powerful family that had merged its various holdings in Tuscany, Lombardy and Emilia by uniting local alliances and serving the emperors of the Holy Roman Empire. When Boniface was assassinated by means of a poisoned spear in 1052, Matilda's mother took the reins of power in Canossa for Matilda's young brother Frederick, ruling capably for two years. Matilda's mother, Beatrice of Lorraine, married a second time in 1054, not only without the consent of Henry III, the then Holy Roman Emperor, but to Godfrey the Bearded – the emperor's sworn enemy (Hay 2008: 32–33).

In a number of respects this Matilda was following in her mother's footsteps. Beatrice of Lorraine (ca. 1020–1076) was known for her establishment of religious institutions and Beatrice actively engaged with her second husband in his military pursuits to the point that Hay (ibid., 38) writes of situations that 'required Godfrey and Beatrice's military intervention'. She and her husband Godfrey were leading proponents of the reform movement in Rome. Through their efforts the couple helped Godfrey's brother Frederick to become Pope Stephen IV (1057–1058), and after him Godfrey's close ally, Gerard, Bishop of Florence, to reign as Nicholas II (1058–1061). Beatrice was also an ardent defender of Nicholas, having escorted him into Rome in 1059, safeguarding him from the anti-pope Honorius II (Bishop of Cadalus of Parma). From 1061–1065, Beatrice prevented Honorius from entering Rome by attacking him and driving off his forces. In 1064 she performed the same service for Pope Alexander II at the Council of Mantua. Although Beatrice is most frequently considered in connection to her husband's military campaigns, it seems clear that she was both a military and diplomatic force in her own right, taking on diplomatic duties between Pope Gregory VII and her kinsman, King Henry IV of Germany. Furthermore, she looks to have been elemental in grooming her daughter in politics and even helped in gathering Matilda's first army (ibid., 8).

Matilda was more than a worthy successor to her mother's military competence. As a girl it has been said that she was eager to acquire the arts of war that she supposedly learned from Arduino della Paluda, a Tuscan nobleman, but Hay refers to the evidence as ambiguous. What is not ambiguous is her ability to gather and command an army that she learned from her father,

stepfather and mother (ibid., 36–37). With her father, she engaged in a struggle against German Emperor Henry IV. Despite Vedriani's view, written in 1666 (Duff 1909: 77), that she disdained 'with a virile spirit the art of Arachne she seized the spear of Pallas', she did learn embroidery, was well educated, and conversant in German, Italian, French and Latin; she also wrote in Latin. She had an extensive library and helped establish the law school at Bologna (Shahar 2003: 158). Her education and intellectual achievements were extraordinary for someone of her time, female or male.

Matilda's first appearance on the battlefield is unclear, but from the early 1060s she seems to have accompanied her parents, thereby observing strategies and battles. By the time of her stepfather's death in 1069 she had 'so firmly establish[ed] her right to the patrimony of Canossa that no serious rivals would emerge to challenge her succession, even though she was a woman' (Hay 2008: 42–43). Shortly after her stepfather's death she married the first of two husbands, Godfrey the Hunchback, son of Duke Godfrey (her stepfather) by a previous marriage. By Godfrey she had a son who died in infancy, and not long after the marriage essentially ended despite Godfrey's repeated attempts at reconciliation. Officially, the marriage lasted until his death in 1076. Her second marriage came thirteen years later, when she was 43, and this husband, Duke Welf V of Bavaria was twenty-six years her junior.

It was for Pope Gregory VII (1073–1085) for whom she fought most fervently, until he was sent into exile at Salerno and the anti-Pope, Clement III, occupied the papal throne. After Gregory's death, she gave her allegiance to Pope Urban II, who had persuaded her to marry Welf V – a political marriage based on strategy without a whiff of romance. The house of Welf held not only their lands in Bavaria but also extensive holdings in northern Italy, in Emilia and Lombardy. Duke Welf IV (Matilda's new father-in-law) had had a falling out with Emperor Henry IV, creating a natural ally of Matilda and against whom she had successfully led her army (ibid., 124–25).

Her military career lasted until she was well into her sixties, and although the actual amount of time she spent on the battlefield is debated, it is clear that she was in command of her armies, relying 'heavily upon the principles of intelligence, manoeuvre and surprise' (ibid., 241). Matilda avoided Joan of Arc's pitfall of dressing like a man (for which Joan was ultimately convicted), and although she has occasionally been said to wear armour, she is never depicted in such garb. According to Hay, her:

> preferred method [against her enemies] would be to assemble broad coalitions of her allies, isolate her opponents both politically and militarily, and then threaten to grind them down methodically

through the coordinated application of large concentrations of force ... [Furthermore her] relatively bloodless victories remain testaments to her sensitivity to war's political context as well as to her growing reputation for command (ibid., 161).

Only after the deaths of Urban II in 1099 and the anti-Pope Clement III in 1100, did she lay down her arms.

Matilda died at age 70 in 1115 without an heir and no one to carry on her family line. She left two wills. In the first, dated 1077, she left her property to St Peter. But in her later will of 1102, she left her property to Emperor Henry V, the heir of her old enemy Henry IV (and the Empress Matilda's husband), with whom she had reconciled. These two wills created great difficulty and denied the church and state the peace she had desired (ibid., 179–83).

Matilda was extremely devout, and despite her enemies' attempts to smear her with scandal, she maintained her piety throughout her life. While clearly not an anatomical virgin, her life seems to have been somewhat chaste, but perhaps not of her own doing. Cosmas of Prague relates in somewhat lurid detail the story of Matilda's first three nights with her second husband that reveal him as either impotent, or that she absolutely did not appeal to him. After the third night of her enticements ending in utter failure, she told him to get out: 'Go far from here, monster, so that you might not pollute our kingdom. You are viler than a worm, viler than discarded seaweed. If you appear before me tomorrow, you will die a bad death.' (Cosmas 2.32)

She was also an aristocrat of extraordinary wealth. She ruled Tuscany for over thirty years, and although a great deal of her time was spent in defence of the Church, she was able to establish and endow hospitals, churches and monasteries, build roads and bridges, see that laws were properly administered and aid the poor and needy. Her fame was so great that two centuries later Dante immortalised her in *Purgatorio Purgatory Canto* XXXIII (the Earthly Paradise).

Matilda of Tuscany was fully recognised as a woman warrior as well as a woman of achievement in her own time, but inscriptions above her tomb at San Benedetto appear, according to the lettering and form of abbreviations, to have been added later (Holman 1999, n. 34). Nevertheless, the inscriptions praise her war exploits and compare her to an Amazon queen.

Quae meruit clara Mathildis nomina, vide:
Pro qua Pontifici reddita Roma fuit
Et tunc disposuit turmas invicta Virago,
Qualis Amazonides Pentisilea solet.
Qua nunquam saevi per tot discrimina belli

Mars potuit veri vincere iura Dei.
Haec igitur tanto belli defuncta labore
Hoc niveo tandem marmore clausa iacet.

[See what the renowned name of Matilda deserved, through whom Rome was given back to the Pope. And then this warrior-woman disposed her troops as the Amazonian Penthesilea is accustomed to do. Thanks to her – through so many contests of horrid war – man was never able to conquer the rights of God. She therefore, having performed the labours of so much war, now rests enclosed in this marble.]

Hoc Sua, dum vitae immortalis restituantur,
Ossa adservari voluit Mathilda Sepulcro.

[Matilda – famous for her race, beauty, and powerful Kingdom as for the merits of virtue, and fame of her piety, wishes that her bones should be preserved here, until they are restored to the life immortal. (Duff 1909: 275–76).]

Nearly 500 years after her death in 1587 a portrait of her was commissioned. It was carried out by the Veronese artist Paolo Farinati and attached to her tomb. This portrait, although not done from life, shows her riding astride a white horse (Duff 1909: facing p. 224) and is inscribed:

Stirpe, opibus, forma, gestis,
et nomine quondam
Inclyta Mathidis hic iacet:
Astra tenens.

[Matilda, once illustrious by her birth, riches, beauty, deeds and name, lies here, but lives in heaven. (Duff 1909: 276).]

Perhaps the only, or at least closest, likeness we have of her is unusual itself as it shows Matilda as the central figure reaching out as a supplicant to Pope Gregory VII on behalf of Emperor Henry IV, who kneels before her. This is found in her chronicle's Domnizo's *Vita Mathildis*. Beneath the likeness it reads *Rex rogat Abbatem Mathildim Supplient Atq*. [The king asks the abbot and implores Mathilda].

Unlike most women we have seen, Matilda's war was what might be called a 'holy war' most comparable to those of the Arab women of the early days of Islam, noted earlier in this chapter.

India

Rudradeva
India did not produce many women who fall into our area of interest during our time period, but the Telugu-speaking people have given us at least one. Telugu is in the Dravidian family of languages as opposed to Indo-European. The Kakatiya dynasty of India, in the area of modern Warangal, produced a golden age during the time of Ganapati Deva, who in 1199 brought together the Telugu-speaking people. He had no sons but renamed his daughter, Rani Rudramma Devi (the name she was given at birth), to the male equivalent, Rudradeva, in what is known as the *putrika* ceremony. Despite her sex she became one of the dynasty's most prominent leaders, as she was an able fighter as well as ruler, putting down disputes in and outside of her kingdom. The Cholas, Pandyas and Yadavas count among her advisories. She ruled from 1262 to 1295 (Latif 2010: 69–70).

Non-Royal Women

Maria of Pozzuoli
Most of the women we have examined have been royal women, or at least from the aristocracy, but towards the end of the period under study we find three women who do not fit the mould of the others. The great poet Petrarch wrote on 23 November 1343 to Cardinal Giovanni Colonna about a young woman from Pozzuoli, near Naples. He speaks of her in glowing terms in regard to her as 'sturdy in body and soul'. Suitably, her name was Maria and she was not only a virgin, but the men who surrounded her never made advances to her even in jest.

> Men are put off, they say, more by fear than respect. Her body is military rather than maidenly, her strength is such as any hardened soldier might wish for, her skill and deftness unusual, her age at its prime, her appearance and endeavour that of a strong man. She cares not for charms but for arms; not for arts and crafts but for darts and shafts; her face bears no trace of kisses and lascivious caresses, but is ennobled by wounds and scars. Her first love is for weapons, her soul defies death and the sword. She helps wage an inherited local war, in which many have perished on both sides. Sometimes alone, often with a few companions, she has raided the enemy, always, up to the present, victoriously. First into battle, slow to withdraw, she attacks aggressively, practises skilful feints. She bears with incredible patience hunger, thirst,

cold, heat, lack of sleep, weariness; she passes nights in the open, under arms; she sleeps on the ground, counting herself lucky to have a turf or a shield for pillow (Moriarty 1989: 144–45).

Petrarch had met her a few years earlier on a visit to the king of Sicily, which leads one to believe she was not a peasant, and he remarks at the change in her from a sweet young girl to this fierce fighter. He goes on to say that because of her he gives more credence to the stories of Amazons, that of Camilla and her Italian virgin warriors. But with her we do not have a queen fighting for her throne or heir or cause. Here is a woman who appears to be a warrior, ostensibly just for the sake of being a warrior.

Margret Paston
While we can find many examples of noble women who took charge of the defence of their land, castles or properties when their husbands were off at war, more ordinary women also engaged in battle on the home front. Margret Paston is an example of a non-noble woman who was concerned with the protection of her home. The Paston family was extraordinary in that members of the family carried out prodigious correspondence, and by a stroke of good fortune many of these letters have come down to us. In 1448 Margret wrote to her husband, John Paston, to procure for her 'crossbows, and windases[20] to bend them with, and quarrel'.[21] She also wanted 'bars to bar the doors cross-ways, and they handmade wickets on every quarter of the house to shoot out at both with bows and with hand-guns'. Although she was concerned with the defence of her home, she did not neglect the more ordinary supplies of the household as she also asked for almonds and sugar as well as some cloth for gowns (N. Davis 1983: 13–14).

Christine de Pisan
We don't know what Margret Paston read, but there was a 'manual' that she might have consulted – *The Book of Deeds of Arms and of Chivalry*. This 'manual' instructed women to be prepared to defend their castles or manor houses and how they should go about it. Her advice is well defined and the reasons for the advice equally well expressed. The author of this work, Christine de Pisan[22] (ca. 1364–1430), is a surprising inclusion in this corpus of women involved in the military. This extraordinary woman was never directly involved in the military, but she lived through war and revolution. Her *Book of Deeds* gives diverse advice on how to select a campground, what was good camp food, how to attack a stronghold, how to defend a castle and what was required for a general's bed. This knowledge she gleaned from soldiers she had met, some of whom were undoubtedly highly placed due to her position in various courts. Henry VII of England, a man of great practicality and parsimony, was

so impressed with the utility of her advice that he had the book translated into English by William Caxton for his armies. Remarkably for a woman in the fourteenth–fifteenth century, (as a widow) she supported herself, her three children, her mother and a niece with her writing, which included poems and books on practical advice. The totality of her major works number nineteen or twenty (de Pisan 1985: 24–25). It is, however, de Pisan's work of 1405, *The Treasure of the City of Ladies* or the *Book of the Three Virtues*, that is her best-known book. In this work she gives advice to noblewomen. Included in her advice is what they should do when their husbands are away attending to war or their estates. This advice is not only practical, it recognises that it was as important for women to be prepared for war as it was for men:

> It is also fitting for her to have the spirit of a man. This means that she ought neither to be educated entirely indoors, nor in only the great feminine virtues.
>
> There is no doubt that if he wants to be honoured according to his rank it is the responsibility of every baron to spend the least possible time at his manors and his own estate, for his duties are to bear arms, to attend the court of his prince and to travel. Now, his lady and companion stays behind and she must take his place ... there has to be someone in charge ... and therefore it is proper that she should take on this responsibility ... Her men should be able to rely on her for all kinds of protection in the absence of their lord ...
>
> [S]he ought to have the heart of a man, that is she ought to know how to use weapons and be familiar with everything that pertains to them, so that she may be ready to command her men if the need arises. She should know how to launch an attack or to defend against one, if the situation calls for it. She should take care that her fortresses are well garrisoned (ibid., 128–29).

Clearly her advice would have been of great value to any woman, and man for that matter, in preparing for the civil unrest that was so prevalent during this time.

The Iberian Peninsula

In the year 711 Muslim armies first invaded the Iberian Peninsula, but the reconquest began as early as 722 at the Battle of Covadonga. By 1085 the peninsula was mostly Christian, and by 1249 only the area around Granada remained in Muslim hands. In the late eleventh century and early

twelfth century the Iberian Peninsula (Map 4) north of the Tojo River was a collection of small, mostly Christian states, but overseen by Muslim armies of the Caliphate of Córdoba. Between 985 and 1002 these minor northern states reached their lowest ebb due to the repeated efforts of the Muslim general Almanzor, who had sacked all the major cities (Reilly 1999: 4). This situation remained until 1008 when Almanzor's son and successor died. When a younger son tried unsuccessfully to usurp the office of the Córdoban caliphate, the caliphate suddenly collapsed. At this point Alfonso V of León stepped into the vacuum and asserted authority over some of the Christian areas, ultimately strengthening the Christian states. León-Castile was the most powerful state, under Alfonso V's grandson, Alfonso VI; and Aragón under Alfonso I was the second.

Urraca and Teresa

It was under these circumstances that we turn to two royal sisters who spent much of their lives on the battlefield – frequently opposing each other.[23] Alfonso VI (1065–1109) of León-Castile, the father of Teresa and Urraca, was perhaps the most influential ruler of the Christian states who continued expanding his power, the base of which had been laid down by his father, King Fernando I (1035–1065) of León-Castile. Alfonso was able to take most of Navarre when his cousin, Sancho García IV, was assassinated in 1076, as well as annex Rioja along with many of the Basque Provinces (O'Callaghan 1975: 194–200). Alfonso, like the later Henry VIII of England, married several times in pursuit of a male heir. Having failed this, he was left with one legitimate heir, his daughter Urraca (1079–1126) by his second wife, Constance of Burgundy.[24] When Urraca was only about 8 years old (ca. 1087), she was betrothed (and probably married) to her mother's great nephew, Count Raymond of Burgundy. It was perhaps also at this time that a marriage was arranged for another of Alfonso's daughters, Teresa (ca. 1080–1130), to Count Henry of Burgundy, a cousin of Count Raymond. This daughter, however, was illegitimate. Nevertheless, about 1094 Alfonso granted to Teresa and her husband, a man of great abilities and experience, the land of Portugal (ibid., 213).[25]

It seems that from the very beginning Urraca's husband, Count Raymond, held a huge amount of influence and he and his brother-in-law, Henry of Burgundy, entered into a 'Pact of Success', giving Henry Toledo or Galicia in exchange for Henry's aid in securing León-Castile. Alfonso surely was aware of this, as Hugh, Abbot of Cluny, had negotiated the pact. At this time, it is also possible that Henry was already Count of Portugal. This was a period of intrigue and changing alliances, but for our purposes, the manoeuvres of the husbands form the prelude to the remarkable military careers of the two wives.

Two years before the death of her father in September 1107, Urraca's husband died, and in December of the same year Urraca issued her first charter

in her own name, which seems to have been the opening of a more independent life for her; she was 27 and mother of Infanta Sancha (born 1095) and Infans Alfonso (born 1105) – the future Alfonso VII. Upon her husband's death Urraca became ruler of Galicia – if she remained unmarried – as well as Zamora, Salamanca and Ávila.

In May 1108, Sancho Adefónsez, Alfonso's only male, but illegitimate heir (son by his Muslim mistress), died at the Battle of Uclés, fighting against the Murâbits. Despite his illegitimacy, at the council at León in 1107, Sancho had been declared Alfonso's heir. Nevertheless, on his deathbed on 30 June 1109, at the age of 72, Alfonso VI designated Urraca as his heir, and the day after his burial twelve of the sixteen bishops confirmed it. It was declared that '*Urraca dei nutu totius yspanie regina*' (Urraca by the will of God, queen of the whole of Spain) (Reilly 1999: 56). Among the secular conferments were her present and future lovers.

The death of Urraca's husband, father and half-brother left her not only the reigning queen '*tocius Gallecie imperatrix*', as she termed herself, but with all political attention turning to her. Nevertheless, her brother-in-law, Count Henry of Portugal, was now also in a much more powerful position. Furthermore, not long before his death, her father had arranged a second marriage for Urraca – to Alfonso I of Aragón – a marriage for which neither she, nor apparently anyone around her, was enthusiastic, but it seems that the strength of Alfonso VI's influence survived his death. The disaster of the marriage was almost immediately evident due to war within the family, and the Pope nullifying the marriage (O'Callaghan 1975: 216–17).

In the meantime, Teresa, who already had two daughters, gave birth to a son whom she named Alfonso Enríquez after her father. While Count Henry continued to make adroit political moves that increased his power and position, tensions grew as Teresa, at least in the eyes of her sister, took on more trappings of royalty. In May 1112 Henry was seriously injured, probably in battle, and died soon after.

After Count Henry's death, Urraca wasted no time reoccupying areas that had been ceded to Henry as the price of his alliance against Count Raymond. Teresa, for her part, secretly accused her sister of plotting to kill her own husband, Alfonso I of Aragón. A questionable treaty finally resolved this triangle of distrust and dislike in 1113 when Queen Urraca recognised Teresa's right to the lands Count Henry had controlled before his death. This, however, did not end the difficulties between the sisters. In 1116 Queen Urraca's son, Prince Alfonso Raimúndez (later Alfonso VII), asserted his independence; he demanded from his mother his inheritance and gathered support in Galicia. The queen rode at the head of an army to put a stop to him but ultimately, after an unpleasant attack on her, she wisely found a solution that for the moment satisfied him (ibid., 217–18). Teresa took the opportunity, and with her own

troops surprised the queen. Urraca was unprepared and was forced to negotiate; Prince Alfonso returned to Toledo. At about the same time, Teresa's son, Alfonso Enríques, also began to assert his independence and gathered around him a group of nobles that were in opposition to his mother.

In May of 1117 Teresa began using the title *regina*, 'but in many ways this grasping at royal status merely underlined the fundamental weakness of her position' (Lay 2009: 63). Nevertheless, the Pope recognised the title.

In 1120 the sisters again met each other in combat, but while this seems to have been their last battlefield encounter, their relationship does not appear to have improved. These two sisters had much in common besides their paternity; for our purposes they were both women of great strength and determination (although Urraca appears to have been the wiser of the two) who succeeded in what was ostensibly their goal – the handing over of power to their respective sons – Urraca by her death in 1126, Teresa by the defeat of her army by her son at the Battle of São Mamede on 24 July 1128, which is considered the pivotal event in the establishment of Portugal.[26]

Isabella I of Castile

Isabella I of Castile (1451–1504) is an appropriate woman on which to end our survey of historical women involved in military pursuits. She was the daughter of Juan II of Castile and his second wife, Isabella of Portugal. Upon Juan's death in 1457, his son by his first marriage, Enrique IV, came to the throne. Juan's widow, Queen Isabella, fell into a state of depression, and her two children, Isabella and Alfonso, were left to the goodwill of the new king. Scandal in his personal life filled Enrique's reign with discontent, and it reached the point where it was widely believed that Enrique's daughter Juana was actually the daughter of Beltran de la Cueva, duke of Albuquerque. The opposition to his reign was so great that the nobles offered the crown to the Princess Isabella, the then surviving heir of King Juan. To her credit, and no doubt perspicacity, she refused and subsequently was named Enrique's heir. In October 1469, against the wishes of Enrique, she married Ferdinand of Aragon who would become king of Aragon and was already king of Sicily, but Isabella was a perceptive and shrewd woman who aspired to be more than a mere co-ruler with Ferdinand. She wanted the crown for herself and in 1469 adroitly negotiated the marriage agreement of Cervera, in which Ferdinand 'swore to take no political or military action in Castile without Isabella's consent, and not to give any office or power in the kingdom to "foreigners", by which was evidently meant Aragonese or Catalans' (Edwards 2000: 11). In addition to these concessions Isabella was to be given a large sum of gold florins, 4,000 lances, and a splendid ruby and pearl necklace.

Five years after her marriage to Ferdinand, Enrique IV died on 12 December 1474. The next day Isabella had herself proclaimed queen of Castile. Ferdinand,

who was not present, was declared 'legitimate husband' (ibid.). Thus, Isabella took the Castilian throne in her own right, but initially had to settle the domestic problem of Ferdinand's assumption that he would be the ruler and she the consort, as they both had sound claims to the Castilian throne – Isabella prevailed. Under this 'concordat of Segovia', Salic Law was cast aside and:

> Isabella remained 'proprietary queen' of the domains of the crown of Castile, with clear implication that her descendants, and not Ferdinand, would inherit the Crown on her death ... [Thus] sovereignty in the crown of Castile including the appointment of accountants and treasurers and the disposal of the entire royal patronage, would reside in the queen alone (ibid., 22).

Next, she had to fight a war of succession with Enrique's Juana, who laid claim to the throne – this despite the suspicion that Juana was possibly the illegitimate daughter of Enrique's wife. At the time of Enrique's death Juana was only 13 years old, but was in negotiations to marry Alfonso of Portugal. The marriage of Juana and Alfonso took place 29 May 1475, and it was Alfonso who in fact waged the war in Juana's name, but again Isabella overcame this obstruction to her objective.

The war for the Castilian succession was successfully concluded in 1479. Isabella and Ferdinand were now able to rule Aragon and Castile jointly, with equal authority, thereby uniting Spain.

Next came the ouster of the Muslims from Spain, which became Isabella's most important and pressing objective. She was deeply involved in planning strategy and organisation of the campaign. It is reported that she was so involved in a war council in 1482 that she needed to excuse herself to give birth to her daughter Maria and a stillborn twin that arrived a day-and-a-half later (Downey 2014: 158, 186–87). While the extent of her time on or near the frontlines is not clear, Edwards remarks that on 11 June 1486, 'Isabella paid her first visit to the front line, at Illora', and in June 1487, 'Ferdinand persuaded her to leave Córdoba ... and join the troops in the field' (2000: 112, 114). Edwards further remarks *in passim* that her presence is said to have bolstered the morale of the troops. Isabella even introduced her 6-year-old daughter Juana to the taste of a war victory when the two of them rode on horseback to accept the surrender of Moclín. Isabella encouraged both her husband and army with heartening words that they were doing God's work, she did not shrink from dangers, even from the plague, when she saw the importance of her presence at the battlefront, and while she seems to have been genuinely saddened by the deaths on all sides of a battle, she was able to mete out punishment where she thought it due. When Isabella and Ferdinand's army targeted the seaport of Málaga, Isabella took up residence, despite rumours of plague. The battle was horrific and the

surviving Muslims were taken as slaves and given to Christians, including the Pope (Downey 2014: 197–98).

As one of her chivalric symbols, Isabella used 'a bundle of arrows ... [the] prime missiles of war and the execution of justice ... Her arrows, gathered together and bound, resembled as well Ceres' bundle of wheat, and so fertility' (Liss 2004: 122).

The year 1492 was a momentous one and marked events, both good and ill – depending on who you were – that secured Isabella's place in history as both a powerful admired leader and as a religious fanatic. On 2 January, the Moors of Granada surrendered and Spain was free of Muslim rule for the first time since the eighth century. In that year the Moors were driven from Spain and all Jews who did not convert to Christianity were also expelled. These two events were to cause much havoc and misery, particularly for the Jews. It was, however, a seemingly small event on the part of Isabella that changed the world the most – she sponsored the exploration of an undistinguished adventurer, Christopher Columbus. On 12 October 1492, Columbus first landed on the Bahaman Islands and thus the 'New' world was 'discovered'.

This 'discovery' cemented Isabella's prominence in history much more than her military activities, but it was her 'unwomanly' military activities that affected the lives of countless people at the time and changed the course of religion in the Iberian Peninsula.

For the purpose of this study, the 'New World' changed nothing. In what might be thought of as a no longer ancient or even a medieval world, the position of women changed neither, societally nor militarily. We can point to women such as Æthelflæd, Matilda of Tuscany and Isabella of Castile herself as examples of women who donned their war clothes, drew their swords and went into battle, not so much for self-aggrandisement (although surely there was some of that) but for the causes they espoused. These causes frequently ran to holding on to power for their son or husband. Few were successful in holding power for their own sake, but Isabella was one of the few.

Conclusion

This work has been offered as a repudiation of the too often expressed view that 'women do not fight' and to show that women's participation in war goes far beyond fighting. The archaeological and historical evidence presented makes the participation of women in warfare beyond question. Legendary and mythological figures also provide cultural evidence that ties women to warfare. Taken as a whole, the cultural, archaeological and historical data demonstrate beyond any doubt that women certainly did fight in ancient times and continue to do so today. Nevertheless, it is equally true that in ancient times they did not fight to the same degree and manner as men. Furthermore, they did not seem to fight for the same things that men do – or at least not to the same level. Although why men fight is not the purpose of this work, a cursory appraisal of history tells us that many, if not most, of the wars instigated by men have been for advancement of power or territory. While I would not deny that power was also a factor in women's fighting, women, in general, have more often fought to defend the inheritance of their children (principally sons), their own titles, possessions that were already theirs or a cause. These are all forms of power but are less discernible than that displayed by many powerful male leaders.

Conquering territory for its own sake is rarely a reason for a woman to go to war. While it is true that powerful female rulers, such as Elizabeth I and Catherine the Great, expanded the territories over which they ruled, history does not provide us with a female Rameses II, Alexander the Great, Julius Caesar, Genghis Khan or Hitler. However, we need to remember that power need not be great power. Nicolaa de la Haye fought for her castle in order to maintain the power she had and ultimately for the king from whom she received power.

The second issue for this work has been to show that women have been involved in warfare beyond actual combat. My thesis is that we must think beyond the obvious sword-wielding Amazon. We need to be more inclusive, taking in women who not only went into battle with sword in hand, but also those who raised and organised armies as well as those who strategised the battles. We also should not forget those women who performed what are usually thought of as menial tasks, or were unwilling combatants as addressed in the *Cáin Adomnáin*.

We have seen a significant variety of evidence that women not only engaged in combat but also organised and commanded battles. What then do we make of the stories of teachers of the warrior arts? The legendary stories of women training warriors do not, at first, seem to go on into reality, but it is important to remember that women raised the boys and shaped their thinking. While not in the same class of trainer, we have the perhaps apocryphal story of the Spartan mother urging her son to return with his shield or on it, and we should not forget that Audata-Eurydice is said to have taught her daughter Cynane military skills. Once widowed, Audata-Eurydice refused all marriage proposals in order to devote herself to her daughter's military education. Matilda of Tuscany learned military lessons from both her stepfather and her mother. Women such as Busa, who simply provided provisions for soldiers, should also not be overlooked. Participation in the military can come in many forms.

We have literary, iconographic and funerary evidence of women who were clearly combat warriors. This is not to say that Indo-European society was filled with women who rejected the more traditional female roles for one of warrior. There is, however, a preponderance of evidence to show that enough women engaged in warrior activities that they were not anomalies. These women either stepped in when society needed them or simply that society did not have the rigid gender roles to which we have subscribed for too long. Both of these views are equally possible. The 'We Can Do It' motto of 'Rosie the Riveter' surely precedes the twentieth century.

It should be clear from this work and the number of books recently published on the subject of women and warfare that although males may be the most common warriors, the reality of the woman warrior is not as rare as previously believed, examples can be drawn from many societies, not just Indo-European. Moreover, these societies reach back to some of our earliest histories. The Egyptian queens Ahhotep and Hatchepsut are two examples of our earliest female military commanders, but the even earlier Near Eastern war goddesses such as Inanna and her sister goddesses laid the groundwork for these military women. These early deities are followed by legendary figures such as valkyries, epic characters such as Camilla, Gordafarid and Medb, Celtic warrior trainers such as Aife and Scáthach and most importantly the Greek stories of Amazons.

While not physical evidence of warrior women, these diverse examples constitute cultural evidence of a widespread tendency to acknowledge within the culture itself that women were intimately engaged in the preparation for and participation in warfare. That these mythical-cultural manifestations reflect a reality that is demonstrated by later historical instances in which the mythic or legendary scenario is put into play.

The later historical examples include the Sarmatian queen Amage, both Artemisias, Æthelflæd, Gwenllian of Wales, the Empress Matilda, Matilda of

Boulogne, the Countess of Norfolk and the celebrated Joan of Arc. The fame of some of these women has become widespread, while others can only be found if we search ancient records. Even when we lack names or know only a few, as with Greek and Celtic women, we have abundant evidence of their being involved in battles or the planning of battles.

It is also clear that the idea of a female ruler or warrior is one that has for millennia been held in contempt, distain or just ignored. Furthermore, it is equally apparent that men have been disinclined to have women rule them, and although there are times when women do command, they often imitate men, such as Hatchepsut donning a beard, Elizabeth I reminding her audience that she has the heart and stomach of a king and Irene using the masculine form *basileus*. Undoubtedly, these women saw the advantage of maleness.

We also see recurrent warnings by men in regard to allowing women to rule. This attitude is evident from a variety of societies. We have seen repeatedly that men do not care to be led by women. Even when women prove themselves in battle they are often rejected as leaders. In more than one instance it is mentioned that to men it is a disgrace or embarrassment to be ruled by a woman, or the idea is held that if women rule, things turn out badly. While examples of this can be found, so can the opposite – certainly Xerxes found Artemisia's advice the more reliable. Nevertheless, we have a number of legendary examples that point to men's reticence to be led by women. The story of Gordafarid and Sohrab illustrate that a man would be embarrassed to be bested by a woman. Hetha was appointed to rule over part of the Danish lands, but later the Sjællanders decided it was a disgrace to be led by a woman. Rusila was rejected as leader of Denmark despite having defeated her brother Olaf. Similarly, the Irish Medb's lover Fergus mac Róich disparages her leadership, leading O'Connor (1967: 32) to assert 'the purpose of the original author [of *The Táin*] would seem to have been to warn his readers against women, particularly women in positions of authority'. Even when a woman was raised to be independent, she was usually not allowed to follow through with her plans. Such was the case of Alvild who had been discouraged to marry by her mother, but ultimately Alvild, tracked down by her pursuing prince, is convinced to return to the feminine life. This returning to the 'feminine life' is also a common end to a female's independent life – the 'feminine life' does not present a threat to men.

Soon after the period that this work encompasses, several exceptionally strong female leaders occupied thrones in Europe and all led their countries in major wars. During the last half of the sixteenth century, Elizabeth I of England became what many scholars believe to be the most capable monarch England has had thus far had – this included strategising the military. The eighteenth century saw three female rulers who successfully reigned over great empires. Two of these monarchs were Russian empresses, Elizabeth and Catherine the Great, both of whom took the throne by coups and led Russia in several wars.

Marie Therese of Austria became the ruler of a number of countries, engaged in war for much of her reign but did not give up child bearing.

War, however, is not the only thing these women had in common. Throughout this work fertility has been an important ancillary facet of their makeup. We see it first in the earliest Sumerian texts closely associated with war goddesses and agriculture, but it evolves in the historical period to human fertility and the need for heirs – particularly sons. Although Elizabeth may have been the 'virgin' queen, Maria Therese did her part for fertility. Fertility takes in procreation itself, but also sex. It is perhaps Cleopatra who best used sex as a means to an end, but she was not the only female leader to use this tactic.

Nevertheless, there are the incidences where women used men for sex and got rid of them when they had served their purposes. It is said Semiramis did this and almost certainly Cleopatra used both Caesar and Marc Antony as a means to an end. This may also have been Zenobia's tactic.

One of the great questions regarding female warriors is whether or not Amazons were real or a figment of the Greek imagination? The essential point about Amazons is the persistent nature of their characteristics and the stories themselves. Stories of Amazons have found their way into Irish origin tales, used as role models for Boccaccio and are a part of our vocabulary. In light of many of the finds of women with weapons buried in the Eurasian steppe more credence may need to be given to the Amazon legends.

We have an ever-growing amount of archaeological evidence for women warriors from the Steppe, but in the West, we are left primarily with literary and historical evidence but still lack comparable archaeological evidence. However, the literary and historical evidence is so undeniable that with modern scientific techniques, particularly DNA, the discovery of female warriors in graves will undoubtedly grow in number. Grave Bj.581 from Birka may prove to be the first of the graves of female leaders, but it should be expected that the number of female warrior graves will remain fewer than male graves. It may also be that despite their warrior aspects, women were not, by choice or custom, buried with weapons. The ability to find women in warrior graves requires a sound methodology. DNA provides the tool to give us this genetic information. In light of the literary evidence and analogy from the Eurasian steppe, it is fallacious to assume that all burials with weapons are male.

Having surveyed the mythological, legendary and archaeological evidence, and examined a number of historical women, the conclusion that some women held military positions and took an active role in combat in ancient societies is unquestionable. While not all these women led the charge, they were clearly involved in the conduct of warfare and some did indeed lead the charge. It may not be possible to use myth and legend as hard evidence, but we can use them as guides in regard to societal attitudes, and they make clear the antiquity of the interaction of women and war.

Endnotes

Introduction

1. The threat of the Spanish Armada in 1588 caused Elizabeth I to inspect her army at Tilbury, where it was famously reported that she declared, 'I know I have the body of a weak and feeble woman, but I have the heart and stomach of a king, and of a king of England too'. She is also said to have worn a silver cuirass followed by a page carrying a helmet with plumage (Levine 1994: 143–44 ns. 52 and 56; see also Leicester and Christy 1919; Schleiner 1978).
2. *Confessio Amantis*, Vol. 2, Book 4, ll. 2135–70. https://d.lib.rochester.edu/teams/text/peck-gower-confessio-amantis-book-4
3. The word 'Amazon' has come to mean 'warrior woman' used in this sense by just about everyone when dealing with a fighting woman and is commonly used as a generic term meaning any woman who has engaged in battle or is large in stature. Penrose (2016: 9) points out 'the word "Amazon" was not fixed' and has been used inconsistently. As a consequence, in order to differentiate, I have tried to avoid using the term except when referring specifically to the group of women referred to as such by the Greeks, and in these cases I spell it with an upper case A. There are, however, incidences when it is more convenient to use the term generically and in these cases I spell it with a lower case a. This is a small point but one that indicates how completely the term Amazon has been absorbed into our vocabulary and culture.
4. While at first sight it might appear that both virago and virgo 'virgin' are related to Latin *vir* 'man', 'husband', it is only the first connection between vir and virago that is generally accepted. The relationship to 'virgo' is considered excessively doubtful. (See Walde-Hofmann, 1938: vol. 2: 797 and 799; Buck 1949: 2.21; Mallory and Adams 1997: 366, 548.)
5. Cf. *Oxford Latin Dictionary* (1982: 2070 cols. 1–2). Lewis and Short (1879: 1995 col. a) are even more specific in their definition: 'a man-like, vigorous, heroic maiden, a female warrior, heroine, virago'.
6. Although all the women in the *Iliad* are treated as prizes, Helen is the primary example. At the Judgment of Paris, Helen is the prize; moreover, she

is designated as such by the goddess Aphrodite, indicating the regard Helen and all women were held. For an alternate view on Briseis see King (1987).
7. The work of Kathy Gaca provides explicit examples of the savagery committed on girls and women in ancient times and also gives modern unsanitised illustrations (see particularly Gaca 2016; 2018).
8. See the work of Jonathan Shay, particularly (2014).
9. Women who performed these duties were quite frequently thought of as prostitutes.
10. Skaine (2011: 19–25) gives a brief history including fairly recent history of women in combat.
11. Cf. Mayor (2014); Penrose (2016); Man (2017).
12. The earliest Olympic games began about 3,000 years ago; the exact date is debated, but the first written reference appears in 776 BC. (See Rashke 1988 and Swaddling 2008.) However, preocursoers to the Olympics can be found in Hittite texts (Puhvel 1988).
13. A possible exception may have been in the West African kingdom of Dahomey (modern day Republic of Bénin) where in the eighteenth and nineteenth centuries soldiers were recruited from the king's wives (see Law 1993; Alpern 1998).
14. Feudal Japan had a number of female rulers some of whom went into battle. Between the twelfth and nineteenth centuries many Japanese women of the samurai class learned military skills in order to defend their homes when their husbands were off to war; in some cases, they rode with their husbands. One of the most famous of these women (but one whose reality is sometimes contested) was Tomoe Gozen who not only went to war (the Genpei War – 1180–1185) but was also a captain in the army of her daimyo (warlord and possible husband Manamoto no Yoshinaka who was prominent in the Japanese epic *The Tale of the Heike*). She was quite famous for her swordsmanship and riding abilities and has become the subject of many prints, a number of which are in the Print Collection of the Library of Congress. Women of Feudal Japan, http://www.angelfire.com/wv2/rising_sun/history.html. See also Turnbull (2014).
15. Born in the first century AD to a military family, the two sisters, Trung Trac and Trung Nhi (also known as Hai Bà Trung [the two ladies Trung]), were schooled in the military arts and studied warfare. At this time China had ruled Vietnam for a thousand years and this rule had become more and more despotic. In AD 40 the sisters decided it was time to rid the country of the oppressors and gathered an army (some have said it was made up primarily of women). They declared Vietnam independent and for the next two years the sisters' army repeatedly defeated the Chinese in battle. Ultimately, they were no match for the disciplined Chinese troops and in AD 43 the sisters committed suicide by drowning. Temples have been set

up in their honor, and they are considered the most honoured heroines in Vietnam. During the American-Vietnamese War they were regarded as role models for women (Tucker 2001: 410). Two hundred years after the Trung sisters in AD 248 Trieu Thi Trinh, a Vietnamese peasant woman, again led an army of thousands against the Chinese and won a short-lived independence. Like the Trung sisters, she committed suicide – she was 21 (Bergman 1974: 30–32).

16. Two nineteenth-century works are worth noting for their scholarship. Ellen Clayton's *Female Warriors: Memorials of Female Valour and Heroism, From the Mythological Ages to the Present Era* (1879), and an even earlier, 1853, work by John S. Jenkins, *The Heroines of History*.
17. Even during World War II, long out of the period of this work, other women (aside from the already noted Soviet women) played a vital role in the war effort. Notably were the WASPs (Women Airforce Service Pilots) in the United States and ATA (Air Transport Auxiliary) in Britain who ferried airplanes but did not engage in combat. These women were treated not only with disdain but were dismissed after the war without benefits or even transportation home. Only in November 1977 – thirty-two years after the end of World War II – did President Carter sign into law legislation that recognised the WASPs as veterans. After another thirty-three years, in March 2010, President Obama signed legislation awarding the WASPs the Congressional Gold Medal and thereby officially recognising their heroic service to the United States and their war contribution. An interesting comparison can be made between the American female pilots and the Soviet Union's female pilots. The Soviet women were not just transport pilots; they were fighter pilots. German flyers referred to the women Soviet fighter pilots as *Nachthexen* 'night witches' (see Schrader 2006).
18. See e.g., Boardman (1993, figs. 56B, 96, 97, 154.)
19. *Berdache* (since 1991 referred to as two-spirits) was the term French explorers gave to North American Indians who did not conform to biological conformity (see Medicine 2002). In Albanian culture the 'sworn virgins' are women who take on the persona of males by choice (Young 2001).
20. See Moilanen *et al.* (2021) for discussion and bibliography.

Chapter 1: In the beginning

1. 'Club' seems to be a loose translation of *vajra*. For greater details see Mallory and Adams (1997: 110–12). Stone maceheads with gear-like carvings on them are known. Kuznetsov (2005) describes a long metal weapon excavated in an early Bronze Age burial in the Samara area of Russia that he identifies with the *vajra*.

2. Taking *aigis*, from Greek *aegis* αἴξ αἰγος 'goat' is a commonplace derivation, but Paul Friedrich points out (1970: 133) that Herman Hirt (1892: 482) had once argued that it was actually an oak shield. Not only is the oak Zeus's totemic tree (his priests foretell the future at Dodona by listening to the rustling of the oak leaves), but oak is much more suited to shields than goatskin the leather of which is soft (unlike ox hide or pigskin) and used for gloves.
3. The *Rigveda* is believed to have been composed ca. 1500–1000 BC and handed down orally for about a thousand years. The earliest written manuscript dates to around the eleventh century AD. See Jamison and Brereton's (2014) Introduction for an in-depth overview of the *Rigveda*. The *Avesta* (the ancient Iranian religious text associated with Zoroaster), like the *Rigveda*, was originally passed down orally. The dating of the *Avesta* is much less secure but thought to have been composed about the eleventh century BC and written down about the fourth to sixth centuries AD. For a survey of Indo-European languages and culture see Mallory and Adams (1997). For a review of the major Indo-European homeland theories see Mallory (1989).
4. An important point to remember is that Sumerian is not a gender specific language. That is Sumerian has two grammatical classes, animate and inanimate. The animate nouns are for humans and gods, and the inanimate nouns are for animals and inanimate things. Confusion is compounded in that a deity could be male in one place and female in another. We are left with iconography and some epithets to determine gender (see Westenholz 1998). The earliest Sumerian writing dates to around 3400–3000 BC but was not deciphered until the late nineteenth century. Today there is a great deal of Sumerian literature available in translation (see Kramer 1972; Black *et al.* 2006).
5. For a good discussion of these two goddesses including likenesses and differences see Westenholz (2009).
6. See also Leick (1994: 56–47).
7. Uruk, located on the southern Euphrates in southern Iraq, was one of the first and most important cities in Mesopotamia beginning in the fifth millennium BC and at one time probably its biggest with a population of about 50,000. It was also the city of the great king Gilgamesh who built the wall that surrounded the city.
8. Although Inanna is known less for 'romantic' love, it does exist in what Leick (1994: 64–79) refers to as 'Bridal Songs'.
9. For some time, this epithet could not be adequately explained as 'Kur' in two of the three versions of the myths of Kur was believed to be a serpent-like monster who guarded the primeval waters. If the monster was destroyed, calamity would occur and the water would rise making

agriculture impossible. The third version appeared on a tablet that was too fragmented to be understood. After several additional pieces of the tablet were found and restored, the noted Sumerologist, S.N. Kramer, was able to reconstruct and translate most of the third version. In the third version, 'Kur' is the 'mountain Ebih' an area northeast of Sumer and not the cosmic Kur (Kramer 1972: 76–83). Therefore, to be 'destroyer of Kur' did not mean that a calamity would beset the earth just the people of Kur.

10. *Inana and Išme-Dagan*, l.22, Black *et al.* (2006: 91); Kramer (1972); Black and Green (1992).
11. The name is also given, depending of the language and translator, as Anath, Anit or Anta. The Norwegian scholar Arvid Kapelrud (1969) discusses the confusion of names and the goddesses themselves.
12. The 382 Amarna tablets date to the middle of the fourteenth century BC and were found at Tell el-Amarna the site of Akhenaten's (the heretic pharaoh) capital in 1887. They consist primarily of diplomatic correspondence between Pharaohs Amenhotep III and his son Akhenaten (eighteenth dynasty) and other Near Eastern rulers including those of Mitanni, Hatti, Babylonia and Assyria. The clay tablets are written in Akkadian cuneiform and considered our earliest example of diplomatic correspondence as well as a very important source for Semitic linguistics and biblical studies (see Moran 1992).
13. See also Gordon (1966, ns. 14–16).
14. Queen Elizabeth I was known as the 'Virgin Queen,' and while there are those who question her anatomical virginity, this would be, by the above definition, an appropriate title.
15. *Homeric Hymn* 5, ll. 80–81. This type of honorific title has continued into more modern times, e.g., the French will refer to an older but unmarried woman as 'madam' and even cooks and housekeepers in upper class English households were previously referred to as 'Mrs' although they may never have been married.
16. In the tale, the Tsar tells his three sons to shoot an arrow each in a different direction and the girl who brings it back will be that son's wife. Shooting an arrow is a not so veiled reference to intercourse and in this case the son would have had relations with his bride before the wedding.
17. The other 'regenerating virgins' in the *Mahābhārata* are Satyavatī, Kuntī and Draupadī.
18. For discussion and translation of *The Baal and 'Anat Cycle* see Gordon (1949); for *The Baal Cycle* see Smith in Parker (1997); for discussion of the wars between Baal and Môt, see Cassuto (1962). Also see Pritchard (1958: 92–117).

Chapter 2: Indo-European Goddesses Affiliated with War

1. It is not completely clear if there were one or two Tudhaliyas (see Bryce 1998: 131–54).
2. Also, Shaushka, Šauša, Šawuška and Šaušga.
3. The Mitanni were a Hurrian speaking people (but their kings were Indo-Iranians) who lived between the Tigris and Euphrates in what is today Syria. They incorporated into their treaties (dating to ca. 1400–1330 BC) a substantial number of Indo-European (specifically Indo-Aryan) terms; several of the god names are identical to Vedic deities. The Mitanni were known for their skill with horses and a Mitanni treatise, referred to as the Kikkuli Text, a treatise on horse breeding, is justly famous (see Mallory and Adams 1997: 306; Raulwing 2005[06]).
4. Macqueen (1959: 177–78; 1986: 110), however, equates her with Sumerian Ereshkigal, goddess of the Underworld, who was in conflict with her sister Inanna.
5. The *Avesta* is broken down into a number of parts one of which is the Yašts; these are twenty-one hymns dedicated to various divinities. See Darmesteter (1880, 1882); Mills (1887); Boyce (1982, 1984, 1996); and Insler (1975).
6. The *Homeric Hymns* are a collection of thirty-three hymns praising various gods and attributed from antiquity to Homer. Today they are considered anonymous and to have been written over a large expanse of time from as early as the seventh century (some say eighth) BC to the Hellenistic period (see Janko 2007). They range in length from a few lines to several hundred lines.
7. There are those who also attribute her origins to Middle Eastern influences (see Teffeteller 2001).
8. Many scholars have in the past associated Aphrodite with fertility (e.g., Frederick 1978: 93 'it is Aphrodite who most centrally symbolises growth, fertility, and procreation.') More recently Budin (2003: 21) has rejected her as a fertility-goddess. She argues that 'although Aphrodite does have a role to play in fertility, especially in later Greek and Roman tradition, in the earlier periods Aphrodite should not be identified as a fertility-goddess, for fertility is only a symbolic extension of her primary attributes of love, desire, and sexuality'.
9. For an earlier discussion of her origins and a very different conclusion see Friedrich (1978). He gives no small credit to Aphrodite's origins to the goddess of Old Europe as laid out by Marija Gimbutas particularly (1974).
10. Not all scholars agree that Artemis is a moon goddess. Bell (1991: 73) says most people see her a huntress or ethereal moon. Grimal (1996: 62) says antiquity 'explained Artemis as a personification of the Moon' but not all

her cults had lunar significance. Budin (2016: 5) claims that because of the syncretism of Artemis with the Mesopotamian Nanaya, 'it is clear that both goddesses were influenced by the Roman Age conflation of Artemis with Diana, such that all three goddesses came to take on lunar (and even solar) imagery.' Budin goes into greater detail in her chapter 'War Goddess?' in her work devoted to Artemis (2016: 59–67) where she also gives credit to the Romans for Artemis' war attributes.

11. Examples of Minerva on coins: 240–225 BC Aes Grave Triens – Obverse: helmeted Minerva, Reverse: Prow of a galley right, four pellets below. (See the Virtual Catalog of Roman Coins http://vcrcartemis.austincollege.edu.) Accessed 21 May 2016.
12. For some of the latest work on these tablets see *Le lamine di Pyrgi Nuovi studi sulle iscrizioni in etrusco e in fenicio nel cinquantenario della scoperta* a cura di Vincenzo Bellelli e Paolo Xella 2015–16.
13. According to Price and Kearns (2003: 305, col. b), this epithet derives from *monere* 'to warn' is generally accepted but the origin is unknown. However, the first mint is near her temple and thus the association of 'money' from Moneta.
14. See F. Kelly (1988: particularly 68–79) for a discussion of the legal status of women in early Irish law. It should, however, be remembered that these laws originate (at least in written form) in the seventh–eighth centuries AD, after Christianity had a firm hold in Ireland. In his Introduction, Kelly discusses some of the inconsistencies that appear to conflict with earlier times.
15. MacCana (1983: 42) points out that 'threeness is a more or less universal feature of traditional thought ... It received particularly free and elaborate expression among the Celts'.
16. A possible affirmation of this idea, and one adopted by Christianity, is the crossing of oneself with 'holy water' when entering and leaving a Catholic church – the boundary between secular and non-secular spaces.
17. While war is not associated with Sequanna, proof of the belief in her curative abilities have been found at the headwaters of the Seine where over 200 models of body parts have been recovered. Many of these body parts are on display at the Archaeological Museum in Dijon, France.
18. The reader unfamiliar with Celtic linguistics should not be confused with the change of q to p in a number of words, e.g., Latin *equus* and Gaulish *epona*. This represents a linguistic change over time much as Latin *pater* and Germanic (Gothic) *fathar*. For a more in-depth discussion of this and other linguistic changes, see Mallory and Adams (1997: 96–102).
19. This lengthy note by Anne Ross (1962) is a good explanation of a number of curious points of Celtic religion.
20. Other spellings include Mórríoghan and Mórrígu.

21. Whether or not the meaning of her name is 'great goddess', 'phantom goddess', or 'queen of nightmares', from Old Irish *mōr*, 'great' and *ri*, *rig* 'king', *rigain* 'queen', there is no question that the 'Morrigan became a feared goddess' (Dexter 1990: 221, n. 5). Dexter and Mair (2010: 149, n.253) claim 'The most likely etymology for Morrígan is not "great queen", as many have thought (Old Irish *mōr*, "great" + *rigain*, "queen"), but "queen of death", from *moro (PIE *mor-o-s, "death, nightmare" cf. Skt. māras, "death").' But also see the *Royal Irish Academy Dictionary of the Irish Language*, 1953–1975, 173. See also eDIL – *Electronic Dictionary of the Irish Language* (www.dil.ie2019).
22. There are three Recensions of *The Táin* and each is somewhat different. Cecile O'Rahilly's *Táin Bó Cúalnge* (1967 [1984]) version is from Recension II and Thomas Kinsella's, *The Táin* (1970) draws from all three. I have used examples from both O'Rahilly and Kinsella and noted them accordingly.
23. The washer is a Scottish Gaelic tradition (also called *bean nighe*) but is also found in Welsh and Irish where she is nearly synonymous with the *banshee*. In Irish she may be either the Morrígan or Badb (MacKillop 1998: 378).
24. But see Green (1996: 43).
25. Diodorus (5.31) tells us that the Gaels speak 'with few words and in riddles'. We see this in 'The Wooing of Emer' (Cross and Slover 1936: 153–71). Also see the story of Chiomara in Chapter 5.
26. The events in this story precedes those of the much better known *Táin* 'and tells us of one of the many provocations which led to that Raid' (Leahy 1902: xiii).
27. In Celtic tradition the colour red is associated with death, reference to it is frequently found in *The Táin*.
28. I will not go into the details of these investigations but will only point out the highlights. For a full bibliography see Epstein (1997; 1998a; 1998b) and Egeler (2009).
29. Valhalla should not be thought of as the equivalent of the Otherworld but a place where chosen warriors go after their death – more of a paradise. It is one hall, 'hall of the slain', of Asgard, the realm of the gods, where warriors are taken after they die in battle and are served mead (although Oðinn only drinks wine) and choice meats as a means of hospitality. It is neither well understood nor even well described in the poems, the most effusive about it being *Grímnismál* which Ellis [Davidson] (1943: 68) says 'at least suggest that the Valhöll [Valhalla] conception, as seized on with enthusiasm by the court poets and later by Snorri, was only one small part of a much larger conception, which the later writers have forgotten.' (See also Simek 1993: 346–48.)

30. Daughter of Swedish king Níthoth 'The Lay of Volund' (Hollander 1962: 159–67).
31. Daughter of a Swedish king in the Old English poem *Deor's Lament* (ibid., 159).
32. A Valkyrie as well as daughter of Frankish King Hlothvér 'The Lay of Volund' (ibid., 160–67).
33. Until quite recently depictions of Valkyries have only been two dimensional, the May 2013 edition of *Current Archaeology* (2013: 9) reports a three dimensional Valkyrie figure rendered in silver. This small (3.4cm) figure was found on the Danish Island of Funen outside Hårby and dates to ca. AD 800. The figure is a female with hair pulled back and tied in a knot, in a long dress, holding a sword in her right hand and a shield in her left. There is a small hole in the back of the head suggesting it was used as a pendant. (See also Davidson 1969: 46–47.)
34. See also *Grímnismál* (Hollander 1962: 60, stz. 37), but Hollander (1962: 6, fn. 32) says the stanza is a later edition. Hollander includes most of the Lays mentioned here.
35. *Flateyjarbók* is the magnificent Icelandic manuscript of about 2,500 pages begun in 1387 and finished in 1394 – there was ever only one copy. It is considered one of the most beautiful of medieval manuscripts and relates stories of the Viking kings. A translation into Norwegian was completed in 2019. (See Rowe 2005.) An English translation is in progress by the Saga Heritage Foundation of Norway. (https://sagaheritage.com. Accessed 21 February 2022.)
36. Archaeologically this is only seen on a sled found in the Viking Age Oseberg ship burial, which held two women. However, felines, often in the form of lions and leopards, have associations with Near Eastern goddesses. (See Dexter 2009.)
37. The numbers used here are for the three monuments are from the Internet site Roman Inscriptions of Britain (romaninscriptionsofbritain.org.) (Accessed 26 July 2015.) These numbers are used here for ease of identification.
38. The punctuation and what is in parenthesis and brackets are provided by Bosanquet and discussed in his article but have no bearing on the Alaisiagae or the subject of this work.
39. For a brief note on this see Shaw (2011: 38).
40. Both the *Mahābhārata* and *Rāmāyana* are written in Sanskrit a language descendant from the earlier Vedic in which the *Rigveda* is written.
41. The Welsh story of *Branwen Daughter of Llyr* from the 2nd Branch of the *Mabinogi* (Ford 1977: 63) presents another instance of a warrior arriving at birth as a fully armed warrior only in this case it is a boy. The mother of this warrior is Cymidei Cymeinfoll (Kymidei Kymeivoll) a giant twice the size of her enormous husband. MacCana (1983: 86) says Cymidei

Cymeinfoll has two attributes of a goddess: 'fertility and warlike vigour'. He also claims that her name, which means 'Big-bellied Battler' seems to confirm this.
42. The *Mahābhārata* is approximately ten times the length of both of Homer's great works combined.
43. The Indus Civilization, also called the Harappan culture, flourished from ca. 2600–1900 BC. It was the largest urban culture during this time having a population of about a million people and covering an area of 80,000 km² of what is today northwest India and the adjoining Pakistan and Afghanistan areas. It is best known from the large sites of Mohenjo-daro and Harappa. Although lacking the great palaces and temples of Mesopotamian and Egyptian cultures, it excelled in the planning of cities and water engineering including toilets, the elimination of waste water through pipes, the maintenance of covered street drains, and water reservoirs.
44. The majority of calibrated radiocarbon dates for BMAC range from 2009 BC to 1740 BC (see Hiebert 1994: 83).
45. The other hymns in which she is mentioned are *RV* I.164.32, VII.104.9, X.10.11, X.18.10, X.95.14, X.164.1, and X.165.1. See Jamison and Brereton (2014). For all but X.95.14 also see O'Flaherty (1981).

Chapter 3: Legendary Figures – Mortal and Supernatural

1. Some modern scholars have given other interpretations to Viśpalā. In an article written by a medical doctor as a review of amputations and prostheses, Vanderwerker, Jr. (1976: 15) refers to Viśpalā as a queen whose leg was 'amputated in battle'. Mayor (2014: 408) interprets the tale of Viśpalā [Vishpala 'Strong Defender of the Village'] as 'literary evidence for military training for girls in north-western India ... found in the *Rig Veda*.' Her reference is unclear.
2. For a brief review of how the views of Amazons differ from ancient Greece to the late twentieth century see Kirk (1987). For an in-depth study of Amazons see Blok (1994).
3. Wonder Woman began in *All Star Comics* Issue 8, December 1941. A rash of books about Wonder Woman and her origins appeared in 2014, among them Jill Lepore's *The Secret History of Wonder Woman*. Also see Man (2017: Chapter 12).
4. This is a view long held in society (Pierson 1987).
5. See Tyrell (1984). Aristotle considered it 'monstrousness' that women should take up arms. In 1558 Knox concurred railing against female monarchs, particularly Elizabeth I. In 1559 John Aylmer countered and

questioned Knox's views ostensibly through the words of God. Project Gutenberg eBook, www.gutenberg.org/ebooks/9660.
6. See Mayor (2014: Appendix: Names of Amazons and Warrior Women in Ancient Literature and Art from the Mediterranean to China).
7. According to Macalister (1939: 146) 'The details as to the manners of the Amazons are a commonplace of Classical tradition, and may have reached the Irish compilers through Isidore [of Seville and the] ... Amazons were said to have been established in many regions'.
8. See, e.g., von Brothmer (1957, pls. LXIV-1–4b, LXV-4); Rolle (1989: 90–91, figs. 64–65).
9. See e.g., von Brothmer (1957, pls. LXXIII-6, LXX-1, LX-a). For a more in-depth discussion of the Amazon wardrobe, particularly in regard to the exposed breast see Cohen (1997: 74–77).
10. E.g., von Brothmer (1957, pls. XXVIII–XXXIII); Fantham *et al.* (1994, fig. 4.1).
11. Isidore of Seville (*Etymologies*, IX, ii, 64.) says they are called Amazons either because they live alone with men or that they burnt of their right breasts in order to better shoot arrows.
12. http://nrs.harvard.edu/urn-3:hlnc.essay:Nagy.The_Sign_of_the_Hero.2001
13. See for example, von Bothmer (1957, pls. LXXXVII.4, 9, LXXXIX.1–3, 5–6, XC.1, 3); Boardman (1993, figs. 94A–B, 97, 127A–B).
14. Sworn virgins are not unique among the Amazons. Coon and other observers of Albanian (the one in the Balkans as opposed to the one in the Caucasus) customs report that Albania has a tradition of 'sworn virgins' who dress and behave as men. They report that even in the twentieth century, women who reject matrimony must take an oath to remain as virgins and that from then on they dress and are referred to as males (Durham 1909: 36; Lane 1922: 172–75; Coon 1953: 24–25). The custom may have grown out of the *Code of Lekë Dukagjini*, which is a very strict code of honour that can only be satisfied by a man (Book 8). These virgins are not particularly warriors but would undoubtedly take up arms as a man would. The tradition continues to this day (see Young 2000).
15. See von Bothmer (1957, pl. I–1a); Hampe and Simon (1981, fig. 95).
16. See Blok (1995) for an extensive survey of Amazon passages.
17. Burn (1991, fig. 38); also see von Brothmer's Index of Inscribed Names (1957: 234).
18. See also Carpenter (1991, fig. 198); von Brothmer (1957, pl. LXXVII-1–2).
19. See von Brothmer (1957, pls. XL-2, LXXV-b, d); see Erol (2008) for an analysis of these shields.
20. Both Greek and Roman authors contributed to the stories of Hippolyte. See Pausanias (I.41.7); Plutarch (*Theseus* 26–27); Apollodorus (*The Library* 2.5.9); Euripides (*Hippolytus* ll.306–10); Apollonius Rhodius (II.779).

21. Bell (1991: 51); Pausanias (1.2.1); Plutarch (*Theseus* 26–27); Apollodorus (*Epitome* 5.2). See von Brothmer (1957: 124 #5, pl. LXVII-3), #7 (pl. LXVIII-4); (125 #9; pl. LXVIII-1, 4); Boardman (1974: fig. 200).
22. Apollodorus (*Epitome* 5.1, 2); Pausanias (5.11.6, 10.31.8); see also von Brothmer (1957: 80 #105, pl. LV-4); Broadman (1974: fig. 98).
23. Note there is no mention of only one breast.
24. Later in the battle we are given the names of two of her other female comrades, Acca and Opis.
25. Unlike the great Greek epics *Iliad* and *Odyssey*, Latin *Aeneid*, and the monumental Indian *Mahābhārata* and *Rāmāyana* which are stories of essentially one person or event, the *Shahnameh*, written in the late tenth early eleventh centuries AD, extends over many generations and purports to be a history of Iran from its prehistoric origins up to the time of the Islamic invasion in the seventh century AD at the end of the Sasanian empire. Thus, the *Shahnameh* is more like the Norse sagas in that it is about more than one person or event and should not be thought of as an epic. (See Davis' Introduction in Ferdowsi 2006 for a full introduction to this work.)
26. We need to remember that in Persian prose romances the motif of a warlike or warrior woman is a 'metaphor of love' (see Venetis 2007: 227 and Kruk 1993; 1994).
27. C. O'Rahilly (1967, ll. 4846–48); Kinsella (1970: 251); P. Kelly (1992: 79). Myanmar (Burma) is another society where women have ostensibly held a position of 'high status', but a Burmese proverb, like the Irish, declares, 'when a woman rules a country, the country will be destroyed' (Löfving 2013). (Also see Ikeya (2005/06.)
28. There is a tendency to neglect the misogynistic aspect of Celtic tales. In another Irish tale, MacDatho's rashness in listening to his wife's duplicitous advice precipitates the destruction of his hostel. Although women seemingly assert a great deal of power, the message in the stories is that assertion of power is destructive and wrong. Certainly, the writers of these late tales are making their most misogynistic use of the tales. However, we cannot discount the influence of the Christian monks on these stories; the views of the pre-Christian Celts must be left to conjecture.
29. *The Wooing of Emer*, part 2, in Cross and Slover (1936: 162–71).
30. Two Scotas are mentioned in *Lebor Gabála Érenn (The Book of the Taking of Ireland)*, both are daughters of Pharaohs. Scota (1) is the daughter of Cincris and Scota (2) the daughter of Nectanebus. The confusion seems to arise from a later addition to the text but they appear to be the same person. See Macalister, *Lebor Gabála Érenn* (1939) Part II, §129, pp. 136–37 for a complete explanation.

31. http://www.ancienttexts.org/library/celtic/irish/lebor.html (Accessed 30 April 30, 2016).
32. http://www.maryjones.us/ctexts/lebor5.html (Accessed 18 July 2016).
33. MacKillop (1998: 154) points out that several scholars have drawn parallels between this Irish figure and Kāli, Hindu goddess known for her destructiveness. Also see Ross (1973).
34. Civilis was leader of the Germanic Batavian tribe who in AD 69–70 led a revolt against the Romans.
35. See also Gardeła (2021: Ch. 3).
36. 'Visna is the feminine form of Visinn (Wisinnus) found as the name of a champion slain by Starkather in Book VI (note 51) and as Visma in *Sogubrot*. Saxo has a number of references to women warriors (cf. Book V, n. 130; VII, n. 45). The women mentioned here led contingents from Wendland, the Slav territories south of the Baltic. In the *Sogubrot*, we are told that Visma, led a great host of Wends, armed with long swords and bucklers, while Heid bore the king's standard and was followed by a hundred champions and a company of berserks' (Saxo Vol. II: 127–28, n. 11).
37. While some may take this as an example of a transvestite, we will not go there and take the story at face value. Clover (1986), however, examines this story and other like tales in terms of 'functional sons', which, while interesting, again is not the subject of this work.
38. Old Norse Skald means 'poet'. Skaldic poetry refers to Old Norse and Eddic poetry. The poems are usually historic in nature.
39. Davidson in her commentary on Saxo's work is more specific and says Olǫf was the queen of Saxony (Saxo Vol. II: 43, n. 31).
40. Cordelia's name almost certainly derives from the Welsh Creiddylad found in the Welsh tale *Culhwch and Olwen* (Ford 1977) but their stories differ greatly.

Chapter 4: Archaeological Evidence

1. Rolle (1989: 88) describes the fighting belt as 'covered in strips of iron'. Presumably the belt was made of leather.
2. Petersen (1919; 1951) developed typologies of tools and swords that have allowed scholars to date them. These works are extremely useful for chronology.
3. A pair of oval brooches is typical of a Viking female grave and is rarely, if ever, found in male graves.
4. For a good discussion of *seiðr* and its many nuances see Price (2019: 55–190).
5. Stolpe's hand written notebooks along with his drawings can be found on the Internet at http://historiska.se/birka/digitala-resurser/

6. I am grateful to Brenda Wright for first calling this paper to my attention. This paper is available at https://org/10.1002/ajpa.23308; Gardeła (2013).
7. The chronology of these people is not clear-cut but the following is a brief and abbreviated chronology. Scythian: Early – seventh–sixth centuries BC, Middle – late sixth–fifth centuries BC, Late – fourth to early third centuries BC, Latest – third century BC to third century AD (Melyukova 1995: 34). Sauromatian-Sarmatian: fourth – early third centuries BC. Sarmatian: third – second centuries BC – ca. first century AD (see Moshkova 1995: 85–89). Saka: sixth century BC – fourth century AD (but see Yablonsky 1995: 193–96). Sargat: fifth century BC – third century AD (see Ražev and Šarapova 2014: 161). There is little doubt that these people are related although artefacts, particularly pottery, distinguish the groups. For descriptions of many of the graves from these cultural groups see Davis-Kimball, Bashilov, and Yablonsky (1995). This volume brings together many articles by Russian and Ukrainian archaeologist who had access to scholarly material produced during Soviet times.
8. This phenomenon extends even into China during the Wu Ding period (1250–1200 BC) with the burial of Lady Hao, concubine of the king and according to oracle bone inscriptions, a famous military leader. She was buried with numerous weapons including many *ge* halberds. A second concubine of the same king, Lady Jing, was also buried with military equipment (Linduff 2001: 266–67).
9. Skeletal sexing of prepubescent children is nearly impossible and the distinctions between gracile, slightly built adolescent males and 'bigboned' adolescent females are also hard to make. If a skeleton is reasonably complete and an adult, sexual distinction may be determined by the broader pelvic area of adult females and the heavier brow-ridges and crania of adult males are more diagnostic. When the skeleton is fragmentary, it is extremely difficult if not impossible to determine sex. Happily, DNA analysis has come to the rescue.
10. In E. H. Minns' monumental survey *Scythians and Greeks* published in 1913, he stated that: 'Among the [Scythian women] … they were apparently entirely subject to the men and were kept in the waggons to such an extent that, as Hippocrates says, their health suffered from want of exercise. Whereas among the Sarmatians they took part in war, rode about freely' (1913: 84). This was the prevailing view of Scythian women until recent years.
11. See von Bothmer (1957) and a number of Gaulish coins.
12. These mummies have been associated with Tocharian speakers but may extend into the eastern most part of the 'Scythian World' (see Map 2).
13. Murphy's 2003 monograph is a part of her 1998 Ph.D. dissertation, and many of her references are from Russian sources. I have used her 2003

work for these references rather than repeat the Russian ones that are more difficult to access.
14. Pazyryk is the designation given to Iron Age nomadic tribes generally thought to be eastern Scythian peoples. S. Rudenko (1970) excavated the most famous find of these people in 1947–1949.
15. In general, male burials on the Steppe are much more common that female and females are much less likely to the buried in central position.
16. While not common, skull deformation is not unusual in Steppe burials. See Jones-Bley (1999: 67) and especially Sharapova and Razhev (2011).
17. (https://www.archaeolog.ru/ru/expeditions/expeditions-2019/donskaya-arkheologicheskaya-ekspeditsiya; https://globalnews.ca/news/6371900/russia-amazon-warrior-women-skeletons/) (Accessed 25 January 2020.)
18. The Standard of Ur, an early wagon illustration from Ur, is frequently referred to as a 'war wagon' as it is shown with military equipment (see Hansen 1998, fig. 36a).
19. The chariot, much like the airplane, can be used as an implement of war and, like the chariot, the airplane also has other uses such as transport and prestige. The airplane is not, however, usually thought of as transport to the Otherworld – although it has certainly served this purpose.
20. An interesting conflict in evidence comes from the Irish evidence. Despite a great deal of verification from the Irish tales (particularly *The Táin*), the *Corpus Iuris Hibernici*, and *The Book of Leinster*, all of which are filled with chariots and a chariot also depicted on the Ahenny High Cross, County Tipperary, Ireland, not one chariot has ever been found in the Irish archaeology. (See Karl 2003.) However, Mallory (1998: 457) points out that although evidence is minimal it is not so minimal as to 'exclude altogether the existence of chariots'.
21. The pig bones may suggest animal sacrifice, which further suggests that these women may have been seeresses or prophetesses of some sort perhaps foretelling the outcome of the battle. If so, can we consider such 'intelligence officers' as members of the military? Earlier societies may have had a broader view of 'warrior' and 'soldier'.
22. These burials, like most of the Yorkshire vehicle burials, were dismantled and then placed in the grave. The most recent cart burial was found not in Yorkshire but in Newbridge near Edinburgh in 2001 and was placed in the grave intact. The Newbridge burial has been radiocarbon dated to 520–370 BC (Halkon 2013: 75) and finds its closest parallels both in being buried intact and date to Champagne and the Belgian Ardennes on the Continent which are typically fifth–fourth centuries BC. None of the organic remains from the Newbridge burial, including the corpse, have survived (Carter and Hunter 2003: 532–33).
23. A reconstruction of the woman's face was made and showed that in life she had a disfigurement. This disfigurement led to the suggestion that the gods

may have marked her.[http://www.britarch.ac.uk/ba/ba59/news.shtml] (See also Hill (2001.)
24. It should be noted that in Arnold's dissertation (1991b: 80), she considers this burial 'ambiguous gender'.

Chapter 5: Historical Women Through the Roman Period

1. Is it only a coincidence that Wonder Woman's alter ego is Diana Prince?
2. Ralph de Diceto (ca.1120–ca. 1202) was an early English chronicler and historian who became dean of St. Paul's in London.
3. Egyptian had no word for queen. A woman of high rank was addressed by her relationship to the king, e.g., King's Wife, King's Mother (Tyldesley 1996: 135).
4. Georgian lacks grammatical gender thus there is no feminine word for ruler.
5. Because of some confusion regarding her (their?) burial site Ahhotep I and II are often confused or conflated. Here is not the place to rework or even review this problem, and I will leave her as a single personage. See Tyldesley (2006: 84–85) for a brief description of this problem and Jánosi (1992) for an expanded view that makes the case for two Ahhoteps.
6. Much of Diodorus' Books 1 and 2 are considered to be derived for Ctesias' *Persian History* and can be seen in Llewellyn-Jones and Robson (2013: 116–30).
7. The modern author George Roux in his classic *Ancient Iraq* comments that it is a 'most baffling problem' that a queen who has left so little in the Assyrians records could have 'acquired the reputation of being "the most beautiful, most cruel, most powerful and most lustful of Oriental queens".' He further points out that she 'also shares some traits with Ishtar as a war goddess who, like her, destroyed her lovers' (Roux 1992: 301).
8. Diodorus gives a different account of Cyrus death saying that the Scythian queen (unnamed) had Cyrus crucified (Diodorus Siculus 2.44.2), but there are also several other accounts of his death.
9. Plutarch's *Moralia* also provides a list on the *Bravery of Women*.
10. Ctesias (Books 4–6 [34.3–5], F7b); (Llewellyn-Jones and Robson (2013: 156).
11. Ctesias (Books 7–11, F9. Photius, p. 36a9–37a25 §3); (Llewellyn-Jones and Robson (2013: 171).
12. Chapters 26–71 of Book 8 of Polyænus *Stratagems to War* are devoted to women and how they featured in war strategies. He tells the exploits of many women, but the manuscripts end abruptly.
13. His name gave us the word 'mausoleum' and was one of the seven wonders of the ancient world. Artemisia was also known as a botanist and medical researcher; Artemisia, a plant genus, is named after her.

Endnotes

14. Like the Iranian tribes of the Scythians, Saka, and Sarmatians, the Carians were an Indo-European speaking people known mostly through short fragmentary (mostly tomb) inscriptions and a few Carian-Greek bilingual inscriptions. While the Indo-European status of the Iranians was never in doubt, it is only in recent years that confirmation of the Carian kinship with the Hittites and their Indo-European status as members of the Anatolian branch has been accepted. Consequently, much of the material from this society on the borders of the classical world has an almost legendary quality to it. An extensive Carian-Greek bilingual inscription was discovered in 1996, which has allowed for great advancement in this little known language. For a brief but informative overview of Carian see Melchert (2004).
15. Ducrey (2015) recounts a number of events in which Greek women were involved in battle – on both the winning and loosing side.
16. See Georgoudi (2015: 200–13) for an insightful discussion of these incidents.
17. See Tronson (1984) on the much-married Philip.
18. Here we clearly have another warrior queen but other than this allusion to her death (see Polyænus 8.60); we know virtually nothing about her.
19. The general view of Olympias has always been quite negative, but Carney (1993) has made an attempt to put her in a more favorable light.
20. Again we have some confusion of names. This Antigonus is the father of Demetrius (see Plutarch) and although father and son were saluted as kings after the victory over Ptolemy in 306 BC, the dynasty did not last long.
21. Germanicus was the grandson of the Empress Livia and her first husband Tiberius Claudius Nero and therefore the younger brother of the Emperor Tiberius.
22. Tacitus' views on Agrippina taking part in the German campaigns of her husband Germanicus are clear (Tacitus, *Annals* 2.42).
23. See L'hoir (1994) for a discussion of Tacitus' views on women leaders, who we could class as 'viragos'.
24. In this same passage Plutarch comments in a rather derisive manner '[t]herefore Cleopatra was indebted to Fulvia for teaching Antony to endure a woman's sway, since she took him over quite tamed, and schooled at the outset to obey women' (*Antony* 10.6.3).
25. Theda Bara in 'Cleopatra' 1917; Claudette Colbert in 'Cleopatra' 1934; Vivian Leigh in Shaw's 'Caesar and Cleopatra' 1945; Elizabeth Taylor in 'Cleopatra' 1963.
26. Plutarch is our major source for the queen but his work that deals most extensively with her, Life of Antony, dates to second century AD. Our next most important source is Dio Cassius' *Roman History*, which dates to AD 200–222. Our shortage of sources for this most famous of women

can be laid to the collapse of Alexandria into the Mediterranean Sea taking with it not only the great library but so much of the city of Cleopatra.
27. The Ptolemies were the last ruling family of Egypt and had ruled the country since 308 BC. See Roller (2010), Genealogy of the Later Ptolemies, Appendix 2: 163–62.
28. Aetolia is a mountainous area of southern Greece on the northern border of the Gulf of Corinth. The people were considered much less civilized than most of the rest of Greece and worshipped Apollo, Artemis, and Athena in their untamed and war aspects.
29. See Wilkes (1992) and Mallory and Adams (1997). This is an area that is today occupied by Albanian speakers.
30. *Teuta is the feminine noun form of *teuto- which also gives us the Irish tuath 'people, tribe' also Oscan touto, Lithuanian tautà, and Old English þēod. The fact that the form occurs in Celtic doesn't exclude its independent occurrence in Illyrian.
31. There are numerous variations of spelling of Boudica. I have chosen this spelling as it is according to the noted British scholar Kenneth Jackson (1953 and 1979), the most accurate.
32. We should keep in mind that Dio Cassius wrote more than a hundred years after these events.
33. According to Ammianus (27.4), the Scordisci were 'accustomed to offer up their prisoners as victims to Bellona and Mars, and from their hollowed skulls greedily to drink human blood.'
34. See the Introduction of Meyer (1905) and Ryan (1936: 269).
35. Abbott (1941) identifies numerous women who, one way or another, were pre-Islamic queens. The earliest (perhaps as early as tenth century BC) being the unnamed 'Queen of Sheba' of King Solomon fame. Fraser (1988) and Stoneman (1994) relate (with references) a number of pre-Islamic women who took up the sword including Muhammad's last wife Aishah, who in 656 'was present at the Battle of the Camels … [but] [m]ore than that … [this] showed that at this date men would still follow a woman to war' (Fraser 1988: 110).

Chapter 6: Historical Women from the Roman Period to 1492

1. Cross and Sherbowitz-Wetzor (1953: 81, fn. 57) refer to the 'legendary account of Olga's … revenge is complicated by the introduction the "incendiary bird" motive', which they say is fairly common elsewhere. They also say it 'obviously came into Russia from Scandinavia' and cite Snorri Sturluson's *Heimskringla* and Saxo Grammaticus among others.

Endnotes

2. It is generally believed that Alfred the Great (r. 871-899) commissioned the *Chronicle*. There are seven extant manuscripts and two fragments that make up the *Chronicle*, as we know it. See Swanton (1996) for a good introduction to the *Chronicle* and explanation of the difficulties associated with the various versions.
3. Anglo-Saxon names frequently have more than one spelling.
4. This is Manuscript A, also known as the Winchester manuscript of the *Chronicle*, and sometimes referred to as the *Parker Chronicle*.
5. The terms Danes, Vikings, Norwegians and Norsemen are here, as in other works, used interchangeably.
6. Clarkson (2018) expands on her campaigns.
7. The location of Scergeat, Weardbyrig and Bremesbyrig are unclear.
8. See O'Donovan (1860); Wainwright (1990: 54, n. 8).
9. See Wainwright (1990) for a fuller discussion of this plan.
10. This quotation is from the Abingdon (C) manuscript of the *ASC*. The Winchester (A) manuscript does not mention her death until the entry for the year 922 (Swanton 1996: 98, 100, 103); neither manuscripts D (Worcester) nor F (Canterbury) have any entries for 918. The Peterborough (E) manuscript simply states, 'Here Æthelflæd, Lady of the Mercians, passed away' (Swanton 1996: 103).
11. According to Fell the use of this word 'had not then acquired any contemptuous overtones' (Fell *et al.* 1984: 92).
12. See Chibnall (1993: 53–56) on the importance of this alliance.
13. Henry had great concerns in regard to his successor and according to Chibnall (1993: 51) 'Mathilda provided him with an insurance policy'.
14. Stephen's second son William I, Count of Boulogne (ca.1137–1159) renounced his claim to the throne and was set-aside in the Treaty of Wallingford.
15. This Matilda is sometimes referred to as Matilda II. Her aunt, wife of Henry I of England, is sometimes referred to as Matilda I; her grandmother, wife of the Conqueror, was Matilda of Flanders.
16. Appleby (1963: 30, fn. 2, citing D. Stenton's Pipe Rolls 2 Richard I, p.89) says that '[i]n 1190 the king [Richard], in return for 700 marks, gave Gerard a charter confirming him in those offices by his wife's right'.
17. A building at the University of Lincoln was named for Nicolaa de la Haye in May 2017 commemorating the 800th anniversary of the Battle of Lincoln.
18. At one point during the Third Crusade, Richard the Lionheart is said to have ordered all women be left behind except for the washer-women who could cleanse the soldiers of lice (Verbruggen 2006: 120).
19. Turner (2011: 77) discounts the legend of her and her companions dressing as Amazons; he considers it 'improbable'.
20. A form of winch.

21. A bolt for a crossbow.
22. A bolt for a crossbow. She is perhaps the only woman to be included in a list of great medieval authors.
23. For these two sisters I have relied heavily on the on-line version of *The Kingdom of León-Castilla under Queen Urraca* by Bernard F. Reilly provided by *The Library of Iberian Resources Online*, 1999. The cited page numbers refer to the printed edition provided in the online version. Reilly also delivers a good background of this convoluted period in Iberian history.
24. Constance died in 1093 without producing a son and Alfonso VI went on to marry three additional times but failed to produce a legitimate son.
25. Lay (2009: 38) quotes from the *Chronic Adefonsi Imperatoris* which seems to give Portugal to Count Henry and Teresa, but Lay questions that it was an outright gift, suggesting that strings were attached.
26. It was not, however, until 1143 and the Treaty of Zamora that Portugal became a fully independent country.

Bibliography

Abbott, Nabia. 1941. 'Pre-Islamic Arab Queens'. *American Journal of Semitic Languages and Literature* LVIII: 1–22.
Alexievich, Svetlana. 2006. *Internet Home Page*. Accessed 8 October 2015.
Allen, Derek. 1944. 'The Belgic Dynasties of Britain and their Coins'. *Archaeologia* XC: 1–46.
_____. 1980. *The Coins of the Ancient Celts*, Daphne Nash (ed). EdinBurgh: University Press.
Allen, N. J. 2001. 'Athena and Durgā: Warrior goddesses in Greek and Sanskrit Epic'. In *Athena in the Classical World*, S. Deacy and A. Viling (eds.). London: Brill, 367–82.
Alpern, Stanley B. 1998. 'On the Origins of the Amazons of Dahomey'. *History in Africa* 25: 9–25.
Appleby, John T. (ed.). 1963. *The Chronicle of Richard of Devizes of the Time of King Richard the First*. London: Thomas Nelson and Sons Ltd.
Arbman, Ernst.1922. *Rudra. Untersuchungen zum altindischen Glauben und Kultus*. Uppsala.
Arman, Joanna. 2017. *The Warrior Queen: The Life and Legend of Æthelflæd, Daughter of Alfred the Great*. Gloucestershire, GL, England.
Arnold, Bettina. 1991a. 'The Deposed Princess of Vix: The Need for an Engendered European Prehistory'. In *The Archaeology of Gender: Proceedings of the Twenty-second Annual Chacmool Conference of the Archaeological Association of the University of Calgary*, Dale Walde and Noreen Willows (eds.). Calgary: University of Calgary, 366–74.
_____. 1991b. *The Material Culture of Social Structure: Rank and Status in Early Iron Age Europe*. Harvard Ph.D. Dissertation. Ann Arbor: UMI.
_____. 2002. '*Sein und Werden*': Gender as Process in Mortuary Ritual. In *In Pursuit of Gender: Worldwide Archaeological Approaches*, Sarah Milledge Nelson and Myriam Rosen-Ayalon (eds.). Walnut Creek: Altamira Press, 239–56.
Babcock, Charles L. 1965. 'The Early Career of Fulvia'. *The American Journal of Philology* 86 (1): 1–32.
Bailey, Maggie. 2001. 'Ælfwynn, second lady of the Mercians'. In *Edward the Elder: 899–924*, N.J. Higham and D.H. Hill (eds.). London: Routledge, 112–27.

Barbarunova, Zoya A. 1995. 'Early Sarmatian Culture'. In Davis-Kimball, *et al.* (eds.). 1995, 121–31.

Barber, Elizabeth Wayland. 1997. 'On the Origins of the vily/rusalki'. In *Varia on the Indo-European Past: Papers in Memory of Marija Gimbutas*, Miriam Robbins Dexter and Edgar C. Polomé (eds.). (JIES Monograph Series Number 19). Washington D.C: *JIES*, 6–47.

_____. 1999. *The Mummies of Ürümchi*. New York: W.W. Norton and Company.

_____. 2013. *The Dancing Goddesses: Folklore, Archaeology, and the Origins of European Dance*. New York: W.W. Norton & Company.

Beckman, Gary. 1998. 'Ištar of Nineveh Reconsidered'. *Journal of Cuneiform Studies* 50: 1–10.

Bell, Robert E. 1991. *Women of Classical Mythology: A Biographical Dictionary*. New York: Oxford University Press.

Bellelli, Vincenzo Bellelli, e Paolo Xella (eds.). 2016. *Le lamine di Pyrgi Nuovi studi sulle iscrizioni in etrusco e in fenicio nel cinquantenario della scoperta*. Verona: Essedue edizioni.

Bergman, Arlene Eisen. 1974. *Women of Viet Nam*. San Francisco: Peoples Press.

Bernbeck, Reinhard. 2008. 'Sex/Gender/Power and Šammuramat: A View from the Syrian Steppe'. *Fundstellen Gesammelte Schriften zur Archäologie und Geschichte Altvorderasiens ad honorem Hartmut Kühne*. Dominik Bonatz, Rainer M. Czichon und F. Janoscha Kreppner, (Herausgegeben). Wiesbaden: Harrassowitz Verlag, 351–69.

Berseneva, Natalia. 2008. 'Women and Children in the Sargat Culture'. In Linduff and Rubinson (eds.). 2008, 131–51.

_____. 2012. '"Armed" Females of Iron Age Trans-Uralian Forest-Steppe: Social Reality or Status Identity'. In *Tumuli Graves – Status Symbol of the Dead in the Bronze and Iron Ages in Europe*, Valeriu Sîrbu and Christian Schuster (eds.). Oxford: BAR International Series 2396, 53–60.

Best, R. I. 1907. 'The Adventures of Art Son of Conn, and the Courtship of Delbchæm'. *Ériu* 3–4: 149–73.

Bielman, Anne. 2015. 'Female Patronage in the Greek Hellenistic and Roman Republican Periods'. In *A Companion to Women in the Ancient World*, Sharon L. James and Sheila Dillon (eds.). Maldon, MA: Wiley Blackwell, 238–48.

Black, Jeremy, and Anthony Green. 1992. *Gods, Demons and Symbols of Ancient Mesopotamia*. Austin: University of Texas Press.

Black, Jeremy, Graham Cunningham, Eleanor Robson, and Gábor Zólyomi (trans. and introduced). 2006. *The Literature of Ancient Sumer*. Oxford: University Press.

Blok, Josine H. 1994. *The Early Amazons: Modern and Ancient Perspectives on a Persistent Myth*. Leiden: E. J. Brill.

Blondell, Ruby. 2013. *Helen of Troy: Beauty, Myth, Devastation*. Oxford: University Press.

Bloomfield, Maurice. 1908. *The Religion of the Veda: The Ancient Religion of India (From Rig-Veda to Upanishads)*. New York: G.P. Putnam's Sons,

Boardman, John. 1974. *Athenian Black Figure Vases: A Handbook*. 1991 reprint. London: Thames and Hudson.

———. ed. 1993. *The Oxford History of Classical Art*. Oxford: Oxford University Press.

Bobrinskoi, A.A. 1887–1901. *Kurgany i slu
vajnye archeologi
eskie nachodki bliz meste
ka Smely*, vol. I–III, St Petersburg.

duBois, Page. 1991. *Centaurs and Amazons: Women and the Pre-History of the Great Chain of Being*. Ann Arbor: The University of Michigan Press.

Bokovenko, Nikolai A. 1995. 'Tuva During the Scythian Period'. In Davis-Kimball, *et al.* (eds.). 1995, 265–84.

Bosanquet, R.C. 1922. 'On an Altar Dedicated to the Alaisiagae'. *Archaeologica Aeliana* 19: 185–92.

von Bothmer, Dietrich. 1957. *Amazons in Greek Art*. London: Oxford University Press.

Boyce, Mary. 1982. *A History of Zoroastrianism, Volume II: Under the Achaemenians*. Leiden: E. J. Brill.

———. 1984. *Textual Sources for the Study of Zoroastrianism*. 1990 edition. Chicago: The University of Chicago Press.

———. 1996. *A History of Zoroastrianism, Volume One: The Early Period*. 3rd impression with corrections. Leiden: E. J. Brill.

Brashinsky, I.B. 1973. 'Raskopky Scythskih kurganov na Nizhem Donu'. ['Excavation of Scythian kurgans on the Lower Don']. *Kratkiye soobsheniya Instituta Archeologyi Brief* [*Reports of the Institute of Archaeology*], 133: 59–67.

Brennan, T. Corey. 2015. 'Perceptions of Women's Power in the Late Republic: Terentia, Fulvia, and the Generation of 63 BCE.' In *A Companion to Women in the Ancient World*. Sharon L. James and Sheila Dillon (eds.). Maldon, MA: Wiley Blackwell, 354–66.

Brereton, Joel P. 2002. 'The race of Mudgala and Mudgalani'. *The Journal of the American Oriental Society*. April 1, 2002. thefreelibrary.com.

Bryce, Trevor. 1998. *The Kingdom of the Hittites*. Oxford: Clarendon Paperbacks.

———. 2004. *Life and Society in the Hittite World*. Oxford: Oxford University Press.

Buck, Carl Darling. 1949. *A Dictionary of Selected Synonyms in the Principal Indo-European Languages*. 1988 paperback reprint. Chicago: The University of Chicago Press.

Budin, Stephanie Lynn. 2003. *The Origins of Aphrodite*. Bethesda, Maryland: CDL Press.

_____. 2016. *Artemis*. New York: Routledge.

_____. and Jean Macintosh Turfa, (eds.). 2016. *Women in Antiquity: Real Women Across the Ancient World*. London: Routledge.

Bunyatyan, E.P. 1981. 'Ryadovoe naselenie stepnoi Skifii IV–III vv. do n.e. *adKIN*'. ["Ordinary Population of the Scythian Steppe of the IV–III Century B.C." *adKIN*]. Kiev.

Burn, Lucilla. 1991. *The British Museum Book of Greek and Roman Art*. London: Thames and Hudson.

Burney, Charles. 2004. *Historical Dictionary of the Hittites*. Lanham, Maryland: The Scarecrow Press Inc.

Carney, Elizabeth Donnelly. 1987. 'The Career of Adea-Eurydice'. *Historia* 36: 496–502.

_____. 1993. 'Olympias and the Image of the Virago'. *Phoenix* 47, no. 1: 29–55.

_____. 2000. *Women and Monarchy in Ancient Macedonia*. Norman, Oklahoma: University of Oklahoma Press.

_____. 2004. 'Women and Military Leadership'. *Ancient World* 32, no. 2: 184–95.

_____. 2005. 'Women and *Dunasteia* in Caria'. *American Journal of Philology* 126, no. 1: 65–91.

Carpenter, T.H. 1991. *Art and Myth in Ancient Greece: A handbook*. London: Thames and Hudson.

Carter, Stephen, and Fraser Hunter. 2003. 'An Iron Age chariot burial from Scotland'. *Antiquity* 77, no. 297: 531–35.

Cassuto, U. 'Baal and Mot in the Ugaritic Texts'. *Israel Exploration Journal*. 12, no. 2 (1962): 77–86.

Chadwick, John. 1976. *The Mycenaean World*. 1980 reprint. Cambridge: Cambridge University Press.

Chadwick, Nora K. 1946. *The Beginnings of Russian History: An Enquiry into Sources*. 1966 reprint. Cambridge: University Press.

_____. 1950. 'Þorgerðr Hölgabrúðr and *Trolla Þing*: A Note on Sources." In *The Early Cultures of North-West Europe: (H.M. Chadwick Memorial Studies)* Sir Cyril Fox and Bruce Dickins (eds.). 2013 paperback edition. Cambridge: The University Press, 397–417.

Chibnall, Marjorie. 1990. 'Women in Orderic Vitalis'. *The Haskins Society Journal* 2: 105–21.

_____. 1993. *The Empress Matilda: Queen Consort, Queen Mother and Lady of the English*. 1999 reprint. Oxford: Blackwell Publishers.

Christensen, T. 1981. 'Gerdrup-graven'. *Romu* II Arsskrift fra Roskilde Museum, 19–28.

———. 1997. The armed woman and the hanged thrall. In *The Ages Collected – From Roskilde Museum*, Frank Birkebæk (ed.). 8. Roskilde: Roskilde Museum, 34-35.

Clarkson, Tim. 2018. *Æthelflæd: The Lady of the Mercians*. Edinburgh: West Newington House.

Clayton, Ellen C. 1879. *Female Warriors*: Memorials of Female Valour and Heroism, From the Mythological Ages to the Present Era. 2 vols. London: Tinsley Brothers.

Clover, Carol. 1986. 'Maiden Warriors and Other Sons'. *The Journal of English and Germanic Philology* 85, no. 1: 35–49.

Cocozza, Paula. 2018. 'Does new DNA evidence prove that there were female Viking warlords'? *The Guardian*. 13 March 2018. https://www.theguardian.com/science/shortcuts/2017/sep/12/does-new-dna-evidence-prove-that-there-were-female-viking-warlords

The Code of Lekë Dukagjini. 1989. Albanian Text Collected and Arranged by Shtefën Gjeçov, translated with Introduction, by Leonard Fox. New York: Gjonlekaj Publishing Company.

Cohen, Beth. 1997. 'Divesting the Female Breast of Clothes in Classical Sculpture'. In *Naked Truths: Women, sexuality, and gender in classical art and archaeology*, Ann Olga Koloski-Ostrow and Claire L. Lyons (eds.). London: Routledge, 66–94.

Coleman, Kathleen. 2000. 'Missio at Halicarnassus'. *Harvard Studies in Classical Philology* 100: 487-500.

Collins, Billie Jean. 2007. *The Hittites and Their World*. Atlanta: Society of Biblical Literature.

Connolly, Sharon Bennett. 2023. *King John's Right Hand Lady: The Story of Nicholaa de la Haye*. Barnsley, England: Pen & Sword.

Coon, Carleton S. 1953. *The Mountains of Giants: a racial and cultural study of the North Albanian Mountain Ghegs*. (Papers of the Peabody Museum of American Archaeology and Ethnology, 23, no. 3.). Cambridge, Mass.: Peabody Museum.

Cornelius, Izak. 2008. *The Many Faces of the Goddess: The Iconography of the Syro-Palestinian Goddess Anat, Astarte, Qedeshet and Asherah, c.1500-1000 BCE* (Orbis Biblicus Et Orientalis #204.

Cosmas of Prague. 2009. *The Chronicle of the Czechs*. Translated with introduction and notes by Lisa Wolverton. Washington, D.C.: The Catholic University of America Press.

Cross, Tom Peete, and Clark Harris Slover. 1936. *Ancient Irish Tales*. New York: Barnes and Noble Books.

Cross, Samuel Hazzard, and Olgerd P. Sherbowitz-Wetzor (trans. and eds.). 1953. *The Russian Primary Chronicle: Laurentian Text.* Cambridge, Massachusetts: The Mediaeval Academy of America.

Crystal, Paul. 2017. *Women at War in the Classical World.* Barnsley, South Yorkshire: Pen & Sword Military.

Cuchet, Violaine Sebillotte. 2015. 'The Warrior Queens of Caria (Fifth to Fourth Centuries BCE): Archeology History, and Historiography'. In *Women & War in Antiquity*, Jacqueline Fabre-Serris and Alison Keith (eds.). Baltimore: Johns Hopkins University Press, 228–46.

Current Archaeology 2013. 'Insight of the Valkyrie'. XXIV, no. 2: 278: 9.

Cyrino, Monica S. 2010. *Aphrodite.* London: Routledge.

Dalley, Stephanie. 1989. *Myths from Mesopotamia: Creation, the Flood, Gilgamesh, and Others.* Oxford: Oxford University Press.

Dark, Patricia. 2007. '"A Woman of Subtlety and a Man's Resolution:" Matilda of Boulogne in the Power Struggles of the Anarchy'. In *Aspects of Power and Authority in the Middle Ages*, Brenda Bolton and Christine Meek (eds.). Turnhout, Belgium: Brepols Publishers n.v., 147–64.

Darmesteter, James, trans. 1880. *Zend-Avesta, Part I, The Vendîdâd.* Oxford: The Clarendon Press.

_____. 1882. *Zend-Avesta, Part II, The Sîrôzahs, Yasts and Nyâyis.* Delhi: Motilal Banarsidass Publishers.

Davidson, H.R. Ellis. 1964. *Gods and Myths of Northern Europe.* 1981 reprint. New York: Penguin Books,

_____. 1969. *Scandinavian Mythology.* London: Paul Hamlyn.

_____. 1988. *Myths and Symbols in Pagan Europe: Early Scandinavian and Celtic Religions.* Syracuse: University Press.

_____. 1993. *The Lost Beliefs of Northern Europe.* 1994 reprint. London/ New York: Routledge.

_____. *See also* Ellis, Hilda Roderick.

Davis, Norman (ed. and Intro.). 1983. *The Paston Letters: A Selection in Modern Spelling.* Oxford: Oxford University Press.

Davis, R.H.C. 1990. *King Stephen.* 3rd edition. London: Longman.

Davis-Kimball, Jeannine. 1995/96. 'Excavations of Kurgans in the Southern Orenburg District, Russia'. *Silk Road Art and Archaeology* 4. (Journal of the Institute of Silk Road Studies). Kamakura, 1–16.

_____. 1997/98. 'Amazons, Priestesses and Other Women of Status – Females in Eurasian Nomadic Societies'. *Silk Road Art and Archaeology* 5. (Journal of the Institute of Silk Road Studies). Kamakura, 1–50.

_____. 2001. 'Warriors and Priestesses of the Eurasian Nomads'. In *The Archaeology of Cult and Religion*, P. Biehl, F. Bertemes, and H. Meller (eds.). Budapest: Archaeolingua, 243–59.

_____. 2012. 'Among Our Earliest Amazons Eurasian Priestesses and Warrior-Women'. *labrys, études féministes/ estudos feministas* juillet/ décembre.

Davis-Kimball, Jeannine, Vladimir A. Bashilov, and Leonid T. Yablonsky (eds.). 1995. *Nomads of the Eurasian Steppes in the Early Iron Age*. Zinat Press: Berkeley, CA.

Davis-Kimball, Jeannine, and Leonid T. Yablonsky (eds.). 1995. *Kurgans on the Left Bank of the Ilek: Excavations at Pokrovka, 1990–1992*. Berkeley: Zinat Press.

Deacy, Susan. 2008. *Athena*. London/New York: Routledge.

Dean, Rebecca. 2013. *Women, Weaponry and Warfare in Ancient Egypt: A Brief Examination of Available Evidence*. https://www.memphis.edu

Delia, Diana. 1991. 'Fulvia Reconsidered'. In *Women's History and Ancient History*, Sarah B. Pomeroy (ed.). Chapel Hill: The University of North Carolina Press, 197–217.

Dent, John. 1985. 'Three cart burials from Wetwang, Yorkshire'. *Antiquity* LIX no. 226: 85–92.

Devī-māhātmya. The Glorification of the Great Goddess. 1963. Vasudeva S. Agrawala (ed. and trans.). Banaras: All-India Kashiraj Trust.

Dewald, Carolyn. 1981. 'Women and culture in Herodotus' *Histories*'. In *Reflections of Women in Antiquity*, Helene P. Foley (ed.). New York: Gordon and Breach Science Publishers, 91–125.

Dexter, Miriam Robbins. 1990. *Whence the Goddesses: A Source Book*. New York: Pergamon Press.

_____. 2009. 'Ancient Felines and the Great-Goddess in Anatolia: Kubaba and Cybele'. In *Proceedings of the 20th Annual UCLA Indo-European Conference*, Stephanie W. Jamison, H. Craig Melchert, and Brent Vine (eds.). Hempen Verlag: Bremen, 53–67.

Dexter, Miriam, and Victor Mair. 2010. *Sacred Display: Divine and Magical Female Figures of Eurasia*. Cambria Press: Amherst, New York.

Dillon, Myles. 1936. 'The Relationship of Mother and Son, of Father and Daughter, and the Law of Inheritance with Regard to Women'. In *Studies in Early Irish Law*, R. Thurneysen, Nancy Power, Myles Dillon, Kathleen Mulchrone, D.A. Binchy, August Knoch, and John Ryan (eds.). (Royal Irish Academy). Dublin: Hodges Figgis & Co., 129–79.

Dixon-Kennedy, Mike. 1998. *Encyclopedia of Russian and Slavic Myth and Legend*. Santa Barbara, California: ABC-CLIO, Inc.

Donahue, C. 1941. 'The Valkyries and the Irish War-Goddess'. *Publications of the Modern Language Association* 56: 1–12.

Doniger, Wendy. 2009. *The Hindus: An Alternative History*. New York: Penguin Press,

_____. *See also* O'Flaherty, Wendy Doniger.

Dorman, Peter. 2005. 'Hatshepsut: Princess to Queen to Co-Ruler'. In *Hatshepsut: From Queen to Pharaoh*, Catharine H. Roehrig (ed.). New York: The Metropolitan Museum of Art, 87–90.

Downey, Kirstin. 2014. *Isabella: The Warrior Queen*. New York: Nan A Talese, Doubleday.

Ducrey, Pierre. 2015. 'War in the Feminine in Ancient Greece'. In *Women & War in Antiquity*, Jacqueline Fabre-Serris and Alison Keith (eds.). Baltimore: Johns Hopkins University Press, 181–99.

Dudley, Donald R., and Graham Webster. 1962. *The Rebellion of Boudicca*. London: Routledge & Kegan Paul.

Duff, Nora. 1909. *Matilda of Tuscany: La Gran Donna D'Italia*. Classic Reprint Series of Forgotten Books, 2012. London: Methuen & Co.

Durham, Edith. 1909. *High Albania: A Victorian Traveller's Balkan Odyssey*. 2000 paperback edition. London: Phoenix Press.

Duval, Paul-Marie. 1977. *Les Celtes*. Gallimard.

Dziobek, Eberhard. 1992. *Das Grab des Ineni: Theben Nr. 81*. Archäologische Veröffentlichungen (Deutsches Archäologisches Institut, Abteilung Kairo) 68. Mainz am Rhein: Philipp von Zabern.

Earenfight, Theresa. 2013. *Queenship in Medieval Europe*. New York: Palgrave Macmillan.

Edmunds, Lowell. 2002–2003. 'Helen's Divine Origins'. *Electronic Antiquity* 10.2: 1–45.

Edwards, John. 2000. *The Spain of the Catholic Monarchs 1474–1520*. Oxford: Blackwell Publishing.

Egeler, Matthias. 2009. 'Textual Perspectives on Prehistoric Contacts: Some Considerations on Female Death Demons, Heroic Ideologies and the Notion of Elite Travel in European Prehistory'. *JIES* 37, nos. 3 & 4: 321–50.

_____. 2012. 'Some thoughts on "Goddess Medb" and her typological context'. *Zeitschrift für Celtische Philologie* 59: 67–96.

Ellis, Hilda Roderick. 1943. *The Road to Hel: A Study of the Conception of the Dead in Old Norse Literature*. 2013 paperback edition. Cambridge: University Press.

_____. *See also* Davidson, Hilda Ellis.

Ellis, Peter Berresford. 1996. *Celtic Women: Women in Celtic Society and Literature*. Grand Rapids, Michigan: William B. Eerdmans Publishing Company.

Epstein, Angelique Gulermovich. 1997. 'The Morrígan and the Valkyries'. In *Studies in Honor of Jaan Puhvel: Part Two: Mythology and Religion*, John Greppin and Edgar C. Polomé (eds.), (JIES Monograph 21). Washington DC: Institute for the Study of Man, 119–50.

_____. 1998a. *War Goddess: The Morrígan and her Germano-Celtic Counterparts*. Ph.D Dissertation. University of California, Los Angeles.

_____. 1998b. 'Divine Devouring: Further Notes on the Morrígan and the Valkyries'. In *Proceedings of the Seventh UCLA Indo-European Conference, Los Angeles 1995*, Angela della [sic] Volpe and Edgar C. Polomé (eds.), (JIES Monograph 24). Washington DC: Institute for the Study of Man, 86–104.

Erol, Ayse F. 2008. 'Analysing the Relationship between the Crescent Shaped Shield and the Amazons'. *JIES* 36, nos. 3 & 4: 411–27.

Evans, D. Ellis. 1999. 'Onomaris: Name of Story and History'. In *Ildánach Ildírech: A Festschrift for Proinsias MacCana*, John Carey, John T. Koch, & Pierre-Yves Lambert (eds.). Andover: Celtic Studies Publications, Inc., 27–37.

Fantham, Elaine, Helene Peet Foley, Natalie Boymel Kampen, Sarah B. Pomeroy, and H.A. Shapiro (eds.). 1994. *Women in the Classical World: Image and Text.* New York: Oxford University Press.

Farnell, Lewis Richard. 1896. *The Cults of the Greek States*, vol. I. Oxford: The Clarendon Press. https://archive.org

Fell, Christine, Cecily Clark, and Elizabeth Williams. 1984. *Women in Anglo-Saxon England: and the impact of 1066.* Bloomington: Indiana University Press.

Ferdowsi, Abolqasem. 2006. *Shahnameh: The Persian Book of Kings.* Dick Davis (trans.). New York: Penguin Books.

Fialko, E.E. 1991. 'Zhenskiye pogrebenya s oruzhiem v skyphskih kurganah stepnoi Skyphii'. ['Female burials with weapons among the Scythians Kurgans on the Scythian Steppe'], 4–18. *Editorial Naukova Dumka.*

Florence Chronicles. 1854. *The Chronicle of Florence of Worcester With The Two Continuations; Comprising Annals Of English History, From The Departure Of The Romans To The Reign Of Edward I.* Translated from the Latin, with notes and illustrations, by Thomas Forester, A. M. London: Henry G. Bohn, York Street.

Ford, Patrick K. 1977. *The Mabinogi.* Berkeley: University of California Press.

Fraser, Antonia. 1988. *The Warrior Queens.* New York: Alfred A. Knopf.

Frazer, Sir James George. 1963. *The Golden Bough.* 1971 printing. New York: Macmillan Paperbacks.

Freisenbruch, Annelise. 2010. *Caesars' Wives: Sex, Power, and Politics in the Roman Empire.* New York: Free Press.

Friedrich, Paul. *Proto-Indo-European Trees.* 1970. Chicago: The University of Chicago Press.

_____. 1978. *The Meaning of Aphrodite.* Chicago: The University of Chicago Press.

Fryde, E.B., E. Greenway, S. Porter, and I. Roy (eds.). 1996. *Handbook of British Chronology.* Reprint of 1986 3rd edition. Cambridge: Cambridge University Press.

Gaca, Kathy L. 2011. 'Girls, Women, and the Significance of Sexual Violence in Ancient Warfare'. In *Sexual Violence in Conflict Zones: From the Ancient*

World to the Era of Human Rights, Elizabeth D. Heineman (ed.). University of Pennsylvania Press: Philadelphia, 73–88.

_____. 2018. 'Ancient Warfare and the Ravaging Martial Rape of Girls and Women: Evidence from Homeric epic and Greek drama'. Mark Masterson, Nancy Sorkin Rabinowitz, and James Robson (eds.). First Published 2014. Routledge: London, 278–97.

Gantz, Jeffrey, trans. 1981. *Early Irish Myths and Sagas.* 1983 reprint. Middlesex: Penguin Books.

Gardeła, Leszek. 2013. '"Warrior-women" in Viking Age Scandinavia? A preliminary archaeological study'. *Analecta Archaeologica Ressoviensia* 8 (2013): 273–314.

_____. 2021. *Women and Weapons in the Viking World: Amazons of the North.* Casemate: Philadelphia & Oxford.

Garland, Lynda. 1999. *Byzantine Empresses: Women and Power in Byzantium, AD 527–1204.* London: Rutledge.

Geldner, Karl Friedrich. 1951. *Der Rig-Veda: Aus dem Sanskrit ins Deutsche Übersetzt und mit einem Laufenden Kommenstar Versehen.* 2003 paperback reprint of all 4 books in one volume. Cambridge/London: Department of Sanskrit and Indian Studies, Harvard University.

Gening, V.F. 1979. 'The Cemetery at Sintashta and the Early Indo-Iranian Peoples'. *JIES* 7: 1–30.

Gening, V.F., G. Zdanovich, and V. V. Gening. 1992. *Sintashta: Arkheologicheskie pamyatniki ariyskikh plemen Yralo-Kazakhstanskikh [Sintashta: Archeological Sites of Aryan Tribes of the Ural-Kazakh Steppes.] Yuzhno-Ural'skoe Knizhnoe Izdatel'stvo*, Chelyabinsk.

Geoffrey of Monmouth. 1966. *The History of the Kings of Britain.* Lewis Thorpe (trans.). 1979 reprint. Middlesex: Penguin Books.

Georgoudi, Stella. 2015. 'To Act, Not Submit: Women's Attitudes in Situations of War in Ancient Greece'. In *Women & War in Antiquity* Jacqueline Fabre-Serris and Alison Keith (eds.). Baltimore: Johns Hopkins University Press, 200–13.

Gera, Deborah. 1997. *Warrior Women: The Anonymous Tractatus De Mulieribus.* Leiden: E. J. Brill.

Gerald of Wales. 1978. The Journey through Wales and The Description of Wales. Lewis Thorpe (trans. and Intro.) 1980 reprint. Hammondsworth, Middlesex, England: Penguin Books.

Gesta Stephani. 1955. *The Deeds of Stephen.* Translated from the Latin with Introduction and Notes by K.R. Potter. London: Thomas Nelson and Sons Ltd.

Gibbon, Edward. 1882. *The History of the Decline and Fall of the Roman Empire.* New Edition with notes by The Rev. H.H. Milman. 6 Volumes. New York: Harper & Brothers, Publishers.

Gildas. 1899. *De Excidio Britanniae; or, The Ruin of Britain.* Hugh Williams (trans.). Dodo Press.

Gimbutas, Marija. 1971. *The Slavs.* London: Thames and Hudson.

———. 1974. *The Gods and Goddesses of Old Europe: 7000–3500 BC Myths and Cult Images.* Berkeley: University of California Press.

Gordon, Cyrus H. 1949. *Ugaritic Literature: A Comprehensive Translation of the Poetic Texts.* Roma: Pontificium Institutum Biblicum.

Gower, John. 2013. *Confessio Amantis*, Volume 2, Book 4. Russell A. Peck (ed.). Andrew Galloway (trans.). Robbins Library Digital Projects. University of Rochester. https://d.lib.rochester.edu/teams/text/peck-gower-

Graf, Fritz. 1984. 'Women, War, and Warlike Divinities'. *Zeitschrift für Papyrologie und Epigraphik* 55: 245–59.

Graham-Campbell, James. 1981. *Viking artefacts: a select catalogue.* London: British Museum.

Gray, Louis. 1929. *Foundations of the Iranian Religions.* Bombay: The Kama Oriental Institute Lectures.

Green, Miranda Aldhouse. 1992. *Dictionary of Celtic Myth and Legend.* London: Thames and Hudson.

———. 1996. *Celtic Goddesses: Warriors, Virgins and Mothers.* New York: George Braziller.

———. 2006. *Boudica Britannia: Rebel, war-leader and Queen.* Harlow, England/London: Pearson Longman.

Griffith, Ralph T.H. (trans.) 1987. *Hymns of the RgVeda*, 2 vols. 1889. Rev. ed. New Delhi: Munshiram Manoharlal Publishers Pvt. Ltd.

Grimal, Pierre. 1996. *The Dictionary of Classical Mythology.* A.R. Maxwell-Hyslop (trans.). 1997 reprint. Oxford: Blackwell Publishers Ltd.

Grøn, Ole, Anne Hedeager Krag, og Pia Bennike. 1994. *Vikingetidsgravpladser på Langeland.* Langelands Museum, Rudkøbing, Denmark.

Groneberg, Brigitte. 2009. 'The Role and Function of Goddesses in Mesopotamia'. In *The Babylonian World*, Gwendolyn Leick (ed.). 319–31. New York: Routledge.

de Grummond, Nancy Thomson. 1982. *A Guide to Etruscan Mirrors.* Tallahassee, Florida: Archaeological News, Inc.

Guliaev, V.I. 2003. 'Amazons in the Scythia; new finds at the Middle Don, Southern Russia'. *World Archaeology* 35, no. 1: 112–25.

———. 2019. Press Conference of the Institute of Archaeology at the Russian Academy of Sciences. 6 December 2019. (www.archaeolog.ru) (https://www.archaeolog.ru/ru/expeditions/expeditions-2019/donskaya-arkheologicheskaya-ekspeditsiya)

Gurney, O.R. 1977. *Some Aspects of Hittite Religion.* Oxford: Oxford University Press.

Gwynn, Edward. 1924. *Metrical Dindshenchas.* (Royal Irish Academy Todd Lecture Series). Dublin: Hodges, Figgis, & Co., Ltd.

Halkon, Peter. 2013. *The Parisi: Britons and Romans in Eastern Yorkshire.* Stroud, Gloucestershire: The History Press.

Hallett, Judith. 2015. 'Fulvia: The Representation of an Elite Roman Woman Warrior'. In *Women & War in Antiquity,* Jacqueline Fabre-Serris and Alison Keith (eds.). Baltimore: Johns Hopkins University Press, 247–65.

van Hamel, A.G. 1934. 'The Game of the Gods'. *Arkiv For Nordisk Filologi*, 50: 218–42.

Hampe, Roland and Erika Simon. 1981. *The Birth of Greek Art: From the Mycenaean to the Archaic Period.* New York: Oxford University Press.

Hanks, Bryan. 2008. 'Reconsidering Warfare, Status, and Gender in the Eurasian Steppe Iron Age'. In Linduff and Rubinson (eds.), 2008, 15–34.

Hansen, Donald P. 1998. 'Art of the Royal Tombs of Ur: A Brief Interpretation'. In *Treasures from the Royal Tombs of Ur.* Richard L. Zettler and Lee Horne (eds.). Philadelphia: University of Pennsylvania Museum, 42–72.

Harding, D.W. *The Iron Age in Lowland Britain.* 1985. London: Routledge & Kegan Paul.

Harmatta, J. 1950. *Studies on the History of the Sarmatians.* Budapest: Pázmány Péter Tudományegyetemi Görög Filológiai Intézet.

Harrower-Gray, Annette. 2009. 'That brawling, boisterous Scottish Wench'. *Scotland Magazine* 43: 21.

Hastrup, Kirsten. 1993. 'The Semantics of Biology: Virginity'. In *Defining Females: The Nature of Women in Society,* Shirley Ardener (ed.). Oxford: Berg, 34–50.

Hay, David J. 2008. *The Military Leadership of Matilda of Canossa 1046–1115.* Manchester: Manchester University Press.

Hedenstierna-Jonson, Charlotte, Anna Kjellström, Torun Zachrisson, Maja Krzewińska, Veronica Sobrado, Neil Price, Torsten Günther, Mattias Jakobsson, Anders Götherström, Jan Storå. 2017. 'A female Viking warrior confirmed by genomics'. *American Journal of Physical Anthropology* (September): 1–8. https://doi.org/10.1002/ajpa.23308.

Henderson, George. (ed., trans., introduction, and notes.) 1899. *Fled Bricrend (The Feast of Bricriu).* London: Published for The Irish Texts Society.

Hennessey, W.M. 1870. 'The Ancient Irish Goddess of War'. *Revue Celtique* 1: 32–57.

_____. (ed. trans., and notes). 1887. *The Annals of Ulster: Otherwise Annals of Senat; A Chronicle of Irish Affairs from A.D. 431, to A.D. 1540.* Vol. I A.D. 431–1056. HardPress Publishing photocopy. Dublin: Published by the Authority of the Lords Commissioners of Her Majesty's Treasury, under the directions of the Council of the Royal Irish Academy.

Henry of Huntingdon. 1853. *The Chronicle of Henry of Huntingdon: Comprising The History of England, From the Invasion of Julius Cæsar to the Accession of II. Also, The Acts of Stephen, King of England and Duke of Normandy.* Thomas Forester (trans.). Nabu Public Domain Reprints. London: Henry G. Bohn.

Herrin, Judith. 2001. *Women in Purple: Rulers of Medieval Byzantium.* Princeton: Princeton University Press.

Hiebert, Fredrik Talmage. 1994. *Origins of the Bronze Age Oasis Civilization in Central Asia.* Cambridge, MA: Peabody Museum of Archaeology and Ethnology, Harvard University.

Hiebert, Fredrik, and Pierre Cambon (eds.). 2008. *Afghanistan: Hidden Treasure from the National Museum, Kabul.* Washington D.C.: National Geographic.

Hill, J.D. 2001. 'A New Cart/Chariot Burial from Wetwang, East Yorkshire'. *PAST* (The Newsletter of the Prehistoric Society) 38, August: 410–12.

———. 2002. 'Wetwang Chariot Burial'. *Current Archaeology* 178 (March): 410–12.

Hillebrandt, Alfred. 1980. *Vedic Mythology* 2 Vols. S. Rajeswara Sarma (trans.). 1990 reprint. Delhi: Motilal Banarsidass Publishers,

Hilton, Lisa. 2010. *Queens Consort: England's Medieval Queens from Eleanor of Aquitaine to Elizabeth of York.* New York: Pegasus Books.

Hirt, Herman. 1892. 'Die Urheimat der indogermanen'. *Indo-germanische Forschungen* 1: 464–85.

Hoffner, Harry A. Jr. 1998. *Hittite Myths.* 2nd ed. Atlanta: Society of Biblical Literature, Writings from the Ancient World Series, Atlanta, Georgia: Scholars Press.

Hollander, Lee M. (trans.). 1962. *The Poetic Edda.* 2nd ed. rev. 1988 printing. Austin: University of Texas Press.

Holman, Beth L. 1999. 'Exemplum and Imitatio: Countess Matilda and Lucrezia Pico della Mirandola at Polirone'. *The Art Bulletin* 81, no. 4: 637–64.

Howarth, Nicki. 2008. *Cartimandua: Queen of the Brigantes.* Stroud, Gloucestershire: The History Press Ltd.

Huld, Martin E. 1993. 'Early Indo-European Weapons Terminology'. *Word* 44, no. 2: 223–34.

———. 2002. 'Some Thoughts on Amazons'. *JIES* 30, nos. 1 & 2: 93–102.

Hume, David. 1860. *The History of England in Three Volumes,* Vol. I, Part A. *'From the Britons of Early Times to King John.'* iBooks.

Huneycutt, Lois K. 1998. 'Queenship in Medieval Denmark'. In *Medieval Queenship,* John Carmi Parsons (ed.). New York: St. Martin's Press, 189–201.

Ibn Sa'd, Muhammad. 1995. *The Women of Madina.* Aisha Bewley (trans.). 2006 reprint. London: Ta-Ha Publishers.

Ikeya, Chie. 2005/06. 'The "Traditional" High Status of Women in Burma: A Historical Reconsideration'. *The Journal of Burma Studies* X: 51-81.

Illynskaya, V.A. 1966. 'Skyphskiye kurgany bliz Borispola' ['Scythian kurgans near Borispol town']. *Sovetskaya Arkheologiya* [*Soviet Archaeology*] 3: 152–70.

Insler, S. 1975. *The Gāthās of Zarathustra*. Leiden: E. J. Brill.

Jackson, Kenneth. 1953. *Language and History in Early Britain*. Edinburgh: University Press.

_____. 1979. Queen Boudicca? *Britannia* 10: 255.

Jacobsen, Thorkild. 1976. *The Treasures of Darkness: A History of Mesopotamian Religion*. New Haven: Yale University Press.

Jamison, Stephanie W. 1996. *Sacrificed Wife/Sacrificer's Wife: Women, Ritual, and Hospitality in Ancient India*. Oxford: Oxford University Press.

Jamison, Stephanie W., and Joel P. Brereton (trans. and eds.). 2014. *The Rigveda: The Earliest Religious Poetry of India*. 3 vols. Oxford: University Press.

Janko, Richard. 2007. *Homer, Hesiod and the Hymns: Diachronic Development in Epic Diction*. Cambridge: University Press.

Jánosi, Peter. 1992. 'The Queens Ahhotep I & II and Egypt's Foreign Relations'. *Journal of Ancient Chronology* 5: 99–105.

Jay, Mandy, Colin Haselgrove, Derek Hamilton, J.D. Hill, and John Dent. 2012. 'Chariots and context: New radiocarbon dates from Wetwang and the chronology of Iron Age burials and brooches in East Yorkshire'. *Oxford Journal of Archaeology* 31, no. 2: 161–89.

Jenkins, John S. 1853. *The Heroines of History*. Auburn: Alden, Beardsley & Co.

Jesch, Judith. 1991. *Women in the Viking Age*. 2005 paperback reprint. Woodbridge, England: The Boydell Press.

_____. 2014. 'Viking women, warriors, and valkyries'. *British Museum Blog*. 19 April. https://blog.britishmuseum.org/?s=Viking+women%2C+warriors%2C+and+valkyries

_____. 2019. 'Viking "warrior women": Judith Jesch, expert in Viking studies, examines the latest evidence'. https://www.historyextra.com/period/viking/birka-warrior-woman-vikings-female-argument-judith-jesch/2019.

_____. 2021. Women, War and Words: A Verbal Archaeology of Shield-maidens. *Viking Norsk Arkeologisk Årbok* Vol. 84 Nr 1.

Jones-Bley, Karlene. 1999. *Early and Middle Bronze Age Pottery from the Volga-Don Steppe*. Oxford: BAR International Series 796.

_____. 2000. 'The Sintashta "Chariots."' In *Kurgans, Ritual Sites, and Settlements Eurasian Bronze and Iron Age,* Jeannine Davis-Kimball, Eileen M. Murphy, Ludmila Koryakova, Leonid T. Yablonsky (eds.). Oxford: BAR International Series 890, 135–40.

_____. 2006a. 'The Evolution of the Chariot'. In *Horses and Humans: The Evolution of Human/Equine Relations*, edited by Sandra Olsen, Susan Grant, Alice M. Choyke and László Bartosiewicz (eds.). Oxford: BAR International Series 1560, 181–92.

_____. 2006b. 'Traveling to the Otherworld: Transport in the Grave'. In *Anthropology of the Indo-European World and Material Culture*, Marco V. García Quintela, Francisco J. González García, and Felipe Criado Boado (eds.). Budapest: Archaeolingua, 357-68.

Jones, David E. 1997. *Women Warriors: A History*. 2000 paperback edition. Washington: Brassey's.

Jones, Gwyn, (trans.) 1961. *Eirik the Red and other Icelandic Sagas*. 1988 reprint. Oxford University Press.

Jones, Gwyn, and Thomas Jones (trans.) 1974. *The Mabinogion*. 1977 reprint. London: Everyman's Library.

Jones, Prudence J. 2006. *Cleopatra: A source book*. Norman: Oklahoma University Press.

Jordana, Xavier, Ignasi Galtés, Tsagaan Turbat, D. Batsukh, Carlos Garcia, Albert Isidro, Pierre-Henre Giscard, Assumpció Malgosa. 2009. 'The warriors of the steppes: osteological evidence of warfare and violence from Pazyryk tumuli in the Mongolian Altai'. *Journal of Archaeological Science* 36: 1319–27.

Jullian, Camille. 1906. 'A Propos des Scordisques'. *Revue des Études Anciennes* 8:124.

[Google Books]

Jurić, Dorian. 2010. 'A Call for Functional Differentiation of the South Slavic Vila'. *JIES* 38, nos. 1&2: 172–202.

Kapelrud, Arvid S. 1969. *The Violent Goddess: Anat in the Ras Shamra Texts*. Oslo: Scandinavian University Books.

Karl, Raimund. 2003. 'Iron Age chariots and medieval texts: a step too far in "breaking down boundaries?"' *e-Keltoi* Volume 5:1–29 *Warfare* © UW System Board of Regents ISSN 1540-4889 online. Date Published: 28 September 2003.

Kastholm, Ole Thirup and Ashot Margaryan. 2021. Reconstructing the Gerdrup Grave – the story of an unusual Viking Age double grave in context and in the light of new analysis. *Danish Journal of Archaeology*, 10:1-20.

Keegan, John. 1994. *A History of Warfare*. Vintage Books Edition. New York: Alfred A. Knopf.

Kelly, Fergus. 1988. *A Guide to Early Irish Law*. Dublin: Dublin Institute for Advanced Studies.

Kelly, Patricia. 1992. 'Medb: sovereignty goddess or all-too-human?' In *Aspects of the Táin*, J. P. Mallory (ed.). Belfast: The Universities Press, 77–83.

Kenoyer, Jonathan Mark. 1998. *Ancient Cities of the Indus Valley Civilization.* Karachi: Oxford University Press.

Khudaverdyan A.Y., A.A. Yengibaryan, S.G. Hobosyan, A.A. Hovhanesyan, A.A. Saratikyan. 2019. 'An Early Armenian female warrior of the 8–6 century BC from Bover I site (Armenia)'. *International Journal of Osteoarchaeology* 30: 119–128. https://doi. org/10.1002/oa.2838

Kilunovskaya, M.E., V.A. Semenov, V.S. Busova (Saint Petersburg, Russian Federation), Kh. Kh. Mustafin, I.E. Alborova, A.D. Matzvai (Moscow, Russian Federation). 2020. 'The Unique Burial of a Child of Early Scythian Time at the Cemetery of Saryg-Bulun (Tuva)'. *Stratum plus* No. 3.

Kimmig, Wolfgang. 1988. *Das Kleinaspergle: Studies zu einem Fürstengrabhügel der frühen Latènezeit bei Stuttgart.* Konrad Theiss Verlag, Stuttgart.

King, Katherine Callen. 1987. *Achilles: Paradigms of the War Hero from Homer to the Middle Ages.* Berkeley: University of California Press.

Kinsella, Thomas (trans.) 1970. *The Táin.* Dublin: Oxford University Press.

Kinsley, David. 1988. *Hindu Goddesses: Visions of the Divine Feminine in the Hindu Religious Tradition.* Berkeley: University of California Press.

Kirk, Ilse. 1987. 'Images of Amazons: Marriage and Matriarchy'. In *Images of Women in Peace & War,* Sharon MacDonald Pat Holden, and Shirley Ardener (eds.), 27–39. Madison, Wisconsin: The University of Wisconsin Press.

Kjellström, Anna. 2017. 'People in transition: Life in the Mälaren Valley from an Osteological Perspective'. In *Shetland and the Viking World. Papers from the Proceedings of the 17th Viking Congress 2013,* V. Turner (ed.). Lerwick: Shetland Amenity Trust, 197–202.

Knox, John. 2011. *The First Blast of the Trumpet against the monstrous regiment of Women.* London. Reprint of the 15 August 1878 London edition. Project Gutenberg eBook, www.gutenberg.org/ebooks/9660.

Koch, John T. (ed.). 2006. *Celtic Culture: A Historical Encyclopedia,* 5 volumes. Santa Barbara: Abc CLIO.

Kramer, S.N. 1972. *Sumerian Mythology: A Study of Spiritual and Literary Achievement in the Third Millennium B.C.* First published 1944. Rev. ed. Philadelphia: University of Pennsylvania.

Kruk, Remke. 1993. 'Warrior Women in Arabic Popular Romance: Qannâṣ bint Muzâhim and Other Valiant Ladies. Part One'. *Journal of Arabic Literature* 24, no. 3: 213–30.

Kuznetsov, P. 2005. 'An Indo-Iranian Symbol of Power in the Earliest Steppe Kurgans'. *JIES* 33, nos. 3 & 4: 325–38.

Lal, Shyam Kishore. 1980. *Female Divinities in Hindu Mythology and Ritual.* Pune: University of Poona.

Lepore, Jill. 2014. *The Secret History of Wonder Woman.* New York: Vintage Books.

Latif, Bilkees I. 2010. *Forgotten*. New Delhi: Penguin.

Law, Robin. 1993. The 'Amazons' of Dahomey. *Paideuma: Mitteilungen zur Kulturkunde*, Bd. 39: 245–60.

Lay, Stephen. 2009. *The Reconquest Kings of Portugal: Political and Cultural Reorientation on the Medieval Frontier*. New York: Palgrave MacMillan,

Leahy, A.H. 1902. *The Courtship of Ferb. An Old Irish Romance transcribed in the Twelfth Century into the Book of Leinster*. London: David Nutt, at the Sign of the Phoenix.

Lefkowitz, Mary R., 1986. *Women in Greek Myth*. Baltimore: The Johns Hopkins University Press.

Lefkowitz, Mary R., and Maureen B. Fant. 1982. *Women's Life in Greece & Rome: A source book in translation*. Baltimore: The Johns Hopkins University Press.

Leicester, R., and Miller Christy. 1919. 'Queen Elizabeth's Visit to Tilbury in 1588'. *The English Historical Review* 34, no. 133: 43–61.

Leick, Gwendolyn. 1994. *Sex & Eroticism in Mesopotamian Literature*. London: Routledge.

_____. (ed.). 2009. *The Babylonian World*. New York: Routledge.

Lescue, Brigitte. 1991. 'The Hillfort and Sanctuary at Roquepertuse'. In *The Celts*, Milano: Bompiani, 362–63.

Levin, Carole. 1994. *The Heart and Stomach of a King: Elizabeth I and the Politics of Sex and Power*. Philadelphia: University of Pennsylvania Press.

Lewis, Charlton T., and Charles Short.1879. *A Latin Dictionary; Founded on Andrews' edition of Freund's Latin dictionary*. Revised, enlarged, and in great part rewritten by Charlton T. Lewis, Ph.D. Reprinted 1996. Trustees of Tufts University. Oxford: Clarendon Press.

L'hoir, F. Santoro. 1994. 'Tacitus and Women's Usurpation of Power'. *Classical World* 88: 5–25.

Lieverse, A.R., V.I. Bazaliiskii, O.I. Goriiunova, & A.W. Weber. 2009. 'Upper limb musculoskeletal stress markers among Middle Holocene foragers of Siberia's Cis-Baikal Region'. *American Journal of Physical Anthropology*, 138: 458–72. https://doi.org/10.1002/ajpa.20964

Lindow, John. 2001. *Norse Mythology: A Guide to the Gods, Heroes, Rituals, and Beliefs*. Oxford: Oxford University Press.

Linduff, Katheryn M. 1979. 'Epona, A Celt Among the Romans'. *Latomus* 38, no. 4: 817–37.

_____. 2001. 'Women's Lives Memorialized in Burial in Ancient China at Anyang'. In *In Pursuit of Gender*, Sarah Milledge Nelson and Myriam Rosen-Ayalon (eds.). Walnut Creek: AltaMira Press, 257–87.

Linduff, Katheryn M., and Karen S. Rubinson. 2008. *Are all Warriors Male?* Lanham/New York/Toronto: Altamira Press

Liss, Peggy K. 2004. *Isabel the Queen: Life and Times*. Revised edition. Philidelphia: University Press.

Littauer, Mary Aiken, and Joost H. Crouwell. 1979. *Wheeled Vehicles and Ridden Animals in the Ancient Near East.* Drawings by J. Morel. Leiden: Brill.

Llewellyn-Jones, Lloyd, and James Robson. 2013. *Ctesias' History of Persia Tales of the Orient.* New York: Routledge.

Lloyd–Morgan, Glenys. 1999. 'Memesis and Bellona: A Preliminary study of two Neglected goddesses'. In *The Concept of the Goddess*, Sandra Billington and Miranda Green (eds.). London: Routledge, 120–28.

Löfving, Annami. 2012. Review of *Authority of Influence*, Jessica Harriden. Copenhagen: NIAS Press, *New Mandala: New Perspectives on Southeast Asia*, 6 January, 2013. https://www.newmandala.org/ … /review-of-authority-of-influence-tlc-nmrev- xlviii/

Loman, Pasi. 2004. 'No Woman No War: Women's Participation in Ancient Greek Warfare'. *Greece & Rome*, 2nd ser. 51, no. 1: 34–54.

Lottner, C. 1870–72. 'The Ancient Irish Goddess of War'. *Revue Celtique* I: 32–57.

Lurker, Manfred. 1974. *The Gods and Symbols of Ancient Egypt: An Illustrated Dictionary.* English edition revised and enlarged by Peter A. Clayton. 1995 reprint. London: Thames and Hudson.

_____. 1987. *Dictionary of Gods and Goddesses, Devils and Demons.* (Translated from German by G.L. Campbell). 1988 reprint. London: Routledge.

Mac Cana, Proinsias. 1983. *Celtic Mythology.* Revised edition. Feltham, Middlesex: Newnes Books, a division of The Hamlyn Publishing Group Limited.

Macalister, R.A. Stewart (ed. and trans.) 1939. *Lebor Gabála Érenn: The Book of the Taking of Ireland*, Part II. 1986 reprint. Irish Texts Society, Dublin: The Educational Company of Ireland, Ltd.

_____. (ed. and trans.) 1940. *Lebor Gabála Érenn: The Book of the Taking of Ireland*, Part III. Irish Texts Society, Dublin: The Educational Company of Ireland, Ltd.

Macdonell, Arthur A. 1897. *Vedic Mythology.* Delhi: Low Price Publications,

_____. and Arthur Berriedale Keith. 1912. *Vedic Index of Names and Subjects.* 2 vols. 1958 reprint. Varanasi: Motilal Banarsidass.

Mace, Arthur C., and Herbert E. Winlock. 1916. *The Tomb of Senebtisi at Lisht.* 1973 Reprint Arno Press. Forgotten Books 2015. New York: The Metropolitan Museum of Art.

MacKillop, James. 1998. *Dictionary of Celtic Mythology.* Oxford: Oxford University Press.

Macqueen, J. G. 1959. 'Hattian Mythology and Hittite Monarchy'. *Anatolian Studies* 9: 171–88.

_____. 1986. *The Hittites and Their Contemporaries in Asia Minor.* (rev. ed.). London: Thames & Hudson.

Macurdy, Grace Harriet. 1929. 'The Political Activities and the Name of Cratesipolis'. *American Journal of Philology* 50: 273–78.

———. 1932. *Hellenistic Queens: A Study of woman-power in Macedonia, Seleucid Syria, and Potolemaic Egypt*. Chicago: Ares Publishers, Inc.

The Mahābhārata. 1973. J. A. B. van Buitenen (trans. and ed.). Vols. 1-3 (Books 1-5). Chicago: The University of Chicago Press.

Mallory, J.P. 1989. *In Search of the Indo-Europeans*. London: Thames and Hudson.

———. 1998. 'The Old Irish Chariot'. In *Mír Curad: Studies in Honor of Calvert Watkins*, Jay Jasanoff, H. Craig Melchert and Lisi Olivier, (eds.). Innsbruck: Sonderdruck, 451–464.

Mallory, J.P., and D.Q. Adams (eds.). 1997. *Encyclopedia of Indo-European Culture*. Chicago: Fitzroy Dearborn Publishers

Mallory, J.P., and Victor M. Mair. 2000. *The Tarim Mummies: Ancient China and the Mystery of the Earliest Peoples from the West*. London: Thames & Hudson.

Man, John. 2017. *Amazons: The Real Warrior Women of the Ancient World*. London: Bantam Press.

Marazov, Ivan. 1996. *The Rogozen Treasure*. Sofia: Secor Publishers.

Markale, Jean. 1975. *Women of the Celts*. A. Mygind, C. Hauch and P. Henry (trans.). Rochester, Vermont: Inner traditions International, Ltd.

Marshall, H.E. 2017. *Scotland's Story: A History of Scotland for Boys and Girls*. First published 1906. Sandycroft Publishing,

Marshall, Rosalind K. 1983. *Virgins and Viragos: A History of Women in Scotland from 1080–1980*. Chicago: Academy.

Mayor, Adrienne. 2014. *The Amazons: Lives & Legends of Warrior Women Across the Ancient World*. Princeton & Oxford: Princeton University Press.

McCullough, Ann. 2016. 'Female Gladiators in the Roman Empire'. In *Women in Antiquity: Real women across the Ancient World*, Stephanie Lynn Budin and Jean Macintosh Turfa (eds.). London: Routledge, 954–63.

McLaughlin, Megan. 1990. 'The woman warrior: gender, warfare and society in medieval Europe'. *Women's Studies* 17: 193–209.

Medicine, B. 2002. 'Directions in Gender Research in American Indian Societies: Two Spirits and Categories'. *Online Readings in Psychology and Culture*, Unit 3. Retrieved from http://scholarworks.gvsu.edu/orpc/vol3/iss1/2

Megaw, Ruth, and Vincent. 1989. *Celtic Art from its beginnings to the Book of Kells*. London: Thames and Hudson.

Meid, Wolfgang. 2010. *The Celts*. Innsbruck: Innsbrucker Beiträge zur Kulturwissenschaft.

Melchert, H. Craig. 2004. 'Carian'. In *The Cambridge Encyclopedia of the World's Ancient Languages*, Roger D. Woodard (ed.). Cambridge: Cambridge University Press, 609–13.

Melyukova, Anna I. 1995. 'Scythians of Southeastern Europe'. In Davis-Kimball, *et al.* (eds.). 1995, 27–58.

Meyer, Kuno (ed. and trans.) 1905. *Cáin Adamnáin: An Old-Irish Treatis on the Law of Adamnan.* Reproduced by Bibliolife. Oxford: Clarendon Press.

Michaud, Joseph Francois. 1891. *The History of the Crusades, Vol. 3.* W. Robson (trans.). New York: A.C. Armstrong & Son. Google Book.

Mierow, Charles Christopher. 1915. *The Gothic History of Jordanes: In English Version with an Introduction and a Commentary.* Princeton: Princeton University Press. Kessinger Publishing's Legacy Reprints.

Miller, Dean. 2012. 'The Mórríoghan and Her Indo-European War-Goddess Cohorts'. *Cosmos* 28: 1–18.

Mills, L.H., trans. 1887. *Zend-Avesta, Part III, The Yasna, Visparad, Âfrînagân, Gâhs and Miscellaneous Fragments.* 1993 reprint. Delhi: Motilal Banarsidass Publishers.

Minns, Ellis Hovell. 1913. *Scythians and Greeks: A Survey of Ancient History and Archaeology on the North Coast of the Euxine from the Danube to the Caucasus.* Cambridge: Cambridge University Press.

Moilanen, Ulla, Tuija Kirkinen, Nelli-Johanna Saari, Adam B. Rohrlach, Johannes Krause, Päivi Onkamo, and Elina Salmela. 2022. 'Woman with a Sword? – Weapon Grave at Suontaka Vesitorninmäki, Finland'. *European Journal of Archaeology* 42–60.

Moran, William L. (ed. and trans.) *The Amarna Letters*. Baltimore: The Johns Hopkins University Press, 1992.

Moriarty, Catherine (ed.). 1989. *The Voice of the Middle Ages: In Personal Letters 1100–1500.* New York: Peter Bedrick Books.

Moshkova, Marina G. 1995. 'A Brief Review of the History of the Sauromatian and Sarmatian Tribes'. In Davis-Kimball, *et al.* (eds.). 1995, 85–89.

Murray, Steven. 2003. 'Female Gladiators of the Ancient Roman World'. *Journal of Combative Sport*, July 2003. http://ejmas.com/jcs/jcsart_murray_0703.htm

Murphy, Eileen M. 2003. *Iron Age Archaeology and Trauma from Aymyrlyg, South Siberia.* Oxford: BAR International Series 1152.

_____, and J. Davis-Kimbal [*sic*]. 2001. 'Iron Age Weapon Trauma from the Chowhougou Cemetery Complex, Western China'. *Journal of Paleopathology* 13, no. 1: 27–34.

Nelson, Sarah Milledge, and Myriam Rosen-Ayalon (eds.). 2002. *In Pursuit of Gender: Worldwide Archaeological Approaches.* Walnut Creek: Altamira Press.

New Larousse Encyclopedia of Mythology. 1959. London: Hamlyn.

Nicholson, Helen. 'Women on the Third Crusade'. *Journal of Medieval History* 23, no. 4 (1997): 335–49.

Nikoradze, G.K. 1928. 'O nekotorom snachenii Zemo-Avchalskoi Mogili'. RANION, Institut Arkheologii i iskustvoznaniya, *Trudi sektzii arkheologii*. Moscow.

Njal's Saga. 2001. Robert Cook (trans., Intro., and notes.). London: Penguin Books.

Nordal, Sigurdur. 1954. 'Introduction'. In *The Prose Edda of Snorri Sturluson Tales from Norse Mythology*, Jean I. Young (trans.). Berkeley: University of California Press, 7–15.

O'Callaghan, Joseph F. 1975. *A History of Medieval Spain*. Ithaca: Cornell University Press.

O'Connor, Frank. 1967. *The Backward Look*. London: Macmillan.

O'Donovan, John, (trans. and ed.). 1860. *Annals of Ireland, Three Fragments*. Copied from the ancient sources by Duald MacFirbis. Nabu Public Domain Reprints. Dublin: Irish Archaeological Society.

O'Flaherty, Wendy Doniger. 1980. *Women, Androgynes, and Other Mythical Beasts*. Chicago: The University of Chicago Press.

―――. (trans.). 1981. *The Rig Veda*. New York: Penguin Books.

―――. *See also* Doniger, Wendy.

O'Rahilly, Cecile (ed.). 1967. *Táin Bó Cúalnge: from the Book of Leinster*. 1984 reprint. Dublin: Institute for Advanced Studies.

O'Rahilly, T.F. 1946. 'On the Origin of the Names Érainn and Ériu'. *Ériu* 14: 7–28.

Oxford Latin Dictionary. 1982. P. G. W. Glare (ed.). 1983 reprint. New York: Oxford University Press.

Parker, Simon B. (ed.). 1997. *Ugaritic Narrative Poetry*. Scholars Press.

Pallotino, Massimo. 1978. *The Etruscans*. F. Cremona trans.). New York: Penguin Books.

Parpola, Asko. 1999. 'Vāc as a Goddess of Victory in the Veda and her relation to Durgā'. *Zinbun* 34, no. 2: 101–43.

Pearson, Mike Parker. 1999. *The Archaeology of Death and Burial*. 1999 reprint. Phoenix Mill, Gloucestershire, England: Sutton Publishing Limited.

Pennington, Reina (ed.). 2003. *Amazons to Fighter Pilots: A Biographical Dictionary of Military Women*, 2 vols. Westport, Connecticut: Greenwood Press.

Penrose, Walter Duvall, Jr. 2016. *Postcolonial Amazons: Female Masculinity and Courage in Ancient Greek and Sanskrit Literature*. Oxford: Oxford University Press.

Petersen, Jan. 1919. *De norske Vikingesværd*. Kristiania.

―――. 1951. *Vikingetidens redskaper*. Stavanger.

Petrie, Sir W.M. Flinders. 1896. *Naqada and Ballas*. 1974 edition. Warminster, Wiltshire, England: Aris & Phillips Ltd.

Petrenko, V.G., V.E. Maslov, and A.R. Kantorovich. 2004. 'Pogrebenie znatnoi skifyanki iz mogilnika Novozavedennoe-II' (predvaritelanaya publikatia). [Burial of a Noble Scythian Woman from Novozavedennoe-II Cemetery (preliminary publication)]. In *Arkheologicheskie pamyatmiki rannego zheleznogo veka Uga Rossi*, Leonid T. Yablonsky (ed.). Moscow: IA RAN-Press, 179–210.

Pierson, Ruth Roach. 1987. 'Did Your Mother Wear Army Boots?: Feminist Theory and Women's Relation to War, Peace and Revolution'. In *Images of Women in Peace & War*, Sharon MacDonald, Pat Holden, and Shirley Ardener (eds.). Madison, Wisconsin: The University of Wisconsin Press, 205–27.

de Pizan, Christine. 1985. *The Treasure of the City of Ladies or The Book of the Three Virtues*, translated by and Introduction by Sarah Lawson. 1987 reprint. London: Penguin Books.

———. 1999. *The Book of Deeds of Arms and of Chivalry*. Sumner Willard (trans.), Charity Cannon Willard (ed.). University Park, PA, Pennsylvania State University Press.

Pomeroy, Sarah B. 1975. *Goddesses, Whores, Wives, and Slaves: Women in Classical Antiquity*. New York: Schocken Books.

———. 1984. *Hellenistic Egypt: From Alexander to Cleopatra*. Detroit: Wayne State University Press

———. 2002. *Spartan Women*. Oxford: University Press.

Poole, Austin Lane. 1993. *From Domesday Book to Magna Carta 1087–1216*. 2nd ed. Oxford: Oxford University Press.

Price, Neil. 2019. *The Viking Way: Magic and Mind in Late Iron Age Scandinavia*. 2nd edition. Oxford: Oxbow Books.

Price, Neil, Charlotte Hedenstierna-Jonson, *et al.* 2019. Viking warrior women? Reassessing Birka chamber grave Bj.581. *Antiquity* 93, no. 367: 181–98.

Price, Simon, and Emily Kearns (eds.). 2003. *The Oxford Dictionary of Classical Myth & Religion*. Oxford: Oxford University Press.

Pritchard, James B. (ed.) 1958. *The Ancient Near East: Volume I: An Anthology of Texts and Pictures*. 6th printing, 1973. Princeton: Princeton University Press.

Puhvel, Jaan. 1987. *Comparative Mythology.* Baltimore: Johns Hopkins University Press.

———. 1988. 'Hittite Athletics as Prefigurations of Ancient Greek Games'. In *The Archaeology of the Olympics: The Olympics and Other Festivals in Antiquity,* Wendy Rashke (ed.). Madison, Wisconsin: The University of Wisconsin Press, 26–31.

Radner, Joan Newlon. 1978. *Fragmentary Annals of Ireland*. Dublin: Dublin Institute for Advanced Studies.

Ramayana. 2004. Retold by Krishna Dharma. Badger, CA: Torchlight Publishing, Inc.

Rankin, David. 1987. *Celts and the Classical World.* 1998 reprint. London: Routledge.

Rashke, Wendy (ed.). 1988. *The Archaeology of the Olympics: The Olympics and Other Festivals in Antiquity*. Madison, Wisconsin: The University of Wisconsin Press.

Raulwing, Peter. 2005 [2006]. 'The Kikkuli Text (CTH 284). Some Interdisciplinary Remarks on Hittite Training Texts for Chariot Horses in the Second Half of the 2nd Millennium B.C'. In *Les Équidés dans le monde méditerranéen antique. Actes du colloque organisé par l'École française d'Athènes, le Centre Camille Jullian, et l'UMR 5140 du CNRS, Athènes, 26-28 Novembre 2003.* 61–75, Armelle Gardeisen (ed.). (Monographies d'archéologie méditerranéenne.) Lattes: Éd. de l'Association pour le développement de l'archéologie en Languedoc-Rousillon.

Ražev, Dimitrij, and Svetlana Šharapova. 2014. 'Peopling the Past: female burials of the Iron Age forest-steppe in the Trans-Urals'. *Praehistorische Zeitschrift* 89, no. 1: 157–76.

———. 2012. Warfare or Social Power: A Bioarcheological Study of the Iron Age Forest-Steppe Populations in the Trans-Urals and Western Siberia'. *Praehistorische Zeitschrift* 87, no. 1: 146–60.

Reade, Julian Edgeworth. 2018. 'Ashurbanipal's Palace at Nineveh'. In *I am Ashurbanipal king of the world, king of Assyria*, Gareth Brereton (ed.). London: The British Museum: 20–33.

Reilly, Bernard F. 1999. *The Kingdom of León-Castilla under Queen Urraca, 1109–1126*. The Library of Iberian Resources Online.

Rees, Alwyn, and Brinley Rees. 1961. *Celtic Heritage: Ancient tradition in Ireland and Wales.* 1978 reprint. Thames and Hudson.

Rehak, Paul. 1984. 'New Observations on the Mycenaean "Warrior Goddess"'. *Archäologischer Anzeiger* 4: 535–45.

———. 1998. 'The Mycenaean "Warrior Goddess" Revisited'. In POLEMOS. *Le contexte guerrier en Égée a l'Âge du Bronze. Actes de la 7è Rencontre égéenne international (Liège, 14-17 avril 1998) (Aegaeum 19)*, R. Laffineur (ed.). Liège & Austin: Université de Liège and the Program in Aegean Scripts and Prehistory, University of Texas at Austin, 227-39.

Rice, Tamara Talbot. 1957. *The Scythians.* New York: Frederick A. Praeger.

Richmond, I.A. 1954. 'Queen Cartimandua'. *Journal of Roman Studies* 44: 43–52.

Rohrbacher, David. 2013. The Sources of the Historia Augusta Re-examined. *Histos* 7: 146–80.

Rolle, Renate. 1989. *The World of the Scythians.* W. G. Walls (trans.). Berkeley: University of California Press.

Roller, Duane W. 2010. *Cleopatra: A Biography.* New York: Oxford University Press.

Ross, Anne. 1962. Chapter 4, fn. 2. In *The Rebellion of Boudicca.* Donald R. Dudley and Graham Webster, London: Routledge & Kegan Paul, 151–52.

———. 1967. *Pagan Celtic Britain*. London: Routledge.

———. 1973. 'The Divine Hag of the Pagan Celts'. In *The Witch Figure: Folklore essays by a group of scholars in England honouring the 75th birthday of Katharine M. Briggs*, Venetia Newall (ed.). London: Routledge & Kegan Paul, 139–64.

———. 1986. *The Pagan Celts*. London: B.T. Batsford Ltd.

Roux, Georges. 1992. *Ancient Iraq*. 3rd edition. Penguin Books: Middlesex, England.

Rowe, Elizabeth Ashman. 2005. *The Development of Flateyjarbók*. Odense: The University Press of Southern Denmark.

Royal Irish Academy Dictionary of the Irish Language. 1953–1975. See also eDIL – *Electronic Dictionary of the Irish Language* (www.dil.ie2019).

Rudenko, Sergei I. 1970. *Frozen Tombs of Siberia: The Pazyryk Burials of Iron Age Horsemen*. Berkeley: UC Press.

Runciman, Steven. 1974. 'The Empress Irene'. *Conspectus of History* 1, no. 1: 1–11.

Ryan, J. 1936. 'The *Cáin Adomnáin*'. In *Studies in Early Irish Law*, R. Thurneysen, Nancy Power, Myles Dillon, Kathleen Mulchrone, D. A. Binchy, August Knoch, and John Ryan (eds.). Royal Irish Academy. Dublin: Hodges Figgis & Co., 269–76.

Salmonson, Jessica Amanda. 1991. *The Encyclopedia of Amazons: Women Warriors from Antiquity to the Modern Era*. New York: Anchor Books, Doubleday.

Saxo Grammaticus. 1979. *The History of the Danes Books I–IX*. Peter Fisher (trans.) Hilda Ellis Davidson (ed.). 1998 reprint. Cambridge: D. S. Brewer.

Scarisbrick, J.J. *Henry VIII*. 1997. New Haven: Yale University Press.

Schiff, Stacy. 2010. *Cleopatra: A Life*. New York: Little, Brown and Company.

Schleiner, Winfried. 1978. '"Divina Virago": Queen Elizabeth as an Amazon'. *Studies in Philology* 75, no. 2: 163–80.

Schrader, Helena Page. 2006. *Sisters in Arms*. Barnsley, South Yorkshire: Pen & Sword Books Limited.

Schramm, W. 1972. 'War Semiramis eine assyrische Regentin'? *Historia* 21: 513–21.

Selz, Gebhard J. 2000. 'Five Divine Ladies: Thoughts on Inana(k), Ištar, In(n)in(a), Annunītum, and Anat, and the Origin of the Title "Queen of Heaven"'. *NiN* 1: 29–62.

Senden, Arjan. 2008–09. 'Zenobia in Nummis'. *Talanta* XL–XLI: 137–50.

Seymour, Thomas Day. 1963. *Life in the Homeric Age*. New York: Biblo and Tannen.

Shahar, Shulamith. 2003. *The Fourth Estate: A History of the Women in the Middle Ages*. Rev. ed. 2007 reprint. London: Routledge.

Shapiro, H.A. 1983. 'Amazons, Thracians, and Scythians'. *Greek, Roman, and Byzantine Studies* 24, no. 2: 105–14.

Sharapova, Svetlana, and Dmitrij Razhev. 2011. 'Skull Deformation during the Iron Age in the Trans-Urals and Western Siberia'. In *The Bioarchaeology of the Human Head: Decapitation, Decoration and Deformation*, M. Bonogofsky (ed.). Gainesville: University Press of Florida, 202–27.

Sharrock, Alison. 2015. 'Warrior Women in Roman Epic'. In *Women & War in Antiquity*, Jacqueline Fabre-Serris and Alison Keith (eds.). Baltimore: Johns Hopkins University Press, 157–78.

Shay, Jonathan. 2014. 'Moral Injury'. *Psychoanalytic Psychology* Vol. 31, No. 2: 182–191.

Shaw, Philip A. 2011. *Pagan Goddesses in the Early Germanic World: Eostre, Hreda and the Cult of Matrons*. London: Bristol Classical Press.

Siddall, Luis Robert. 2014. 'Sammu-Ramat: Regent or Queen Mother'? In *La famille dans le Proche-Orient ancien: réalités, symbolismes, et images*: Proceedings of the 55th Rencontre Assyriologique Internationale at Paris 6–9 July 2009. Lionel Marti (ed.). Eisenbrauns: Winona Lake, Indiana, 497–504.

Simek, Rudolf. 1993. *Dictionary of Northern Mythology*, Angela Hall (trans.). Cambridge: D.S. Brewster.

Sissa, Giulia. 1990. *Greek Virginity*. Arthur Goldhammer (trans.). Cambridge: Harvard University Press.

Sjoestedt, Marie-Louise. 1994. *Gods and Heroes of the Celts*. Myles Dillon (trans.). Portland, Oregon: Four Courts Press.

Skaine, Rosemarie. 2011. *Women in Combat: A Reference Handbook*. Santa Barbara, California: Abc-CLIO.

Smirnov, K.F. 1982. '"Amazonka" IV beka do n. e. na Nizhnem Donu'. *Sovetskaya arkheolgiya*, 1 ['"Amazonian Female" in the 4th Century B.C. on the Lower Don'] *Soviet Archaeology* 1: 120–31.

Smith, Mark S. (trans.) 1997. 'The Baal Cycle'. In *Ugaritic Narrative Poetry*, Simon B. Parker (ed.), 81–180. Scholars Press.

Stafford, Pauline. 1989. *Unification and Conquest: A Political and Social History of England in the Tenth and Eleventh Centuries*. London: Edward Arnold.

———. 1990. 'The King's Wife in Wessex, 800–1066'. In *New Readings on Women in Old English Literature*, Helen Damico and Alexandra Hennessey Olsen (eds.). Bloomington: Indiana University Press, 56–78.

Stein, Diana L. 1989. 'Art and Architecture'. In *The Hurrians*, Gernot Wilhelm, Jennifer Barns (trans.). Warminster, England: Aris & Phillips Ltd.

Stenton, Doris Mary. 1957. *The English Woman in History*. 1977 reprint. New York: Schocken Books.

Stenton, Frank Sir. 1968. *Anglo-Saxon England*. 3rd ed. Oxford: The Clarendon Press.

Stokes, Whitley. 1895. 'The Prose Tales in the Rennes Dindshenchas'. *Revue Celtique* 16: 31–82, 135–67, 269–312.

———. 1900. 'Da Choca's Hostel'. *Revue Celtique* 21: 149-65, 312-27, 388-402.

Stol, Marten. 2018. *Women in the Ancient Near East*. Helen and Mervyn Richardson (trans.). Boston: de Gruyter, Inc.

Stoneman, Richard (trans.) 1991. *The Greek Alexander Romance*. London: Penguin Books.

_____. 1994. *Palmyra and Its Empire: Zenobia's Revolt against Rome*. Paperback edition. Ann Arbor: The University of Michigan Press

Strickland, Agnes. 1886. *Lives of the Queens of England*. Abri. ed. London: George Bell and Sons.

Sturluson, Snorri. 1954. *The Prose Edda of Snorri Sturluson: Tales from Norse Mythology*. Jean I. Young (trans.). Berkeley: UC Press.

Stylegar Frans-Arne. 2007. 'The Kaupang Cemeteries Revisited'. In *Kaupang in Skiringssal*, (= Kaupang Excavation Project Publication Series Vol. I, Norske Oldfunn XXII), Dagfinn Skre (ed.). Aarhus: Aarhus University Press, 65–101.

Sulimirski, Tadeusz. 1970. *The Sarmatians*. London: Thames and Hudson.

Svärd, Saana. 2015. *Women and Power in Neo-Assyrian Palaces*. State Archives of Assyria Studies. Vol. XXIII. Helsinki: The Neo-Assyrian Text Corpus Project.

Swaddling, Judith. 2008. *The Ancient Olympic Games*. London: British Museum Press.

Swanton, Michael, (trans. and ed.). 1996. *The Anglo-Saxon Chronicle*. New York: Routledge.

Syme, Ronald. 1983. *Historia Augusta Papers*. Oxford: Clarendon Press.

Szarmach, Paul E. 1998. 'Æðelfæd of Mercia: *Mise en page*'. In *Words and Works: Studies in Medieval English Language and Literature in Honour of Fred C. Robinson* Baker, Peter S., and Nicholas Howe (eds.). Toronto: University of Toronto Press, 105–26.

Taylor, Jon. 2018. 'Knowledge: The Key to Assyrian Power'. In *I am Ashurbanipal king of the world, king of Assyria*, Gareth Brereton (ed.). London: Thames & Hudson, The British Museum, 88–97.

Taylor, Timothy. 1994. 'Thracians, Scythians, and Dacians, 800 BC–AD 300'. In *The Oxford Illustrated Prehistory of Europe*, Barry Cunliffe (ed.). Oxford: University Press, 373–410.

_____. 1996. *The Prehistory of Sex: Four Million Years of Human Sexual Culture*. New York: Bantam Books.

Teffeteller, A. 2001. 'Greek Athena and the Hittite Sungoddess of Arinna'. In *Athena in the Classical World*, S. Deacy and A. Viling (eds.). London: Brill, 349–65.

Terenozhkin, A.I., and V.A. Illynskaya. 1983. 'Skyphyia period VII–IV vekov do nashei ery' [*Scythia in the Seventh and Fourth Centuries* BC]. Kiev: Naukova Dumka.

Thompson, R. Campbell (trans.). 1928. *The Epic of Gilgamish: A new translation from a collation of the cuneiform tablets in the British Museum rendered literally into English hexameters*. London. At sacred-texts.com

Thompson, Victoria. 2004. *Dying and Death in Later Anglo-Saxon England*. Woodbridge: The Boydell Press.

Todd, James Henthorn (ed., trans. and intro.) 1867. *The War of the Gaedhil with the Gaill, or The Invasions of Ireland by the Danes and other Norsemen*. The Origial Irish Text. London: Longmans, Green, Reader, and Dyer.

Tolkien, Christopher (trans.). 1960. *The Saga of King Heidrek the Wise*. Translated from the Icelandic with Introduction, Notes and Appendices. London: Thomas Nelson and Sons Ltd.

Tronson, Adrian. 1984. 'Satyrus the Peripatetic and the Marriages of Philip II'. *The Journal of Hellenic Studies* 104: 116-126.

Tucker, Spender C. (ed.). 2001. *Encyclopedia of the Vietnam War: A Political, Social, and Military History*. Oxford: Oxford University Press.

Turnbull, Stephen. 2014. *Samurai Women 1184–1877*. 3rd impression. Oxford: Osprey Publishing Ltd.

Turner, Ralph V. 2011. *Eleanor of Aquitaine: Queen of France Queen of England*. New Haven/London: Yale University Press.

Turville-Petre, E.O.G. 1964. *Myth and Religion of the North: The Religion of Ancient Scandinavia*. New York: Holt, Rinehart and Winston.

Tyldesley, Joyce. 1996. *Hatchepsut: The Female Pharaoh*. London: Viking.

———. 2006. *Chronicle of the Queens of Egypt: From early dynastic times to the death of Cleopatra*. New York: Thames & Hudson.

———. 2008. *Cleopatra: Last Queen of Egypt*. New York: Basic Books.

Tyrrell, Wm. Blake. 1984. *Amazons: A Study in Athenian Mythmaking*. Baltimore: The Johns Hopkins University Press.

Ustinova, Yulia. 1999. *The Supreme Gods of the Bosporan Kingdom: Celestial Aphrodite & the Most High God*. Leiden: Brill.

Vanderwerker, Jr., Earl E. (M.D.). 1976. 'A Brief Review of the History of Amputations and Prostheses'. *ICIB; Inter-Clinic Information Bulletin* 15, no. 5: 15–16.

Vaughan, Agnes Carr. 1967. *Zenobia of Palmyra*. New York: Doubleday & Company, Inc.

Venetis, Evangelos. 2007. 'Warlike Heroines in the Persian Alexander Tradition: The Cases of Araqit and Burandukht'. *British Institute of Persian Studies* 45: 227–32.

Verbruggen, J.F. 1982 [2006]. 'Women in Medieval Armies'. 2000 translation by Kelly DeVries. *Journal of Medieval Military History* 4 (1982): 119–36.

Vita Edwardi Secundi. 1957. *The Life of Edward the Second by the So-called Monk of Malmesbury*, N. Denholm-Young (trans. from Latin. Notes and Introduction). London: Thomas Nelson and Sons Ltd.

Wace, Alan J.B., and Frank H. Stubbings. 1962. *A Companion to Homer*. London: MacMillan & Co. Ltd.

Wainwright, F.T. 1975. 'Æthelflæd, Lady of the Mercians.' In *Scandinavian England*, H.P.R. Finberg (ed.). Chichester, Sussex: Phillimore, 305–24.

⸻. 1990. 'Æthelflæd, Lady of the Mercians'. In *New Readings on Women in Old English Literature*, Helen Damico and Alexandra Hennessey Olsen (eds.). Bloomington: Indiana University Press, 44–55.

Walde-Hofmann: Walde, A., and von J.B. Hofmann. 1938. *Lateinisches etymologisches Wörterbuch*. Vol. 2., 3te Aufl. Heidelberg: Carl Winter's Universitätsbuchhandlung.

Walker, Ian W. 2000. *Mercia and the Making of England*. Phoenix Mill, Gloucestershire, England: Sutton Publishing Limited.

Walls, Neal H. 1992. *The Goddess Anat in Ugaritic Myth*. SBL Dissertation Series 135. Atlanta, Georgia: Scholars Press.

Watkins, Calvert. 1986. 'The Language of the Trojans'. In *Troy and the Trojan War*, Machteld J. Mellink (ed.). (Bryn Mawr Archaeological Monographs). Bryn Mawr College, 53–55.

Webster, Graham. 1985. *Rome against Caratacus: The Roman Campaigns in Britain AD 48–58*. No Place: Dorset Press.

West, M.L. 1997. *The East Face of Helicon: West Asiatic Elements in Greek Poetry and Myth*. Oxford: Clarendon Press.

Westenholz, Joan Goodnick. 1998. 'Goddesses of the Ancient Near East 3000–1000 BC'. In *Ancient Goddesses: The Myths and the Evidence*, edited by Lucy Goodison and Christine Morris (eds.). Madison, Wisconsin: The University of Wisconsin Press, 63–82.

⸻. 2009. 'Inanna and Ishtar – the dimorphic Venus goddess'. In *The Babylonian World*, Gwendolyn Leick (ed.), 332–47. New York: Routledge.

Whittaker, H. 2006. 'Game-boards and gaming-pieces in funerary contexts in the Northern European Iron Age'. *Nordlit* 20: 103–12. https://doi.org/10.7557/13.1802

Wilhelm, Gernot. 1989. *The Hurrians*, Jennifer Barnes (trans.). Warminster, England: Aris & Phillips Ltd.

Wilkes, John. 1992. *The Illyrians*. 2000 reprint. Oxford: Blackwell.

William of Malmesbury. 1847. *William of Malmesbury's Chronicle of the Kings of England. From the earliest period to the reign of King Stephen*. With Notes and Illustrations by J.A. Giles. (2012 reprint Forgotten Books). London: Henry G. Bohn.

Williams, Hugh. (ed. and trans.) 1899. *Gildas, The Ruin of Britain, Fragments from Lost Letters, The Penitential, Together with The Lorca of Gildas*. London: David Nutt.

Yablonsky, Leonid T. 1995. 'The Material Culture of the Saka and Historical Reconstruction'. In Davis-Kimball, *et al.* (eds.). 1995, 201–39.

Young, Antonia. 2001. *Women Who Became Men: Albanian Sworn Virgins*. 2001 reprint. Oxford: Berg.

Classical References

All Classical references are from the Loeb Classical Library unless otherwise stated

Aeschylus, (H. Weir Smyth, trans.). 1938. *Suppliant Maidens, Prometheus.*
Ammianus Marcellinus, (John C. Rolfe, trans.). 1935. *Book XV.*
Apollodorus, (Sir James George Frazer, trans.). 1921. *Epitome.*
Apollodorus, (Sir James George Frazer, trans.). 1921. *The Library, Book III.*
Apollonius Rhodius, (R.C. Seaton, trans.). 1988. *The Argonautica, Book II.*
Aristophanes (Moses Hadas, ed. and Intro.). 1981. *The Complete Plays of Aristophanes*. Bantam Classics. Reissue. New York: Bantam Dell.
Aulus Gellius, (John C. Rolfe, trans.). 1927. *The Attic Nights.*
Caesar, (H.J. Edwards, trans.). 1917. *The Gallic War.*
Cicero, *Philippics* (Walter C. A. Ker, trans.). 1926.
Ctesias (Lloyd Llewellyn-Jones and James Robson, trans.). 2013. Ctesias' *History of Persia Tales of the Orient*. New York: Routledge.
Demosthenes, (C.A. Vince, M.A. and J.H. Vince, trans.). 1926. Section 15. Perseus.tufts.edu
Dio Cassius, (Earnest Cary, trans.). 1917. *Books XLVI-L.*
_____, (Earnest Cary, trans.). 1925. *Books LXI-LXX.*
Diodorus Siculus, (C.H. Oldfather, trans.). 1933. Books I and II, I–34.
_____, (C.H. Oldfather, trans.). 1935. II.35-IV.58.
_____, (C.H. Oldfather, trans.). 1954. Books XIV-XV.19.
_____, (Charles L. Sherman, trans.). 1952. *Books XV.20-XVI.65.*
Euripides, (Moses Hadas and John McLean, trans.). 1981. 'Hippolytus'. In *Ten Plays by Euripides*. Toronto: Bantam Books.
FGrHist (*Die Fragmente der griechischen Historiker*) 156 F 9.22–23). http://www.attalus.org (Accessed 25 June 2016.)
The Greek Anthology. (W.R. Paton, trans.). 1916. Vol. I.
Herodotus, (A.D. Godley, trans.). 1920. *Herodotus: Books I–II.*
_____, (A.D. Godley, trans.). 1922. *Herodotus: Book IV.*
_____, (A.D. Godley, trans.). 1925. Herodotus: Books VIII.
Hesiod, (Hugh G. Evelyn-White, trans.). 1927. *The Homeric Hymns* and *Homerica.*

_____, (Glenn W. Most, ed. and trans.). 2006. *Theogony.*
Hippocrates, (W.H. Jones, trans.). 1923. Vol. I. Air Waters Places.
Hippocrates, (E.T. Withington, trans.). 1928. Vol. III. On Joints.
Homer, (A.T. Murray, trans.). 1924-25. *Iliad,* (2 vols.).
Homeric Hymns, (Martin L. West, ed. and trans.) 2003.
Isidore of Seville. 2006. *Etymologies.* Translated by Stephen A. Barney, W.J. Lewis, J.A. Beach, Oliver Berghof. Cambridge: Cambridge University Press.
Livy, (B.O. Foster, trans.). 1929. *History of Rome Books XXI–XXII*
Frag. 125, http://www.perseus.tufts.edu, (Accessed 29 July 2017.)
Frag. 127, http://www.perseus.tufts.edu, (Accessed 29 July 2017.)
Lucian, (M.D. MacLeod, trans.). 1961. *Dialogues of the Sea-Gods.*
Lysias, (W.R.M. Lamb, trans.). 1930. *Funeral Oration.*
Orosius, Paulus, (Roy J Deferrari, trans.). 1964. *The Seven Books of History Against the Pagans.*
1981 printing. Washington, D.C.: The Catholic University of America Press.
Pausanias, (W.H.S. Jones, trans.). 1918. *Description of Greece. Book I. II.*
_____, (W.H.S. Jones and H. A. Ormerod, trans.). 1926. *Description of Greece. Books III and V.*
Plato, (Francis MacDonald Cornford, trans.). 1968. *Laws.*
Plutarch, (Bernadotte Perrin, trans.). 1914. *Lives: Theseus and Romulus, Lycurgus and Numa.*
_____, (Bernadotte Perrin, trans.). 1914. *Lives: Themistocles and Camillus.*
_____, (Bernadotte Perrin, trans.). 1919. *Lives: Alexander and Caesar.*
_____, (Bernadotte Perrin, trans.). 1920. *Lives: Demetrius and Antony; Pyrrhus and Caius Marius.*
_____, (Frank Cole Babbitt, trans. and ed.). 1931. *Moralia.*
_____, (Frank Cole Babbitt, trans. and ed.). 1931. *Bravery of Women* Perseus.tufts.edu
Polyænus, (Dr F.R.S. Sheperd, trans. adapted from 1793 translation). *Stratagems of War,* Book 8.56. http://www.attalus.org (Accessed 25 June 2016.)
Polybius, (W.R. Paton, (trans.). 1922. *The Histories.* Book II.
Quintus Smyrnaeus, (Alan James, trans. and ed.) 2004. *The Trojan Epic: Posthomerica.* Baltimore: The Johns Hopkins University Press.
Strabo, (Horace Leonard Jones, trans.). 1919. *The Geography of Strabo.* Books III-V.
_____, (Horace Leonard Jones, trans.). 1924. Books VI–VII.
_____, (Horace Leonard Jones, trans.). 1928. Books X–XII.
_____, (Horace Leonard Jones, trans.). 1929. Books XIII–XIV.
Suetonius (trans. J.C. Rolfe, trans.). 1913. *The Lives of the Caesars*: Domitian.

Tacitus, (M. Hutton and Sir W. Peterson, trans.). 1914. Agricola, Germania, Dialogus.
 _____, (Clifford H. Moore, trans.). 1925. *Histories: Books I-III.*
 _____, (Clifford H. Moore, trans.). 1931. *The Histories: Books IV-V.*
 _____, (John Jackson, trans.). 1925. The Annals: Books I-III.
 _____, (John Jackson, trans.). 1937. *Histories: Books IV-VI, XI-XII.*
Thucydides. 1934. *The Complete Writings of Thucydides: The Peloponnesian War.* The unabridged Crawley translation with an introduction by Joseph Gavorse. New York: The Modern Library.
Varro, (Roland G. Kent, trans.). 1938. *On the Latin Language.*
Velleius Paterculus, (Frederick W. Shipley, trans.). 1924. *Compendium of Roman History.*
Virgil, (H. Rushton Fairclough, trans.). 1916. *Virgil: Eclogues, Georgics, Aeneid I-VI.*
 _____, (H. Rushton Fairclough, trans.). 1918. *Virgil: Aeneid VII-XII, The Minor Poems.*
Xenophon (E.C. Marchant and G. W. Bowersock, trans.). 1925. *Scripta Minora.* The Lacedaemonians 1.4
 _____, The Economist 22–23 www.perseus.tufts.edu
 _____, Anabasis 3.2.11–12 www.perseus.tufts.edu
 _____, Hellenica 4.2.20 www.perseus.tufts.edu

Index

A

Acca and Opis, 198
Achaians, 65
Achilles, xv, xviii, 22, 61–4, 222
 Achilles' son, xv
 manhood, xv
 sulking, xviii
 shield, 22
 kills Penthesilea, 61
 with Herakles or Theseus, 61
 with Penthesilea, 61
 falls in love with Penthesilea, 63
Ada, queen of Caria, 118–9
Adad-nīrārī, king of Assyria, 114
Adamnán, 133, 138-9, 226
Adea-Eurydice, 121-2, 210
 see also Eurydice
Adea, 121–2
Adonis, 13
Aed the Red, 36
Aed, one of the three kings of Ireland, 36, 139
Ælfwynn, daughter of Æthelflæd, 155–6, 207
Aeneas, 27, 31, 66
Aeneid, 30–1, 59, 64, 66–7, 198, 237
Aeschylus, xiv, 21, 60, 235
 Prometheus
 Suppliant Maidens
Æthelflæd, Lady of the Mercians, 150
 see also Ethelfleda
Æthelflæd, xxii, xxviii, xxix, 108–9, 111, 152–7, 182, 184, 207, 211, 234, 205
 marriage to Æthelræd, 150
 death of King Alfred, 151,
 becomes 'Lady of the Mercians', 151
 dealings with Hingamund, 152
 gives birth to Ælfwynn, 155
Æthelræd, king of Wessex, 151
Æthelred of Mercia, 156–7
Æthelred the Unready, 157, 160
Aetolians, 132
Afghanistan, xxiv, 47, 196, 219
Aganippus, king of the Franks, 81
Agon, king of Illyria, 132
Agrippina the Elder, 124
Ahhotep, 111–2, 117, 184, 202, 220
Ahmose, 112
Ahura Mazda, main Zoroastrian god, 20
Aife, 71–3, 184
aigis, 2, 221, n. 2
Ailill, husband of Medb, 69–70
Akkad Empire, 3
Akkadian, x, 2–4, 6, 11–12, 25, 191
 war god, 4
 goddess of sex, 11
Alaisiagae, war goddesses, 41, 43, 195, 209
Alaisiagis, 41, 43
Alba [Scotland], 153
Albania [in the Balkans], 197, 214, 234
Albania [in the Caucasus], 61, 100
Albanian [in the Balkans], 80, 104, 197, 204, 211, 189

Index

Albanian *zana,* 80
Albigensian Crusade, 164
Alcetas, 121
Aldy-Bel culture, 102
Alecto, 21
Alesia, 31
Alexander [the Great],
Alexander the Great, 120,
 122–3, 183
 had Amyntas killed, 121
 died in Babylon, 121
 Alexander's throne, 121
 after Alexander's death, 121
 Alexander's sister, 121
 Cynane's daughter Adea, 121
 mother of Alexander, 122
 son of Philip, 121
 son of the Macedonian regent
 Polyperchon, 123
 dalliances with Amazon
 queens, xv
Alexander (Persian tradition), 233
Alexander (son of Polyperchon), 123
Alexander II, Pope, 171
Alexander Romance, xv, 232
Alexandria, 204
Alexandrian War (48–47 BC), 130
Alfonso I of Aragón, 179
Alfonso VI (1065–1109) of León-
 Castile, 178–9, 206
Alfred the Great, 150, 157, 205, 207
Allecto, 40
Almanzor, 178
Alvild, 77–8, 185
Amage, xxii, 56, 113, 115–6, 184
Amazon queens, xv, 52
Amazonomachy, xxvi, 62
amazons, 108, 111, 128
 Amazons, xii, xiv, xv, xvi, xvii, xxiv,
 xxvii, xxviii, xxx, 25, 38–9, 42,
 45, 51 54–67, 76, 78, 82–3, 85,
 92–3, 95–6, 100, 108, 126, 162,
 176, 184, 186–7, 196–7, 205,
 209, 212–3, 215–6, 219, 222–3,
 225, 227, 230, 232
 tales of, 54
 symbol of female aggression, 54
 daughters of Ares, 55
 Amazon dress, 56
 Amazons of the East, 58
 the issue of breasts, 58–60
 Scythians, 60–1
 location, 61–2
 iconography, 62
 Amazon queens, 63
Ambrones, 107, 140
Amenophis II, 10
Amenophis III, pharaoh, 17
Ammianus Marcellinus, 131, 137–8,
 215
Amyntas, son of Philip II's brother
 Perdiccas III, 121
Anabasis, 27, 217
Anāhitā, 19–20, 27, 29, 49
Anatolia, vi, 6, 16–18, 61–2, 116,
 118, 136, 213
Anatolian, 57, 203, 224
Anchises, 13
Andraste, 33–4, 136
Andromache, xvii, xxi, 60
Angantyr, 77
Anglo-Saxon Chronicle, xi,
 xxvi–xxvii, 149, 232
Annals of Ireland, Three Fragments,
 152–3, 227
Annals of Ulster, 139, 154, 218
Antimachos, 65
Antipater, 121–3
Antope, 60
Anu/Danu, 34
Aphrodite *Areia*, 26–8
Aphrodite *Morpho*, 28
Aphrodite *Ourania*, 27
Aphrodite *Pandemos*, 27

Aphrodite, 10, 13, 23, 25–9, 120, 188, 192, 210, 212, 215, 233
Apollo, 28, 58, 63, 204
Apollodorus, 24, 58–9, 63, 197–8, 235
Apollonius Rhodius, 62, 197, 235
Appendage Syndrome, xxvi, 110–111
Aramazd, 29
Archidamia, 119
Archives, 17, 86, 165, 232
Arduino della Paluda, 237
Ardvi Sûra Anâhita, 20
Areia, 22, 25–8
Ares, 13, 21–3, 25–6, 55, 61–3, 225
Arədvī Sūrā Anāhitā, 19
Argives, 119
Arinna, 18–9, 23, 232
Armed Aphrodite, 26
Armenia in the Lori Province, 100
Armenian goddess, v, 29
armour, xxiii, xxvii, xxviii, 23, 25, 29, 31, 36, 56, 67–9, 72, 76, 80, 83, 85, 89, 93–4, 98–9, 118, 122, 172
 Gordyeh's armour, 68
 of Diana, 67
 iron armour, 93
 heavy fighting belt, 94
Adventure of Art Son of Conn (Echtrae Airt meic Cuinn), 72
Arras culture, 106
arrowheads, 80, 85, 88, 92–6, 98–9, 102
Arruns, 67
Artemis *Orthia,* 28
Artemis, 2, 13, 26, 27–8, 59, 119, 184–5, 192–3, 202, 204, 210
Artemisia (1) Queen of Caria, 116–18
Artemisia (2), 118–9
Aššur, 114
Astarte, 3, 7–8, 10, 17, 25–7, 30, 211
 similarity to Anat, 10

Aśvins, 53–4, 65
ATA (Air Transport Auxiliary), 118
Atharva-Veda Samhitā, xi, 48
Athena *Hippeia,* 23
Athena *Promachos,* 23
Athena, 1, 8, 13, 21–5, 28–30, 44, 46–7, 49, 52, 59, 80, 204, 207, 213, 232
 characteristics shared with older goddesses, 23
 warrior dress, 58
Attic, 18, 23, 56, 62, 118, 235
Audata-Eurydice, 120–1, 184
Aulus Gellius, *The Attic Nights,* 118
Aurelian, 142–3
Avesta, xi, 1–2, 19, 103, 190, 192, 212, 226
Aymyrlyg, 97, 226

B

Baal, 7–8, 10, 15, 191, 210, 231
Badb Catha, 35
Bahram Chubineh, 68
Barber, Elizabeth, 13, 51, 80, 97, 208
basileus, 111, 147, 185
basilis, 147
basilissa, 111, 147
Batavi war of 69 AD, 74
Battle of Bosworth Field, 109
Battle of Bråvalla, 77–8, 82
Battle of Clontarf, 39
Battle of Covadonga, 177
Battle of Hastings, 109
Battle of Kadesh, 103
Battle of Salamis, 117–18
Baudi 'war', 41
Baudihillie, 43–4
Bé Neít, 34
Beadu 'battle', 41
Beaduhild 'War-Maiden', 41
Beatrice of Lorraine, xxii, 170–1
Bebbe, 149

Bede (one of the two Alaisiagae) 41, 43, 136
Bede (the Venerable), 136
Bellerophon, 56
Bellona, 30–1, 36, 40, 204, 244
Berengaria of Navarre, 164
Bernard of Clairvaux, 110, 166
Besseringen, 105
Bikjholberget cemetery, 88
Birka, x, 86, 88–91, 102, 205, 186, 199, 220, 228
Bj.581, x, 89–92, 105, 186, 228
body and head wounds, xxvii
Bogøvej, 86–7
Bolgic, 36
Book of Deeds of Arms and of Chivalry, 176
Bosanquet, 43–4, 195, 209
Bosnians, 80
Bothvild 'War-Maiden', 41–2
Boudica, xxii, 33–4, 67, 85, 110, 133, 135–8, 150, 159, 204, 217
 speaks to Andrasta, 34
 Green questions her reality, 135
 led her army, 136
 raised her army, 136
Bover, 100–101, 222
breasts, 8, 34, 58–9, 62, 65, 197
Brigantes, 133–4, 219
Briseis, xviii, 188
Brísingamen, 42
Britannia, 33, 136, 217, 220
Bronze Age, 21–2, 26, 37, 96, 189, 219–20
bronze helmets, 85
bronze mirror, 83, 93–4, 102
brooches, 88, 199, 220
Brothers Grimm, xv
Brown Bull of Cooley, 70
Brutus, 81
Brynhild, 39
Brynhildr, 39

btlt, 7–8, 12
Búanann, 72
Budin, Stephanie, 6, 13, 25–7, 192–3, 210, 225
Bulgarian *samovila,* 80
Busa, 129, 184
Byzantine Empire, 145
Byzantium, 11, 145–6, 219

C
Caesar, xxiv, 31–2, 103–104, 112, 125–30, 183, 186, 203, 215, 235–6
 observer of Celtic religion, 32
 used for sex, 186
Cáin Adamnáin (Law of Adamnán), 226
Caius Marius, 140, 236
calathos, 102
Caliphate of Córdoba, 178
Camilla, xiv, xv, 66–7, 82, 176, 184
Camillus, 30, 236
Carians, 116, 118, 203
carrion birds, xiv, 30, 42, 49
cart burial, 105–106, 201, 213
Carthage, 30
Cartimandua, 133–5, 137, 229
 her consort not king, 133
carts, 104, 106
casket handle, 88
Cassander, 122–3
Castellani Painter, 62
Catherine of Aragon, 71, 109
Catherine the Great of Russia, xvii
cats, 42
Celtiberian, 38
Celtic evidence, xxv
Celtic Goddesses, 31–3, 46, 217
Celtic linguistics, 193
Celtic myths, xxvi
Celtic religion, xxv, 32, 193, 212
Celtic traditions, 32

Celtic war goddesses, 33, 39
Celtic women, xxiv, 131, 137–8, 185, 214
Celts, xxvii, xxviii, 31–35, 37, 51, 69–70, 82, 85, 106, 131–2, 137–9, 193, 213, 225, 228–31
 three entities in one, 31–2
 Continental Celts, 32
 war goddesses, 32
 Irish Celts, 34
 mirrors, 106
 Onomaris, 137
 Galatian, 138
Chadwick, Nora, 44, 148
chamber grave, 87, 228
Chandika, 46–7
chariot, xxvii, 10, 19–20, 30, 36, 42, 60, 67, 72, 81, 103–106, 201, 210, 219–21, 225, 229
 inventor of chariot, 23
 difference between cart and chariot, 104
 chariot burials, 105
charioteer, 67, 103–4
Chersonesians, 115–16
Chibnall, Marjorie, 180, 210
children, ix, xvii, xxiii, 12, 28, 47, 49, 54, 57, 59–60, 65–6, 84, 94, 107, 120, 124–5, 140, 156, 159–60, 162, 168, 170–1, 177, 180, 183, 200, 208
 treatment in war, xviii, 66, 140
Chilonis, wife of the Spartan King Cleonymus, 119
China, 68, 96–7, 159, 188, 197, 223, 225–6
Chiomara, 136–7, 194
Cholodny Yar, 87, 93
Chowhougou cemetery complex, 96, 226
Christian scholars, xxvi
Christine de Pisan, 176

Christopher Columbus, 182
Cimbaeth, 36, 139
Cimbri, 107, 140–1
Cimmerians, 100
Ciumeşti helmet, 37
clay spindle-whorls, 83
Clayton, Ellen, 189, 221, 224
Cleopatra VII, xxix, 108, 112, 129
Cleopatra, xxix, 108, 112, 129
Code of Lekë Dukagjini, 197, 221
coinage, 29, 143
coins, 27, 84–5, 125, 129, 134, 143, 193, 207
Colbert, Claudette, 203
Connacht, 69
Constantine V, 146–7
Constantine VI, 146
Constantinople, 143, 145, 147–8
Continental Celts, 32–3
Corcyrean women, xxv
Cordelia, 81–2, 199
Corinthian, 56
Coriolanus, xv
Cornwall, 81
Cosmas of Prague, 170, 173, 211
Countess Agnes Randolph Dunbar, 163
crania trauma, 99
Cratesipolis, 123–4, 225
Croats, 80
Cronus, 21
crows, 17, 38, 49
Cruinniuc, 36–7
crusades, 164–5, 225
Ctesias, 116, 202, 224, 235
Cú Chulainn, 34, 36–7, 54, 70–3, 82, 103
cuirass, 29, 165, 287
Culhwch and Olwen, 199
cultural attitudes, xxvi
cumalach 'female bond servants', 139

Cyclopes, 1
Cynane, 109, 120–1, 123, 184
Cyrus the Great of Persia, 115

D
Da Choca's Hostel, 35, 231
Da Derga's Hostel, 35
Dahomey, 207
daimyo, 188
Danish king Harold Wartooth, 77–8
Darraðarljóð, 39
Davis-Kimball, Jeannine, 83, 92, 95–97, 200, 208, 212–3, 226, 234
 'warrior-priestess', 89
 Sintashta "Chariots," 220
Deichtine, 103
Deir el-Bahri, 112
Delbchaem, 74
Denmark, 76, 78, 86–8, 164–5, 164, 185, 217, 219, 230
Deo Marti, 43
Deor's Lament, 195
Derevlyanins, 148
Despensers, 168–9
Devī-māhātmya, 45, 49, 213
Devī, 45, 49–50, 101, 175
Devitsa V cemetery, 101
Dexter, Miriam, viii, 10–11, 26, 28, 37, 44, 49–50, 194–5, 208, 212
Diana, 66–7, 193, 202, 213, 215, 231, 234
Dio Cassius, xxiv, 31, 34, 74, 126, 131, 136, 203–204, 235
Diodorus Siculus, xxiv, 55, 57–8, 100, 113, 121–4, 131, 202, 236
 Scythians were connected to Amazons, 60
Diomedes, 24, 27
Dione, 25
dirham Arabic coin, 87
Discordia, 30–1
dísir (sing. *dís*), 41

Dithorba, 36, 139
DNA analyses, 87
DNA testing, 84, 91, 93
Domitian, 29, 128, 236
Domnall Mildemail, 'the war-like', 71
Don, 65, 93–5, 101, 209, 217, 231
Duellona, 30
Durgā Pūjā, 45
Durgā, 8, 24, 45–9, 207, 220, 227
Dürkheim, 105

E
Edict of Caracalla, 142
Edict of Milan in 313, 145
Edict of Thessalonica, 145
Edward the Elder, 150–1, 155–6, 207
Edwin, king of Northumbria, 150
Egeler, Matthias, 38, 70, 194, 214
Egyptians, xxiii, 3, 103, 130
Eleanor of Aquitaine, 164, 166, 219, 233
Eleanor of Castile, 164
Elizabeth I of England, xiii, xvii, 183, 185, 187, 191, 196, 223
 virgin as a title, 108
 her male connections, 110
Elvira, wife of the Count Raymond of Toulouse, 166
Emain Macha, 36–7, 140
Emer, xxv, 2, 26, 73, 164, 172, 194, 198
Emma, Countess of Norfolk, 162
Emperor Augustus, 124
Emperor Hadrian, 43, 141
Emperor Meihad III (842), 148
Emperor Nicephorus, 147
Emperor Septimius Severus, 142
Emperor Tiberius, 125, 203
Empress Elizabeth, daughter of Peter the Great, xvii
Empress Irene, 111, 146, 149, 230

Empress Matilda of England, 110
Empress Matilda, x, xxix, 110,
 157–62, 171, 173, 184, 211
 claim to throne, 157
Enyo, 21–2, 30–1, 52
epigraphy, 32
Epona, 33, 193, 223
Epstein, Angelique Gulermovich, 34,
 36, 38, 194, 214
equus, 33, 224
Ereshkigal, goddess of the
 Underworld, 3, 192
Erinyes, 21–2, 28, 31, 51
Erinys, 40
Eris, 21–2, 31, 52
Erni, 73
Ernmas, 34–5
Estrildis, 81
Etruscan goddess, 29
Etruscan, 29–30, 217, 227
etymologies, xxx
Etymologies, 197, 236
Eumenides, 21
Eurasian Steppe, xvi, xxviii,
 14, 83, 86, 91–2, 186,
 213, 218
Euripides, 26, 62–3, 197, 235
Eurydice, 121–3
Exekias, x, 62–3
Exodus, 39

F
falkhamn 'falcon coat', 42
Fea, 34, 37
Feast of Bricriu, 54, 218
female cart burials, 106
female grave, 88–9, 92–5, 98, 100–1,
 105 107, 111, 199
 weapons in female grave, 83
 survey of weapons, 88
 votive items, 111
female skeleton, xxix, 86, 94, 98

female warriors, xix, 62, 86, 97, 186,
 189, 211
 on Eurasian Steppe, 83
 social status, 95
Fenian Cycle, 72
Ferdinand of Aragon, 180
Ferdowsi, 68, 198, 215
Fergus mac Roich, 71, 185
fertility-goddess, 192
fertility, xiv, xxvii, 3–4, 7–8, 13–5,
 17–19, 25, 28, 32, 42, 45, 49–52,
 108, 124, 182, 196
 fertility and prosperity, 4
 pairing of war and fertility, 30
 three aspects of fertility, 37
 vile, rusalki and fertility, 80
 sex and fertility, 103
 Maria Therese, 186
 fertility-goddess, 192
fetialis, 31
Fialko, Elena, 93–5, 215
Fimmilene, 41, 43
 see also Alaisiagae
Findmór wife of Celtchair, 70
Finn mac Cumall, 72
Finnilene, 43
 see also Alaisiagae
First writing, 15
Flateyjarbók, 42, 195, 230
Flinders Petrie, 111
Flodden, 109
Florence Chronicle, 154, 215
Florine of Denmark, 164
Fólkvangr 'battlefield', 42
forest-steppe, 93, 95, 98, 208, 229
Fragmentary Annals of Ireland,
 152, 228
Fraser, Antonia, xxvi, 110, 215, 204
Fravši, 20
Freyja, 42
Freyr, 42
Friagabi, 43–4

244

Frog Princess, 13
Fulvia Flacca Bambula, 125–7, 203, 207, 209, 213, 218
 universally disliked, xxii
furies, 21, 31, 40

G
ga bulga, 71
Gaia, 21
Gaius Marius, 107
Gaius Scribonius Curio, 125
Galatians, 136–7
Galava, 13
Gallic War, xxiv, 103–104, 235
Gardeła, Leszek, 87–9, 91, 199–200, 216
Gaulish inscriptions, 32
Gauls, 32, 131, 138
Gaveston, Piers, 167–9
Gazhdaham, 67
geese, 14, 27, 30
Gening, V.V., 14, 104, 107, 216
Genpei War, 188
Geoffrey of Monmouth, 81–2, 136, 216
Gerard de Camville, 163
Gerðr (see Þorgerðr Hölgabrúðr), 44
Gerdrup, 86, 93–4, 211, 221
Gerdui, 69
German Emperor Henry V, 158, 173
Germanicus, 124, 203
Gesta Stephani, 110, 161, 216
Gildas, 136, 159, 217, 234
Gimbutas, Marija, 208, 217
Gladiators, x, 128, 225–6
Godfrey the Hunchback, 172
Gordafarid, 67–8, 184–5
Gordyeh, 68–9
Gostahm, 69
Goths, 143–4
Graeco-Roman iconography, 56
Graf, xix, 26–7, 217

grave, x, xxv–xxvii, 14, 37, 61, 73, 77, 83–96, 98–102, 104–7, 111–12, 171, 186, 226
 curse of Macha, 37
 Cholodny Yar, 93
 double grave, 221
 oval brooches, 199–219
 Devitsa V cemetery, 101
 Zenobia coins, 143
 Birka Bj.581, 228
 Minerva coins, 193
greaves, xxiii, 56
Greek Anthology, 59, 235
Greek vase painters, 56
Green, Miranda, 217
Griffith, Ralph T. H., 53–4, 217
Grímnismál, 42, 194–5
Guliaev, Valerii, 62, 85, 93–5, 101, 217
Gungnir, 1
Gurith, 77–8
Gwendolen daughter of Corineus, 81
Gwenllian, 162, 184

H
Hadrian's Wall, 43
Hakon the Good, 38
Hákonsrmál, 39
Halathguth the Swanwhite, 42
Halicarnassus, x, 54, 117–8, 128, 211
Hallstatt period, 105, 107
Hamðir, 41
Hannibal (219–202 BC), 129
Hathor, 10
Hatshepsut, 110, 112. 214
Hattuša, 17
Hector, xviii, xix, xxi
Ḫedammu, 18
Hedenstierna-Jonson, Charlotte, 89–90, 218, 228
Heimskringla, 204
Helen of Troy, 64, 209

Helena, 148, 148
Hellenic period, 29
helmet, xxiii, xxvii, xxviii, 22–3, 28 29, 32, 37–9, 47, 56, 58, 68, 72, 85, 120, 165, 187, 193
 goat-skin shield, 2
 boar's tusk helmets and swords, 23
 helmet with two horns, 25
 Bellona with a helmet, 31
 Ciumeşti helmet, 37
Henry Count of Portugal, 178
Henry of Huntington, 150
Henry VIII, xvii, 71, 109, 160, 178, 230
Hephaestus, 13, 24
Hera, xxiii, xxvii, 7, 24, 30, 51, 56, 61–3, 94, 208, 211
Heraia, xxiii
Herakles, 24, 56, 61–3, 94
Herfiǫturro 'war-fetter', 41
Hermaeus, the Festival of Impudence, 120
Herodianus, 142
Herodotus, xv, xvii, xxiv, 25, 55–8, 60–1, 100, 115, 117–18, 213, 235
 stories of Amazons, 93
 women Zauekes were chariot drivers, 103
 often our chief informant, 113
Hervor, 42, 77
Hesiod, xiv, 20, 22, 25, 220, 235
Hetha, 77, 185
Hippocrates, xvi, 52, 236, 200
Hippodameia, 65, 82
Hippolyta, 60
Hippolytus, 26, 62–3, 197, 235
History of the Danes, 75, 230
History of the Kings of Britain, 81, 216
Hitler, xxii, 183
Hittite goddesses, 19

Hittite texts, 188
Hittites, xxv, 16–20, 62, 103, 203, 209–11, 224
Hlathguth, 41
Hnossa, 42
Hollander, Lee M., 41, 76, 195, 219
Homer, xii, xiv, xviii, xix, 20, 22–3, 25–7, 50, 52, 57, 61, 63, 191–2, 196, 216, 220, 222, 230, 233, 235–6
Homeric Hymns, 20, 192, 235–6
horse bit, 88
horse, xiv, 10, 13–14, 20, 23–4, 33, 36–8, 52–7, 59–60, 62–3, 88–9, 91–3, 95–6, 98–9, 104–106, 116, 221, 230
 horse milk, 59
 twin horse gods, 65
 Fergus (mac Róich), 70
 Valkyries in various forms, 80, 84
 horse gear usually thought for men, 102
 Viking army given horses, 151
 Matilda of Tuscany riding astride, 174
 Isabella's daughter, 181
 Kikkuli Text, 229
 Horse treatise, 192
Housesteads, 41, 43
Hrafnsmál, 39
Hrólfr Gautreksson Saga (*Hrólfs saga Gautrekssonar*), 79
Hugh Despenser, 168
Huld, Martin, xxviii, 60, 85, 219
Hunno-Sarmatian period, 97
Hurrian, 3, 16–17, 192, 231, 234

I

Iberian Peninsula, 177
Icelandic Sagas, 75–6, 222
Iceni, 34, 67, 110, 135
iconoclasm, 146

iconography, xxvi, 2, 23, 32, 55–6, 128, 190, 211
Idrieus, 118–19
Iliad, xii, xiv, xvii, xix, 21, 23–7, 47, 58, 61, 187, 236
Illyrian, 120–1, 132, 234, 204
Inanna, 2–6, 8, 10, 17, 25–6, 47, 50, 184, 190, 192, 234
Indo-European traditions, 32
Indus Civilization, 47, 196
Ingimund, 152
Iraq, xxiv, 3, 17, 190, 202, 230
Ireland, 13, 36, 52, 70, 72–4, 133, 139–40, 152–3, 193, 198, 201, 224, 227–9, 233
 war goddesses, 34
Irish Celts, 34
Iron Age graves, 105
Iron Age, 93, 95, 97–9, 105, 201, 207–8, 210, 213, 218, 220–1, 226, 228–30, 234
iron hook, 88, 139
iron mount, 88
Irpa, 44
Isabella I of Castile (1451–1504), 180
Isabella of France, xxix, 167
Isabella Queen of England, xxvii, xxix, 167–70
Išhara, 17
Ishtar, x, 3, 6–8, 20, 26, 204, 234
Isidore of Seville, 197, 236
Iskorostan, 148
Íslendingasögur, 75
Ištar, 3, 6, 8, 12, 16–20, 27, 47, 208, 230
Ivar the Boneless, 77

J
Jackson, Kenneth, 204, 220
James IV, 109
Jamison and Brereton, 48, 54, 190, 196
Jeanne de Champagne, Queen of Navarre and Brie, 167

Jenkins, John S., 189, 220
Jesch, Judith, 76, 78, 86, 88, 91, 220
jewellery, 8, 46, 83, 99
Joan of Arc, xiii, xiv, xxii, xxvii, 167, 172, 185
John Gower, xv
Jones-Bley, Karlene, 14, 104, 201, 220
Jordanes, xv, 143, 226
judgment of Paris, 187
Julia Vipsania Agrippina, known as Agrippina the Elder, 124
Julius Caesar, *see* Caesar
Juno *Moneta*, 30
Juno *Sospita*, 30
Juno, 30, 51, 143
Juturna, 67, 104

K
Kaiyeyi, 80–1
Kālī, 8, 45, 47–9, 199
Kapelrud, Arvid, 7, 10, 12, 35, 51, 201, 222
Kara, 39
Kaupang, 88, 212
Keegan, Paul, xii, xx, xxi, xxii, xxiii, 64, 221
Kelly, Patricia, 71, 221, 198
Khela, 53–4
Khosrow II, 68–9
Kidwelly (Cydweli) Castle, 162
Kikkuli Text, 192, 229
King Amorges, 136
King Caratacus of the Silure tribe, 133
King Cydraeus of the Saka, 116
King Dasaratha, 80
King Eirekr, 79
King Harald Wartooth, 77
King Ḫattušili III, 17
King Henry I of England, 157
King Hlothvér, 195
King Hrolf, 79
King Lear, 81

King Louis VII, 166
King Mahishasura, 45
King Muršili II, 18
King Níthoth 'Grim Warrior', 42, 195
King Níthoth, 42, 195
king Prasutagus, 135
King Richard, 163, 207
King Šamši-Adad V, 113
King Tudhaliya IV, 18
Kingdom of León-Castilla under Queen Urraca, 206, 229
Kinsella, Thomas, 37, 70–2, 139, 194, 198, 222
Kjellström, Anna, 90, 218, 222
knives, xxviii, 83, 85, 93, 99, 102, 111
Krákumál, 41
Kumarbi Cycle, 18

L

La Tène period, 105, 107
Lacedaemonians (Spartans), 26
Lacedaemonians, 28, 119–20, 237
Lady Hao, 200
Lady Macbeth, xx, xxii
Lady of the Mercians, 152, 154, 205, 207, 211, 234
Lampeto, 143–4
Langeland, 86–7, 217
Lanuvium, 30
Late Bronze Age, 26
Lathgertha, 77
Latins, 30
Law of Adamnán, 133, 226
Lay of Volund, 42, 195
Lebor Gabála Érenn, 72, 198, 224
legends, vii, xv, xxv, xxxvi, 14, 32, 51, 57–8, 62, 74–5, 82, 186, 225
Leigh, Vivian, 203
leprosy, 36
Leto, 28
Lindisfarne, 86

Linear B tablets, 22, 27
Linear B, 21–2
Lisht, 111, 224
Littaurer and Crouwel, 104
Locrinus, 81
Lokasenna, 42
Loki, 42
Lottner, C., 38–9, 224
Lucius, 126–7
Lycurgus, 28, 236
Lygdamis of Halicarnassus, 117
Lysias, 55, 60, 236

M

Mabinogi, 195, 215, 221
Macalister, R.A.S., xv, 36, 73, 197, 198, 224
Macdonell, Arthur, 53–4, 224
Macha Mongruad, 36, 139
Macha, 18, 33–4, 36–8, 72, 139–40
Mādhavī, 13–14
Maev, 36
 see also Medb
Mahābhārata, 13, 46–7, 191, 195–6, 198, 225
Mahisha, 46–55
Maid of Orleans, xiv
 see also Joan of Arc
Maiden Castle, xxvii
male burials, 99, 201
Mallory, James P., 58, 87, 187, 189–90, 192–3, 102, 204, 221, 225
 major IE homeland theories, 190
Mallory, James P. and D. Q. Adams, 58, 97, 187, 189–90, 192–3, 204, 225
Manamoto no Yoshinaka, 188
Manlius Capitolinus, 30
Marazov, Ivan, 59, 225
Margaret of Anjou, 71
Marguerite de Provence, 164
Maria of Pozzuoli, 175

Marc Antony, 112, 125–6, 129, 186
Markale, Jean, xxvii, 225
Marpesia, 143–4
Mars, 29–31, 41, 43–4, 67, 174, 204
Matilda of Boulogne, 159–60, 164, 212
Matilda of Tuscany, xvi, xvii, xxii, xxix, 108, 170, 173, 182, 212
 a woman of achievement, 173
 military lessons from her mother and stepfather, 184
Matriarchal, xxvii
Mausolus, 118
Medb, 14, 34, 36, 38, 69–73, 137–8, 140, 184–5, 212, 221
 see also Maev
Megaera, 21
Melanippe, 62–3
Menerva, 29
Mercia, xxvi, 108–109, 111, 149–56, 205, 207, 211, 232, 234
Mercian Register, 153
Mermerus, King of the Parthians, 116
Messenians, 28, 120
Messianic, xx, xxii, xxiii
Migration Period, 38
Minerva, 29–30, 66, 72
Minoan divinity, 23
mirror, 83–4, 105–106, 217
Mitanni, 17, 191–2
Mjollnir, 1, 89
Moralia, 120, 202, 236
Morrígan, 33–8, 45, 49, 71–2, 194, 214–5
Mórríoghan, 194, 226
Môt, 15, 191, 210
Mothers, xviii, xx, xxii, 43, 45, 47, 54, 58, 197
Mudgalānī, 103, 209
Muhammad, 145–6, 204, 219
mummification, 102
mummy of a child, 102

Murâbits, 179
Murphy, Eileen M., 83, 96–7, 200, 220, 226
Muslim armies, 177–8

N

Nachthexen 'night witches', 189
Nanaya, 193
Nane, 29
Napoleon, xxii
Naqada, 111, 227
needle case, 86
Nemain, 33–4, 37–8, 70
Neman, *see* Nemain
Nemed, 36
Nennius, 136
Neoptolemus, ruler of Molossia, 122
Nerio, 31
Nicolaa de la Haye, xxii, 162, 171, 183, 205
Nikalmati, 16
Nine Witches of Gloucester, 72
Nineveh, 6, 17, 208, 229
Niobe, 28
Nirṛti 'Black Bird', 49
Njal's Saga, 39, 227
Njörd (the sea god), 42
non-Indo-European, 16, 29
Norman Conquest, 86, 149
Norns, 40
Norse sagas, xxiv, xxvi, 198
Northumbria, 86, 149–51, 153, 162
Nuada, 37
numismatic evidence, 84
Nürenguo, 58
Nusayba Bint Ka'b (Umm 'Umara), 146

O

O'Flaherty, Wendy, 53, 196, 214, 227
O'Rahilly, Cecile, 33–5, 70, 194, 198, 227

O'Rahilly, T., 36, 71, 227
Octavian, 31, 127, 131
Octavius, 127
Odaenathus, 142
Odin, *see* Oðinn
Oðinn, 1, 38, 41–2, 194
Oedipus, 21
Old Europe, 197, 192
Olympias, 120, 122–3, 203, 210
Olympic games, xxiii, 188, 232
On Heroes, 59
Onomaris, 137–8, 215
Orderic Vitalis, 161, 210
Ordzhonikidze, 94
Orenburg oblast, 95
Orosius, xv, 58, 236
Oscans, 30
Oseberg ship burial, 91, 195
Osteoarthriti, 96
Otherworld, 14, 104, 106, 194, 201, 221
Ottoman Turks, 145

P
Pallas Athena, 24
Palmyra, 110, 141–3, 232–3
Pandatería, 125
Papal Bull of 1189, 166
Parthenon, 24, 56
Paston, Margret, 176, 212
Paulus Silentiarius, 59
Pausanias, xxiii, 25–7, 120, 197–8, 236
Pazyryk, 97, 201, 221, 230
pelta, 56, 62
pelvic area, 84, 200
Penthesilea, x xv, 59–67, 162, 174
Perdiccas, 121–2
Peredur, 72
Persians, v, 27, 56, 67, 115, 118
Perusine War, 41–40 BC, 127
Peter the Great, xvii

Petersen type H axe, 88
Petrarch, 175–6
Philip Arrhidaeus, 121
Philip II of Macedonia, 120–4, 233
Philip III, 121
Philippa of Hainaut, 170
Philippe IV (the Fair) of France, 167
Philostratus, 59
Phoenicians, 25
Phrygian Kybele, 29
Phrygian, 29, 56
pig bones, 105–106, 201
Pisindelis, 117
Plato, 25, 28, 236
Plutarch, 28, 30, 107, 119–20, 126–7, 129–31, 137, 140, 197–8, 202–203, 236
 women did not shirk from battle, 119
 says how charming Cleopatra's voice, 198
Plutarch's *Moralia*, 202
Poetic Edda, 76, 219
Pokrovka, 95, 193
Polyænus, 115, 118, 120–1, 202–3, 236
Polyperchon, 122–3
Pomeroy, xxvi, 13, 24, 28, 121, 126, 215, 228
Pompey, 130
pottery, 83, 93, 99, 200, 220
Prasutagus, 133, 135
pre-Christian texts, 32
Prema and Pertunda, 30
President Carter, 189
Priam, xii, xiv
Price, Neil, 218, 228
priestess, 5, 33, 40, 74, 87, 89, 92, 95, 141, 212–13
primary central position, 95
Primary Chronicle, 148, 212
Prince Alfonso Raimúndez, 179

Prince Edward, 168–9
Prince Igor (ca. 913–945) the son of Rurik, 148
Princess Olga, 148–9
Prose Edda, 41, 76, 227, 232
Ptolemy XIII, 130
Ptolemy XIV, 130
Ptolemy, 123–4, 130, 203
Publius Clodius Pulcher, 125
Puduḫepa, 17
Puhvel, Jaan, 13–14, 188, 214, 228
Punic, 30
Purgatorio Purgatory Canto, 173
Pyrgi gold tables, 30
Pyrrhus, 28, 119, 236
Pyrrhus, the Molossian king, 119

Q

Queen Ahhotep, 111, 117
Queen Archidamia (ca. 340–241 BC), 119
Queen Cartimandua, 133, 229
Queen Hatshepsut, 110
Queen Isabella of Castile, x, 180
Queen Matilda of England, 110, 160–1
Queen Melisende of Jerusalem, 110
Queen Olǫf, 79
Queen Puduḫepa, 17
Queen Septima Zenobia of Palmyra, 110
Queen Teuta, 132
Queen Urraca, 179, 206, 229
Quintus of Smyrna, 65
Quintus Smyrnaeus, 22, 63, 66, 236

R

racehorse, 53–4
Ralph of Diss, 110
Rāmāyana, 46, 80–1, 195, 198, 228
ravens, 37, 49
Red Macha, 37

regenerating virgins, 13, 191
Rennes Dindshenchas, 36, 231
Rhodes, 118
Richard III, 109
Richard the Lionheart (Richard I), 167, 205
Ricola, 149
rite of the vultures, 38
Rolle, Renata, 14, 83, 92–4, 199, 229
Roman army, 33, 133
Roman Britain, 133
Roman goddesses, 29
Roman, xi, xv, xxii, xxvii, 4, 10, 16, 21–2, 26, 36–8, 43, 51, 62, 65–6, 74–5, 107, 127–47, 151, 157–58, 170–2, 190, 192–3, 195, 197, 199, 202–4, 208, 210, 215–6, 218, 222–3, 225–6, 229–32, 234, 237
 Roman goddesses and gods, 29–34, 72
 tales and iconography of Amazons, 54, 56
 Geoffrey on pre-Roman times, 81
Ross, Anne, 33–5, 36, 72, 229
Rudenko, S. I., 201, 230
Rudradeva, 175
Rumi helmet, 68
Runic inscriptions, 37
Rurik, 148
Rusila, 77–8, 185

S

Sabine War, xxi
Sabines, 30–1
Saga of King Heidrek the Wise, 77, 233
Saka, 54, 83, 93, 116, 200, 203, 234
Samhasura, 80
Sammu-ramāt, 113–15, 231
Šamši-Adad, 113–14
Sancho García IV, 178
Sarasvatī, 48

Sargat, 54, 94, 96, 98–100, 200
Sarmatians, 54, 58, 92, 115–6, 200, 203, 218, 232
Saryg-Bulun in the Tuva republic, 102, 222
Sauromatians, 54, 60, 95
Šauška-Ištar, 17–18
Šauška, 3, 8, 16–18
Saxo Grammaticus, 75–6, 204, 230
scabbards, 106
Scáthach, 71–3, 184
Scenn Menn, 73, 82
Scordisci, 137–8, 204
Scota, 72–3, 198
Scribonia, 124
Scriptores Historiae Augustae (SHA), xi, 141, 143
Scythian graves, 61, 83, 95
Scythian, 27, 54, 56–8, 60–3, 83, 92–8, 100–102, 106, 115–16, 200–203, 209–10, 215, 220, 226, 228–30, 232
Seiðr, 89, 199
Sekhmet, 8, 10–11
Sela, 77–8
Semiramis, 110, 113–14, 186, 230
Semitic, 2, 7–8, 12, 191, 207
Senakhtenre Taa I, 112
Seqenenre Taa II, 112
Sequanna, 33, 193
Serbs, 80
Sermo Lupi, 40
sex and fertility, 103
sexing techniques, 84
Shahnameh, 67–8, 198, 215
Shakespeare, xv, 81–2
Shalmaneser III, 114
shield, xv, xxiii, xxvii, 2, 10–11, 29–31, 33, 39, 58, 60–3, 79, 84–5, 88–9, 96, 106–107, 140, 176, 184, 190, 195, 197, 215
 Achiles' shield, 22
 figure-eight shield, 22–3
 round shield, 26
 Skuld's shield, 41
 held by Mars, 44
 crescent shield, 64, 67, 85
shieldmaidens, 76–8, 82, 87, 220
Shumbha, 47
sickle, 88
Sigrun, 39
Sintashta graves, 107
Sintashta vehicles, 107
Sintashta, 107, 220
Slavic war goddess, 44
Slovaks, 80
Snorri, 41, 44, 75–6, 194, 204, 227, 232
soapstone vessel, 88
Sǫgubrot, 230
Sohrab, 67–8, 185
Solon, 24
sorceress, 35, 87
Sörli, 41
southern England, xxvii
Southern Sweden, 86, 88
sovereignty, 32–3, 37, 78, 181, 221
Soviet women, xxi, xxiii, 189
Spanish Armada, 187
Sparethre, 116
Sparta, xxii, 25, 28–9, 119
Spartan, 28, 119, 184, 228
Spartan King Agis IV, 119
Spartan king Cleomenes, 119
spearheads, 93, 95, 106–107
spindle-whorl, 83, 88, 93–4, 105
Standard of Ur, 201
Stephen of Blois, 158
Stikla, 77–8
Stolpe, Hjalmar, x, 86, 89–90
Strabo, xxiv, 55, 58, 60–1, 100, 118–19, 131, 141, 236
Strategemata of Polyænus, 115
strike-a-light, 87

Index

Stuttgart-Bad Cannstatt, 107
Substrate, xxvi, xxvii, 2
Suetonius Paulinius, 135
Sulimirski, Tadeusz, 92–3, 232
Sulis, 30
Sumerian Civilization, 2
Sumerians, xiv
Sun Goddess of Arinna, 18
Svafa, 39
Svarog, 80
Svetlana Alexievich, xxi
swans, 27, 80
swords, xxvii, xxviii, 23, 60, 62, 85, 93–5, 97–9, 105–7, 140, 182, 188, 199
 makes an aristocratic grave, 89
 infrequent in female graves, 93
symbols of power, 1, 85
Synod of Biri, 138

T

Tacitus, xxiv, 37, 74, 124, 128, 132–6, 203, 223, 237
Táin Bó Cúalnge (*The Cattle Raid of Cooley*), 34
Tale of the Heike, 188
Tamara of Georgia, 111
Tarquina, 106
Taurica (modern-day Crimea), 115
Taylor, Elizabeth, 203
Taylor, Timothy, 59, 232
Telesilla of Argos, 119
Teresa of Portugal, xxii, 178–80, 237
terracotta shield, xv, 61, 63
Teššube, 18
Thalestria, 60
The Library, 57, 59, 188, 197, 206, 229, 235
The Táin, 36–7, 69–72, 103, 139, 185, 194, 201, 221–2
Thebans, 28
Theda Bara, 203

Theogony, 21–2, 236
Thermodon River, 61–2
Theseus, xv, 61–3, 197–8, 236
Thracians, 56, 230, 232
Thutmosis I, 112–13
Thutmosis II, 112
Thutmosis III, 112–13
Tinesus, 41
Tinia, 30
Tisiphone, 21, 40
Tisiphononos, 65
Tocharian speakers, 200
Tochmarc Ferbe (*The Courtship of Ferb*), 36
Tomoe Gozen of Japan, xxiv
Tomyris, xxii, 115
Tovorg, 68
trainers, xix, xxiv, 72, 184
Treasure of the City of Ladies or the Book of the Three Virtues, 177, 228
Treaty of Zamora, 206
Trekroner-Grydehøj, 86
Trieu Thi Trinh, xxiv, 189
Trinovantes, 135
Trojan Epic, 22, 35–6, 63, 236
Trojan War, xxi, 21, 64, 234
Trojans, xviii, 24, 56–7, 61, 63–4, 234
trousers, 56, 103
Trung sisters, xxiv, 189
Trung Trac and Trung Nhi (also known as Hai Bà Trung), 188
Tuatha De Dannan, 73
Turnus, 66–7
Turnus' charioteer, 67, 104
Tušratta, 17
Týr, 44

U

Ugarit, 17
Ukraine, 87, 92–4
Ulster Cycle, 35
Ulster, 18, 35, 37, 70, 139, 154, 218

Ulstermen, 18, 37
Umbrians, 30
Uni, Etruscan Great Goddess, 30
Uranus, 21, 25
Urartu (Bianili) Kingdom, 100
Urraca of Leon-Castile, xxii
Urraca of Spain, xxii, 178–80, 206, 229
Uruk, 3–4, 14, 190
Ürümchi and Korla Museums, 97

V

Vāc, 47–8, 178, 227
vajra, 1, 189
Valhalla, 38, 194
 see also Valhöll
Valkyries, *wælcyrge*, xxvi, 20, 35, 38–43, 46, 50–2, 77–8, 80, 88, 184, 195, 212–15, 220
valkyrja, pl. *valkyrjur*, 40
Vanir gods, 42
Vebiorg, 77–8
Vedic deities, 192
Vedic scholars, 54, 103
Veleda of the Bructeri tribe, 74, 137
Velleius Paterculus, 127, 237
Vellocatus, 134–5
Venerable Bede, 136
Venutius, 133–4
Vietnam, xxiv, 188–9, 233
Viking Age, 38, 86, 88–9, 195, 216, 220–1
Viking kings, 195
Viking warrior, 90–1, 218, 228
Vikings, xxix, 38, 151, 153–4, 205, 220
Vile, 80, 134, 139, 173
Virago, xvi, xvii, xix, xxii, xxviii, xxx, 6, 24–5, 47, 51, 55–6, 67–8, 71, 74, 79, 108, 111, 115, 122, 125, 135–6, 138, 147, 154–5, 173, 187, 203, 210, 225, 230

viragos, xvi, xvii, xix, xxviii, xxx, 47, 51, 55–6, 108, 111, 128, 203, 225
Virgil, xiv, xv, xxx, 59, 63–4, 66–7, 237
virginity, xiv, xvii, 11–14, 19, 27–8, 51, 68, 108, 124, 155–6, 191, 218, 231
virgins, xvi, xxviii, xxx, 12–13, 60, 108, 111, 189, 191, 197, 217, 225, 234
Virtus, 31
Viśpalā, 53–4, 103, 196
Vîstâspa, 20
Volnaya Ukraine, 94
Vǫluspá, 41
Voronezh Oblast, 101
Vṛtagna, 80

W

wælcyrge, 40
war chariots, 103–105
war goddesses, xxvi, xxviii, 1–2, 4, 14–6, 18–21, 23–8, 31–5, 37–9, 43–5, 49–52, 69, 82, 186
 associated with fertility, sex and virginity, xiv
 Ugaritic war goddesses, 7
 Egyptian war goddesses 10–12
 first evidence, 14
 Near Eastern, 184
warrior woman, xiii, xiv, xvii, 54, 73, 92, 95, 187, 198
warrior's grave, 85
Washer at the Ford, 35–6
WASPs (Women Airforce Service Pilots), 189
Watkins, Calvert, 61, 225, 234
weapons, xx, xxvi, xxviii, 1, 3, 6, 10, 23, 28, 35–6, 41, 46, 49–50, 55–6, 59, 60–2, 67, 76, 80, 83, 85–6, 89–91, 95, 99–100, 102, 105–106, 122, 175

Welsh Creiddylad, 230
Western Europe, xxvii, 91, 107
Wetwang Slack, 105–106
Wetwang Village, 105
Wetwang, 105–107, 213, 219, 220
wheeled vehicle, 103–105, 107, 224
William II (William Rufus), 157–8
William Montague, Earl of Salisbury, 163
Woman/women, xiii–xvi–xix, xxi–xxiii, xxvii–xxix, 1, 4–5, 7, 11–2, 24–5, 28, 34–7, 45, 47, 51, 53–4, 60, 65–71, 73, 76–8, 84, 86–9, 91–2, 94–6, 101–102, 106, 108, 110–11, 114–8, 120, 124–5, 128, 130–3, 135–40, 142–3, 146, 148–50, 154–5, 157–8, 160–3, 166–7, 169–70, 172–7, 180, 182–5, 187, 191, 198, 200, 203–206, 208–18, 220–8, 230–1, 233–4
Wonder Woman, xvi, 54, 196, 202, 222
wooden arrowheads, 85
Wooing of Emer, 73, 194, 198
Wright, Brenda, 200

X

Xenophon, xix, 27–8, 237
Xerxes, 117–18, 185

Y

Yablonsky, Leonid, 83, 95, 200, 213, 220, 228, 234
Yalan-Sineh, 69
Yašt, 19–20, 192, 212
Yazılıkaya, 17
Yrsa, 79

Z

Zarinaea, 116
Zauekes, 103
Zemo-Avchala, 92
Zenobia of Palmyra, 110, 141–4, 186, 230, 232–3
Zenobian coinage, 143
Zeus, 1–2, 21–2, 24–6, 46, 65, 190
Zoroaster, 190
Zoroastrian, 20, 209
Zroya (Zarya), 44

Þorgerðr Hölgabrúðr, 44, 210
Þornbjörg, 79